A FINE LINE

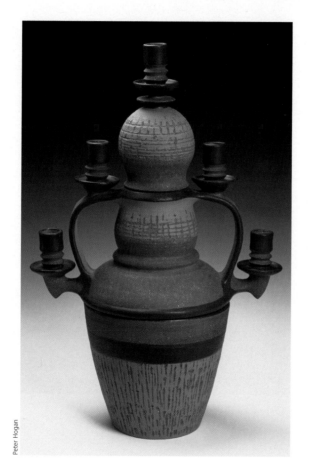

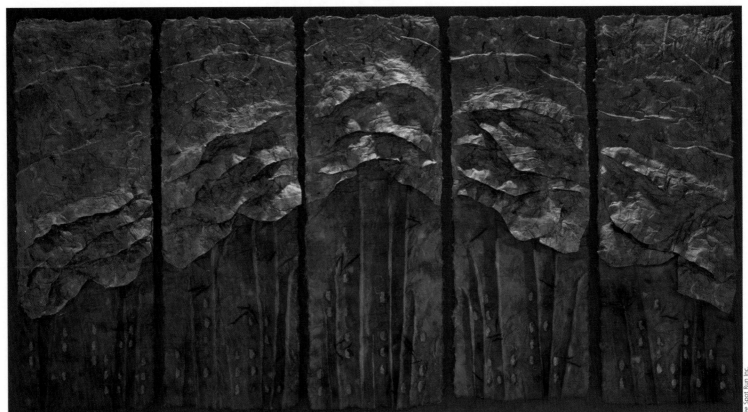

A FINE LINE

Studio Crafts in Ontario from 1930 to the Present

by Gail Crawford

Principal photographer: Peter Hogan

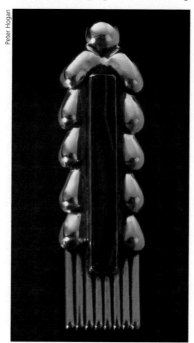

Peter Hogan

DUNDURN PRESS
TORONTO • OXFORD

Editor: Dennis Mills
Book design: V. John Lee
Page layout: Kim Monteforte/Heidy Lawrance Associates
Printer: Transcontinental Printing - Book Division.
Front cover photograph: Peter Hogan

Canadian Cataloguing in Publication Data

Crawford, Gail (M. Gail)
 A fine line

ISBN 1-55002-303-9

I. Handicrafts — Ontario — History — 20th century. I. Title

NK842.O5C72 1998 745.5'09713'0904 C98-931591-6

1 2 3 4 5 DM 02 01 00 99 98

THE CANADA COUNCIL | LE CONSEIL DES ARTS
FOR THE ARTS | DU CANADA
SINCE 1957 | DEPUIS 1957

Dundurn Press is grateful to **The Canada Council for the Arts**, Writing and Publishing Section and Visual Arts Section, for the additional funding provided to make the publication of this book possible. We also acknowledge the support of the **Ontario Arts Council** and the **Book Publishing Industry Development Program** of the **Department of Canadian Heritage**.

Care has been taken to trace the ownership of copyright material used in this book. The author and the publisher welcome any information enabling them to rectify any references or credit in subsequent editions.

Printed and bound in Canada.

 Printed on recycled paper.

Dundurn Press
8 Market Street
Suite 200
Toronto, Ontario, Canada
M5E 1M6

Dundurn Press
73 Lime Walk
Headington, Oxford
England
OX3 7AD

Dundurn Press
2250 Military Road
Tonawanda, NY
U.S.A. 14150

Dundurn Press also thanks the **Jean A. Chalmers Fund for the Crafts**, administered by the Visual Arts Section of The Canada Council for the Arts. Assistance from the fund made possible the research and design of this book.

Dundurn Press also expresses its appreciation to Miss Elisabeth Wallace and the Burlington Art Centre for their invaluable assistance.

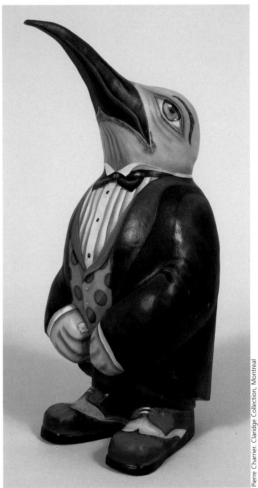

Pierre Charrier. Claridge Collection, Montreal

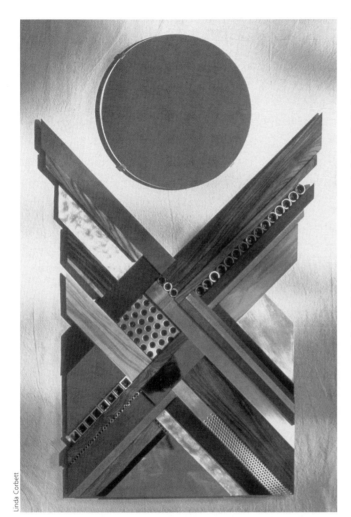

Linda Corbett

Page i: Trained in England, United States, and Canada, Toronto potter Molly Satterly had a bent for research, a gift for science, and a curiosity to experiment with new glazes. Using a wax-resist technique, she made this sectioned stoneware candelabra about 1959, which reflects an adventurous approach to materials and an assured sense of design.

Page ii: In 1981, Susan Warner Keene created the 3.7 x 1.8-metre *Metaphoric Landscape: Callanish*, her first large-scale work in the felted flax medium that has become her specialty. It first appeared in London, England, in a Canadian exhibition marking the opening of the Barbicon Centre and later toured continental Europe.

Page iii: Gold wheat-sheaf pin with malachite, designed and executed by Toronto jeweller Nancy Meek in 1937. The piece was first shown in the Canadian Pavilion at the Paris Exposition that same year. Meek wore it publicly in 1992 when she received the Order of Ontario for her work with refugees, a cause in which she was known as Mama Nancy.

Page iv: Folk artists James and David Paterson added to their stable of saucy wooden figures with *Mr. Penguin Off To The Club*, a 46-cm-tall sculpture made in 1989.

Although he is primarily a goldsmith, Barrie's Donald A. Stuart has demonstrated a gift for inlay in any medium. In this 1997 57 x 86 cm mirror that he calls *Egoiste*, he has combined copper, brass, aluminum, steel, with various exotic hardwoods.

Table of Contents

Glossary of Organizations

AGO	Art Gallery of Ontario
AGT	Art Gallery of Toronto
AISG	Artists in Stained Glass
BCC/BAC	Burlington Cultural (Art) Centre
CC	Canada Council/ Canada Council for the Arts
CBBAG	Canadian Bookbinders and Book Artists Guild
C_2G_2	Canadian Clay & Glass Gallery
CCC	Canadian Crafts Council (now Canadian Craft Federation)
CGC	Canadian Guild of Crafts (Ontario)
CHG	Canadian Handicrafts Guild (Ontario Branch)
CGP	Canadian Guild of Potters
CMC	Canadian Museum of Civilization
CNE	Canadian National Exhibition
CQA	Canadian Quilters' Association
FUS	FUSION: The Ontario Clay and Glass Association
GAAC	Glass Art Association of Canada
HAC	Handcrafts Association of Canada Inc.
JLT	Junior League of Toronto
MAG	Metal Arts Guild
MT	Museum for Textiles
OAC	Ontario Arts Council
OCA (D)	Ontario College of Art (and Design)
OCC	Ontario Crafts Council
OCF	Ontario Craft Foundation
OHCG	Ontario Hooking Craft Guild
OHS	Ontario Handweavers and Spinners
OWA	Ontario Woodworkers Association
OWCA	Ontario Wood Carvers Association
OC	Order of Canada
OPA	Ontario Potters' Association
RCA	Royal Canadian Academy of Arts
ROM	Royal Ontario Museum
SCL	Society for Creative Leathercraft
SNAG	Society of North American Goldsmiths
SOCAD	School of Craft and Design (Sheridan College)
SWO	Spinners and Weavers of Ontario/Toronto Guild
SUR	Surfacing: Textile Dyers and Printers Association (Ontario)
WCC	World Crafts Council
WAAC	Women's Art Association of Canada

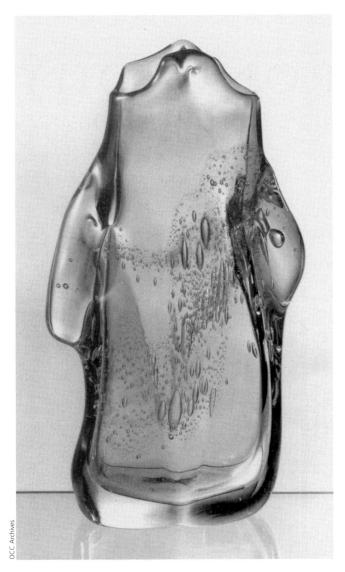

Glass blower Brian J. Ashby studied his craft at Sheridan College and built a studio practice in Muskoka. This 7.6 x 15 cm vase was part of *Art In Craft* in 1975.

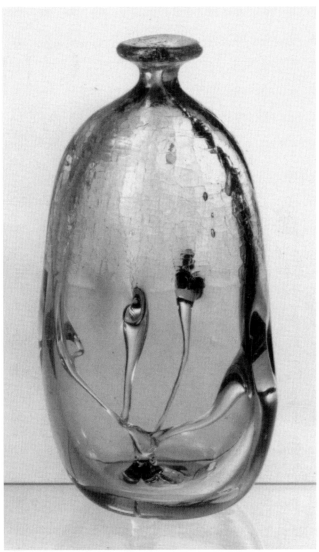

Michael Robinson won the glass award for this root crackle vase in the 1975 exhibition, *Art In Craft*.

CHRONOLOGY

MAJOR EVENTS IN ONTARIO'S CRAFT DEVELOPMENT

1930s

1931
- HAC established in Toronto, changed its name legally in 1938 to CHG, and later to CGC.
- A three-week exhibition of Canadian contemporary crafts opened in January at the Toronto galleries of Ridpaths Limited furniture store, featuring demonstrations by metalsmith Rudy Renzius; woodcarver Stephen Trenka; batik artist Constance Pole; weavers L. Van Berkel, Antoinette Brunet, Hephzibah Stansfield; potters John W. Gratton, Gwyneth Pullen, Vera Clark, Mary Basset. Thousands attended.
- Swedish metalsmith Rudy Renzius opened an art studio/home at 65 Gerrard Street West in Toronto's Greenwich Village, then just beginning to develop as an art and craft colony. He moved from The Grange Studios, 15 Grange Road, a short-lived cooperative space for working, living, and retailing. Other craftspeople soon followed, notably jeweller Nancy Meek and potter Nunzia D'Angelo.

1932
- The foyer of the new Eaton's College Street in Toronto and Eaton Auditorium were the site of a second Canada-wide craft exhibition, April 25–30, attended by 7,281 and coordinated by HAC. In mid-July HAC opened a craft retail outlet, The Guild Shop, on the main floor of Eaton's where it remained until 1950. Managed by Adelaide Marriott until 1944, the shop had sales of $8,000 in its first eight months.
- In the fall, Rosa and Spencer Clark began The Guild of All Arts in Scarborough with its first craft studios in woodworking and hand-loom weaving. Other craft mediums soon followed.

1933
- HAC staged a multi-cultural Canada-wide craft festival June 5–10 at Eaton Auditorium, attended by 8,000.

1936
- CGP formed in Toronto under the leadership and encouragement of Robert J. Montgomery, ceramic engineering professor at the University of Toronto. Intending to represent national interests and makers from coast to coast, CGP nonetheless functioned mainly as an Ontario-centred organization, as dictated by Canadian geography.

1937
- International exposure for Ontario crafts came at the Paris International Exhibition of Arts and Crafts in Modern Life when 30 ceramic pieces were selected by CGP together with other work assembled and arranged for the national office of the Canadian Handicrafts Guild by Adelaide Marriott. Following Paris were exhibitions in Glasgow, Scotland, and at Madison Square Gardens in New York.

1938
- Ten members of CGP invited to participate in the prestigeous 7th National Ceramic Exhibition in Syracuse, New York; their work was first seen at the Guild's inaugural annual exhibition at AGT, site of its annual exhibitions for 15 years.
- The Guild of All Arts in Scarborough opened a second craft retail outlet in central Toronto, at 44 Bloor Street West, which remained in business until 1943 by which time war-time yarn shortages made shop supplies hard to come by.

1939 • Reflecting popular interest in weaving, the Spinners and Weavers of Ontario staged an inaugural exhibition at the Lyceum Women's Art Association galleries on Prince Arthur Avenue in Toronto. By mid-1950s the organization was known as the Toronto Spinners and Weavers and, today, simply as the Toronto Guild of OHS.

1940s

1940 • The restored Barnham House at Grafton, owned by the Architectural Conservancy of Ontario, officially opened. As main tenant, CHG operated an outlet with a comprehensive range of Canadian handcrafts. It continued on and off until December 1948.

1941 • Canadian potters invited to participate in the *Contemporary Ceramics of the Western Hemisphere* exhibition in Syracuse, N.Y. Of 26 participating Canadians, 18 were from Toronto.
 • War-time shortages in personnel and materials spelled the closing of most craft operations at The Guild of All Arts in Scarborough, from which disruption they never completely recovered.

1942 • CHG hosted a third exhibition at Eaton Auditorium April 28–May 2. Opened by the Governor General, the Earl of Athlone, and Princess Alice, some 4,700 attended. The Guild's public meetings suspended during the war.
 • The CNE, a major source of show space and prize money, was cancelled 1942–46.

1945 • To celebrate achievements in contemporary design, CHG and ROM sponsored *Design in Industry* May 17–June 10 at ROM, the first in a series of ambitious postwar-time exhibitions featuring ceramics, glass, jewellery, leatherwork, silver work, textiles, and objects from wood.
 • OCA expanded its campus to Nassau Street to accommodate returning service personnel; that campus served as a focus for design and much-expanded craft training

for five years, the first such institution in Canada to establish an industrial design department.

1946 • MAG organized in Toronto with the expressed aims of establishing standards, providing instruction, conducting tests and examinations, and promoting proficiency.
 • Quebec weaving guru Oscar Bériau engaged as craft consultant by Ontario Ministry of Planning and Development to encourage and promote craft making in rural and northern sections of Ontario. His successor, Joseph Banigan, had been a president of HAC. Department renamed the Home Weaving Service of the Department of Education, reflecting its mandate to develop domestic weaving. Mary Eileen Muff joined Service as an instructor in 1949 and helped to bring weaving to many small communities. In addition, her department helped establish provincial guilds in leather, lapidary work, metal and jewellery crafts, and rug hooking.

1948 • The Kingston Hand-Weavers organized a club with guidance and assistance from professional weaver "Rie" Bannister, Dutch-born craftsperson and teacher. In September the following year, the Ottawa Valley Weavers Club evolved from the Bytown Weavers' Guild formed in 1947; and in London, the London District Weavers formed and soon organized the first of its Shuttlecraft exhibitions. Other weaving guilds came together in a number of major centres.
 • Ryerson Institute of Technology opened. English-trained jeweller Percy W. (Jim) Green headed jewellery department 1948–53 when program moved to the Provincial Institute of Trades. Most prominent alumnus was B.C. carver and metalsmith Bill Reid.
 • The province's most durable arts-and-crafts umbrella organization, the Guelph Creative Arts Association, established under the leadership of Prof. Gordon Couling of the Fine Art Department at Macdonald Institute. Among the founding groups were weavers, silversmiths,

leatherworkers, and two pottery groups: The Guelph Potters and Royal City Ceramists. Membership has remained remarkably constant at the 170 figure.

1949 • With $500 in borrowed capital, "Millie" Ryerson opened The Artisans at 51 Gerrard Street West in Toronto's Greenwich Village, a retail outlet and craft support service that was a bedrock to many, and which she operated until the late 1960s when it was sold to the World University Service.

1950s

1950 • Celebrating AGT's golden jubilee, *Contemporary Canadian Arts* exhibition held March 3–April 16. Work was selected by CGP, CHG, and SWO to provide a panoramic overview of bookbinding, ceramics, leatherwork, printed fabrics, metalwork, needlework, spinning and weaving, stained glass, and wood carving.

• Seventeen committed leather craftspeople formed the Society for Creative Leathercraft to encourage original designs and establish high standards of craftsmanship. A quarterly bulletin, *Canadian Leathercraft*, appeared the next year, and the year after that, the first of its travelling exhibitions.

• The Guild Shop moved from Eaton's College Street to 1217 Bay Street, in Toronto, and by 1952 had relocated to 77 Bloor Street West, its home for another 19 years.

• British ceramic authority Bernard Leach added Toronto to his North American tour of lectures and workshops and made the clay community aware of a Japanese-British sensibility that was to influence generations. His appearance began a yearly tradition of CGP bringing internationally acclaimed potters to Toronto for workshops and lectures.

1951 • Massey Report on the Royal Commission on National Development in the Arts, Letters and Sciences consolidated attention briefly on the world of arts and crafts

and spawned the formation of the CC in 1957, renamed Canada Council for the Arts in 1997.

1953 • On February 6, First Annual Canadian Home Weaving Exhibition at the London Public Library and Art Museum, organized and sponsored by the London District Weavers.

1954 • As part of the growing internationalism in the craft world, ROM staged *Design in Scandinavia* October 19–November 21, attracting the who's who of Toronto society.

1955 • ROM followed the success of the Scandinavian exhibition with *Designer Craftsmen USA* May 17–June 22; accompanied by afternoon lectures, it received extensive media coverage.

• CGP annual exhibitions became biennial events held at ROM in Toronto and Montreal Museum of Fine Arts. The arrangement continued to 1971.

• Jewel Schwartz opened an upscale craft retail store, Trade Winds, at 150 Bloor Street West in Toronto, relocating in 1963 to 138 Cumberland Street.

1956 • OHS formed to bring together the weaving guilds throughout the province. From its inception, OHS published its own newsletter and organized classes for members.

1957 • Ottawa's National Gallery held its first national, juried, fine-crafts exhibition attended by invitation only. From the exhibition, a group of about 50 works comprised the fine-crafts section of the Canadian Pavilion in the Universal and International Exhibition, Brussels, Belgium, in 1958.

1958 • CGP brought craft to the world of theatre by organizing a successful exhibition at the Stratford Shakespearean Festival. The following year, CHG went one better by presenting a national juried exhibition and sale of work in all craft media in Exhibition Hall. CHG continued these Stratford presentations until 1964.

1959 • At the Second International Congress of Contemporary Ceramics at Ostend, Belgium, Toronto potter Helen

Copeland captured a silver medal for a slab-built vase, heightening the growing profile of Ontario ceramists.

1960s

1960 • Toronto Outdoor Art Exhibition, which also showcased crafts, began at Nathan Phillips Square and has grown to the largest event of its kind in North America.

1961 • CHG hosted a high-profile international jewellery exhibition, *Dali In Jewels*, at ROM, one of the first large-scale fundraising events staged by its Women's Committee.
 • *Weaving '61* mounted by ROM, its only contemporary exhibition of weaving since 1950, featured work of Toronto Spinners and Weavers, formerly Spinners and Weavers of Ontario.
 • Biennial exhibitions of CGP moved beyond Toronto and Montreal to tour other Canadian cities and awakened general public to professional accomplishments.
 • The Hamilton Handicraft Guild united potters, weavers, puppet makers, leathercrafters, jewellers, and other metal workers in a multi-craft organization. In 1967 it reconstituted itself as The Artisans' Guild of Hamilton.

1962 • In Prague, Czechoslovakia, Canada's potters competed with 11 countries, its general exhibit winning a silver medal. Dorothy Midanik and Marion Lewis, two of The Five Potters, won individual gold medals, six other Ontarians won silver, and four received honourable mentions.
 • One of Ontario's most enduring grass-roots support groups, Muskoka Arts and Crafts Association, came into being. Its annual summer outdoor exhibition in Bracebridge has, since 1963, been a fixture of the Muskoka scene.
 • In November, Alan Jarvis, then editor of *Canadian Art*, officiated at the opening of 100 Avenue Road in Toronto, national headquarters of CGP as well as its retail outlet. Five weeks later, sales in the shop had totalled $4,500.

1963 • The Guild Shop, owned and operated by CHG, was enlarged at 77 Bloor Street West in Toronto to include a small gallery on the second floor. A branch opened in 1965 at 98 Wellington Street in Stratford, which remained in business to 1969.
 • In April, Bill 162 created OAC as a vehicle for provincial patronage of the cultural scene; its first annual budget was $300,000. A first priority was the whole field of problems that faced craft development in the province.

1964 • WCC, which drew on some Ontario organizational talent, staged its inaugural meeting at Columbia University in New York City.

1965 • Following a federal initiative to allocate one percent of estimated construction costs of new federal buildings to art projects, Ontario Premier John Robarts commissioned large-scale craft work along with art to enhance government buildings in larger centres.
 • Joining the swelling ranks of provincially based media guilds, the OHCG was formed.
 • CHG's Women's Committee presented *Ontario Master Craftsmen* as the first exhibition in the Guild's upstairs gallery.

1966 • A second craft service organization, OCF, grew out of two conferences sponsored by OAC and Community Programmes Branch of the Ontario Department of Education. During its 10-year history, OCF promoted quality craft education for professionals, produced a regionally focussed magazine, and attempted to develop marketing systems for craft work.

1967 • Ontario opened 22 community colleges, many of which taught craft programs. Most influential and durable has been Sheridan College, now in Oakville, whose School of Design first provided a full range of craft courses at its Lorne Park Campus in Mississauga.
 • *Canadian Fine Crafts* prepared for the Canadian Pavilion at Expo '67 in Montreal reflected the growing excellence of contemporary crafts.

- Toronto craft pioneer and advocate Adelaide Marriott awarded the Canada Medal for her work in the arts, the first major award to recognize work in the craft field as part of our national culture.
- Grass-roots pottery activity exploded, guilds forming first in Kingston and Waterloo, then Burlington, Hamilton and Region, Sudbury, Thunder Bay, Stratford, Ottawa, and Toronto.

1969 • On February 1, CGC (renamed from CHG in 1967) purchased 140 Cumberland Street in Toronto for $105,000 for its retail shop.
- *Craft Dimensions '69*, a pivotal exhibition mounted by CGC at ROM, was the largest and most comprehensive national craft exhibition to that time and the first of four biennials that CGC staged. Two years in the planning, the show featured work by 123 craft makers. Of the 22 prizes of $100 each, more than half were earned by Ontario residents.
- Toronto bookbinder Robert Muma named the first winner of a new scholarship for professional craftspeople donated by CGC's Women's Committee. He was then 52 and used the $1,000 to study in the United States.

1970s

1971 • *Jewellery '71* at AGO (formerly AGT) surveyed international trends in contemporary jewellery by showcasing the work of 119 painters, sculptors, and craftspeople, 24 of whom were Ontario residents.
- Canadian, American, Mexican, and Japanese potters exhibited together in *Contemporary Ceramic Art* at Japan's National Museum of Modern Art, confirming Japan's growing interest in western ceramics.
- CGC continued its biennials by co-sponsoring *Make (Mak)* at the Ontario Science Centre, an exhibition of contemporary Ontario crafts. It also initiated a craft magazine,

Craft Dimensions/Artisanales, which eventually developed a national profile.
- In Ottawa, Barbara Ensor opened Wells Gallery on Sussex Drive where she presented fine craft alongside fine art. Five years later, on the same street, Vicky Henry founded Ufundi and soon after, Martha Scott began Hibernia Gallery devoted solely to fine craft. In Kingston, Thelma Edge opened Upper Edge Gallery. Similar gallery activity took place in London.

1972 • CGC opened a new craft gallery at its headquarters on Prince Arthur Avenue in Toronto to provide more extensive space in which to focus attention on leading work.
- CC's Art Bank opened in May, purchasing craft, sculpture, paintings, and prints for rent to corporate offices. In a cost-cutting measure, the federal government in 1996 reduced the scale of the Bank's activities.

1973 • CGC's third biennial, *Entr'Acte*, at the O'Keefe Centre in Toronto, featured 94 Canadian craftspeople, whose entries were based on theatrical themes. The exhibition then toured seven Canadian cities.

1974 • The most talked-about show of craft ever staged internationally, *In Praise of Hands*, came to the Ontario Science Centre in conjunction with meetings of WCC in Toronto. From it, Jean A. Chalmers purchased the Canadian entries for the Jean A. Chalmers Collection of Contemporary Canadian Craft. June 10–15 was declared craft week in Toronto.
- On Toronto's waterfront, craftmakers were hired as summer public entertainment when former industrial spaces became makeshift craft studios that eventually grew into the Harbourfront Craft Studio.
- CCC, based in Ottawa, emerged from an amalgamation of the Canadian Guild of Crafts and the Canadian Craftsmen's Association, founded in 1965.

1975 • The Canadian Museum of Textiles and Carpets was

established by Max Allen and Simon Waegemaekers in Toronto's Mirvish Village.

- Canadian Craft Show (One of a Kind) introduced a Christmas retail market on the CNE grounds with 88 participants (now more than 600). A spring show was added five years later.
- International Women's Year featured a range of craft exhibitions in several centres. In Toronto, they appeared at Harbourfront, AGO, and CGC's Prince Arthur Gallery.
- *Art In Craft*, the swansong biennial of CGC staged at the London Art Gallery, showcased work of 81 craftspeople, chosen from 603 entries across the country.
- OPA came into being in April with Hamilton-area potter Donn Zver as founding president, a post he held for five years.
- AISG formed and became incorporated in Ontario two years later. Founding members of the Toronto-based national organization worked mainly in the architectural field and on autonomous pieces.
- North York's Koffler Gallery opened under founding director Jane Mahut with a mandate to highlight leading craftspeople. Its first exhibition in 1977 showcased weaving innovators.
- Pearl B. Whitehead of Toronto, a stellar volunteer with CHG and a board member, made a member of OC, the first craft supporter to be acknowledged by the governor general.

1976
- OCC grew out of a second amalgamation: OCF with CGC. First executive-director was Paul Bennett of CGC; founding president was M. Joan Chalmers, CGC's last president. Vice-president was Jean Burke of Sault Ste. Marie, OCF's last president. Its first exhibition, *Crossroads*, held at OCC's new gallery on Dundas Street West, honoured both functional and decorative work by the province's leading makers.
- CGP devolved into Master Craftsmen of Canada and

then Ceramists Canada, to serve the needs of professional masters. CGP's informative newsletter *Tactile*, first published late in 1966, was put to bed August 1976.

1977
- OWCA formed to promote an interest in and appreciation of woodcarving, through regular newsletters, meetings, workshops, demonstrations, annual exhibitions. Its membership today averages 350 men and women.
- To honour individuals who made both outstanding work and major contributions in their craft field, Montreal's Bronfman family established the Saidye Bronfman Award for Excellence in the Crafts. First recipient was potter Robin Hopper, then a resident of the Barrie area. Since then, Ontarians have been honoured on many occasions.

1978
- BCC coalesced the area's art and craft guilds: weaving, pottery, woodcarving, as well as painting and sculpture. In 1993 the facility evolved into BAC.
- *Artisan '78*, organized by CCC, was the first national touring exhibition of contemporary Canadian craft, comprising 122 pieces invited from craftspeople representing every province and the Northwest Territories. The work eventually formed the Jean A. Chalmers National Craft Collection.

1979
- Two enduring galleries enlivened the Toronto craft scene: The Glass Art Gallery on Hazelton Lane under Janak Kendry, who hoped to make Toronto an international glass centre, and Prime Canadian Crafts on Queen Street West under Suzann Greenaway, who focussed on multimedia. In 1992 she relocated her premises to more spacious quarters on McCaul Street, under the banner Prime Gallery.
- Craft midwife Mary Eileen "Bunty" Muff Hogg made a Member of OC for her seminal work on provincial, national, and international stages.
- SUR organized, reflecting the growing trend for fibre craftspeople to work with printed rather than woven textiles.

- OWA founded and soon attracted 200 members. It mounted major conferences in 1980, '82, and '84, and published a newsletter, but by 1986 its executive decided to suspend all activity. Its legacy was an annual OWA award, in wood, presented at OCC's annual general meetings.
- Funded by Museums Assistance Programmes of the National Museums of Canada, OCC beefed up its travelling craft exhibition schedule. In its "Craftpacking" series, professional makers had mini-exhibitions in lucite cases offered to galleries, community colleges, festivals, libraries, and other organizations. Within a year, 30 such exhibits became available for touring.
- Muskoka Autumn Studio Tour established by a vanguard of craftspeople and artists who opened their homes and studios for a weekend of drop-in visitors. Ontario now has some two dozen such events in both spring and fall.

1980s

1981
- GAAC became reality at a conference in Trois Rivières, to forge links between Canadian glass artists through conferences and seminars. Since 1986 it has regularly published a forum for the hot-glass community, *Glass Gazette*.
- CQA was created to unite quilters across the country.

1982
- Toronto quilt-artist Joyce Wieland named Officer of OC, the second of Ontario's working craftspeople to be honoured by the governor general's office at that level, joining medallist Dora de Pedery-Hunt, who became an Officer in 1974. Four others were to join them as Members: Toronto tapestry artist and teacher Helen Frances Gregor (1987); stained-glass designer-maker Russell Goodman of West Hill and now Parry Sound (1988); Toronto gobelin-tapestry-maker Tamara Jaworska (1994); and Guelph metalsmith Lois Etherington Betteridge (1997).

- OAC initiated a new grant program to assist individual craftspeople with projects.
- *20th Century Bookbinding* at the Art Gallery of Hamilton introduced work by leading contemporary hand binders from Canada, the United States, England, and Europe.

1983
- Work by 35 Ontario student craftspeople chosen for *Crafts of the World, Kaleidoscope '83*, a gigantic summer cultural exhibition staged for the World Student Games at Edmonton.
- CBBAG founded in Toronto to make public more familiar with all forms of the book arts and to carry out a program of education and to tour exhibitions.

1984
- Clay and glass moved into Rideau Hall, home of the governor general, through a nation-wide competition called *The Perfect Setting*, organized by OPA. Porcelain dinnerware by Jan Phelan, then of Hillsdale, and blown-glass goblets by Robert Held, then living in Calgary, won the two commissions for the Schreyers' private dining room. 22 finalists had entries on view in the Ambassador's Room at Rideau Hall, at ROM and later, at the new headquarters of OCC.
- For Ontario's 200th birthday, Jean A. Chalmers purchased work by the 14 Ontario professionals who had been nominated for the Bronfman Award for Excellence in the Crafts in its first 8 years. Also for Ontario's bicentennial, 51 American and Canadian craftspeople were bought together at Harbourfront's art galleries in *Celebration '84: A Sense of Occasion*.
- *Works of Craft from the Massey Foundation Collection*, the first comprehensive exhibition of professional Canadian craftspeople, opened at the National Museum of Man in Ottawa and toured nationally. Three years earlier, the Massey Foundation published *The Craftsman's Way*, one of the earliest illustrated books to document contemporary craftspeople and their work. The Massey Collection today is housed at CMC in Hull.

- OCC created a public forum for fine craft work in *Craft Focus I*, the first of 3 biennial, national, juried slide competitions for OCC members, which contributed significantly to professionalism in the craft field. Results were published in full colour and distributed in OCC's magazine, *Ontario Craft* in 1984, '86, and '88.

1985
- Jean A. Chalmers gifted $500,000 to CC to establish a fund in her name to assist with special projects: craft research, seminars, symposia, and investigations into craft practices.
- OPA moved its offices and retail shop from 100 Avenue Road to Yorkville Avenue where it remained to 1990 when financial constraints forced it to close its doors and relocate its administrative wing. Next year, it formally became FUS.
- Snag '85, a June assembly in Toronto of some 500 metalsmiths from Canada, the United States, and Europe, hosted for SNAG by MAG and OCC, the only time the conference of metalsmiths has come to Canada.
- Edges: In Thought, In History, in Clay, The Fourth International Ceramics Symposium held in Toronto, the first time the Institute for Ceramic History (now the Ceramic Arts Foundation) had convened outside the U.S. to examine work that was, in its time, leading edge. To complement the 400-strong conference, more than 40 Toronto galleries mounted exhibitions of local, national, and international clay artists.
- *Contemporary Canadian Quilts*, organized by OCC, presented to Europe the work of 10 of the province's most innovative quiltmakers. Opening in July at Ontario House in London, the exhibition then toured continental Europe, Wales, and Northern Ireland.

1986
- Termed a "coming of age" for the Canadian fibre community, a prestigeous conference brought some 2,200 weavers and spinners to Toronto for Convergence '86, a biennial meeting of the Handweavers Guild of America,

held for the first time outside the U.S. More than 40 galleries in Toronto and Southern Ontario mounted exhibitions related to weaving. Co-hosts of Convergence were OCC and OHS.
- Barrie metalsmith Donald A. Stuart commissioned to make the first Glenn Gould International Prize for exceptional contribution to music, a silver rosebowl presented to Canadian composer R. Murray Schafer. The second Gould prize, by Burlington enamellist Fay Rooke, was given in 1990 to British laureate Sir Yehudi Menuhin; the third, in 1993, by Dundas furniture-maker Robert Diemert, went to Mississauga jazz pianist Oscar Peterson; and the fourth, in 1996, a wooden music-box, by Toronto's Gordon Peteran, went to Japanese composer Toru Takemitsu.
- Lonsdale porcelain-potter Harlan House awarded a special $10,000 prize donated by M. Joan Chalmers to honour OCC's 10th birthday.
- A major new showcase for Canadian ceramics established in September in the form of the Biennale Nationale de Céramique at Trois Rivières, Quebec.

1987
- Craft activist and patron M. Joan Chalmers made Member of OC and also an honorary doctor of fine arts by Nova Scotia College of Craft and Design. The following year Chalmers was presented with an arts medal from RCA and made an honorary member of WCC. In 1992 she was elevated to the Officer category of OC, in 1994 admitted to the Order of Ontario, and, in 1998, invested as Companion of OC.

1988
- On February 28, Lieutenant-Governor Lincoln Alexander officially opened the new craft studios on Sheridan College's Oakville campus, where 4,185 square metres housed the most up-to-date equipment for ceramics, glass, wood, and surface design on fabric, and brought the 21-year-old SOCAD from its Mississauga location.
- The Olympic Arts Festival allied crafts with sports in

two exhibitions associated with the XV Olympic Winter Games in Calgary: *Restless Legacies: Contemporary Craft Practice in Canada*, an invitational exhibition of Canadian work in all media, and *Fired Imagination '88*, which brought together 32 ceramists whose work illustrated the move to non-functional and sculptural forms, and which then toured Australia.

- Among the international exhibitions, *Embellished Elements* with more than 200 works by 17 of Ontario's contemporary jewellers, moved from RCA's gallery in Toronto to the Electrum Gallery in London, England.

- General Foods (now Kraft General Foods) joined forces with OCC to add fine coffee-service sets to its permanent craft collection through a competition for glassblowers, ceramists, and metalsmiths. From 147 entries, jurors chose 26 finalists, whose work toured the country before being on permanent display at Kraft General Foods' headquarters in the Don Mills quarter of Toronto.

- At the request of the Finnish Glass Museum, the work of 19 leading Canadian glass artists was brought together in *Glass in Sculpture* at the Koffler Gallery in North York, an exhibition which then toured Finland and West Germany.

1989
- CMC unveiled on the Ottawa River in Hull with built-in craftwork for various public areas. To christen the Fine Crafts Gallery of its Arts and Traditions Hall, *Masters of The Crafts* showcased 75 works by the first 10 recipients of the Bronfman Award for Excellence in the Crafts.

- *Sesqui Liturgical Arts Festival* at The Cathedral Church of St. James in Toronto launched the most comprehensive exhibition of liturgical textiles ever held in Canada. Some 300 works in three categories demonstrated the richness and diversity of contemporary ecclesiastical craftwork.

- At the 2nd International Ceramics Competition at Mino, Japan, Scarborough potter Ron Roy won a special judges' award for outstanding achievement. Roy was one

of 6 Canadians to win awards in a competition that brought potters from 49 countries.

- Some 150 basket makers came together, formally, as The Basketry Network, primarily to form a work group to stage conferences, serve as a communications vehicle, and raise the profile of the medium.

- In September, MT opened four floors of exhibition, collection, and office space at 55 Centre Avenue, a gift from developer Fred Braida, who arranged a 99-year lease in his large condominium tower in Toronto's original Chinatown district.

- In December, OCC formally inaugurated its new home in the Chalmers Building at 35 McCaul Street. The year before, it had received $2.2 million from the Ministry of Culture and Citizenship to acquire and renovate two 1920s, brick, industrial buildings it had purchased with funds raised by selling its two real-estate assets: at 140 Cumberland and at 346 Dundas Street West. OCC committed 2% of building costs to built-in craftwork.

1990s

1990
- For its new headquarters in downtown Ottawa, the Regional Municipality of Ottawa-Carleton commissioned glass and clay installations from three Ottawa-area craftspeople. Three years later, Ottawa's new city hall acquired handcrafted work in clay and wood.

- As part of OCC's expanding international program, it took an exhibition of three glass sculptors, *The Passage of Light*, to the Art Gallery of the Canadian Embassy in Washington.

- Quilted works by three Ontario fibre artists, chosen for a horticultural exposition at Osaka, Japan, for which 70 international craftspeople submitted 800 pieces. The exhibition then toured the United States for two years.

1991
- To give craft a higher profile with the travelling public, OCC opened a custom-designed Trillium Guild Shop at

Pearson Airport's new Terminal 3. Ill-fated, it closed in less than a year, victim of the recession.

- The German province of Batten-Württemburg and Ontario paired comparable craftspeople in a first-ever working, living, and exhibiting craft cultural exchange.
- Examining the work and careers of 13 glass artists, *Canadian Glassworks 1970–1990* at OCC's Craft Gallery highlighted milestones in the development of studio glass.
- In celebration of OCC's 15th birthday, patron M. Joan Chalmers sponsored a special $15,000 award presented to master silversmith Lois Etherington Betteridge of Guelph.
- OCC sent 22 individually designed quilts far afield to New Zealand, in *Cold Comfort: Contemporary Canadian Quilt Works*, an exhibition that toured the country's galleries for two years.

1992
- Institute for Contemporary Craft formed in Toronto to encourage dialogue about, scholarly research into, and collection and presentation of issues facing today's craft community. Through two symposiums, in Ottawa in 1993, and Montreal in 1997, it set the process in motion.
- Craft project manager at Harbourfront Centre, Jean Johnson, inducted as a Member of OC for her tireless work on behalf of craft development.
- Included among contracts for craftwork from the public sector, Toronto's new Metro Hall ordered site-specific accessories from 11 Ontario craftspeople for furniture, upholstery fabric, carpet designs, glass panels, and raku planters.
- By late November, OCC entered into a custodial relationship with Ministries of Government Services and Culture and Communications, whereby OCC occupied only one-and-a-half floors of the Chalmers Building at 35 McCaul Street, reduced staff, and down-sized programs. Remainder of building rented to government departments and to not-for-profit organizations to help offset mortgage of $3.3 million.

1993
- Designated Year of Crafts in the Americas, a year-long jubilee marked the accomplishments of craftspeople in Canada, the Caribbean, Latin America, and the United States. Planned for two years, it was sponsored officially by the American Craft Council.
- In June, C_2G_2 in Waterloo opened to the public, housed in an award-winning building designed by Vancouver architects John and Patricia Patkou. Through lectures, workshops, demonstrations, and exhibitions, C_2G_2 interprets, documents, and collects contemporary clay, glass, stained glass, and enamel art.
- Newmarket ceramist and craft organizer Ann Mortimer recognized by the Everson Museum of Syracuse, N. Y. with an International Ceramics Symposium Award for her "broad services to the field of ceramics" over two decades.

1994
- OCC's permanent collection of some 400 works in all media donated to CMC in Hull.
- Susan Jefferies, joint head of education programs at the George R. Gardiner Museum of Ceramic Art in Toronto, elected to the distinguished International Academy of Ceramics, made up of makers, collectors, curators, educators, and writers from 46 countries. Other Ontario members include Steven Heinemann, Les Manning, Ann Mortimer, Ann Roberts, and Bruce Taylor. Ontario hosted the Academy's 1998 conference, A Question of Identity, held at the University of Waterloo and C_2G_2.
- Barrie metalsmith Donald A. Stuart became the second recipient of the Jean A. Chalmers Award for Crafts, valued at $20,000. Administered by OAC, it honours a Canadian craftsperson who has led by example through creativity, technical innovation, and conspicuous distinction. In 1997, the purse became $25,000 and the gift renamed the Jean A. Chalmers National Crafts Award.

1995
- Leather sculptor Rex Lingwood of Bright became the first non-German craftsperson to be recognized in a solo exhibition in Offenbach's Deutsche Ledermuseum, a

forum for contemporary leather arts and crafts. 40 of his boxes and bowls went on to travel to France, Holland, and England, and to Ontario in spring 1997.

- England's Victoria and Albert Museum added Canadian potters to its contemporary ceramic collection, among them Sheridan College's ceramics department head Bruce Cochrane.
- Twenty-nine contemporary Canadian ceramic works from the private collection of Raphael Yu of Ajax were paired with their aesthetic counterparts from ROM's East Asia collection. The exhibition, *Reshaping Tradition: Contemporary Canadian Ceramics in Asian Modes*, ran to June 1997 and featured work by 10 of the province's established potters.

1996
- Deprived of its federal operating grant, the 22-year-old CCC ceased day-to-day operations in Ottawa.
- FUS re-established its offices and archives at Cedar Ridge Creative Centre in Scarborough, although diminished funding from OAC made it necessary to change program strategies.
- After years of lobbying from the craft community, CC created a separate designation for craftmakers in its Grants to Professional Artists program, ensuring that juries would be composed of craft peers who would apply criteria appropriate to the field.
- Marking its golden jubilee, MAG staged *Celebration*, an exhibition that included a historical survey of work held in private collections and finalists in its current biennial juried competition. Through 1997 and 1998 the exhibition travelled to Saint John, Waterloo, Saskatoon, Montreal, and Memphis, Tenn.
- *White on White*, C$_2$G$_2$'s first exhibition to travel abroad, toured Japan and China before appearing at the Gardiner Museum in Toronto in 1997–8.
- Showcasing work by recipients of the Saidye Bronfman Award for Excellence in the Crafts, *Transformation: Prix*

Saidye Bronfman Award 1977–1996 opened at CMC and toured other major Canadian galleries.

1997
- Donald A. Stuart assumed the presidency of SNAG, the first non-American to hold that office.
- Ontario potter Ruth Gowdy McKinley, who died of cancer in 1981, honoured in a retrospective exhibition at BAC. It also staged *Fire and Earth*, a survey exhibition of its comprehensive collection of contemporary Canadian clay works, now two decades old.
- OCC moved out of the Chalmers Building at 35 McCaul, which was sold to private interests. It currently rents much smaller quarters in midtown Toronto.
- Waterloo ceramist Ann Roberts accorded membership in RCA.

1998
- Textile designer Dorothy Caldwell of Hastings named a member of RCA. Earlier, in 1991, she received the Bronfman award for her work with printed textiles.
- Reviving the Elliot Lake Centre for Continuing Education created in 1965 by Lester B. Pearson and Ontario Premier John Robarts, the White Mountain Academy of the Arts in Elliot Lake opened in August with veteran Quebec potter Robert Kavanagh as dean. Emphasizing traditional Native arts, it offers a four-year program in ceramics, video, art history, computers, and a range of fine-arts disciplines.
- Toronto multi-media craft artist Kai Chan named 1998 recipient of the Jean A. Chalmers National Crafts Award.
- CCC now operates under a new banner, Canadian Craft Federation, functioning by means of electronic communication links between member provincial crafts councils. CCF plans to have its head office rotate every two years from province to province, beginning with Ontario for the 1998–2000 term.

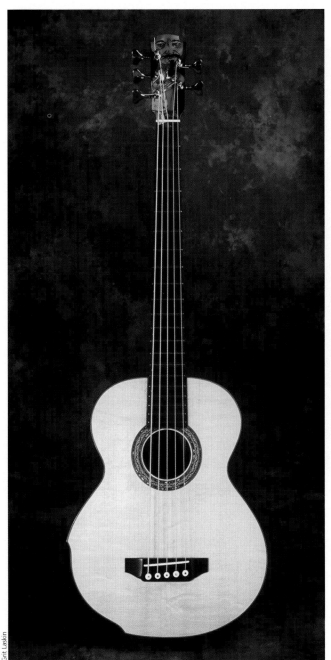

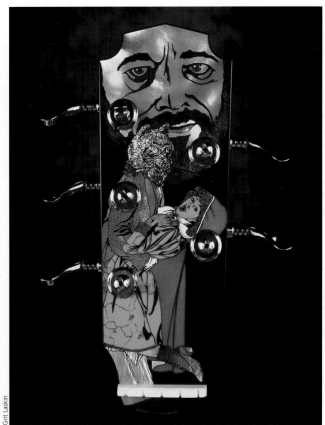

Stephen Sondheim, Little Red Riding Hood, and the Big Bad Wolf shared the inlay headstock of an accoustic bass guitar on a whim of William "Grit" Laskin. His inlay details for this 1996 piece, enti-tled *Into the Woods*, included 7 types of shell, 12 types of stone, various metals, and legal ivories.

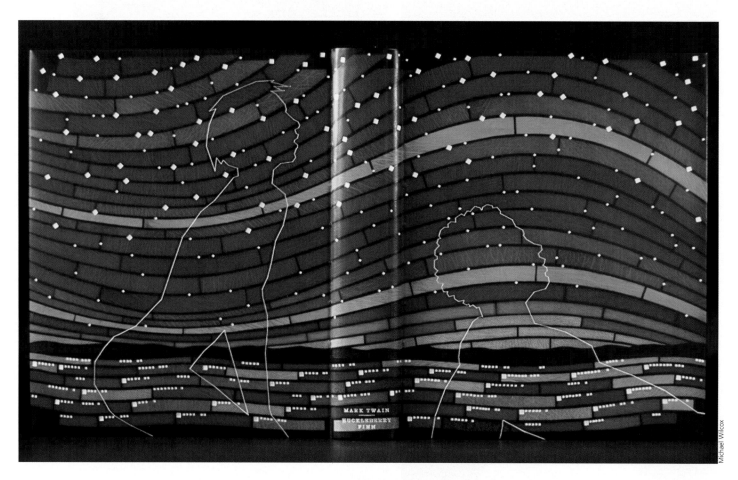

Michael Wilcox

Bookbinder Michael Wilcox used Huck's line "It's lovely to live on a raft" as the inspiration for his 1988 commission to bind Mark Twain's *Adventures of Huckleberry Finn.* He used coloured leather onlays, and silver- and gold-leaf tooling, on dark navy-blue goatskin binding.

Designed and built in 1992 as a birthday gift to ballerina Veronica Tennant, this music stand by Michael Fortune is composed of curly maple with macassar ebony details. A similar piece was made for the Canadian Museum of Civilization as part of its Saidye Bronfman Award collection.

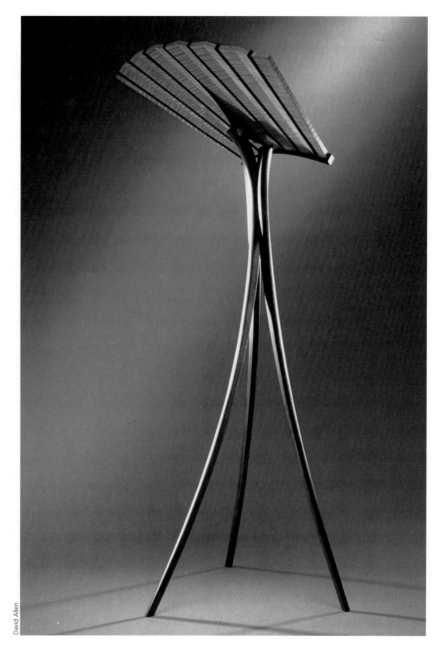

David Allen

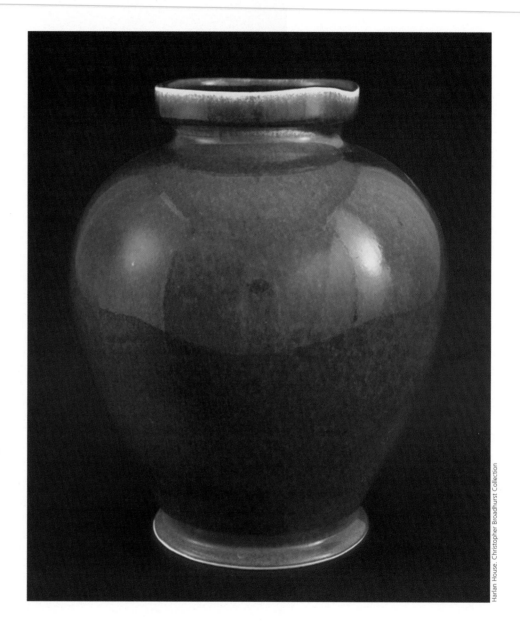

Lonsdale potter Harlan House has the courage and confidence to formulate his own clays and glazes while continually exploring new designs. His work, such as this 1988 ox-blood-stoppered porcelain vase, continues to have a timeless appeal.

Harlan House. Christopher Broadhurst Collection

Preface

All too often we hear that fine crafts in Ontario are a phenomenon of the past twenty-five years. Before then, the canard goes, few studio craftspeople sustained themselves from their work, which was neither fine nor artistic. The story of crafts is peppered with myths. When we don't know our history, we shouldn't be surprised if each generation is convinced it represents the advance guard. Published articles and reviews in each of the six decades covered in this volume consistently trumpeted "crafts come of age," which suggests that crafts have been waiting in the wings for a long time.

Indeed, some form of craft studio activity has been around for much longer than we realize, shepherded along in part by dedicated groups, mainly women, working through national organizations. In Toronto, the Women's Art Association of Canada began in 1887, and the Canadian Society of Applied Art started up in 1904, while in Montreal, the Canadian Handicrafts Guild formed in 1906. We shouldn't overlook the regionally based Arts & Crafts Association of Hamilton, which got its start in 1894. Craft historians can also point to individuals who developed careers well before the time-frame of this book, and although numerically small, they were nonetheless important harbingers. Following World War I and throughout the Twenties, crafts acquired a reputation as therapy for the wounded, infirm, and disabled.

By the beginning of the Thirties, we can observe in Ontario a cluster of new ventures that accelerated the growth of contemporary studio crafts. To gain wider public attention and acceptance, craftspeople need retail outlets and prominent exhibitions; these made their appearance in the Thirties as did organizations to support and nurture makers. Immigrants from Europe had been arriving for some time with new aesthetic concepts and techniques, to further enrich the scene, especially as teachers. Students at the Ontario College of Art and provincial technical schools were able to receive instruction in the new design ideas, particularly in pottery and art metalwork, and graduates set out to establish careers in spite of the economic depression and the difficulty of acquiring supplies and equipment. Taken together, these elements were vital leaven to craft development and suggest that 1930 is an appropriate starting point for this history.

Being a self-supporting craftsperson was never a ticket to an easy life, and it was especially

difficult before 1945. There were fewer than five hundred professional or gifted part-time craftspeople in Ontario then, yet some of their numbers were invited to exhibit abroad, where they won international awards and brought distinction to Canada. Potters and weavers began the province's first media guilds in 1936 and 1939, soon followed by the metalsmiths; many operated studios and raised families. In so doing, they and succeeding generations of makers initiated a contemporary history and a context for modern, as distinct from traditional, craft practices. The task of a chronicler involves pinpointing definitive moments; probing the evolution of attitudes and ideologies; looking at significant work, exhibitions, markets, and education; analyzing the genesis of craft service organizations; and exploring the web of relationships between makers, patrons, consumers, and governments, all the while looking for triggers and asking why events unfolded as they did. It is only in the past decade or so that writers, historians, curators, and critics have begun to chart and analyze the history and phenomenon of modern craft and publish their views. The Americans, Australians, and British seem to have shucked off the lassitude that has attended craftspeople's regard for their history and made impressive forays into the field. In Canada, we are in the process of catching up.

I have chosen to set forth Ontario's story in four historical periods and, where possible, in the words of some noteworthy individuals at the height of their careers. The most exceptional are profiled in short biographies (see "Movers and Shakers" at the back of this book) but these luminaries represent merely the tip of an iceberg. More than words, coloured photographs provide an eloquent testimony to the accomplishments of a selection of our makers. A chronology of significant events (see "Chronology" at the front of the book) serves as a ready reference to the most important happenings decade by decade. Readers may access the book through such windows, follow other themes by way of endnotes and eye-witness accounts, noting the crucial issues that characterized each time frame. What we discern, to borrow the words of American craft curator John Perreault, is "the history of how we see the past today," for history is but present tense.

As well as conducting scores of interviews, many of them on tape, I pored over scrapbooks, memorabilia, archival material, newspaper clippings, and more-recent published material, all the while blaspheming throw-away specialists who discarded the earliest newsletters, correspondence, flyers, and other ephemera. Because of them, reconstructing the early

years of this book was a greater challenge than it need have been. Would that we knew more about the 1930–1945 period. That caveat aside, my five years on this venture let me indulge my love of detective work and has unearthed riches that could serve as the basis for several books. Surveys have inherent limitations, and mine is no exception. This first history of Ontario's studio crafts is, I hope, only a beginning. I hope, too, that general readers will become as captivated and absorbed by the lives and work of our craftspeople as I have.

A cultural history, reference book, and a celebration, *A Fine Line* attempts to balance city and region; various craft media, although not all could be included; and the interests of creators with organizations that promoted what they perceived as the best interests of craftspeople. The various constituencies in the craft world have often misunderstood one another, and each has its own story to tell. The book also examines the fine line that persists between craft and fine art and supports my view that the art of craft is now firmly legitimized in our culture, society, and economy. A wary relationship still exists between fine art and craft; today, it is craft art that appears to be in a healthier state. More about that in chapter one, which is a general discussion about crafts, craftsmanship, and craft as art — topics that have been around a long time but still inspire zealous comment and analysis.

In writing about studio craftspeople, I have focussed my inquiry on designer-makers whose work is entirely original and who have maintained control over all facets of what they produce. Functional or abstract, traditional or experimental, one-of-a-kind or one of a set, commissioned or maker's whim, their work demonstrates a commitment to superior design, thoughtful content, and skilled craftmanship. Work from their studios may have roots in clay, fibre, glass, leather, metal, or wood; may combine found objects or traverse media boundaries to create crossbreeds. The objects run the gamut from baskets, plates, pots, vases, jewellery, and holloware to wearable art, furniture, stained glass, and printed and woven fabrics, offering us always an original concept of reality in material form. *A Fine Line* recognizes these creators' achievements.

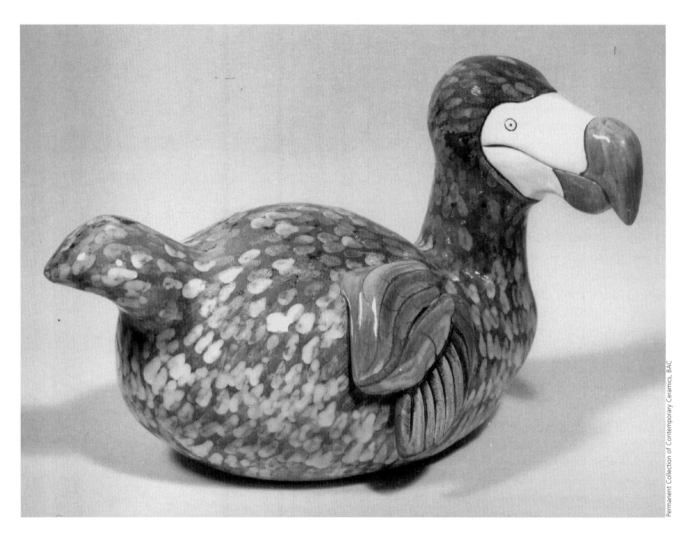

Permanent Collection of Contemporary Ceramics, BAC

In 1981 Jim Long Louie created a series of dodo figures in low-fire, talc-based clay. He gave *Dodo 1*, 38.4 x 30.8 x 55.4 cm, a copper-red glaze, and the work caught the fancy of collector Herbert Bunt, who gave it to the Burlington Art Centre.

A FINE LINE

CHAPTER ONE

THE CRAFT PHENOMENON

The Craft Phenomenon: Defining Matters

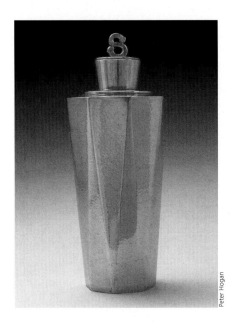

Peter Hogan

Andrew Fussell's 1933 pewter cocktail shaker recently came to light at an antique show and was eagerly purchased by its new owner.

For as long as contemporary crafts have been with us, people have tried to define exactly what they are. Because the word itself — stemming from the Saxon *kraft* meaning power — is both deceptively simple and ambiguous, crafts defy pigeon-holing and codification. Certain to ignite a heated discussion is any request for people to describe what they mean by craft. The closer they think they are to resolving the question, the more complicated it all becomes. Embracing a range of interpretations and types of work, crafts proffer a treasure trove of concepts, value systems, philosophies, materials, techniques, and processes — what British editor and craft authority Martina Margetts calls "a confluence of factors."

After its greening years in Ontario, "craft" seems to have acquired a mystique of its own, an implied originality, attractiveness, stylish functionality. The appeal of popular craft, as distinct from fine craft, is now so widespread that the term is exploited shamelessly by organizers of fundraising events, fairs, bazaars, and supposedly "one-of-a-kind" shows. The fact that many such events may attract only a smattering of craftwork and few original designs is immaterial to promoters. From their perspective, it's smart business to use crafts as a public-relations vehicle. No wonder many fastidious creators are fed up with and embarrassed by indiscriminate use of the word "craft" and suggest we find something else to describe what they make. But as yet no one has come up with an acceptable substitute. None of the alternatives — applied art, design art, decorative art — is adequate for the assignment.

That aside, it's remarkable that crafts survive as well as they do in a society as industrialized as ours and as indifferent to fostering a counterculture or objects of beauty. Since manufactured goods supply most of our needs more cheaply than handcrafted ones, we can

hardly pretend that blown-glass vases, pottery mugs, or woven silk scarves are necessities. Why then do we buy finely crafted articles even in recessionary times? Initially, I suggest, we are drawn to objects that are out of the ordinary, are affordable, and go beyond mere function to serve our deeper needs.

Whether we are members of the general public, collectors, galleries, businesses or governments, we are often moved by craft objects that seem to speak to us, lend a human dimension to our lives, and foster shared experiences between us and craftmakers. Owning such work can enhance our sense of self and compliment us, because to fully appreciate fine craftsmanship in a particular piece, we must be informed, and aware of materials and processes. Living with and using such objects are a means of knowing them and, at times, this can be an empowering experience in itself. As well as frustrating uniformity and flying in the face of mass production, crafts are often seen as forces in opposition to technology or as societal counterbalances. "They subvert the norms," distinguished British potter and teacher Alison Britton maintains, by functioning "as a small but serious cross-current against the drift of development in industrialized society."[1]

Yet modern technology has taken drudgery out of contemporary craftmaking, smoothing the way for craftspeople to be more creative and artful, should they be so inclined. Although machinery once threatened craftspeople's livelihood, it has now liberated them from making objects that have to be exclusively functional. "Handmade" is no longer a restrictive or pejorative term. Weavers create patterns on the computer and work on computer-controlled looms. Potters may choose not to handbuild or work on a wheel but make multiples using modern slip-casting procedures. Furniture designer-makers could not operate without sophisticated power equipment. For craftspeople, machines offer options not possible before, and new materials allow fresh opportunities in surface treatment. Contemporary craft draws on a plethora of techniques and skills, so makers have more choices.

Like the old gray mare, crafts today just ain't what they used to be. They are infinitely more complex, subtle and varied, and global in inspiration. More and more often, makers are finding stimulation through communication outside their own society: through affordable intercontinental travel or, for stay-at-homes, from film and television documentaries. Craftspeople generally thrive on a variety of means to express themselves and are prepared and able to go beyond their borders for new ideas, if not physically, at least mentally. Their

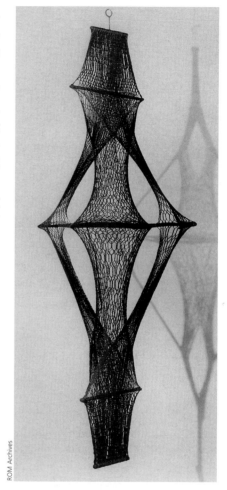

Using a Bronze Age technique called Sprang, Marie Aiken-Barnes used dark red, continuous, synthetic yarn to make this 1.5-metre space hanging, first seen at *Craft Dimensions Canada* at ROM in 1969.

ROM Archives

work might find inspiration in the material cultures of other countries whose exotic craft practices embrace a different and intriguing set of aesthetic and value systems. Thus, as the millennium approaches, contemporary craft seems to have limitless ability to surprise and delight us. "It may be middle class and middle ground," in Alison Britton's opinion, "but the crafts territory as it is now encourages some dazzling and subtle subversions of our expectations."[2]

And it should continue to do so. As crafts become more integrated into the visual mainstream, they find themselves in an artistic dilemma of sorts. To satisfy the voracious appetite of today's marketplace for novel work at better prices, an arena where purchasers are usually anonymous or in any case unknown to makers, craftspeople could find themselves becoming a service industry, "sucked into a vortex akin to the contemporary art world," as Martina Margetts describes the scene. "The result may damage its independent, free-radical spirit which at the moment gives the work and its makers their remarkable quality."[3] It's up to makers to find and create their own public, to lead and direct, not just give purchasers what they think they want, eminent English potter Michael Cardew once told a ceramics symposium in Barrie. In other words, craftspeople must first please themselves, instill into their own work qualities and values they wish to communicate, and, rather than respond to the ever-incessant demands of the marketplace, protect the integrity of their work. Can they do it? Will they do it? "American crafts have survived war and depression," curator Lloyd Herman says, "I believe they will survive fashion, too."[4]

A Hands-On Person

Inspired by a need to enjoy a single cup of tea from a silver pot, metalsmith Anne Barros in 1987 created this 10-cm version in sterling silver with a red acrylic handle.

Jeremy Jones

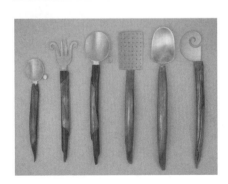

Barros used sterling and heat-treated copper in fabricating her *Table Tools* in 1997. The largest piece stands just over 15 cm tall.

And while we are defining terms, what on earth are we to make of the menu of phrases and nouns used to describe craftspeople? — craftworkers, craft artists, artisans, artists, craft practitioners, handcraftsmakers, producers, designer-craftspeople, object makers, and so on. Small wonder that some craftspeople believe they are in a prolonged identity crisis; for variety's sake, I use many of them interchangeably.

Whatever we are to call them, craftspeople are entrepreneurs often averse to materialism, concerned with the quality of life, resolved to determine their lifestyle while working with objects they love. Sometime in the

Seventies, Montreal craft administrator Virginia Watt put together a composite of a Canadian craft professional from material she had collected during her years with the Canadian Guild of Crafts (Quebec). Her observations are a diverting read:

- he/she is between 30 and 45 years old, is married and has 2.5 children
- his/her spouse works alongside or brings in additional income
- lives in a rural area by choice and grows most of the family's food
- income is at or below the national poverty level
- he/she is above average in intelligence and above average in academic education; has probably completed three years in a Canadian or American university or college
- trusts museum curators, lawyers, bankers, private collectors, and children; distrusts interior decorators, interior designers, architects, dealers, governments, Canada Council, and some craftspeople
- knowledgeable and sophisticated about art, music, and the antiquities
- naive about business, craft organizations, the general public, and other people's money
- articulate, humorous, confident, and vulnerable
- requires a regular input of criticism, encouragement, and discussion
- needs time to dream
- needs all of his/her family, some money, and all of his/her friends
- he/she would rather do what he/she is doing than anything else.[5]

All of which begs the question whether the craftsperson's world is somewhat like the Red Queen's in Lewis Carroll's *Through the Looking Glass*, where "it takes all the running you can do to keep in the same place."

Variations on a Theme

Another of the ongoing topics of discourse in craft circles, magazine and newspaper articles, exhibition coverage, reviews, and critical writing is whether craft can be a form of art, should aspire to be, and, if so, does it matter? That the most accomplished craft pieces should be regarded as art was a sentiment that appeared in newspapers and magazines as

early as the Thirties, perhaps even earlier. Often written by fervent women reporters assigned to the Women's Page, the most respected of whom was Pearl McCarthy of the *Globe and Mail*, the articles, while sometimes romantic, reflected a growing sense of pride in the work of craft professionals, coupled with a mission to goad the so-called art world to take notice. Even then, the implication was that acceptance by art curators, critics, and audiences was the ultimate seal of approval. Accolades from the craft constituency, while appreciated, were not enough.

In the Thirties and Forties, the Art Gallery of Toronto was prepared to make room for annual group shows of the three main crafts at the time: ceramics, jewellery and art metal work, and weaving — solo shows came later. For a time, the Royal Ontario Museum took up where the art gallery left off, but once craft galleries and specialist venues appeared in the Seventies, they became the principal means of presenting quality craftwork to the public. Artistic surroundings, opening receptions with specially invited guests, thoughtful presentation by curators, proper lighting, and, if fortune prevailed, reviews in the media, all helped to further the cause. Such exposure accelerated the careers of a number of prominent Ontario craftspeople whom their peers consider artists. Among them are metalsmiths Lois Etherington Betteridge and Donald A. Stuart; enamellists A. Alan Perkins and Fay Rooke; potters Bruce Cochrane, Harlan House, Ann Mortimer, Steven Heinemann, and Ann Roberts; quilters Judith Tinkl, Judith Dingle, and John Willard; fibre artists Susan Warner Keene, Dorothy Caldwell, Lois Schklar, Sarah Quinton, and Nancy-Lou Patterson; leather sculptor Rex Lingwood; jewellers Sandra Noble and Andrew Goss, Wendy Shingler, and David McAleese and Alison Wiggins; glassblowers Dan Crichton, Laura Donefer, Claire Maunsell, Kevin Lockau, Irene Frolic, Susan Rankin, and Karl Schantz to name a few. Some of them have work included on these pages.

But nagging questions persist: should artist-craftspeople expect to be accepted as equal but different partners in the art world?; are art and craft really part of a continuum or are they two separate categories?; will craft keep its identity if it is lured to the fine-arts world and borrows its recipes for "art soup," a term coined by American fibre artist and teacher Warren Seelig to describe a formula approach to craftmaking: "a little colour, a pound of yarn, a sprinkling of structure and a heavy dose of content and imagery." When ladelled from the art cauldron, Seelig says, such imitative work results in travesties that

Sandra Noble Goss fabricated *B & W: Moon* in 1996 from sterling silver, bronze, and brass with a cupric nitrate patina. She then made a framed mount for it from acrylic and aluminum.

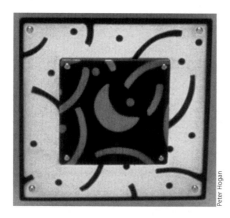

Peter Hogan

"have the look of art but are nothing more than well-designed concoctions of predictable effects."[6]

Craft curators, naturally enough, have no difficulty with the notion of craft as art and have written convincingly on the subject, as their best interests dictate they should. If you were to ask the same questions of a random selection of craft educators, retailers, gallery owners, or craftmakers, you would have a variety of responses: "If it's good, it's good, who cares about nomenclature?"; "I feel I am part of the art world, whether or not it sees it that way is its problem"; "The art world is a straightjacket — why ask to be controlled?"; "Craft is a verb, not a noun; you craft an object, art is the end product"; "We should be clear and unambiguous and call everything intended as art, 'art'." The most sweeping definition I heard was that if a work is useless, it's art; if useful, it's craft. The comment is made partly in jest, but nonetheless speaks for those who continue to separate art/decorative and craft/utilitarian. The distinction is a curious one since the best craft objects function on several levels and are embued with visual and tactile qualities in equal measure. Usefulness does not imply a work cannot enchant, intrigue, amuse, or bring joy. If craftspeople do not make their objects to be used, they risk denying them their full aesthetic potential and creating mere parodies of function. Astute purchasers will not be deluded by ill-formed teapot spouts, flawed handles, or any work that demonstrates thoughtless execution or careless finishing.[7]

Worse still, the urge to conform in the art world is deadly and constrains creativity, says Scarborough potter Ron Roy, a long-established figure in clay circles. "Why would we want to be members of a club that is worse off than we are, that is bankrupt? The only reason we want in is because we want some of the prestige of being artists because we are still looked on as the hicks of the art world."[8]

At the request of *American Craft* magazine in the mid-Eighties, *Globe and Mail* visual arts critic John Bentley Mays discussed why he did not usually review contemporary craft exhibitions. Newspaper coverage of such events was and is important to the craft community because exposure has a perceived impact on power brokers in the art world. Mays rose to the challenge in an insightful commentary that was later rerun in the Ontario Craft Council's newsletter, *CraftNews*. His courage in "dancing with grizzlies," as he described the exercise, was misunderstood by some readers who found his remarks insulting, whereas, if anything, they were cordial and solicitous.

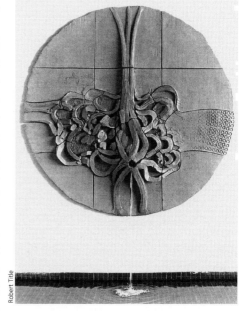

Robert Title

At the beginning of his clay career in the Sixties, Ron Roy received a commission from architect Irving Grossman to build a fountain for the Somerset Apartments in 1967.

7

Sarah Quinton's ideas spring from textile designs and diverse sources in her urban environment. Her *Acanthus*, a 1994 work from an exhibition at The Craft Gallery, uses wood moulding, acrylic paint, and waxed lacing-tape.

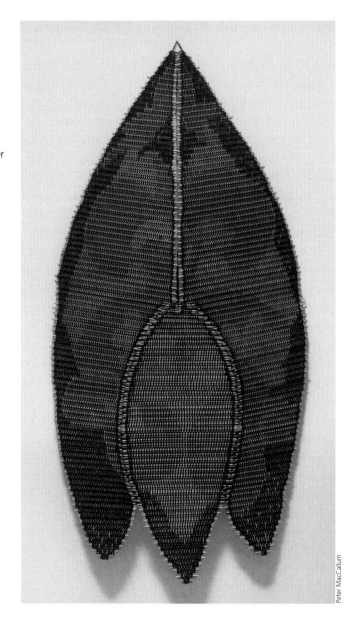

Peter MacCallum

8

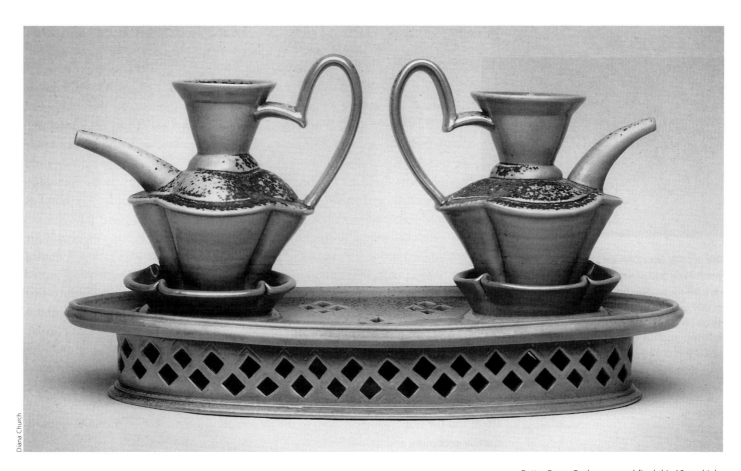

Potter Bruce Cochrane wood-fired this 18-cm-high porcelain cruet set, which he threw on the wheel and then reconstructed.

One of the most successful exhibitions at the OCC's new gallery space at 35 McCaul was Lois Schklar's *Collective Memories* in 1990. Incorporating traditional fibre techniques and sewn burlap, Schklar evoked other places, shapes, and times.

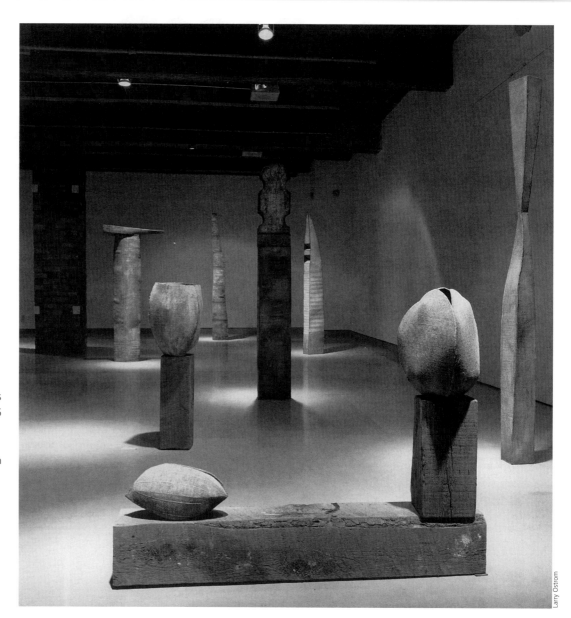

Larry Ostrom

12

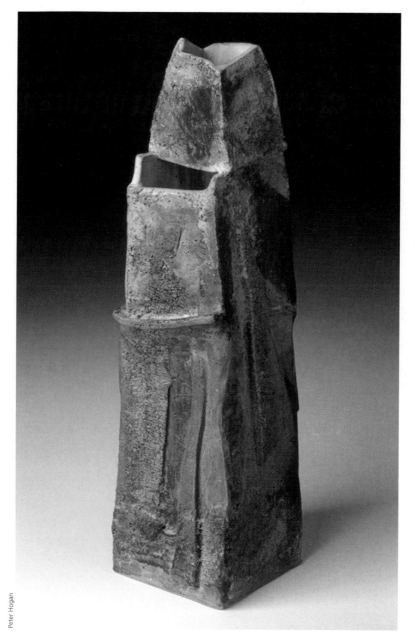

Peter Hogan

The land forms in Northern Ontario so impressed Tess Kidick that she tried to capture in clay their power and ruggedness sometime in the 1960s. In *Northern Gothic*, Kidick glazed a tall stoneware form with copper, iron, and manganese elements, and applied slip with nylon curtaining fabric. Kidick could never bear to part with it and owns it still.

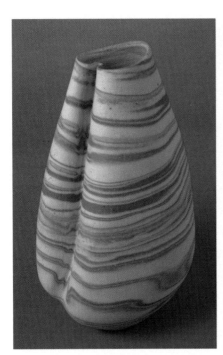

Robin Hopper first made unglazed, agate, porcelain shell-forms while living and working in Hillsdale, outside Barrie. These date from 1974 and were thrown on the wheel and then altered. By the time Hopper became the first recipient of the Saidye Bronfman Award in 1977, he had relocated his pottery outside Victoria in British Columbia.

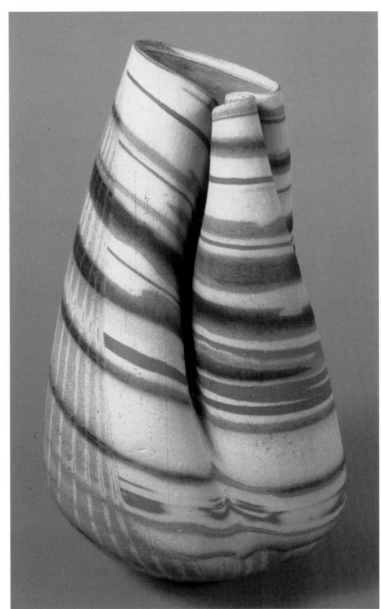

14

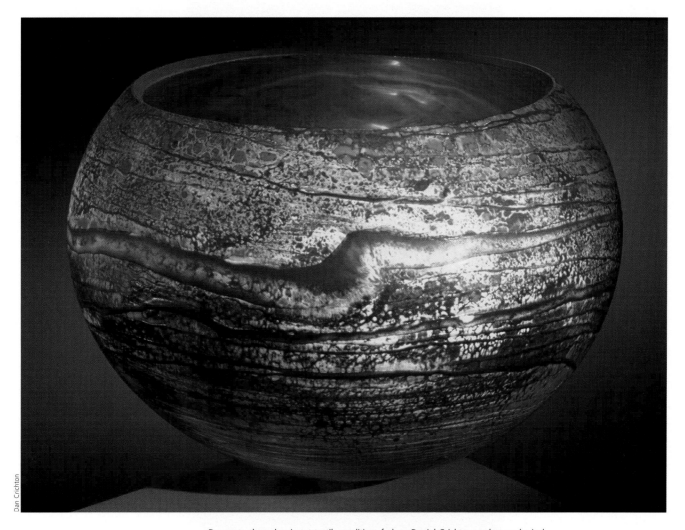

Drawn to the volcanic yet tactile qualities of glass, Daniel Crichton evokes geological textures and natural forces, layering and then eroding his vessel surfaces. In *Citrine Quartz Crucible*, made in 1997, he has etched and gold-lustered the blown-glass form, which stands 25.5 cm and has a diameter of 36.5 cm.

15

Using chasing and repoussé techniques, metal-smith Lois Etherington Betteridge fashioned this 30-cm-tall handmirror in sterling silver mounted on a stand of Quebec serpentine in 1979.

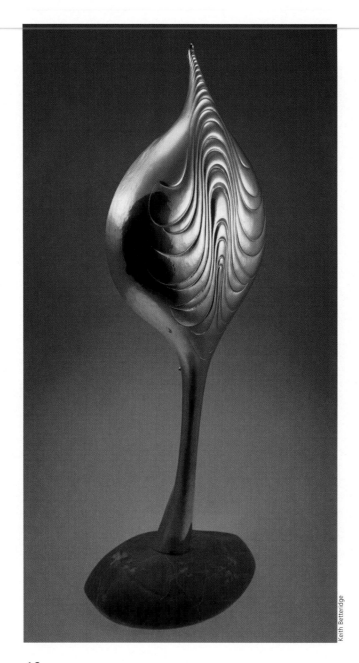

Keith Betteridge

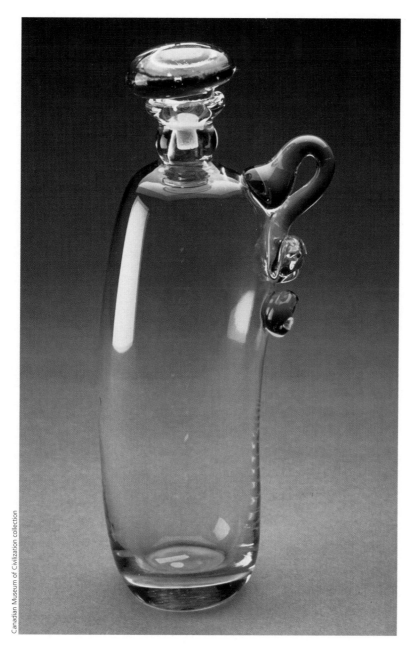

In 1970 Robert Held made his first blown-glass decanter while pioneering the glass program at Sheridan College School of Craft and Design at Lorne Park. He composed the glass and colour himself, pale green with a red cadmium dot below the handle. Standing 30 cm tall, it competed in *Make/Mak* in 1971, and three years later in the Canadian component of *In Praise of Hands*.

Hastings fibre-artist Dorothy Caldwell creates compelling surfaces and textures that are both subtle and private. In this 1991 work, *Alone With the Tinkling of Bells*, she stitched and appliquéd cotton, which she coloured by using wax resists and discharge-dyes with gold-leaf.

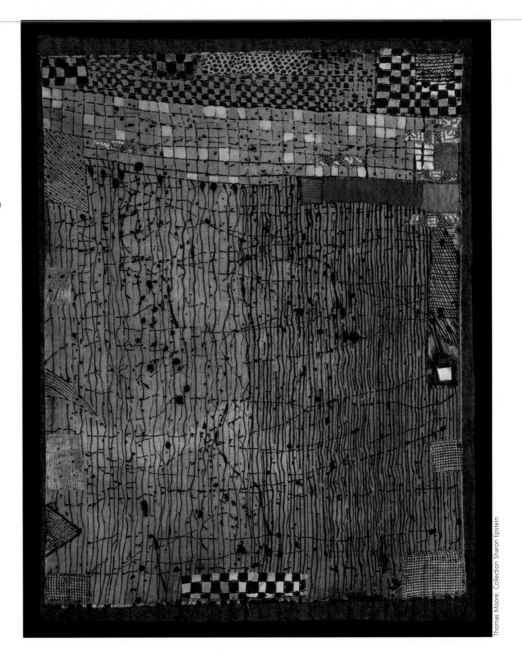

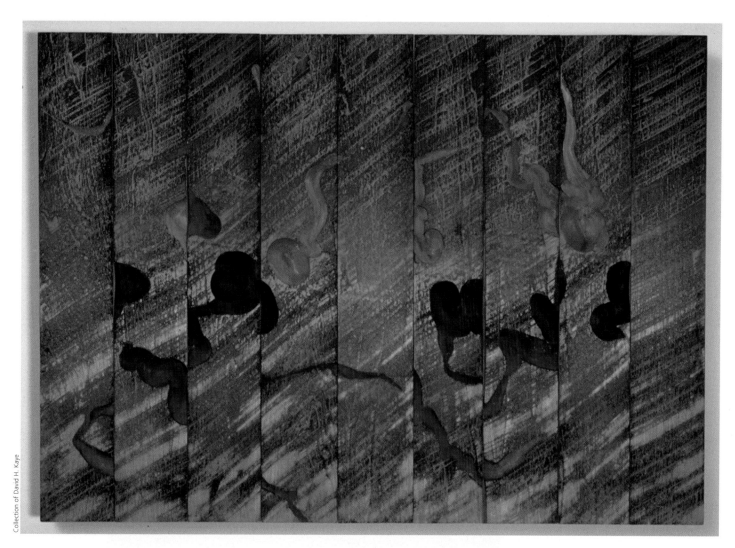

Woodturner Stephen Hogbin created a series of polychrome relief panels in the Eighties, some of which were shown at The Craft Gallery in 1985 in an exhibition titled *Stephen Hogbin: New Work*. For this 46 x 65 cm panel, he has coloured basswood with acrylic paint and ink.

19

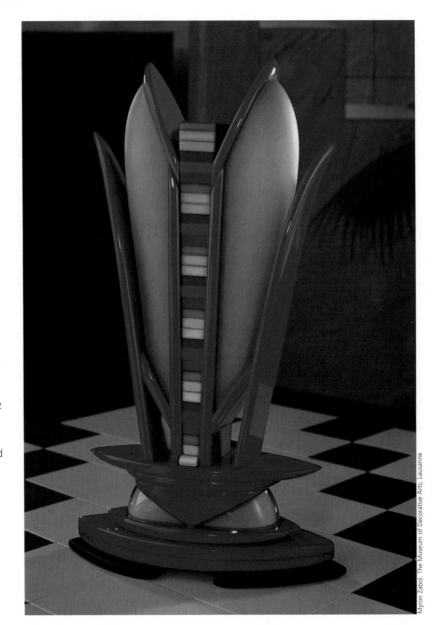

At the time glass-artist Karl Schantz produced *Hedda* in 1987, he was working in a sculptural-vessel format. Here he has used laminated vitrolite and cased opaque blown-glass elements to achieve a spirited work that stands 56 cm tall.

Myron Zabol. The Museum of Decorative Arts, Lausanne

1930– 1945

BOLD INITIATIVES

BOLD INITIATIVES

At the close of the 1920s, Canada had discarded some of its cultural insecurities and, buoyed by the accomplishments of the Group of Seven painters, embraced a community of more confident artists, writers, and craftspeople. The predicted renaissance was soured by the Depression and the gloomy Thirties, which did, however, provide Ontarians with some exquisite paradoxes. Despite the gnawing afflictions of unemployment,[1] hunger, unpaid rent, and homelessness, a generation of pioneering studio craftspeople struck out on independent career paths, undaunted by the terrible odds. Nor did a lack of disposable incomes deter people from attending large-scale craft exhibitions in numbers that today's curators only dream of, and giving craft consumerism a decided boost. This was, after all, a depression without the diversions of television and video. With time on their hands,

people went to exhibitions of all sorts, took craft courses, attended lectures on design, and visited artist studios that were springing up like crocuses through snow. They replaced the mundane with the aesthetically pleasing and innovative. And they dreamed.

Dreaming was not restricted to the poor. Maverick heiress and arts advocate Edna Breithaupt established an artist cooperative at 15 Grange Road in Toronto with live-in studio space, kitchen, gallery, and craft shop. She, her family, and friends underwrote an arts magazine *Etcetera*, which appeared from nowhere in September 1930, dedicating itself to creative living: a brave counterbalance to harsher realities. An adventurous younger sister, Rosa, purchased some thirty-five acres in Scarborough in June 1932, intending to establish a profit-sharing artist colony to be called The Guild of All Arts. The

sisters and others like them had similar motives to American President F.D. Roosevelt's Work Projects Administration. WPA's federal art project attempted to protect art and craft activities by creating work programs involving a wide range of craft skills.

In Canada, craft promoters and exhibition organizers emerged from comfortable pews: architects, business executives, lawyers, arts administrators, professors, visual arts teachers. In March 1931 they founded the Handcrafts Association of Canada Incorporated, whose slogan for a time was "Canadian-designed arts, made in Canada, expressing the mood and the significance of the time in which we live," which scarcely reflected its true purpose — to enable those who derived a living from craft work to survive. Next year, with the backing of the Eaton family, the Association opened the Guild Shop at Eaton's new College Street

emporium. The upscale elegance of this location went a long way to cultivate a public appetite for work by contemporary craftspeople.

The interest in craft was only part of the populist wave sweeping the decade. In 1931 University of Toronto professor Henri Lasserre used his Swiss inheritance to create the Robert Owen Foundation in Toronto, to encourage cooperative social enterprises, most particularly those that offered employees profit sharing.[2] In April 1932 an intellectual assembly of Toronto and Montreal business people, professors, and professionals formed the League for Social Reconstruction, a would-be Canadian Fabian Society, concerned with public ownership, planning, and social services, which attracted craftspeople and artists of all persuasions to its meetings. The League's intellectual arm helped spawn the Cooperative Commonwealth

Federation (CCF).[3] For their part, Toronto craftspeople met regularly to discuss books on current issues, in an effort to find solutions for a society that wasn't working. People everywhere were passionate about politics. The Gerrard Street West village area in Toronto's St. John's Ward (bounded by Elizabeth, Bay, Gerrard, and College) where some craftspeople had studios, earned the reputation of being a hotbed of radicalism in the city.[4]

The print media were part of this wave. To relieve the daily diet of unpalatable stories, newspapers and especially magazines were only too happy to run stories about the burgeoning studio crafts and their unconventional practitioners.[5] In these circles, journalist and critic Pearl McCarthy in the *Mail and Empire* and later the *Globe and Mail* was the most passionate craft partisan and supporter. For at least a decade, crafts had been a respected resource in physiotherapy and manual-skills development, in which context the quality of

the work was not as relevant as the effect of the experience on the maker. That began to change, and crafts were credited with other virtues. Because they ran counter to industrialization and specialization, crafts were said to embody qualities society and manufacturing should emulate by fostering independence, developing self-reliance, creating artistic freedom, and revealing the spirit. As early as 1931, the term "artist-craftsman" began to appear in published articles, and some writers were bold enough to assert that craftwork, especially ceramics, could be considered art.

By the Forties it was fashionable and public-spirited to wear hand-woven clothing and handcrafted jewellery, buy pewter and hand-thrown pots. A larger marketplace beckoned, too. In wartime, foreign imports were somewhat limited, and Americans were showing an interest in Canadian crafts, a fact that pointed the way, it was said, to potential markets outside the

country.[6] During World War II, many craftspeople were involved in war work of some sort, but full-time studio craftspeople who stayed home could sell everything they made. In a space of fifteen years, it was generally acknowledged that mineral-rich Ontario had become a centre of metal and ceramic studio crafts in Canada.

Custom jeweller Nancy Meek shown in her Toronto studio drafting a working drawing of a brooch for a client.

Forging a New Path

In the period between the two world wars, the face of Ontario and, especially, the urban confines around Toronto changed perceptibly. For one thing, skilled craftspeople began arriving from Britain and Europe, many of them opening their own studios, teaching privately or in schools, and, like ripples on a lake, eventually touching the lives and consciousness of hundreds of others. Granted their numbers weren't large and their craft credentials sometimes unpretentious, but their impact was significant. These trained weavers, woodcarvers, stained-glass-window designer-makers, potters, and metalsmiths not only designed and executed work based on contemporary trends, they helped to mold taste.

Among the first arrivals was an enterprising Scandinavian metalsmith, Håkan Rudolph Renzius, who had a decade of experience working alongside his father in the family's wrought-iron, copper, and brasswork business in Malmo, a Swedish industrial city. By the time he was twenty, he was a trained engineer, but the fascinations of the art-metal world lured him to Copenhagen rather than to industry. Copenhagen was then a city resonating with new ideas in metal design, notably Georg Jensen's distinct minimalism and Ibe Just Andersen's "simple lines and happy proportions." Renzius was smitten. Although Jensen is better known, Andersen was a pewter pioneer who also produced designs for Jensen.[7] The sudden death of Renzius's father interrupted his plans to pursue art metalwork, however, and as the eldest of eight children, he had to help keep the family business going until it was sold in 1923.

Now free to strike out on his own, Renzius sailed to Quebec City, travelled on to Hamilton and then to Chicago, a focus for Swedish and Norwegian metal designer-craftspeople. He found daytime work as a Pullman car engineer, studied art metalwork at night, and in a couple years was able to bring out his wife, Ingeborg. With a cadre of assorted European artists, the couple came to Toronto late in 1930 and found living and working studio accommodation in Grange Studios, a cooperative venture Edna Breithaupt had just begun on Grange Road, just south of the Ontario College of Art in the central core of the city.[8]

It wasn't long before Renzius was demonstrating work in pewter and wood (he was also an accomplished sculptor) at Ridpath Galleries and the Canadian National Exhibition, where he was to win awards for years. "Mr. Renzius has but recently come to Toronto," journalist and potter Marjorie Elliott Wilkins wrote in *Etcetera*, "and his brilliant work is a contribution worthy of the aims of those who seek to foster art which may be applied in our daily lives." The magazine was only months old in spring 1931 and, with backing from some fifty patrons, including the wealthy Breithaupts and Renzius himself, it covered the Toronto world of arts, music, letters, and science. With self-possession and flair, the young Swede dressed as an artiste, his appearance attracting as much comment as his work: straw-coloured hair, six-foot frame set off by a bright blue smock, dark scarf tied in a bow under his chin, a lilting Scandinavian accent, full beard, and pointed moustache.

By December of that year he and Ingeborg had enough resources to rent a studio home at 65 Gerrard Street West and hire a metal polisher and general handyman in the person of Albert Chambers, an otherwise aspiring poet. The following spring a third hand joined them, a young man who had a precarious career selling radio advertisements. He had been mesmerized by the shop's display window and gone inside to look and meet the owner. Renzius promptly invited Douglas Shenstone to join his new evening class at Northern Vocational School in North Toronto and later, to become his apprentice.[9]

Imagine their Gerrard Street West — two city blocks of some fifty run-down wooden and brick houses erected in the city's St. John's Ward half a century earlier, without basements or central heating, and walls so thin privacy was wishful thinking. By day the buildings served as laundries; interior decorating studios; shops like The Sea Captain's, The Woolly Lamb, and Kiki's Dresses; restaurants like Georgie's Pink House nearby on Hayter and the local landmark, Mary Johns restaurant. By night the second floors were cramped and sparsely furnished homes.

The Renzius premises, just west of Bay Street, had a small peaked roof with a low bay window facing the street, its showroom filled with bottle openers, bracelets, mirrors, candlesticks and candelabra, coffee and tea sets, trays, and vases. Most were made of pewter, a metal Renzius favoured because it was sensitive, pliant, and affordable to work with, costing him a mere sixty cents a pound. When executing designs in silver, by comparison, he had to pay thirty-one cents an ounce for supplies. No wonder that pewter, essentially

above: Display of Renzius's work while he was living in the co-operative studios at 15 Grange Road in Toronto.

below: At a Ridpath Galleries exhibition in 1931, Rudy Renzius caught the public attention both for his work and his artistic mode of dress.

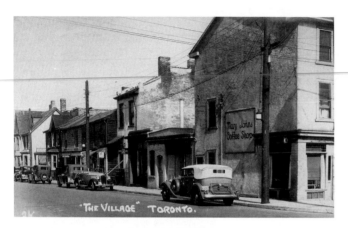

The Renzius's studio home was located at # 65 Gerrard Street West between Bay and Elizabeth Streets, the gable-roofed building at the left of the photograph. The building at the far right was a focus of village life for decades: Mary Johns restaurant.

ninety-five percent tin, was basic to most art metalwork in the Thirties until tin supplies from Bali were cut off by the Pacific Phase of World War II. Renzius used, as his workshop, a second-floor room that ran across the width of the house at the front; whatever space was left over served as living quarters. Shenstone himself moved "from one broken down house to another," one, a tiny cottage on nearby LaPlante for $10 a month, another, a room above a hair salon reached by a stairway beyond the hair dryers.

During Christmas seasons at the new studio, the men worked around the clock to cope with the surge of last-minute gift orders. When overcome by exhaustion, they catnapped at the bench to be rejuvenated by Ingebord's Swedish soul food — she was a gourmet cook and part-time professional chef. Somehow the trio completed the orders, customers came to pick them up on Christmas Eve, and next day they all slept. Such arduous times aside, Shenstone remembered his three years as an apprentice with affection. "I have no unhappy memories of being poor, or hungry or cold," he wrote later. "We were never lonely. Everything was shared. The well documented Great Depression scarcely touched us; we never had much and didn't miss it; it was taken as a matter of course that whatever we got was the result of our own efforts." They ignored or accepted the uncertainties associated with developing a business whose products were one-of-a-kind pieces that had to compete with the increasing flood of mass-produced household wares.

Then as now, complementing studio work with teaching afforded a measure of financial stability to a full-time career in the craft field. Renzius's arrival coincided with the opening of a number of vocational schools in Toronto and the addition of art and craft programs at private schools and summer camps. Having nurtured art metalwork novices at night school for four years in the mid-Thirties, Renzius relocated to Newmarket in 1936, then a sleepy town of two thousand and home of Pickering College, a private boys' school where he was to direct art and manual crafts for twenty-five years. His European clothes gave him a certain panache and distinction in his new community, which he embraced as a town councillor, hydro commissioner, and member of the Lions Club. During summers, he taught both woodcraft at Taylor Statten's Camp Ahmek on Canoe Lake in Algonquin

Park and metalwork at a YMCA camp on Lake Couchiching — both convenient venues to meet future customers. He also had private pupils in Toronto and Newmarket who came for instruction one or two hours a week.

"He was a patient and thorough teacher," Shenstone said, "believing passionately that teaching was the highest calling to which one could aspire." By introducing the basics to a number of promising novices, Renzius kindled the careers of several important metalsmiths: Andrew Fussell, Harold Stacey, and Douglas Boyd as well as Alan Jarvis, who became a sculptor and director of the National Gallery. Guided by his working credo "we live in our age and want to do things our own way with our own designs," Rudy urged his novices to emulate the unfettered lines of the Bauhaus school[10] as he did when carrying out his private commissions or preparing exhibition pieces, activities he maintained until the late Forties when Parkinson's Disease forced him to curtail projects that were particularly demanding and precise. Pewter collectors claim they can easily recognize his best work when it appears for sale in antique stores.

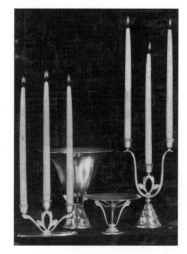

Typical range of work for Renzius's clients included pewter candlestick holders, vases, and candy dishes.

Winds of Change: Crafts Go Public

Renzius and his colleagues might not have realized it at the time, but their careers began at a turning point in Toronto's cultural universe. For some years the Canadian National Exhibition, the Royal Winter Fair, the Women's Art Association of Canada, and, to a lesser extent, the Junior League of Toronto, had provided opportunities for exhibiting and selling craft work that to modern viewers might seem somewhat limited in scope and design. There was as yet no organization in Ontario whose purpose was to promote and foster original work of high quality. This was soon to change and an epochal eighteen months in the early Thirties saw a remarkable flurry of craft initiatives: ambitious exhibitions, new organizations, retail outlets, and an experimental cooperative arts community.

At the time, Toronto was host to the world's largest annual exhibition — the CNE — and a circle of craft enthusiasts[11] had the idea that Toronto should also host the country's most comprehensive craft exhibition. Going large scale would capture public interest, they believed, attract designers to the work of good craftspeople, and encourage improved standards of workmanship. Early in 1931 at the new Ridpath Galleries on Yonge Street,

Rapid Grip & Batten Limited

A weaving and spinning group met on the lower floor of the Lyceum Club and Women's Art Association in mid-Toronto for many years. This group was photographed in mid-war years, a time when wool was often in scarce supply.

they brought together work from across the country: batik, jewellery, ceramics, metalwork, weaving, woodcarving, printed textiles, and tooled leather. Novel attractions were Renzius and other craftspeople demonstrating their techniques, and an essay contest in which contestants had to address six leading questions.[12] Winner was Toronto architectural engineer Joseph Banigan, a manager with deHavilland Aircraft of Canada, Limited, who was to play a key role in the province's craft development. One of his recommendations, an "accessible store" to market crafts, proved to be prophetic.

Ambitious young Toronto jeweller Nancy Meek often wore an original copper brooch designed as a stylized mask. The matching bracelet is shown on page 42.

A few weeks later, Ridpath associate and leading businessman Frederick L. Robson[13] chaired the first meeting of the Handcrafts Association of Canada Incorporated. Its ambitious agenda recommended extensive promotional work, public exhibitions, a craft library, and stimulation of high ideals in craft production. The Association attracted a who's who of Toronto professional and social elite, and had support from art patrons, leading artists, craftworkers, and organizations like the Junior League with small craft programs of its own. Vice-president, for example, was Peter Howarth, a charismatic but irascible stained-glass designer and painter who was also full-time director of art at Central Technical School and a leading member of the Toronto art scene.

Determined to take advantage of the public interest stirred up at Ridpaths, the new organization staged a national craft festival at the new Eaton Auditorium, which integrated craft with music and folk dancing. Among local craftspeople, Rudy Renzius again worked on site and young Toronto jeweller Nancy Meek displayed jewellery under the auspices of the Women's Art Association of Canada. Astute organizers recruited hostesses from women's groups such as the Wimodausis Club and Girl Guides, a tactic that seemed to attract entire memberships from those organizations. By week's end, Eaton's had enumerated more than seven thousand visitors.[14] The following year the Association applied the same formula to a June festival, again at Eaton's, which drew eight thousand viewers,[15] impressive statistics even without an economic depression. Dr. Marius Barbeau of the National Museum in Ottawa had fostered such cultural cross-overs for at least a decade, and he was on hand as opening speaker.

Next on the agenda was Banigan's idea of an "accessible store," and the new Association approached Eaton's management for rent-free space at its spanking new College Street premises. Since Eaton's had been mulling over a similar idea, it agreed to an unprecedented co-venture. Within three months of the spring exhibition, the premier's wife, Mrs. George

S. Henry, formally opened Ontario's first permanent craft-selling centre. Some six decades later, The Guild Shop continues to advance contemporary craft in Toronto's Yorkville area. Its Thirties version was basic glass cases providing 42 square metres of display room at one end of the main floor opposite the perfume counter. Eaton executive O.D. Vaughan nonetheless proclaimed the limited area "the most advantageous merchandising space on the ground floor."[16] It was unquestionably the most historic since the new shop occupied a spot once called Shrapnel Corners, site of a World War I military hospital.

Prominent society matron Mabel Cawthra Adamson, a founding member of the Handcrafts Association, donated "some of her delightful pottery" for the opening and she headed a committee that selected work for sale. She was undoubtedly one of the guarantors who helped raise two thousand dollars as insurance against stock theft, a contingency that never had to be met.

Shop manager for twelve years, Adelaide Marriott had recently returned to Toronto from Montreal where her volunteer work with the Canadian Handicrafts Guild had converted her into a craft afficionado. Always attired in hat and white gloves, even at work, her appearance masked an awesome commitment to craft development. Her motto was "we lead or we die" and, true to form, she tolerated few barriers in her lifetime as craft knight errant.[17] The shop made constant demands on her powers of diplomacy in grappling with Eaton's management, perennially puzzled and annoyed by the Association's lack of merchandising saavy, and also challenged her considerable gifts for displaying work. Sales reached the $18,000 figure for the shop's first eighteen months, but Marriott found herself facing a deficit because from that she had to pay $11,000 to craftspeople for consigned work, staff salaries, and a modest commission to Eaton's. The delicate operation went on for some years, and the shop's survival was due solely to the support of Eaton's and the commitment of the Handcrafts Association executive.

The earliest version of The Guild Shop at Eaton's College Street sometimes showcased displays from other organizations. This one featured weaving from the Women's Art Association.

The Fine Craft of Mentoring

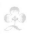

The Thirties proved to be extraordinary times for the number of cultural missionaries like Marriott, whose intensity and energy propelled them out of the ranks of Ontario's middle class. Mabel Adamson's contributions to the young craft scene may have been less evident

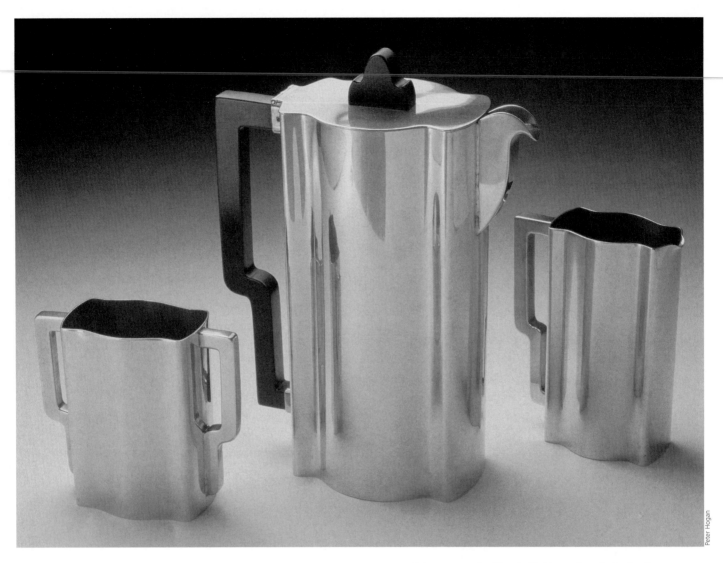

Peter Hogan

Only ten years after his arrival in Toronto from England, with skills he learned at night school, Andrew Fussell made this pewter coffee set, which went to the Paris Exposition of 1937 with other Canadian exhibition pieces.

Peter Hogan

Pewter cocktail shaker, glasses, and tray from Swedish-native
Rudy Renzius, commissioned by the Heaslip family in the 1930s.

31

than Marriott's, but she, too, emerges as a cultural godparent and reformer. An enamelist, needlewoman, painter, and New Woman, Adamson founded the Canadian Society of Applied Art early in the century (an organization that embraced crafts, especially metalwork), and in 1906 established the Canadian branch of W & E Thornton-Smith and Company, which grew to a successful Toronto-based interior decorating firm. To these initiatives she later added executive underpinnings to the Heliconian Club of Toronto, the Handcrafts Association of Canada, and the Canadian Guild of Potters. Although she was creative in many fields and had a catholic interest in crafts, pottery was now her particular passion, an avocation she pursued despite bouts of neuralgia and an ill-tempered thyroid. She records in a diary that she sometimes ignored church on Sunday to pot undisturbed in her gatehouse studio at Grove Farm, part of an inherited forty-acre estate on the shores of Lake Ontario in Port Credit that became her full-time residence.

Clay supplies and kilns were difficult to come by in the Ontario of the Thirties, especially for craftspeople working out of their own studios. As a self-confident woman of means, Adamson had options not available to many. She could personally select what she needed from Sovereign Potters Limited in Hamilton, in 1933 a new commercial dinnerware manufacturer anxious to build goodwill and only too eager to serve as mothership to studio potters. Company staff dubbed her "the carriage trade" as she arrived at its Sherman Street premises in her chauffeur-driven limousine. Studio pieces with potential she brought to Sovereign for final firing; others went to the kilns of National Sewer Pipe Company, the nearest branch being only eight miles away in the village of Swansea.[18]

Mirroring her own directness and no-nonsense approach to life, Adamson's diary chronicles her comings and goings and provides the one record we have of what Ontario's early studio potters contended with on a daily basis. Her rudimentary equipment caused her no end of technical difficulties, and she made frequent trips to Hamilton for replacement parts. As a studio potter she was constrained by her lack of formal technical training, her advancing years, and the inadequacies of her electric kiln — not really powerful enough to properly bisque her work — which prompted her son Anthony to conclude that pottery made demands she could not meet and was therefore "her least effective artistic ability." That judgment aside, her steadfast encouragement and support of potters was valued — she had earlier donated a kiln, tools, and materials to the Ontario College of Art —

and appreciative colleagues made her an honorary member of the Canadian Guild of Potters before she died in 1943.[19] Frustratingly little of Adamson's work has survived, in common with so much from this period, but pieces kept by her son and now in the care of great-grandchildren have considerable presence expressed through clean lines and spare surface treatment.

Cultural parents came from other corners of society, too. A mentor of mentors and an accomplished bookbinder in his own right, Douglas Duncan, began the Picture Loan Society in Toronto in 1936, which helped countless younger artists. What is less well known is that he also supported aspiring metalsmith Harold Stacey, whom he discovered during a jewellery-making demonstration at Eaton's auditorium that same year. He offered him workspace in the Picture Loan's Gallery above a dance studio at 3 Charles Street West, quarters Stacey shared for six years with sculptor Alan Jarvis, "until," Jarvis wrote, "the slow accretion of works of art inexorably drove us out."[20] In point of fact, the demands of World War II side-tracked Stacey, whose skill in forming intricate work in metal made him ideally suited to run a radio-engineering model shop for Research Enterprises Limited, a Leaside company that produced top-secret radar equipment. A retiring, conservative individual, Stacey apparently never felt comfortable with the gallery's offbeat artist characters, but "he remained deeply grateful to Duncan for his support and encouragement," his son Robert later wrote, "without which he might never have been able to concentrate on perfecting his exacting craft."[21] Duncan also took a turn on the board of directors of the Handcrafts Association — soon renamed the Canadian Handicrafts Guild (Ontario Branch) — for a time was its recording secretary, then treasurer, and bequeathed it two thousand dollars on his death.

A Crucible of Idealism and Reality

East of Toronto another mentor was hatching a different plan to promote crafts. Rosa Breithaupt Hewetson, sister of Edna, and a patron of *Etcetera* magazine, was a rather enigmatic widow in her forties when she acquired the H.C. Bickford estate on Scarborough Bluffs early in 1932 with its eighteen-year-old main residence. There, possibly at sister Edna's urging, she hoped to build a cooperative cultural community similar to Roycroft in East Aurora, New York, and fashioned after the teachings of industrial democrats Arthur

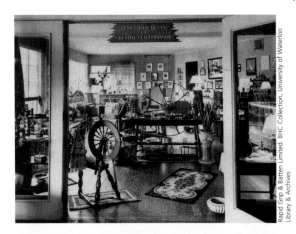

Rapid Grip & Batten Limited, BHC Collection, University of Waterloo Library & Archives

Nash and his pupil, William Hapgood. She had even brought Hapgood to Ontario in an attempt to persuade her horrified in-laws to introduce profit-sharing to the family-owned business, Hewetson Shoe Company of Brampton. Her confidant and collaborator in such utopian notions was H. Spencer Clark, an electrical engineer and social democrat, who became her second husband in August that same year and threw his prodigious energies into developing The Guild of All Arts. Her money, connections, and artistic flare coupled with his engineering know-how, ambition, and relative youth — he was fifteen years younger than she — was a formidable blend of alter egos.

Initially, the couple seemed genuinely interested in exploring alternatives to prevailing manufacturing practices, which they and others regarded as mind-numbing and heartless. He never tired of talking and writing about their ideas, and he became a master at courting publicity, writing copy, and giving interviews. He even developed a unique view of history. "As we looked around the world we found it was the countries that had not swung over to mass scale industry as much as we in Ontario had that were surviving the depression better," he later told a journalist. Quebec had suffered fewer hardships in this period, he stated, because it had protected self-reliance and pioneering skills by maintaining local, rural, habitant industries such as hand-loom weaving, rug hooking, carving, furniture building. At the Guild, their artists and crafts-people would have useful occupations, earn livelihoods, regain pride and independence, and contribute aesthetically to the country.[22]

By converting a two-car garage and Colonel Bickford's stable into craft studios, the Clarks within a year had workshops producing hand-loom weaving, tooled leather, batik and printed fabric, wrought iron, pewter, cabinetry, furniture, and turned wooden objects. Each area was headed by master crafts-people, usually Europeans, who were to live on the premises, teach apprentices, hold classes, and produce serious work for sale.[23] The Clarks also planned lectures; demonstrations; and exhibitions in music, drama, sculpture, and photography, as well as in crafts. For a couple years they operated an alternative school in an attempt to build a fully integrated art and craft village.

Emulating the young retail enterprise at Eaton's, the Clarks opened a craft

shop in the studio's east wing in 1934 for which they augmented work made on the premises with pieces from professionals in the Toronto area. For top quality hooked rugs they had to go to the Maritimes, and for the finest weaving and woodcarving, to Quebec. Three years later they inaugurated The Town Shop at 44 Bloor Street West in mid-town Toronto, which *Gossip* magazine deemed "clever and beautiful. It is modern in its fittings, its lighting and its colouring: cameo rose, soft cool green and chocolate."[24] Work included a range of items for those who could afford to shop: pewter goblets and tea services, glass coffee and tea bottles, hammered copper, wrought iron, handwoven silk-and-wool formal scarves for men, handmade pottery, handwoven placemats, wooden plaques, and a variety of turned wooden objects. Its main focus, however, was merchandising looms and yarn and providing weaving lessons on the premises.

Perhaps because Rosa Clark herself loved the loom and saw to it that she and her three daughters became accomplished, the weaving studio was the first to open and in many ways the most successful. The early weavers brought their equipment from Europe, including the complex Luther Hooper draw-loom (used in intricate work such as damasks), which survives today in the archives of The Guild in Scarborough along with another designed by English master-weaver William C. Dawson. Made on the premises, Dawson's ingenious 2.5-metre machine featured two warp beams, sixteen harnesses, and a flying shuttle, which allowed a single operator to produce wide widths for bedspreads and wall-coverings. He and his showpiece were a novelty at CNE demonstrations in mid-Thirties, but the Clarks soon realized it had little commerical potential. Wide floor-looms like his were noisy, occupied too much floor space, were too complicated for inexperienced weavers, and because they required a large investment in yarn, were suitable only for large-scale production. The Clarks foresaw a market for an intermediate-sized loom, simpler to run, portable but still capable of functional weaving, and they began experimenting with designs.

Meanwhile, Handcrafts Association President Fred Robson at Ridpaths held the license to distribute Thackeray looms, an English invention devised for invalids to operate, which had many qualities the Clarks were looking for. Behind Robson's back, the Clarks went to England and secured patent rights for North America from the inventor's widow, Margaret Thackeray.[25] The Guild studios in Scarborough were soon humming with activity,

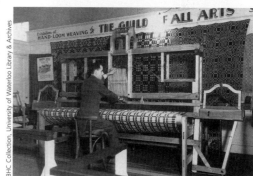

above: William Dawson used a Luther Hooper draw-loom when he wanted to weave intricate patterns. Although 200–300 years old, this type is still used by some OHS members.

below: At the CNE in 1935, English-trained weaver William Dawson illustrated his prowess on a 2.5-metre loom he designed especially for work at the Guild. Metal fittings and all wooden components were made in the Guild's shops and assembled by wood-master Herman Riedl.

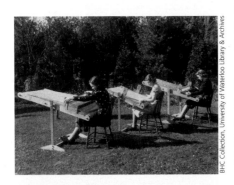

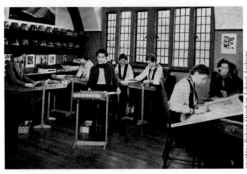

above: Rosa Hewetson Clark's three daughters, left to right, Rosemary, Ruth, and Dorothy worked on three variants of Thackeray looms. The girls learned to weave fabric lengths for coats, scarves, and other clothing.

below: The Bishop Strachan School in Toronto was one of the private schools that included craft subjects in its curriculum. While glazed pottery dried on shelves, a class of eager weavers worked on Thackeray looms in the mid-Thirties.

producing new lines called the Guildcraft-Thackeray Utility and the Guildcraft Silent Speed looms, "made from best quality, kiln-dried Canadian birch." Other variations followed. Clark was optimistic about the market potential in smaller looms since he had read in Montreal newspapers that Quebec had ten thousand handweavers in 1935 whereas Ontario had only two hundred.[26]

Over the next two decades the Guild developed a sizeable mail-order, portable-loom business, manufacturing and shipping more than thirty thousand around the world and teaching some ten thousand eager neophytes to weave on them. Vocational schools, institutions, and rehabilitation hospitals bought them for students and patients, but Thackerays had an even wider appeal: The Bishop Strachan School, the governor of Jamaica, Henry Ford, Taylor Statten camps, Banff School of Fine Arts, and countless others were clients.

Judging from newspaper stories and photographs, Rosa Clark herself demonstrated on looms at specialized institutions, smartly turned out in tailored clothes often made from fabric she had woven herself.

A popular Thackeray teacher was Clark family friend Grace Pogue, whose pupils included furloughed doctors, educators, and missionaries who, after their sessions with her, returned to India, Ceylon (Sri Lanka), China, Japan, Africa, or South America, new Thackerays in hand. Pogue also presided at the Simpson School of Handloom Weaving in the venerable Robert Simpson department store in downtown Toronto, a cooperative venture in the mid-Thirties with The Guild of All Arts. There, potential purchasers could learn on Thackeray looms, buy an eighteen-dollar version with monthly payments of two dollars and fifty cents, and begin to produce items for home use.[27]

Although the Thackerays served to introduce hand-loom weaving to countless individuals around the world and for a period were gratefully embraced by physiotherapists, they barely held their own in the decades to follow. The very advantages the Clarks advertised — portability, lightness, and ease of storage — were offset by tension-control problems, unstable frames, and the length of time it took to produce articles on looms operated entirely by hand.

Weaving aside, few of the Guild programs evolved as the Clarks had planned, except for the woodworking studio, which operated as a small industry. Their idealism faltered under the exigencies of day-to-day existence. Living and working on the premises in a

would-be artist colony posed difficulties they had not foreseen. Craftspeople tended to feel exploited and regarded their situation as undignified, not at all what the Clarks had promised them. It was also hard on the Clark family. "It was a struggle to help crafts-people get enough of a living out of it," Clark claimed, "mostly we had to underwrite and subsidize the crafts." Continually juggling bank loans and keeping creditors at bay, he told an interviewer that "I haven't been free from financial concerns and worries since the time we started The Guild."

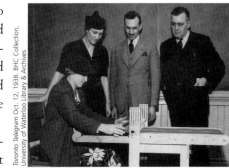

Toronto Telegram Oct. 12, 1938. BHC Collection, University of Waterloo Library & Archives

Wartime created further havoc for The Guild of All Arts since some residents volunteered for service, and all studio supplies except wood were either restricted or in short supply. The federal government used the main buildings to house the Women's Royal Canadian Naval Service (WRENS) in 1942 and 1943 and, from 1944 to 1947, veterans who needed rehabilitation and craft therapy. By then, all that was left of the original cooperative enterprise was the manufac-ture of looms, furniture, and a new line of Austrian educa-tional toys, which were forerunners of today's educational toys. After the war, Rosa and Spencer Clark kept the wood-working studios but moved on to other projects far removed from the studio concept of the Thirties. Their cooperative experiment, in the final analysis, did not have much impact

OCC Archives

above: Rosa Clark (seated) demonstrated how easy it was to operate a Thackeray loom. Standing beside her was Jean Hammond, an orthopaedic teacher; next to her, Spencer Clark; and on the right, Thomas Scott, president of the Wellesley Old Boys' Association.

on the development of contemporary craft in Ontario but rather reflected how they wished to be perceived in public, a position they shared with earlier visionaries on whom they modelled themselves.

Hand-woven towels from the Thackeray looms of the Guild of All Arts.

Making It on Your Own

A craft-teaching program planned for the Guild never materialized, but those living in Toronto's environs had other educational options to choose from in the Thirties: appren-ticeships, studies at the Ontario College of Art, as well as post-high school diploma pro-grams at Central Technical School — in all but name the province's polytechnic institute. OCA offered courses in a few craft disciplines, and during Herbert H. Stansfield's time as head of design and applied art, the curriculum included jewellery and metalwork.

From the beginning, Meek favoured work that reflected the natural world.

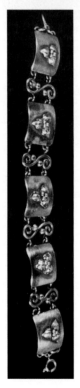

Knowledgeable in many areas of craft expression, Stansfield was every inch a William Morris disciple[28] and willing to give extra assistance to those prepared to embrace his philosophy. "Once I got into his metal classroom, that functioned more as a studio, I didn't want to leave; I skipped classes to be there," Toronto jeweller Nancy Meek recalled some six decades later.[29]

Meek had begun her art studies at Central Technical School and was determined to become some sort of artist, but she wasn't sure what path to take or where it would lead. Fortunately, the craft scene she was entering was notable for the freedom it offered women. Stansfield was not only encouraging, he hired her and classmate Rosina White during summers to produce pins and earrings in copper, silver, and pewter at seventy-five cents each for a shop he ran in Niagara Falls for a couple seasons. His was one of the first attempts after World War I to bring quality crafts to the area's tourists, but neither his nor any other was able to succeed. Meek's designs featured floral motifs — "I always loved flowers, broken sea shells and things from nature" — penguins, kittens, and dogs. After graduation, she accompanied her parents to Europe, and in Paris furthered her jewellery studies and general education, spending all her Stansfield earnings, eighteen dollars, not on jewellery but a treasured glass vase by René Lalique. While in Paris she learned two axioms: it's not what you see that matters but how you see it; and wherever you go, make jottings and drawings. Her professional order books from her fifty-year career are replete with design ideas and sketches for clients, and a delight to modern browsers fortunate enough to have a private viewing.

Eighteen months later Meek returned to Toronto, and with classmate Rosina White set out on a remarkable career path, jewellery being in her words "much the best craft to make your living then." Although studio conditions were abject and earning a livelihood from craft production unpredictable, the local arts and crafts scene nonetheless pulsed with new ideas. Some of them percolated from lectures at the Royal Ontario Museum on Art Deco by French designer and painter René Cera, who came to Canada in 1929 from Eaton's Paris office and remained in Toronto for thirty-eight years. For Eaton's College Street store he conceived the Round Room, designed its windows and fixtures, and became an important influence in Toronto design circles. "He was a very interesting man," Meek remembered, "very exciting and inspiring. All the craftsmen were there and some later formed a cooperative with him in Eaton's warehouses."

After the Cera lectures, Meek, Rosina White, potter Nunzia D'Angelo, and others continued discussions at Andrew Fussell's diminutive metal-working studio at 109 Bloor Street West, a red brick house in Central Toronto that was his base of operations for fifteen years. "Those evenings sitting around the floor of Andrew's studio with candlelight and wine were thrilling and great fun for me just home from Paris," Meek recalled. "At first, we just had parties, then we said 'this isn't right, we should be improving ourselves, we should be reading and talking.' So we developed intellectual evenings where we read books we thought would enlighten us on philosophy, politics, history, whatever." Potter D'Angelo, an absent-minded and indifferent cook, felt obliged to provide pots of spaghetti which she called "them;" frequently "them" boiled over on little studio stoves, became twisted with studio equipment, and had to be pried off the next morning.

Candlelight and wine must have been especially grand for Andrew Fussell, who had been keeping himself alive for some time on oatmeal cereal; by eating it dry, he claimed a twenty-one-cent package lasted for weeks. When he was able to sell a bracelet made at night school for a dollar or two, he "lived high and had milk and sugar on my oatmeal." Fussell had arrived from England in 1926 as an inexperienced and penniless 22-year-old who dreamed one day of becoming a sculptor. He had grown up with artistic parents; his Belgian mother was a painter and needlewoman, and his British father a violinist. But the economics of survival dictated for him bricklaying and carpentry jobs, when there was work at all, relieved by night-school courses at Central Technical School in sculpture, art, and architectural drawing. While there he discovered art metalwork, a course given briefly by a Georg Jensen pupil, Henrik Beenfeldt, and Fussell continued this new interest at Northern Vocational School under Rudy Renzius.

It is one of craft's happier stories that an almost destitute young man could forge a career in such difficult times, based almost entirely on skills learned in part-time high-school courses. Only eight years after immigrating, he was asked to join the board of the Handcrafts Association. It helped that he had an enormous capacity for hard work, gritty perseverance, a never-say-die disposition, and a disregard for creature comforts. He was further blessed with an exceptional guardian: Adelaide Plumptree. Described by the *Globe and Mail* in 1937 as "the outstanding woman in public life that Toronto has produced in fifty years,"[30] Plumptree was resourceful and incredibly well connected in civic, educational, religious, and

English-native Andrew Fussell arrived in Toronto in 1926 to begin a career in the arts that took many twists and turns.

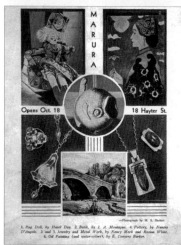

above: For six summers in the 1930s, Nancy Meek grappled with teaching the finer points of jewellery-making at Camp Glen Bernard, one of the summer camps that offered craft programs.

below: The Murura opening was a cover feature of *Gossip* magazine in September 1936.

political circles. One of her many missions was helping young Fussell get on. She garnered commissions for him and donated provisions until he was sufficiently established in his studio business and teaching career. Others of her circle were not amused by his studio operations and wished they would disappear. His balcony overlooked the Windsor Arms Hotel on St. Thomas Street, a carriage-trade location in central Toronto; in good weather his students formed sheets of metal outside, and their noisy hammering, echoing through the laneways, exasperated hotel guests.

Unlike Fussell, Nancy Meek had the advantage of living at home most of the year — her father was a university professor — escaping for eight weeks in summers to teach jewellery fundamentals to teenage girls at fashionable Camp Glen Bernard in Sundridge — a detested sideline endured for the sake of financial independence. In Toronto she shared a succession of studio shops with White, one of the best known being a five-dollar-a-month hovel with earthen floors at 18 Hayter Street in the Gerrard West Village area. If you were ambitious and earnest about your reputation as an artist, as they were, you grasped at opportunities to exhibit outside such humble quarters. An influential alternative was the CNE's Graphic Art Building where invited work by local fine and applied artists mingled with the best from Canada and Europe in exhibitions that had accompanying catalogues valued by today's collectors.[31] The women appeared four times at the CNE, which helped to cultivate new clients and develop lasting friendships among painters, photographers, and musicians.

Friend Jack Montague combined his skill on the violin with batik making; with Meek, White, and D'Angelo he began an artist cooperative called Marura at the Hayter Street studio. Reliving it all, Meek was amused by the disaster that attended the grand opening in October 1936. "The building was an outhouse stuck on the back of a convenience store with two rooms that we covered with burlap and copper strips to hide the broken plaster. We built in cases, planned a grand opening, sent out invitations. It poured rain and no one came." Inglorious it may have been, but in that little studio the group promoted work by a variety of artists and craftspeople. Sometimes there were sales, nothing cost more than a dollar, and those occasions were celebrated with congratulatory parties of rye bread (five cents), salami (ten cents), and some Niagara wine.

Leaving her friends to run Marura, Meek headed for New York to try her wings

teaching for a season at the University School of Handicrafts. To show her most recent work to her employer, she took along a striking gold wheatsheaf pin mounted with a malachite stone. Such jewellery demanded expensive materials, which she couldn't afford but which her mother helped her purchase through the sale of her grandfather's gold watch. Later that year the pin became part of a collection of Canadian crafts for the Canadian Pavilion at the Paris International Exhibition of Arts and Crafts in 1937.[32] To get it there, Meek took it to the New York docks and gave it to Adelaide Marriott before she boarded a ship to Europe. In Paris, Marriott was in charge of the Canadian display and after Expo, she took it to Glasgow for a Scottish Empire Exhibition. The following year the collection went to the Women's International Exposition of Arts and Industries at Madison Square Gardens in New York where it won an award for best display. These early showings of a diverse range of contemporary crafts at foreign exhibitions signalled to the world that craftspeople in Canada and particularly in Ontario had refined their skills to a point where they could hold their own in international circles.

Returning to Toronto and its lingering depression, Meek began a twenty-year love affair with Gerrard Street West, its decrepit houses, "every creaky board, every bump and crack" at number 92, which she and D'Angelo rented late in the Thirties, and the endless variety of its people. Some were young transients like Bill, who lost a leg riding the rails — an all-too-familiar occurrence in the Thirties — and who used a Murphy bed in Nancy's studio in exchange for tending her coal furnace at nights, a winter necessity to keep pipes from freezing. Unemployed young men had more free time than they knew what to do with, and some were frequent studio visitors. Even though the two women often didn't know where next month's rent was coming from, "Every day without fail we had tea at four. We had a tin can to put coins in, our slush fund, so we could buy cookies to serve." A second-floor tenant, fun-loving English aura reader Hiliarion Adams, joined the gatherings and entertained everyone by reading tea leaves, whose portents only D'Angelo took seriously. These same young men — a couple dozen of them — could be counted on to help the women with chores, painting the whole house inside and out when asked. Other regulars were aspiring classical musicians who lived in a nearby residence and used the Gerrard studios to rehearse.

above: Meek's jewellery showed off simple forms and strong gem settings.

below: To show clients samples of the type of work she could make, Meek produced a catalogue of meticulous renderings.

Number 92 was a distinct improvement over Hayter's dirt floor. Of the three rooms on street level, the front was a showroom for craft work and paintings by a few friends. In

41

the middle, D'Angelo toiled at her potter's kickwheel, driven by an old sewing machine, an ingenious adaptation that had appeared first in American pottery circles.[33] Meek worked at the back of the house in the kitchen. Following no particular school or trend, she was evolving her own natural forms, often combining copper, silver, or gold with gems and stones she cut and polished herself, exhilarated by Canadian rose quartz, amazonite, labradorite, sodalite, agate, amethyst, and garnet. Throughout her career, she harboured "a weakness for stones and loved to handle good ones."

While Meek could execute her work entirely from the bench Stansfield had given her when he retired, D'Angelo faced endless logistical challenges, as did Mabel Adamson or any independent studio potter at the time. She had to arrange for Sovereign Potters to pick up and deliver work she had previously bisqued in a crude kiln she kept in her parent's backyard and to keep her fingers crossed. Quite simply, her success rate was appalling. "We would pack up her work for the truck; they would deliver it back," Meek recounted. "Then there would be unwrapping and we would see what had survived. Some of the

above: While sharing #92 Gerrard Street with Nancy Meek, Nunzia D'Angelo autographed a studio photograph for her.

below: Nancy Meek had a succession of studio cats, one named after the celebrated Renaissance goldsmith, Benvenuto Cellini, who kept an eye on her as she worked at the bench H.H. Stansfield had given her.

work was in pieces. It was terribly frustrating for her but she did it. You do what you have to do." In the face of such odds, we wonder how she was able to fill a valuable order from Canada Steamship Lines for 250 ash trays and 25 vases — or any other commissions, for that matter. The public, unaware of such obstacles, found her always cheerful and her work joyful and uncomplicated. Her forms were usually simple and often decorated in the majolica style, reflecting her own Italian background and the prevailing interest in Mediterranean folk pottery.

Feats in Clay

Born in Toronto, Nunziata D'Angelo's personality captivated audiences wherever she demonstrated pottery making: at the Canadian National Exhibition, Royal Winter Fair, Women's Art Association of Canada, at exhibitions, or other events. Of all craftspeople of hers or any other generation in Ontario, she instinctively understood the importance of publicity and

was the decade's best-known professional potter. "Nunzia wasn't just a potter; she was a performer," affirms "Millie" Ryerson, owner of a craft retail shop, The Artisans. "She would throw her clay, bring up a beautiful vase, the audience would go 'oh, how lovely,' and she would look up, smile, pick it up and go smack, bang; the audience would go 'oh' and she'd look up and say 'I'll make another.' It was just so beautiful. It was a real dance with clay."[34] Locally trained for the most part, she learned about working in earthenware at Central Technical School from Zema "Bobs" Coghill Howarth, an English-trained potter, painter, and arts champion who arrived in Toronto with her husband, Peter, in the early Twenties.

It's tempting to claim there's never been anyone quite like "Bobs" in Canadian ceramic circles. Immaculate in a white smockcoat, her hands gleaming with red nail polish, Howarth presided over her twenty or so charges behind a desk rather than teach them in the formal sense. For several decades her courses were regarded as an invaluable source of informed ceramic instruction and leadership.[35] Anyone in Ontario with a genuine interest in ceramics, whether collector, purchaser, critic, writer, or maker, would have been inspired at one time or another by her innate good taste and discrim-

Queen's University Archives, The Howarth Papers, Collection #5033, Box 8/9

ination. As prominent critic, sculptor, and juror Elizabeth Wyn Wood told a New York audience, "Bobs" and her husband "consistently maintained the principle that pottery is not only a craft but a major art." And "art pottery" was certainly an afforable means of acquiring decorative objects for the home. Central was said to be the first technical school in Canada to teach pottery and "graduated thousands of Canadians in the past twenty years who know good pottery when they see it and many who can make it."[36] For many years the school's pottery studio, with a Denver oil-fired kiln, was virtually the only adequate public facility in the province. Women initially formed the core of Central's day-time pottery classes, drawn to clay's approachability and the school's comprehensive studio, which was

above: Toronto potter Nunzia D'Angelo presented a vase built of local clay to Governor General Lord Tweedsmuir when he visited the Royal Winter Fair in 1937, halfway through his five-year Canadian term.

below: A couple who made a difference in Toronto's burgeoning craft scene: (left) Zema "Bobs" Howarth, painter and pottery teacher at Central Technical school for almost four decades, retiring in 1962. (right) Peter Howarth, painter, stained-glass designer, teacher, and director of art at Central Technical School for a quarter of a century, retiring in 1955.

a lifeline to many alumnae until they could afford their own work spaces. Even by the late Forties, there were only three known privately-owned kilns in Toronto.

D'Angelo graduated from Central in 1926 and was Howarth's studio assistant and a part-time instructor for several years, after which she joined forces with Robert J. Montgomery, professor of ceramic engineering at the University of Toronto and an executive member of Ontario's Handicrafts Guild. At Central, Howarth used English earthenware clay bodies that came already prepared. Of more interest to Montgomery and D'Angelo were clay bodies from Northern Ontario — said to be the finest deposits in the province — since both had a vision of indigenous contemporary pottery made from native materials that would "express the life of our people," as D'Angelo told a Canadian Ceramic Society convention in 1938. In a sense, their trail-blazing efforts in promoting clay expressions emulated what the Group of Seven painters had achieved in defining the Canadian landscape — it was a shared belief that it was cultural suicide to import what we could create ourselves.

In 1936, together with "Bobs" Howarth and a group of some thirty assorted students from Central's classes, D'Angelo and Robert Montgomery began the province's and Canada's first craft media guild, The Canadian Guild of Potters, a name it adopted formally the following year. "Bobs" was made its first honorary president and Montgomery served as chairman until a formal executive was in place. His work in the clay community was so extensive, his enthusiasm so boundless that D'Angelo said he was virtually the "guiding star and father of us all."[37]

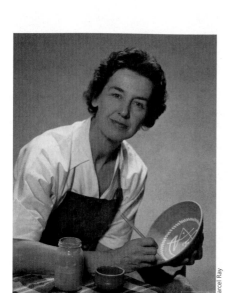

Accomplished potter, teacher, experimenter, and glaze technologist Toronto's Molly Satterly was, in many ways, ahead of her time.

Secretary for the first few years was Molly Satterly, a neighbour of D'Angelo and Meek who operated a studio in a small cottage on Elizabeth Street from 1936 to 1941, when she volunteered for war service overseas. A gifted student, Satterly alternated between academics and pottery studies in England, at Central Technical School with "Bobs" Howarth, and later at Alfred University in New York State. Innovative yet precise, artistic yet scientifically rigorous, she alone had the ability to balance exhibition work with research, education, and employment in the ceramic industry.

Although it purported to be a national organization, the Guild naturally enough mirrored the attitudes and priorities of its Toronto base where most of the early membership lived. Apart from raising awareness for studio pottery as an art form, developing and

forming public taste, the Guild championed high-calibre exhibitions, acted as a medium for exchange of ideas, and encouraged well-designed pottery that would "reflect a Canadian sensibility." Montgomery, always practical, consistently encouraged the group to be progressive, to understand the science of their materials, advice they also received from C.T. Currelly, director of the Royal Ontario Museum.[38] Support came from industry, too. The Canadian Ceramic Society, a professional group of clay products manufacturers used its monthly organ, *Clay Products News and Ceramic Record*, to dispense technical information, print reports on the Guild's annual meetings, and showcase some of the Guild's outstanding studio potters in a who's who column. Industry was no doubt reassured that its help soon paid dividends: sales of clay and clay products early in 1937 were fifteen percent higher than in the same period the year before, and continued to grow.

From the time it was conceived, the Guild set itself an aggressive program of monthly meetings, study sessions, exhibitions, and sales promotions. It sold work wherever it could find cooperative outlets: The Guild Shop, Women's Art Association of Canada, and for a time Edwards Gift Shop on Gerrard Street West in Toronto. In spring 1937 it combined with Central Technical School to mount a week-long showing at the Museum opened by Director Currelly, after which thirty pieces travelled to Paris for the Exposition. The Guild staged annual exhibitions after that for fifteen years at the Art Gallery of Toronto, demonstrations at the Royal Winter Fair, and annual appearances at the CNE, which it regarded as an educational opportunity to mold good taste.

Although ceramics and other craft had been shown at the CNE for years under the aegis of the Women's Art Association of Canada, in 1939 a more comprehensive exhibition was organized by WAAC and a committee of studio craftpeople. They brought together more than sixty leading craftspeople, mainly from Southern Ontario, who worked with wood, leather, metal, clay, or cloth. Some like D'Angelo and gifted metalsmith Harold Stacey were pictured at work in an accompanying catalogue; others like Nancy Meek had their business cards reproduced. If anyone had had any doubts about the survival of contemporary crafts, this exposition put that to rest.

For the morale of the Canadian Guild of Potters, almost more important than praise at home was recognition from the more sophisticated American ceramic community. When ten of its members were invited to take part in the Seventh National Ceramic Exhibition

at Syracuse, New York, the Guild was elated because the National was the dominant show-case for clay artists.[39] The icing on the cake was the arrival in Ontario of Anna Wetherill Olmstead, founder of the National and director of the Syracuse Museum of Fine Arts. She came to look over Canadian work to be included in *Contemporary Ceramics of The Western Hemisphere*, a continental spectacle that heralded the National's tenth birthday in 1941. Olmstead was without doubt the seminal force in American ceramic circles, a leader of a growing phalanx dedicated to improving and promoting ceramics, whose efforts soon catapulted pottery to the top rung of the craft ladder. And she told Pearl McCarthy of the *Globe and Mail*, staging the exhibition also supported her conviction that "as we stand together in defense of our nations by war, so we must stand in defense of art as a factor in that good life for which the war is being fought."[40]

Surviving The War Years

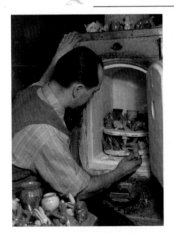

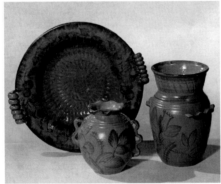

The war years were disruptive, of course, but also rewarding for well-established studio craftspeople like Fussell, Meek, and D'Angelo. After a whirlwind courtship, Nunzia D'Angelo married a new man in town, brilliant Czech ceramist Jarko Zavi, who had fled to Canada at the outbreak of World War II. Their union puzzled friends and generated a great deal of media interest, blending as it did her impetuous nature and charm with his moodiness and meticulous attention to detail. Reporters and radio broadcasters seemed endlessly fascinated by them: their work, the way they lived at 94 Gerrard West, how their business — now called Ceramic Art Studio — operated, and how a European refugee was coping with a new life and language.

It wasn't easy for either of them, and it became impossibly difficult. It wasn't so much the wartime scarcity of supplies as it was Zavi's feeling of alienation, his stomach ulcer, his discomfort with their cramped and dingy quarters where they worked in a kitchen over-heated by a new gas kiln, and his distaste for the Gerrard Street neighbours, many of them his wife's friends. The irony was that the war years were their most productive and lucrative

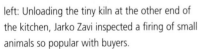

left: Unloading the tiny kiln at the other end of the kitchen, Jarko Zavi inspected a firing of small animals so popular with buyers.

right: D'Angelo was strongly attracted to Mediterranean folk pottery, as demonstrated in this 1942 collection of work.

46

period, even though it took all their energies, seven days a week, to work and raise their two young daughters. Suppliers clamoured for their ornamental pieces: ceramic fish, mallards in flight, buffaloes with heads lowered, prancing horses; buyers could not keep their miniature animals and birds in stock; popular, too, were vases, candle holders, buttons, bowls, ashtrays, decanters, teapots, plaques, and earrings. An instinctive and curious chemist, Zavi experimented obsessively with glazes, and when he did finalize one that met his standards, friends soon knew about it and helped celebrate his success.

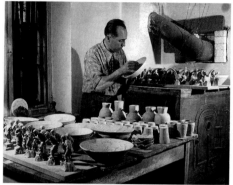

They were not to experience this kind of camaraderie once they relocated to a rural setting outside Cobourg where Zavi dreamed of establishing a ceramic centre to teach and carry on his art. He insisted on being the sole supporter of the family, so D'Angelo gave up studio work, although she continued to appear in public for a few years at the CNE, doing what came naturally: demonstrating, talking, teaching. Over his four-decade career, Zavi perfected new glazes from Canadian materials, experimented with Canadian clay bodies, championed in vain for a school for potters, and along with several others, harangued against cheap, imported souvenirs to sell to tourists. Innovative and technically advanced, he perfected his art within the framework of his European sensibility, preferring to live and work totally isolated from the craft community and the increasingly influential world of museums and galleries.[41]

Isolation held no attraction for jeweller Nancy Meek, whose reputation as a talented craftsperson and teacher was growing steadily in Toronto and whose clientele was mainly city dwellers. Through artist friends she met and married fellow Torontonian John Pocock early in 1943, when he was in military service. They were a striking couple: he six foot, six-and-a-half inches tall, dark and personable; she, serious, petite, with a head of tight red curls. Through their letters to one another, we share the poignancies of war separations, how Meek coped with shortages and blackouts and worried about the expense of running a custom business — seventy-five dollars a month, offset in part by subletting rooms she did not need. Commissions continued to pour in especially for Christmas gifts, and the push to finish work by Christmas Eve left her exhausted, a pattern that persisted throughout her entire career.

When John returned from the war and their daughter was born, they made 92 Gerrard West their home and studio for another decade. She taught him her craft and the Meek &

above: In Cobourg, Jarko Zavi was able to have a more spacious studio. He carefully finished the surfaces of his work before the final glazing and firing.

below: Nancy Meek and John Pocock on their wedding day in 1943.

above: Nancy Meek had this photograph taken to send to her husband while he served overseas during World War II.

below: Both Meek and Pocock shared Nancy's bench in their custom-jewellery studio at 92 Gerrard Street West, from where they moved to Hazelton Avenue in 1955.

Pocock partnership became a bedrock of the city's craft community. They shunned designing monotonous jewellery made of cheaper materials in a small factory setting — an approach that undoubtedly would have made them more money — choosing instead to stay with highly individualized custom work. After the war they formed a professional association, the Metal Arts Guild, together with a handful of others, including professional colleagues Harold Stacey and Andrew Fussell.[42]

Nancy, and later John, taught pupils to supplement their income; Andrew Fussell taught primarily because he loved it, although he, too, was chronically strapped for extra cash. "I've never known anyone who was so outgoing, so giving, so willing to do everything to help everyone," recalls noted painter Doris McCarthy, of her time in his Central Technical classes. "He'd run from person to person so he would not waste time in order to give the next person help."[43] Students, and there were hundreds of them, recall not only his generosity and sweet nature but his unfailing good cheer and humour. Totally absorbed by what he was doing, he ignored practical details, which made some of his female pupils conclude that marriage to him would be hazardous. Private students recall that he was so trusting and unbusinesslike that he left it up to his pupils, who paid per class, to leave whatever they thought they owed. He never checked. Even so, one of them, Margaret Mingay, was brave enough to marry him and bring some order to his life. By April 1949 they established themselves at a commodious studio home at 10 Asquith Avenue, where they remained for the next twenty years, a period in which his career and reputation flowered.

Wartime undoubtedly slowed the advances contemporary craft had made in the Thirties but also provided some promising new starts. In Grafton, near Cobourg, a restored 1817-Barnum House reopened in 1940 as a museum and craft retail outlet. On and off for eight years, the Ontario branch of the Canadian Handicrafts Guild was its major tenant. Meanwhile in Toronto, a quaint century-plus gate house on the Art Gallery of Toronto (now Ontario) grounds was transformed into Craft House. For a dollar a year, the city's Parks Commission rented it to the Handicrafts Guild, which paid for renovations and turned it over to two of its affiliated groups, the potters and the weavers. The city tore it down a decade later.

Professionals like Fussell, Meek and the Zavis, who worked in their studios rather

than in the war effort, could sell everything they made during the war years. In fact, the Guild Shop at Eaton's, Eaton's itself, Birks, and other retailers all had difficulty acquiring enough quality work to meet public demand. This lack of supply adversely affected the Guild Shop's already perilous profit-and-loss picture. The Town Shop of The Guild of All Arts at 44 Bloor Street West fared even worse. With its emphasis on looms and weaving supplies, it had to close, a move no doubt brought on by the scarcity of affordable woollen yarns during wartime.

Although many younger Ontarians were in the armed services or essential war work, the board of directors of Ontario's Canadian Handicrafts Guild continued to attract distinguished leaders to its board. Industrialist Sir Ellsworth Flavelle was president in 1939, followed by University of Toronto architecture professor Eric R. Arthur, and then Dr. Edward A. "Ned" Corbett, who guided the Canadian Association of Adult Education through its first fifteen years.[44] Adelaide Marriott was joined by highly regarded Nora Vaughan, whose husband was Eaton executive O.D. Vaughan. A doyenne of art and design circles, she chaired the Ontario Guild's Development Committee when it was called on to raise money to renovate Craft House. Jean A. Chalmers, wife of the editor of the *Financial Post*, Floyd S. Chalmers, and a person of particular tenacity herself, continued her long-standing association with the Guild by serving as vice-president in the mid-Forties. The board became more democratic, too, and during this period members included representatives of the busiest craft guilds: weaver Lois Brown, spinner Margaret McPherson, jeweller Nancy Meek, woodworker Frank Carrington (who a decade earlier had a brief stint at The Guild of All Arts) and potter Kathleen Towers. For Meek, being officially elected to the Board was "a triumph" and the culmination of years of lobbying on behalf of craftspeople for board representation.

As we're often reminded: when the going gets tough, the tough get going. While newspaper headlines screamed "Vengeful Nazis Bomb Historic Cathedral City of York," Adelaide Marriott marshalled her troops to bring crafts back into the public eye. War had dampened exhibition activity everywhere, forcing the CNE and the Ceramic Nationals in Syracuse to suspend operations. To draw attention from the war and redirect it to the nation's material culture, the Ontario Guild brought together a broad range of art and

Reprinted with permission from *The Globe and Mail*

above: The Fussells acquired 10 Asquith Avenue in the late Forties as their home and studio. It was demolished in the 1970s to make way for the Toronto Reference Library, designed by architect Raymond Moriyama.

below: From his Asquith workshop in 1963, Andrew Fussell began work on raising a copper bowl, an item in constant demand by his clientele.

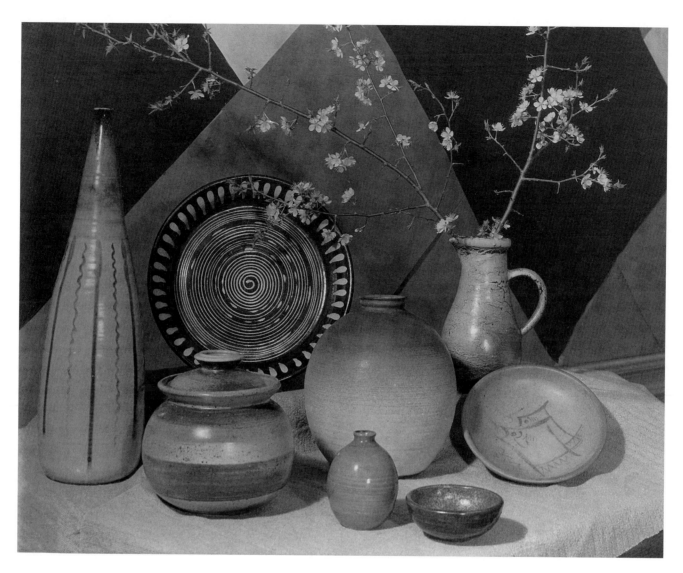

From a Canadian Guild of Potters exhibition in 1945 at Central
Technical School, a display of work from some of the Guild's
Toronto contingent: Eileen Hazell, Mary Dickenson, Kathleen
McKim, Bailey Leslie, Ivy Hamblett, and Evelyn Charles.

journal's articles kept alive an interest in crafts at a time when people everywhere were preoccupied with events in Europe.

As war drew to a close, a new direction for crafts was defined when *Design in Industry* opened at the Royal Ontario Museum in spring 1945. An unabashed clarion call, the exhibition was a joint undertaking of ROM and CHG. "For nearly six years the attention of the world has been focussed upon destruction," the catalogue's introduction read, "contemporary design has been in machines for war, fabrics for safety, and chemicals for sustenance. Now our war in Europe is over. Canada is about to take its first steps in partial peace and security. This exhibition of the arts of peace, is, therefore, timely."[46] It was, at heart, a promotion for a Canadian school of design and technology — a dream realized in 1948 with the birth of Ryerson Institute of Technology — and the role designer-craftspeople could play in the manufacture of all quality products. Talk of design was on everyone's lips. "Design has entered the common consciousness," wrote Ontario College of Art Principal Fred S. Haines in *Canadian Art*, "design in living, design in government, design in business."[47] *Design in Industry* thus identified post-war directions for the craft and design communities to explore together as associates.

Having risen above an economic depression and a world war, Ontario craftspeople were poised to take the peaceful arts in new directions. Before them were changing tastes, returning service personnel who needed further education, the arrival of scores of talented craftspeople from Europe, and a commitment from government to fund new educational initiatives. Together, these circumstances were to have a profound impact on Ontario's crafts and design community, which found itself grappling with very different priorities and problems than those faced by the reformers and cultural activitists fifteen years earlier.

1946–1960

NEW HORIZONS

NEW HORIZONS

After World War II, self-taught potter Alan Johnstone, shown here with his wife, began his Pot-O-Gold Pottery at Desbarats and ran it until 1976, selling work from a roadside stand next to the house.

The war over at last, Ontario's immediate preoccupation was "social reconstruction," part of which was assisting returning service personnel to advance their education and prepare them for peacetime employment. The Ontario College of Art opened a new design school on Nassau Street in Toronto's colourful Kensington Market district, an initiative made possible by an increased endowment from the provincial government.[1] Over a five-year period the College attempted to develop designers for crafts and industry and to train teachers in pottery, leather, metal, furniture, textiles, and other craft fields. As well as the OCA offerings, craft education in day and evening courses was available at Ryerson Institute of Technology, founded in 1948, and later at the Provincial Institute of Trades in Toronto, plus a cluster of technical high schools, the most influential of which were Central Technical School in Toronto and H.B. Beal in London. In the public-school arena, welcome winds of change were also blowing through the dusty cobwebs of art education. Director of art for the province, Dr. C.D. Gaitskill, headed a vanguard who promoted a British notion that craft and art, material and design, are enriched when taught together, and impoverished when separated, as had been the customary practice in Ontario schools.

South of the border, the serious study of craft was finding a new life outside U.S. university home-economics and industrial-design departments and was slowly integrated into art departments. By the early Fifties the first generation of school-educated American craftspeople and teachers, swept up in avant-garde optimism and liberated from traditional craft practices, was ready to explore, experiment, and excite. Canadian universities, with a few exceptions, did not follow their lead or seriously embrace studio crafts, so it was the American institutions that promulgated the new spirit throughout North America by means of workshops, summer courses, craft publications like *Craft Horizons* (by 1948 a glossy magazine with an extensive circulation), and through exhibitions such as *Designer Craftsmen USA*, which arrived at the Royal Ontario Museum in spring 1955 and was, by all accounts, a milestone.

North American museums in this period were credited with improving public taste and widening the public's awareness of the accomplishments of contemporary craftspeople. In Ontario, ROM had hosted

54

exhibitions of the Spinners and Weavers of Ontario since 1945; the Metal Arts Guild since its inception in 1946; and, beginning in 1955, the biennials of the Canadian Guild of Potters, which had previously exhibited at the Art Gallery of Toronto. In 1947 ROM's mandate was expanded to work more closely with Ontario manufacturers and industry, specifically to promote home-grown design, by now everyone's priority, and ROM mounted at least three design-related exhibitions in the Fifties.[2] One on Scandinavian design, under royal patronage, in late 1954, attracted nine thousand viewers, a measure of the public's fascination with Europe's northern peninsula, and a presage of its pervasive influence on North American design in general.

Adult craft education, especially in areas outside metropolitan centres, was given a bracing tonic by the Community Programmes Branch of the Ontario Department of Education. Its aim, after the war, was initially to promote and develop crafts as a home industry to supplement family incomes, but its courses also encouraged the creative use of leisure time. In a few short years its weaving program spawned legions of devotees and weaving guilds throughout the province. By 1948 there were some eight hundred weavers in Ontario (thirteen years earlier there were said to be only two hundred) and by 1967 the figure had swelled to four thousand men and women. In both country and city the Fifties belonged to the loom and its products. The first solo exhibition by a craftsperson, in fact, was that of Danish-born Toronto designer-weaver Signe Lundberg, in June 1947 at Eaton's College Street art gallery. In Ontario's increasingly buoyant craft market, sales of woven scarves, ties, placemats, and other affordable accessories far outstripped those of jewellery, metalwork, leather, and pottery. Precise sales figures are impossible to come by but *Canadian Art* magazine in 1951 informed its readers that more than two hundred Canadian shops reported annual craft sales ranging from two to four million dollars, and that purchasers were now a more discerning group, eager for work that was beautiful, interesting and functional, not merely quaint and rustic.[3]

Enriching this maturing craft scene were more skilled craftspeople from Europe. Between 1945 and 1965 a quarter of Canadian newcomers settled in Toronto, so that Metro's population increased twenty-three percent between 1941 and 1951 and doubled again in the next decade. In twenty years, metropolitan Toronto metamorphosed into a cosmopolitan area of more than one-and-a-half million, and other Ontario cities grew proportionately.[4] While this was

One of the founding members of the Spinners and Weavers of Ontario, Danish-born Signe Lundberg established a reputation for outstanding work with linen, of which this ecru placemat is a rare surviving sample.

Peter Hogan

happening, Toronto became prohibitively expensive for craftspeople to live and work in, especially for those just beginning their careers. Risking artistic isolation and distance from urban markets, the more adventurous moved out, relocating to smaller centres or to the country. The first wave included potters Nunzia and Jarko Zavi, who fled to Cobourg; weavers Dorothy and Harold Burnham and potter Tess Kidick, who went to Jordan in the Niagara Peninsula; textile artist Elizabeth Wilkes Hoey set up her first printing studio in a barn loft in Bronte, west of Oakville, and then moved to Elm Tree Farm near Guelph. Potters Selma and Jim Clennell built Pinecroft Ceramic Art Studio from scratch, on the outskirts of Aylmer; John DeVos turned a Grimsby schoolhouse into a pottery studio; and Alan Johnstone of Desbarats, just east of Sault Ste. Marie, made his hobby a full-time occupation at Pot O'Gold Pottery, selling work from a roadside stand. Émigré German potters Susanne and Theo Harlander arrived late in 1951 and chose to settle on a farm near Brooklin, while Dutch-born weaver and teacher "Rie" Donker Bannister bought an old inn in Queenston and converted it to a weaving resource centre, having previously operated weaving houses in Kingston and Toronto. Still others dreamt of establishing a self-sufficient craft village a hundred or so miles from Toronto; the only stumbling block was the absence of a benefactor willing to provide start-up money.

Retail pottery sales were at the low end of the purchase scale at this time, but exhibition pieces enjoyed a growing reputation for excellence and brought international recognition to accomplished practitioners. The clay vessel no longer had to be satisfied by usefulness. It could exist without apology as an art object. In the new wave of expressive work was Helen Copeland's black-and-white open-necked vase which won a silver medal at the Second International Congress of Contemporary Ceramics at Ostend, Belgium in 1959, a feat she was to repeat at Prague in 1962. On that occasion Canada sent 38 pieces: Torontonians Marion Lewis and Dorothy Midanik received gold awards, another six won silver and four, honourable mentions. The entire Canadian section, said *Craft Horizons*, provided a rewarding experience to viewers. The Canadian Guild of Potters received further accolades from a 1958 appearance at the Stratford Shakespearean Festival, and next year took part in the first juried national craft exhibition and sale at Stratford. The exhilarating Brussels World Fair in 1958 saw work by sixteen of Ontario's most gifted craftspeople chosen for the Canadian Pavilion's fine crafts section. Inch by inch, craftspeople were coming into their own.

At the outset, Alan Johnstone made earthenware cream-and-sugar sets, glazed in brown and cream, and fired outdoors, a product line that was a studio staple.

Peter Hogan

War veterans Selma Caverly and Jim Clennell used their DVA allowances to study pottery and set up Pinecroft Ceramic Art Studio outside Aylmer. In 1952 they took 1,000 earthenware jugs to the Weston Fair, glazed with lead-bearing greens, blues, yellows, and browns and fired in a home-made electric kiln.

above: New arrivals from Germany, Susanne and Theo Harlander, together with Liesel and Ben Harlander, by 1959 had renovated an old inn into a home and pottery at Brooklin. Outfitted with furniture they made themselves, the 16-room Harlander house was a centre of ceramic art and fabulous Sunday parties until 1987.

below: Just five years after arriving from Europe, Susanne Harlander demonstrated her skills on the pottery wheel at the CNE's new Queen Elizabeth Building in 1957.

The Clennells regarded public education through pottery demonstrations as a mission. Shown here in their log cabin studio, they readily shared knowledge and experiences in careers that spanned more than 40 years.

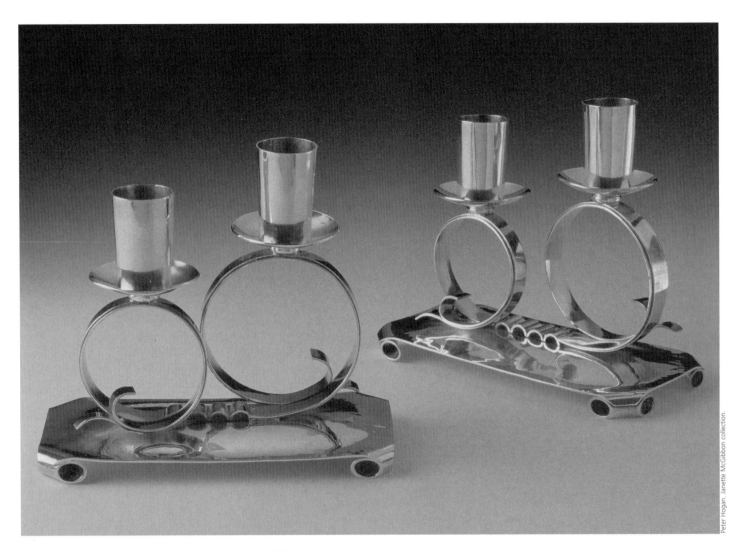

Richmond Hill silversmith Douglas Boyd built a prolific career
mainly on commissions, but this pair of candlestick holders
made in 1953 has remained in the family.

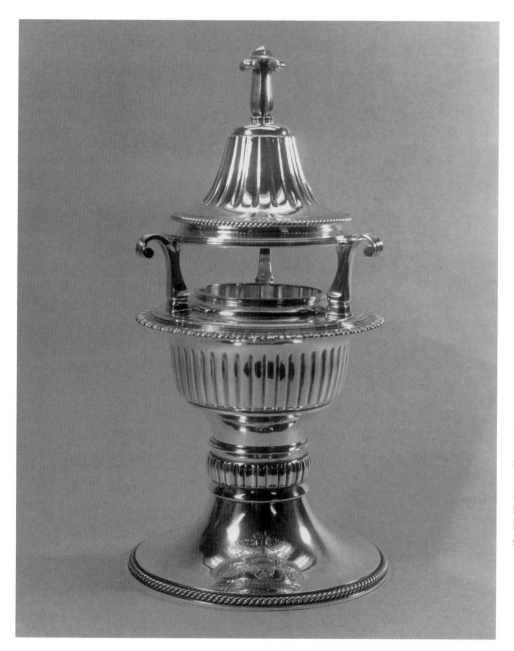

For the University of Western Ontario, the Sommerville family commissioned Toronto metal-smith Harold Stacey to produce a Grace Cup and Great Salt (left) for its main dining room. Completed in 1958, the set prompted ROM curator Helen Ignatieff to comment that the pieces earned the highest regard and recognition in Canadian silversmithing.

The Hinterland Beckons

Even before World War II ended, craft leaders in Ontario had finally succeeded in attracting government interest in their work, an auspicious omen in light of its lacklustre support of craft development up to then. New Premier George A. Drew seemed committed to bringing culture to communities as part of post-war restructuring, and he pledged government support through a Handicraft Advisory Board. Directly or indirectly from this first step came a number of government initiatives in popular craft and design education, as well as some financial support to Ontario's branch of the Canadian Handicrafts Guild, inspired perhaps by Drew, himself, who also oversaw the education portfolio for five years before moving on to the federal political scene.

In common with every province after the war, Ontario's top priority was preparing veterans for peacetime work. Educational grants from the federal Department of Veterans Affairs gave demobilized men and women opportunities to attend colleges and universities, options often unaffordable to them before the war. For five or six years after the armistice, educational institutions of all kinds bulged with new learners, none moreso than the Ontario College of Art in Toronto. Although its craft studios were only rudimentary and severely taxed by the sheer numbers of students, the college resolved to provide new design programs and comprehensive art and craft training.

Typical of the first wave to register in OCA's new courses was former art teacher Tessa Kidick of Thorold, who had spent the war years as a telegraph operator near Moncton, New Brunswick, as a member of the Women's Royal Canadian Naval Service (WRENS). As wartime postings go, hers was pleasant and rather unregimented, since it gave her freedom for field trips such as to Moss Glen where she met the province's premier studio potters Kjeld and Erica Deichmann. Living and working deep in the country and engrossed in experiments with local clays and glazes, the couple made a lasting impression on Kidick.

At OCA, she found herself one of five women in classes of seventy to eighty men at

the College's Nassau Street campus. "The veterans were a happy bunch and teachers enjoyed them because of their enthusiasm and dedication," she recalls. "We had a common experience and made friends quickly. I was one of a group of twelve who kept in touch for years; many became very successful in the art world." No one had any money to speak of, and her sixty-dollar-a-month living allowance permitted only shared rooms. By the end of her first year she gave up the idea of a career in commercial art and committed herself to clay. She rose above the college's deplorable facilities on the main campus, blending her own stoneware clays in endless experiments, and dreaming of a lifestyle she imagined as a potter.

Against a backdrop of lakes and trees, her professional life began in 1949 at Coboconk, north of Lindsay in the Haliburton area, where she rented studio quarters with classmates Kit Ross and Bill McKillop. They dismissed the conventional wisdom that artists starve and pottery would not provide a living; after all, the Deichmanns in New Brunswick were surviving by their craft as were the Zavis in Cobourg, and raising families, too. So were others. The three owned their own kickwheels to shape the clay but had no kiln to fire the results. Because they shared space in an old wooden building with a bakery, their kiln had to be electric. As far as they knew, the only reasonably priced ones were low-firing versions intended for earthenware, but they preferred to work in stoneware, a clay body that requires a kiln to provide an additional four hundred degrees of heat. By trekking across the border to New York State, Kidick found a kiln outfitted with a new high-fire Kanthal element that had been developed in Sweden during the war and just on the market.[5]

Recognition came quickly to Kidick when three of her pieces were accepted for the crafts section of *Contemporary Canadian Arts* in spring 1950, a celebratory exhibition marking the Art Gallery of Toronto's golden jubilee. As encouraging as it was, such praise did not guarantee even the most meagre of incomes. In spite of being in a tourist area, the Coboconk location seemed to conjure endless challenges, the most pressing being the lack of nearby customers interested in what the potters were doing. The trio sold what they could to passers-by and the rest to Toronto's craft retail outlets, now three in number: The Artisans, The Guild Shop, and Trade Winds, but getting pottery to them was daunting. Kidick took her work on a bus to Lindsay, another to Toronto and once in the city, transferred to a streetcar, dragging pots in suitcases and boxes. "How

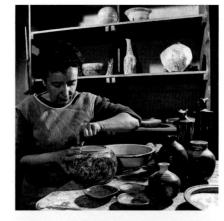

Page Toles

above: Tess Kidick at work in her Jordan Studio in the early 60s, trimming the bottom of a vase to remove clay spurs or abrasions that might mark furniture.

below: The Art Gallery of Toronto celebrated a jubilee in 1950 by showcasing contemporary fine craft and art.

61

did I do it? How did I carry them, I wonder now," she muses, since even then her hands were weakened by arthritis, which tormented her professional life. The only other reliable option was sending boxes to Toronto with friends who had cars, but this happened rarely.

Realizing that Coboconk had one too many drawbacks for her, Kidick left next year, took an office job in Toronto, and then relocated to Brantford where she developed her basic product lines in her sister's garage — bowls, mugs, plates — and also built a reduction kiln fuelled by propane to fire her work. Reputed to be the first person in Ontario to devise such a kiln, she professes she "knew nothing about furnaces and went by guess and by God." By 1955 she found a situation she could afford to buy: a brick-board-and-batten combination studio/home in Jordan, a sleepy Niagara village not too far from where she grew up in Thorold. There, using a larger version of her first propane-fired reduction kiln, she turned out functional work ("design quality is what sells") and exhibition pieces, some of which were purchased for the Canadian Embassy in Washington. Others she entered in the biennial exhibitions of the Canadian Guild of Potters, which began in 1955, and the annual Canadian National Exhibition, where she won several awards for best stoneware, and form and design. One of her last showpieces was for *Women in Clay*, an exhibition held in 1975 at Harbourfront Centre in Toronto during International Women's Year.

It was in Jordan that Kidick found the solitude she craved and the justification for her decision to embrace a potter's lifestyle. "Although I missed out on a lot of things, temperamentally that kind of life suited me," she says. "I needed to be alone by myself. I am not a joiner." In this setting she could concentrate on developing her own glazes, surface decoration, and forms, all the while searching for truths within the medium and establishing in her work a harmony with nature. "Everything I did was inspired in nature, as it lived and was influenced by the seasons and the weather. But most of the time I just let things happen. I wasn't thinking of exhibition pieces." And she had exacting standards. "I will destroy pieces, even if there is nothing technically wrong with them and if the glaze is not right." "I loved her glazes," remembers retailer "Millie" Ryerson of The Artisans, "she was able to get the colour of the sky after a rain."

From time to time the outside world drew her away to teach, to attend a conference, or enjoy a bit of travel to landscapes different from her pastoral village. Rugged, out-of-the-way places gave her unbounded pleasure whether it was terrain devastated by forest fires,

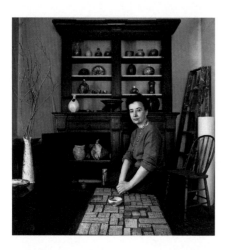

Jordan potter Tess Kidick was proud of her showroom and its coffee table, whose inlaid tiles she fashioned herself.

the craggy outcrops of the Laurentian Shield, northern lights, or the majesty of the Rockies. Back home in her studio, she tried to mirror in her work the textures and colours she had just seen, once described by Arthur Erickson as land forms with cryptic geometry. "Wherever I went I collected interesting rocks. I'd use a hammer, crush rocks to a powder to get textural qualities. I wanted the design to shout at you."

In a few years Kidick was ready to reach out and to share her experiences at college programs in Guelph and Hamilton or at government-sponsored workshops and seminars in Huntsville, North Bay, Parry Sound, and Quetico in Northern Ontario, which began craft courses in 1958. In isolated communities where supplies were scarce, she found it satisfying to teach people accustomed to fending for themselves and just awakening to the joys of creative activity. Her first career as a teacher gradually ripened into a satisfying second career, and she found herself a catalyst for a generation of mature students who, in turn, became teachers or resources in their communities. One of the most dedicated was Elda "Bun" Smith of the Six Nations of the Grand River Reserve near Brantford. She came weekly with her husband, Oliver, to Kidick's studio in Jordan and continued studying with her on the Reserve. Although they did not teach themselves, the Smiths made their facilities available to others, some of whom became professional potters in the Iroquois tradition, an outstanding example being their son Steve. Arthritis unfortunately continued a relentless assault on both Smith and Kidick and eventually forced Kidick to retire in 1988 — after forty plus years at the wheel.

For a time Kidick had neighbours who, like her, were in the vanguard of Ontario's post-war studio craft movement. Weavers Dorothy and Harold Burnham, a banker, had spurned urban life and opened a studio the year before she moved to the Niagara district. "Looking back on it I think we were completely crazy and our families certainly thought so," Dorothy recalls. "We left the bank and bought a little house in Jordan as it seemed like a good place for a direct outlet for crafts. We had enough money saved to last the better part of a year and we hoped to be making a living by the end of that time and we did; we kept it going for five years."

No one had to remind studio craftspeople like Kidick and the Burnhams they needed inexhaustible stores of self-reliance and resolve to succeed. "There were no grants or awards then," Dorothy says, "nor was there support from government or help in any way, size, shape

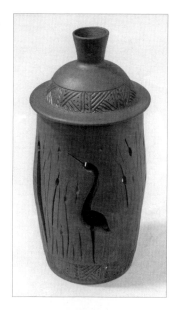

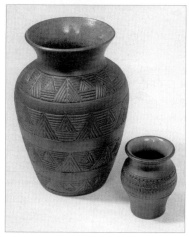

Using designs from traditional Iroquois pottery, "Bun" and Oliver Smith of the Grand River Reserve made these pots in the mid-Sixties for exhibition at the Stratford Shakespearean Festival.

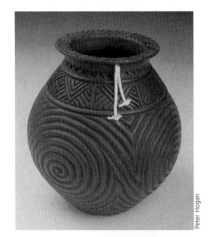

Peter Hogan

above: Steve T. Smith works from his Talking Earth Pottery on the Grand River Reserve. He fired this earthenware pot in an electric kiln to give it strength, then in a smoke kiln to provide an ancient and dusky black finish. He is continuing the tradition begun by his parents, "Bun" and Oliver Smith, by working in predominantly an Iroquois or Eastern Woodland aesthetic.

below: In his Jordan studio home in 1957, Harold Burnham displayed a national design award he received for one of his handsome handwoven wool yardages.

or form." Even so, "I think those years that we lived in Jordan were one of the best stretches of my life, although we were very near the edge all the way along the line." Because of the expense involved, they weighed carefully whether to accept dinner or party invitations when they came along. "I remember we were invited to this party by one wealthy person in Toronto, a patron in a way, and Harold asked 'should we go?' We sort of dithered but we said 'we'll get a good dinner, let's go.' So we got a babysitter, left our work and we went. It was spaghetti and meatballs. We had been living on macaroni and meatballs for months and we looked at each other: 'think of all the money we've laid out for spaghetti and meatballs when we expected roast beef or steak.' And she adds with a twinkle, "When you're entertaining craftspeople see to it they get a seven-course meal."

Absurd though it seemed to outsiders, lives centred on craftmaking did have rewards, as Harold was to tell members of the Canadian Handicrafts Guild in 1958, by which time he had joined the Royal Ontario Museum's textile department and was only able to weave part-time. "Craftwork is not for the weakling. It involves long hours of concentration for small monetary returns, but the true craftsman accepts this as a natural and healthy challenge. In contrast with many less fortunate individuals, he is earning his living doing what he wants to do."

The Burnhams were a remarkable couple. Regal and charismatic, Dorothy K. MacDonald had been Keeper of Textiles at the Royal Ontario Museum before marriage and children, and Harold, equally imposing and of intellectual bent, a rising executive in banking circles.[6] Both were avid weavers, Harold learning from Dorothy and then pursuing his new avocation with intensity and dedication. A born student, he applied himself wholeheartedly to anything he undertook. He soon acquired a large Finnish loom that shared his non-banking life until the early Fifties when they moved to Jordan. Professionalism in craft was a subject that recurred again and again in the Fifties, and Harold was one of the first to write and speak about it, absolutely convinced that professionals formed the core of any creative craft movement in a community. "There is an old, old saying," he remarked, "that the difference between the hobbyist and the professional is that the person who pursues something as a hobby always complains that he has insufficient time for it, while the professional knows very well that he has no time for anything else."[7]

And they didn't; they toiled night and day at the business as well as raise a young family. Their studio life had Harold as chief weaver — this at a time when it was unusual for a man to weave professionally — and Dorothy executed some of the tablemats and did all the finishing by hand or machine. "We worked up quite a good business in the neighbourhood and people came back and back, but the things that kept us going were the tablemats that we sold by ourselves direct and through The Guild Shop, which took a smaller commission than other outlets. The most popular mat of all time was a red-and-white log cabin design in cotton, but we made it in a wide range of colours that we prewashed and shrank. They were our bread-and-butter lines like the potter's mugs. You can't believe the price range we were working with. Five dollars seemed to be the limit."

The Burnham studio also became known for yardages, and Harold "wove the most gorgeous suit lengths," an accomplishment that's a source of enormous pride to Dorothy some forty years later. "These were women's suit lengths and men's sport-jacket lengths, and they never wore out. People came. They saw samples. He would set up a warp and the person could come and see what it was going to be like when finished. People liked it because everything was individual. But we could never get more than ten dollars a yard for a suit length and the profit was maybe five dollars. We also had a second line of all-wool yardage for five dollars a yard, which sold and sold and sold. When you're a professional you never set up less than forty yards; one loom might be occupied with forty yards of one thing and you might get an order for something else so you needed another loom."

Acquiring supplies of affordable quality yarns has preoccupied weavers as long as anyone can remember, and Dorothy always felt buying stock ate up all their profits. "I don't think it was as tough for potters as for weavers since their materials were so much cheaper." While living in Toronto after the war, "when we were all having the most appalling trouble getting yarns that we didn't pay through the nose for," Dorothy and Harold helped start a wool cooperative in 1947. It was a venture with the Toronto-based Spinners and Weavers of Ontario, and blessed by the government's Home Weaving Service, which supplied names of potential participants identified through its courses. Functioning from the unheated Burnham pantry, the co-op bought wholesale and resold mainly to Toronto-area weavers through a mail-order service.

Once he relocated to Jordan, Harold struck up a similar business association with Dutch-

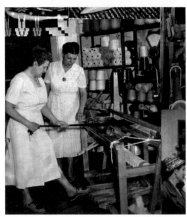

above: Dutch-born "Rie" Donker Bannister ran weaving resource centres at Kingston, Toronto, and Queenston.

below: Known throughout Ontario and the Northern U.S.A. as an effective and dedicated teacher, "Rie" Bannister advises a student on warping a loom for a weaving assignment at her Queenston studio.

born weaver and designer Hendrica "Rie" Donker Bannister, who lived some twenty-five kilometres away in Queenston. She had come to the Niagara district in 1953, converted a century-old inn into a studio, weaving supply house, and teaching facility and called it Old South Landing Craft Centre. Together they bought job lots of silk, wool, cotton — anything they could corner on the wholesale market.

Bannister was a thorough-going professional, and wherever she set up a studio, she infused her particular dynamism into weaving communities struggling with growing pains. When she left Rotterdam, Holland, in the mid-Thirties she set out with a loom and three hundred pounds of wool yarn to protect her fine glass and china, and to furnish weaving materials for the first years of her marriage in Saskatchewan to Lewis Baumeister, later anglicized to Bannister. In the West she taught weaving, won prizes at the Prince Albert Exhibition, and supplemented the straitened family income by selling her woven blankets and clothing at local markets. When World War II broke out, her husband enlisted in the Canadian Army and was posted to Kingston where she established Weefhuis at 76 Brock Street, a shop-studio vibrant with coloured yarns and loom activity. She originated a line of tweeds, skirt lengths, bags, scarves, purses, and baby blankets, and taught adult hobbyists, eventually prodding some of them into forming the Kingston Hand-Weavers Club.[8] As Tante Rie, she also created a shortwave radio program for children that was beamed into occupied Holland. In 1948 she relocated to Toronto where she set up another Weefhuis at 1982 Yonge Street, and created a further range of wearables and yardages. She continued teaching scores of pupils in her studio and also instructed at the new Ryerson Institute of Technology. But country life beckoned and she chose to settle permanently in Niagara.

Charged with unbounded energy, ambition, and physical stamina, Bannister also hoped that her new centre at Queenston would function as a cultural cooperative. She would provide food and facilities to participants; guest teachers would keep what they earned from teaching. She was shattered when they expected her to pay them a salary, as well as provide room and board, a largesse she could not afford. Her renovated inn, thereafter, became a weaving resource centre where she offered lessons, supplies, saavy, and design expertise to residents of Ontario and northern New York State. Pupils boarded for a week at a time and she taught and cooked for them, or they came in car and busloads and stayed for the day. Before her arrival, local weaving consisted of placemats and basic designs. She changed that

66

focus, and to many fledglings she was a ray of light, exposing them to aesthetic influences different from the pervasive Scandinavian sensibility. "She, I suppose, more than any one private weaver," says friend and fellow weaver Mary Eileen Muff, "was by far the most active, did more for more people than anyone I knew. She provided every kind of help that people wanted." South Landing today has reverted to life as an inn, and nearby at St. David's, Bannister's son William and wife, Carol, operate South Landing Craft Centre as a mail-order yarn-supply business located in a restored mill that doubles as their home.

As effective as she was, Bannister's contribution was prescribed by her European background, her need to support herself from her looms, and her determination to do it all her way. In the next generation, weavers and teachers were less individualistic perhaps, but in their own style, pathfinders as well. Of these, Muff herself made a most extraordinary public contribution.[9] Like Kidick, who later became a good friend, she had served as a WREN during the war and used her DVA education grant to study craft and design at MacDonald College outside Montreal. Weaving was her passion, however, and MacDonald did not offer it then, so Muff followed her studies with six months at the Montreal weaving workshop of Danish-born Karen Bulow, who directed a weaving school, then located at 2015 Union Avenue, for veterans. A hard taskmaster, gifted with an uncanny instinct for design and colour, Bulow was particularly well known for her ties and yardages, while her drapery materials were perennial favourites at shops such as the Freda James interior-design studio on Cumberland Street in Toronto, a property eventually acquired by the Canadian Guild of Crafts. [10]

"When I finished my training I wanted to weave fabrics and work with couturiers," Muff recalls. "The customer would have a garment that no one else had or could copy. That's what they are doing now but right after the war no one would put money into anything like that." She worked, instead, at a variety of jobs until enlisted in 1949 by the Department of Education to teach weaving.

Taking Crafts to the Communities

The department Muff joined was a post-war phenomenon. With a few exceptions, government administrators, unlike counterparts in Quebec and Nova Scotia, were only dimly aware of its skilled craftspeople, even though "Ontario people appreciate and buy more

Stalwart craft supporter Joseph Banigan directed craft instruction in the Community Programmes Branch of the Ontario Department of Education.

handmade goods than people of other provinces."[11] With veterans returning to mining and logging camps, to paper-making mills or to farms, bureaucrats and adult educators began to consider craft courses of a non-professional nature in a new light. They began to regard them as a potential means of entertaining hearth-bound wives or teaching them to make articles for sale as well as encouraging others to stay home rather than seek city employment. To head this post-war crusade and beat the drum throughout Ontario, the government contracted national craft authority and weaving expert, Quebecker Oscar Bériau. Residents, mine owners, politicans, chambers of commerce, boards of education, service groups, legions, and home and school associations caught his enthusiasm and were keen to get started.

Before he could put some of his projects into place, however, Bériau died suddenly, so that generations of younger weavers only knew of him through his published works; *Home Weaving*, in particular, became a bible. Premier Drew's newly created Department of Planning and Development minted its Home Weaving Service in 1947, and to replace Bériau found an almost ideal director in long-time craft supporter Joseph Banigan. He brought to the job his Irish charm, imagination, diplomacy, and the right sort of credentials. A university-trained engineer, fifty-eight-year-old Banigan was a former president of Ontario's Canadian Handicrafts Guild, and he continued to serve as a Guild director. At his insistence, he and his four children all mastered at least one craft; his was art-metal work.

During the war years, he was a safety engineer in an Ajax munitions plant east of Toronto. Sensing that his branch director in the Weaving Service could do with some background, Banigan wrote him that craft courses gave Ontarians the most for the least: "Crafts, which are the making of useful and beautiful articles for the joy of creating and using them, have the least limitations of age and physical condition, and usually require the least community equipment. The enjoyment of crafts, like other activities, is based on a minimum of basic technique taught in a continuous phase long enough to acquire a minimum of skill."[12] If such comments seem incongruous from someone knowledgeable about skill levels and acutely aware of the long-standing struggles of the Handicrafts Guild to improve design standards, they doubtless were tailored to conform with the government's growing view of craft as a form of popular culture. From Banigan's corner, of course, some craft was better than none in deprived areas.

Banigan had six instructors in his section, soon renamed Community Programmes

Branch and placed under the Department of Education where it stayed until the early Seventies. The first recruit was his daughter Betty, an early member of the Spinners and Weavers of Ontario and one of the few up-and-comers, who had briefly tried her hand at studio production only to discover how arduous and unprofitable it was to maintain a studio outside the home. She was joined by Lex Cullingham, a naval veteran who had studied with Karen Bulow after the war, taught at her Montreal atelier and was later to manage The Guild Shop; others were Mary Andrews, Betty Beaudin, Henry Longstaff, and Mary Eileen "Bunty" Muff. Despite differing weaving backgrounds, all shared a common ethic and approach to their mandate. Hands down, theirs was the most effective of the post-war government-sponsored craft programs. The weaving curriculum was more comprehensive, instructors were accomplished professionals, and their work in the field inspired the formation and growth of weaving clubs or guilds that became conspicuous in the years ahead.

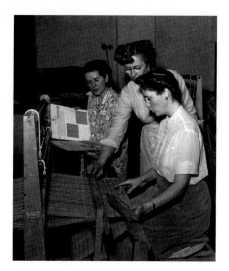

Betty Banigan conducted a weaving workshop in Guelph in a government-sponsored program in the late Forties.

Anyone in Ontario could seek instruction from the home weaving program, but by the early Fifties, requests came mainly from women with free time during the day to develop a hobby and who could afford to buy looms or have husbands make them.[13] Only occasionally did women on farms, in lumber camps, or mill sites ask for classes, although the program was designed for them. Creative use of leisure time was the new focus, and at a cost of seven dollars and fifty cents, the course was a bargain by any yardstick. A community had to guarantee eight to a dozen students for three weeks, and a place to hold classes; the government guaranteed meals and lodging for teachers and costs of shipping looms, warpers, winders, materials, and other supplies — all weighing some two thousand pounds. After a few years, moving heavy equipment all over the province was deemed too expensive and was discontinued, so box looms were pressed into service. Muff's father, a Yorkshire textile expert, devised patterns for box looms that were highly portable, easy to master, less expensive to operate, and could be made for seven dollars and fifty cents each by local carpenters before the teacher arrived.

The Midwifery of Craft Weaving Guilds

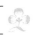

Banigan's worry was that newly acquired skills would soon fall by the wayside once instructors and equipment returned to Toronto. As incentives to keep classes together, he directed his teachers to advise students to form a guild at the conclusion of a course so the local

group could buy wool at bulk prices, meet and exchange ideas regularly, and continue working at the loom to improve skills. Muff visited active groups twice a year taking samples of weaving that she had picked up; "We'd talk about programs and we'd give them ideas; we'd have demonstrations, plan sales and exhibitions." The three-week course and its follow-up visits seem to have ended sometime after Banigan retired in 1951 to enter Leaside politics, and with his departure, craft programs lost a valued champion. Although continuing with occasional teaching, Muff and Longstaff — all that remained of the original six teachers — then moved into more administrative roles when their branch was redesigned again. Thinking back on it today, Muff mourns that the government "did not make it a priority to hire a team of people to keep these initiatives going. In the arts," she says, "it has been very difficult to get money for people to continually visit the communities, which is what the communities needed. In many cases, they stayed in a rut and did the same things simply because they had no resources: no libraries, nobody going in except when there was exceptional talent."

In 1956 Ontario crafts advisor "Bunty" Muff taught weaving at the Ojibway Serpent River Reserve in the Algoma District, after which Acting Chief William Meawasige, in headband, conferred on Muff (front left) the name Misquandakwe or Sunset, and initiated her into the tribe.

In spite of that, many seeds sown by the sextet of teachers had taken root in fertile areas, so that by the mid-Fifties a provincial weaving network had grown like topsy, comprised in large measure of hobbyists and those who wove for personal use. The fifteen-year-old Spinners and Weavers of Ontario, headquartered in Toronto, now found itself among twenty-seven other guilds scattered around the province in Windsor, North Bay, London, Peterborough, Kingston, Ottawa, and other centres. Since its formation in 1939 at the Women's Art Association, the Toronto group had been pioneers in gathering converts to the pleasures and rewards of handweaving. It conducted courses and seminars, provided regular lessons, staged exhibitions at the Royal Ontario Museum, and coordinated demonstrations and exhibitions for the Canadian National Exhibition. Its sisters eventually did likewise in their various communities, some with great distinction. A mere four years after introductory courses from "Bunty" Muff in Community Programmes in 1949, the London District Weavers, for example, spurred on by Clare Bice, curator of the gallery in the London Public Library and Art Museum, staged the first of many juried, Canada-wide exhibitions of handweaving. Forward-thinking and consequential, the exhibitions encouraged Canadian weavers to lead the way in creative design and not be restrained by old patterns and traditions.[14]

70

In that same year, it was obvious to Muff and the weaving fellowship that the time had come to coalesce local groups into a unified provincial organization with chapters. From her base at Queen's Park, Muff together with Carrie Oliphant, president of the Toronto guild, organized a workshop and conference at the Heliconian Club in April 1955, out of which grew a provincial opinion survey. Eighty-nine percent of respondents favoured forming a provincial organization, and the following year the Ontario Handweavers and Spinners (OHS) came into being at St. Catharines, with a membership of 169. A decade later it had grown to more than one thousand individuals in some fifty local guilds, and it continues today with almost seventy guilds spread across Ontario in six autonomous regions.

The warps and wefts of fabric construction latticed weavers and spinners into a remarkably close association quite unlike any other craft medium. Weaving was especially popular in Ontario after the war, Muff believes, because everyone was willing to share what they knew, and they forged an informal teaching chain. For fifteen years Muff's employers lent her to OHS to direct its annual workshops — "some of my most exciting and interesting times with craftsmen in Ontario."[15] She often brought in experts from the United States and the British Isles, who were delighted to come "because nowhere else was there the network of guilds and people as there was in Ontario, nor was it so well organized."[16] And the *Globe and Mail* agreed. These workshops, it reported in 1957, were unique in Canada, being entirely supported by the weavers themselves.

While the more confident applied themselves to exploring creative approaches and fresh designs, others had their livelihoods menaced by industrial power-looms, which could mass-produce bread-and-butter articles such as placemats and table napkins. Rather than trying to compete, retired professional weaver and now museum curator Harold Burnham advised them to take the long view by developing new loom techniques for articles and yardages not threatened by power-driven machinery. He also encouraged raising the general standard and appreciation of weaving — an anthem still hymned today. Burnham saw whole fields of new work awaiting the intelligent hobbyist who had the time to investigate them without the economic pressures that nagged professionals. Without realizing it, the plain-spoken former banker was quite oracular. He divided handweavers into "shuttle pushers, shuttle throwers, and weavers," and accused the first group of relying on explicit instructions to turn out a few pieces a year, without a scrap of originality. The second group, the

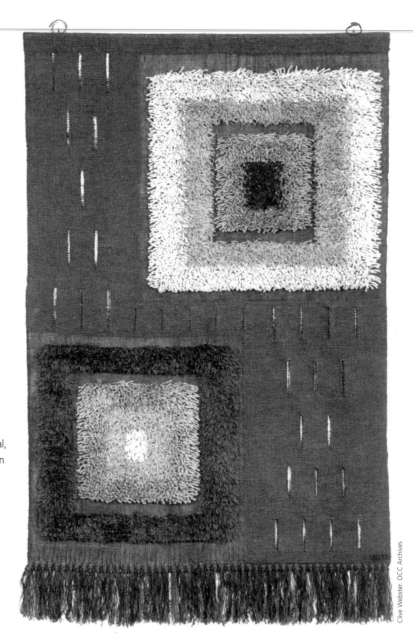

Familiar for decades as a source of quality woven curtains, drapes, wall hangings, upholstery material, and a range of other accessories, Velta Vilsons won a top award for this woven wall hanging in the *Make* exhibition in 1971.

72

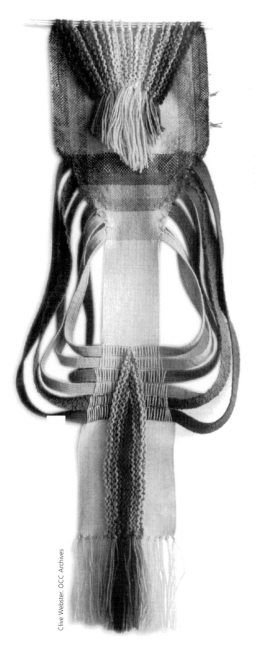

Australian-born Brenda LePoidevin graduated from Sheridan College in 1971, the year her woven wool hanging, *Jewel*, was accepted for *Make/Mak*.

throwers, he regarded as competent if unoriginal technicians, overly dependent on weaving books and written materials, but who could eventually become weavers by study and experimentation. He maintained that only members of the third group, the bona-fide weavers, knew the principles of textile design and cloth construction, were inspired by yarns, and knew what they would like to make.[17] Transforming modern "shuttle pushers and throwers" into full-fledged weavers continues to be a commitment of the Ontario Handweavers and Spinners through its own Weaving Certificate Program.

The Short and Long of Craft Courses

So insatiable for learning were the early "shuttle pushers and throwers" that by the mid-Fifties the Community Programmes Branch could not honour all its requests for courses.[18] It had to accommodate to other realities and shriller voices, for not everyone appreciated the type and cost of instruction the weaving service had been providing. Community Programmes found itself in a bit of a dilemma. It was asked by recreation directors in community centres to provide names of qualified crafts professionals who could prepare teachers in short courses of twenty hours duration. To find such wizards, it turned to the Canadian Handicrafts Guild's Ontario branch, which pointed out that twenty hours was not enough time to educate anyone, and that insufficiently prepared craft leaders created dissatisfied students and lowered standards. Such an approach only provided short-term gain for long-term pain. But the Guild nonetheless passed the request along to its member organizations, suggesting they co-operate for a trial period by regarding the new courses as a form of advertising and public relations. The whole notion outraged John Pocock of the Metal Arts Guild.

To step back to 1946, leading metal-arts practitioners Harold Stacey, Andrew Fussell, Nancy Meek, John Pocock, and others that year had banded together in a separate organization, primarily, Meek explained, to protest the Handicrafts Guild's priorities. The metalsmiths wanted to establish their own outreach and education programs modelled on British metal traditions and standards. Further, they did not believe the Guild was serious about education at such a specialist level or about teaching the public to appreciate its designer-craftspeople, who wished to be regarded as artists and professionals.

In a letter to the Handicrafts Guild executive, John Pocock accurately predicted that community short courses would not succeed and were doomed to failure. "It is futile to

expect a person to learn a craft demanding a high degree of manual dexterity, a sense of design, and years of experience in twenty hours," he wrote. "To expect to give the graduate of this sort of course the status of teachers in their community is just not good enough, and craft education will peter out in the shadows of indifference." The proposal, furthermore, was insulting and insensitive. Serious craftspeople worked for years to break down public apathy towards handmade work, he said. "If this type of education becomes widespread, the result will be to confirm the opinion of the public that 'anyone can do crafts' and that bad workmanship, lack of form and uselessness is synonymous with the term 'hand-made'."[19] Like Burnham, Pocock was far-sighted; the schism between protagonists of craft as popular culture and craft as art grew ever wider and continues to live on.

As for craft instruction at established institutions, the number of courses was scaled down once the wave of veterans had moved through the system. At the Ontario College of Art, for instance, Harold Stacey, for five years, directed a full-time jewellery and metal-work program for veterans, a group that disappointed him since so few seemed to care about craftsmanship or creativity.[20] Thereafter his subject became an elective. At the high-school level, some technical high schools continued to provide individual craft courses, one of the most successful being London's Beal Institute where art director Vera M. "Mackie" Cryderman included jewellery making in her curriculum. An important influence on London art circles, Cryderman also had a reputation as a fine craftsperson and designed jewellery for Tiffany's in New York.[21]

By 1954, when this portrait of Vera McIntyre "Mackie" Cryderman was taken, she had turned the art department at London's H.B. Beal Technical and Commerical High School into a vital centre of creativity.

The Making of Jewellers

In addition to Central and Beal's courses, there were craft-related programs for tradespeople, initially in jewellery and furniture making, courses only peripheral to the studio craft movement, but of some importance nonetheless. When the new Ryerson Institute of Technology opened a two-year Jewellery Arts Programme in 1948, it did so with the financial support of the Canadian Jewellery Institute. The course was run by James Green, a British-trained jeweller who had spent almost two decades at Eaton's, fashioning high-quality traditional jewellery. In the main, Green's protégés were schooled as jewellery technicians, but one in particular aspired to be a contemporary jeweller. Adept and very serious about his studies, British Columbia native Bill Reid worked shifts as a CBC announcer and easily fitted

his Ryerson courses into his off-hours, since the two institutions were close by. Jewellery making seemed to him to be "one of the few crafts you can learn and make a living at,"[22] a point of view he could have developed after his several visits to the Meek and Pocock studios on Gerrard Street West.

After two years with Green, Reid apprenticed with the Platinum Art Company, which supplied jewellery to Birks, and in 1951 he returned to Vancouver. There he found himself drawn more and more to the motifs of his mother's Haida ancestry, which stimulated and fuelled a virtuoso career as jeweller, metalsmith, sculptor, carver, teacher, and inspiration to legions of native artists. When Reid returned to Ryerson in 1985 to receive an honorary award, he told an interviewer that many of the young native artists he had taught in B.C. over the years "think it's their ancestral skills coming out, but it's really Jimmy Green."

Ryerson kept jewellery arts for some five years and then the program moved to the new Provincial Institute of Trades at 21 Nassau Street, where OCA had its satellite campus after the war. Since Green was now running a family retail jewellery shop in Toronto, Gem Creations, the Department of Education asked a new arrival from Holland, master-jeweller Hero Kielman, to head the program. He began in September 1954 and remained at the helm for twelve years, at which time the course moved to the newly created George Brown Community College where it remains.

Kielman's day-time classes at PIT were technically oriented, as were Ryerson's, but attracted a band of women students who also studied with him two or three days a week. They wanted to acquire skills for freelance careers or to make pieces for themselves, since they saw little in the shops they wanted to wear. His evening classes were especially popular among other adults, who were attracted by excellent facilities and Kielman's rigorous insistence on mastery of design and materials. Many of his women students — Gertrude Davidson, Maud Higley, Pat Hunt, Edna Jutton, Joyce Merrifield, Mary Milne, Reeva Perkins, and Tommia Vaughan-Jones — matured into part-time professionals. From their home studios, some concentrated on commission work while others supplied craft shops with contemporary work, which was startlingly different from what the larger retailers carried.

Kielman was a welcome if ascerbic breath of fresh air in Toronto metal circles, trained as he was in contemporary European design, and like many of his countrymen, instinctively

drawn to democratic design. Not for him the very conservative British styles espoused by Green and with which Birks, Ostranders, Kerrs, Eatons, and Simpsons were so comfortable. "Design in Toronto was terrible," Kielman says today. "When I looked in jewellery stores, the only place where I could find a little bit of excitement was Rosenthal; that was the only light hope in Toronto. The majority of work cranked out in Toronto was wedding and engagement rings that were sold alongside watches, porcelain, cameras, and wallets." Though harsh, Kielman's assessment of the Toronto scene was largely accurate. In fact, jewellery sold in large retail shops was remarkably undistinguished and often cliché-ridden, except for the gem-setting field.[23] Kielman had yet to discover the few craft shops and studios devoted to handcrafted work, or to meet founding members of the Metal Arts Guild, a group the commercial outlets regarded as an insignificant subculture, if they knew them at all.

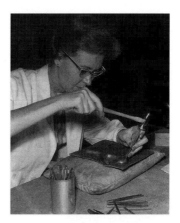

Metalsmith Lois Etherington's early career was based in Oakville, Toronto, and Guelph. One of her commissions in the late Fifties was for stations-of-the-cross and altar pieces for newly constructed Marymount College Chapel in Sudbury.

Ontario's Art Metal World

Among the metalsmiths were a handful of skilled designer-craftspeople in demand for commissioned holloware, art objects, altar pieces, and religious accessories. Conspicuous among the professionals caught up in this flurry of activity were Harold Stacey, Andrew Fussell, Douglas Boyd — students of pewtersmith Rudy Renzius in the Thirties and the Guild's first three presidents — as well as young Lois Etherington from Burlington, a 1956 master of fine arts graduate from Cranbrooke Academy of Art, Bloomfield Hills, Michigan, who had earlier studied the chasing technique part-time under Kielman. A harbinger of the next wave of craftspeople with solid academic and design training behind them, she would eventually establish a distinguished national and international career, crowned in 1997 by the Order of Canada.

By today's measure, Douglas Boyd's formal training was minimal. He had ventured into the metal field as an afterthought, turning a hobby into a thirty-two-year career centred mainly on ecclesiastical work, and augmented with standing orders from craft shops for spoons, small bowls, cuff links, candle snuffers, and dresser sets. One of the first in Toronto to cultivate a global clientele, Boyd executed important commissions destined for Australia, China, Czechoslovakia, England, Thailand, West Germany, and the United States,

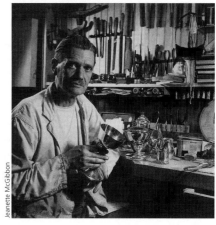

Jeanette McGibbon

Douglas Boyd with some of his commissioned work, which reflected the fluid simplicity of Georg Jensen's work, which he so admired.

to name a few. As if to keep him on his mettle, there were also last-minute demands such as a presentation piece for H.R.H. Princess Elizabeth and Prince Philip, Duke of Edinburgh, when they came to Toronto in October 1951. "I wanted something that would express Canada, full, strong and clean," he told an audience a month later in describing the silver cigarette box he had made. "I was given but two-and-a-half days' notice so the design had perforce to be simple." What he achieved was a work of timeless grace whose aesthetic roots were the contemporary Scandinavian designs that Boyd consistently emulated.

Perhaps because his wife held a permanent job, and they lived modestly outside Toronto, in Richmond Hill, where he grew their own vegetables and worked from home, Boyd never felt compelled to supplement his income by teaching. A dignified and well-dressed figure, towering at six-foot-three, he appeared more a quintessential gentleman, diplomat, or successful businessman than a struggling craftsperson. Few people, in fact, knew he was struggling. His background had been in business and administration, and he seemed comfortable with marketing, posing for photographs, being a spokesman. He was once asked to lecture on the business aspects of craft to a class at Sheridan College and shocked students with his commercial outlook: get a tuxedo, he told them, join a country club, and ignore other craftspeople since they can't afford your work.[24] He was a popular president of the Metal Arts Guild from 1949 to 1951, during which tenure he headed a delegation to Ottawa in 1950 to present MAG's position to the Massey Royal Commission.[25] And from 1967 to 1969, he became only the second craftsperson to lead the board of directors of the Canadian Handicrafts Guild's Ontario branch, the first being weaver-curator Harold Burnham.

Even better known in the craft world than Boyd, although he had none of Boyd's flair for self-promotion, Harold Stacey stood alone as the enigmatic professional artist: reserved, intellectual, idealistic, and fastidious. A perfectionist even at the design stage, he spent so much time and effort on detailed models for projects that friends wondered how he was ever able to summon the mental energy to complete anything. Having persevered with prototypes for the Department of External Affairs, which had asked him in the late Forties to design and manufacture flatwear sets for Canadian embassies, he was disgusted when the order was cancelled. As well, he grew increasingly frustrated by having to deal with paperwork the government heaped on small businesspeople. With no knack or tolerance for

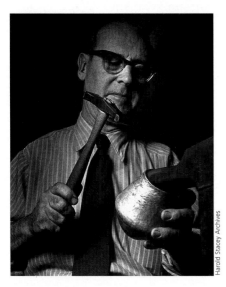

Harold Stacey at work in his studio, shaping the contours of a vase.

Harold Stacey Archives

politics or such minutae, Stacey gave rein to an adventurous streak and deliberately challenged himself to master new smithing techniques — if necessary by leaving Canada. Unlike his more stationary male colleagues, he seemed prepared to let his career follow several twists and turns.

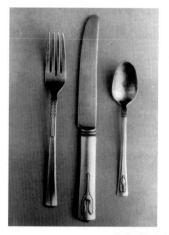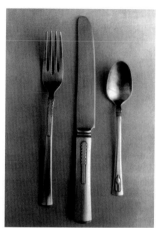

One of these opportunities took him to the Rhode Island School of Design in Providence in summer 1949, the only Canadian selected to study with fourteen other promising North American metalsmiths under Swedish expert Baron Erik Fleming, then considered the world authority in forming and raising silver vessels. Contacts made in Providence eventually led to an eighteen-month consultancy at Steuben Glass, Incorporated in New York City, which, in turn, enabled him to visit New England museums and galleries, and to present his work on an international stage. Back in Toronto, he had a prolific freelance career — first working with engineers on metal product design, then with architects who gave him some of his larger commissions, and in a studio partnership with Steuben colleague, Solve Hallqvist, and later Vickers Head. As well, he taught at OCA and Humber College in Toronto's west end, from where he retired in 1975.[26]

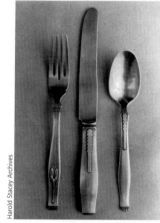

Quiet and scholarly by inclination, Stacey could throw off his habitual reticence and become a tiger when occasion demanded. For some time craftspeople chafed that hefty federal taxes were levied on one-of-a-kind craft commissions, but not on paintings and sculptures. Excise and sales taxes, at times totalling twenty percent, could deter potential customers who had commissioned expensive work, wrote the *Globe and Mail*'s Pearl McCarthy in 1958, since self-employed professional craftspeople had to collect the tax, remit to government, and often had the extra expense of hiring bookkeepers to keep track of details. Stacey on his own initiative lobbied the federal Department of Inland Revenue to reclassify craft commissions as art. It finally acquiesced late in 1958, exempting craft pieces valued over three thousand dollars made by accredited designer-craftspeople and sold directly to clients.[27] The original motivation for Stacey's seeking such equity was to spare the financially challenged Metal Arts Guild from paying taxes on the Steel Trophy it had commissioned him to make and which he unveiled to MAG early in 1958.

Although the prototypes were never mass-produced, the flatwear designs that Harold Stacey presented the Department of External Affairs in the late Forties remain classics.

Harold Stacey Archives

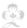

Phoenix in Stained Glass

Metalsmithing wasn't the only craft medium to get a boost after World War II. Almost overnight, the stained-glass field exploded with activity in response to requests for memorial windows to honour war casualties and from new churches in the suburbs. Of all the independent studio practitioners working in the field at the time, the most talked about was Toronto's Yvonne Williams, then 47 years old and a sixteen-year veteran of the business. Her clients by 1948 faced a two-year waiting period for her windows, but reaching that level of acceptance had been an arduous struggle.

Stained-glass designer-craftsperson Yvonne Williams often needed a ladder or stairs to work on cartoons from which patterns were made for stained-glass window elements.

An instinctively gifted painter, Williams had graduated from the Ontario College of Art in 1925 with the governor-general's medal and apprenticed for two years with the Charles J. Connick studio in Boston. A magnetic figure, Connick was unofficial dean of the revived American stained-glass field, whose own windows were renowned for their high quality. Williams had already proven she could design, so Connick stressed dexterity, the handling and painting of glass, making work "converse with architecture." Master and pupil kept in touch by letter until his death in 1945, and through correspondence, conferred about design problems relating to her current commissions or a new book of his that she had reviewed in print.

"Stained glass was a peculiar choice for a career when I started in 1927," Williams said, "more so for a woman and even more so in Canada." Nonetheless, back in Toronto after her Connick sojourn, she set out to carve a career for herself with the Depression in full swing. While demonstrating stained-glass making at the CNE's Graphic Art Building in 1936, she met young architect Bruce Brown, who assigned her two quatrefoil windows for the Toronto Necropolis Chapel, then being remodelled. Another commission soon followed from Basilian Father Oliver for Toronto's Holy Rosary Roman Catholic Church. Orders trickled in but not enough of them to provide a living to Williams and her studio colleague at the time, Esther Johnson. "Not only is it a difficult thing to trust a window commission to a beginner," she admitted in hindsight, "but also, a quite terrific efficiency is required to make a window anywhere within a reasonable cost. Only by long practice and experience can one reach the point where decision and action are instantaneous and right." And for a decade

F. Roy Kemp

or so, Williams divided her greening years between her craft and window-display work for Eaton's, under the eye of French designer René Cera.

Despite slow business ("I probably earned $15 a week spread over the year") and the uncertain economic climate, Williams was encouraged to keep going by journalists such as the *Globe and Mail*'s Pearl McCarthy, who consistently interpreted and promoted her work until she died in 1964. All seemed intrigued that a shy reserved woman was adventurously charting a course through a man's world, taking control of a complex process, expressing her ideas in a refreshing style based on animated figures and intense hues. Always an inspired colourist, her reds, affirmed *Saturday Night,* "are like burgundy and blood, the blues an astonishing, almost tropical, intensity; the yellows flare with heat."[28]

During World War II, stained glass from France, Holland, and England was scarce, since ships carrying supplies from Europe were often sunk crossing the Atlantic. Once war was over, shipments resumed, and with her technique now mature and assured, Williams's career escalated — the Art Gallery of Toronto showcased her and colleague Ellen Simon as early as 1946. Her work offered innovative alternatives to windows produced in traditional commercial studios still mired in Victorian pictorial realism. "Conservative as my work looks now, it was tremendously daring when compared with the PreRaphaelites," she asserted.[29] "I don't know how to describe what people thought was nice. I tried to model myself on the mediaeval artist whose colours so impressed me in France and England." If some new clients were initially timid about her "modern ideas" they took a chance because their friends had recommended her, and she eventually won them over. After all, she reasoned, "stained glass is half fine art and half handicraft and half philosophy and half business. Great things can be achieved in it as pure handicraft; as design, if there is perfect use of transmitted light and colour."[30] Among the ranks of the architectural profession with which she worked closely, she became known as the best in her field. So much did they enjoy working with her, they bestowed on her in 1957 an Allied Arts medal of the Royal Architectural Institute of Canada. Other hallelujahs followed.

By 1949 Williams was able to afford a custom home and small studio in North Toronto and to hire students from the Ontario College of Art — about three trainees at any one time — to help with orders that were piling up. The time-honoured practice in her field was to confine neophytes to working in only one facet of window making, a niche that

81

dictated the boundaries of their careers. Under her, however, they were exposed to everything, including accompanying her to churches to measure windows. Some apprentices became true colleagues and stayed on to share her studio and work alongside her: Ellen Simon, Gustav Weisman, Jerome McNicholl, and Rosemary Kilbourn among them. Cutter and glazier George London, who had worked with her since the Thirties, and his assistant, Michael Nuttgens, provided technical back-up and know-how. All functioned as both independents and collaborators in a radically egalitarian working environment. By the mid-Fifties she was acknowledged as the dominant individual in Canadian stained-glass art, and her studio a Renaissance sort of place — flexible, exciting, unstructured, respectful of everyone's labours, while Williams herself was an eminence grise who stimulated countless others in the field.[31] Her studio was virtually the only source of basic education in the stained-glass field at the time.

With success came notoriety. Williams found herself an unwilling cult figure, in constant demand as speaker, tour guide, and public educator. School children, divinity students, architectural undergraduates, and women's committees of art and craft organizations all wanted to see for themselves what the excitement was about. Although delighted to help them understand her craft medium, the interruptions played havoc with her design time, and she had to be at work by six in the morning to steal a few hours for herself. By the Fifties and Sixties, she moved from her mediaeval phase into work that was more complex, abstract, and elegant, reflecting influences from the Post-impressionists. She felt she needed a change of pace in 1971, and she sold her home and moved her studio to the country, only to have commissions follow her. She was almost 79 before she put away her tools. In 1987 she bought a house in Parry Sound where she continued to garden and paint until her death ten years later.

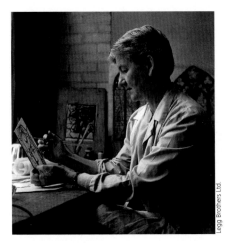

So wide was her popularity that Yvonne Williams, by the 1960s, had to be in her studio by 6 a.m. to work undisturbed on her designs.

Facing a Watershed

Curiously, the post-war period seemed kinder to individual craftspeople than it did to the umbrella organization that represented and fought for their interests. Although Williams, leading metalsmiths, and potters were earning laurels, nothing seemed to go right for the craft motherlode, Ontario's Canadian Handicrafts Guild. It realized the time had come to consolidate and enlarge its work through an Ontario Handicraft Centre, a dream that preoccupied board members for years.

82

To consolidate the present work and continue the development of handicrafts in Ontario, a permanent guild centre is required. This will provide space for a travelling and a Canadian National Exhibition exhibit, lecture hall, workshops, offices, etc. Also, a ceramic centre including firing facilities is incorporated in guild plans and will be an important addition to the facilities provided for Canadian handicrafts.[32]

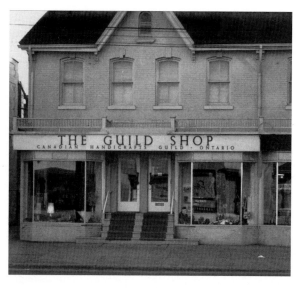

A familiar landmark on Bloor Street West in Toronto for fifteen years was the retail outlet run at #77 by CHG. The second floor housed an office and a small gallery for special exhibitions.

Years of fund-raising by influential and well-connected directors was not enough, however, to coax government and the private sector to make the dream a reality. It didn't help that there was unfavourable publicity toward the Guild generated by an unflattering article in *Saturday Night* magazine in 1948; the incident only served to make the search for capital even more difficult.

While Premier Drew's new Department of Planning and Development did supply modest funds for a Guild office, so that the board executive no longer had to meet in the secretary's apartment, there was not yet a provincial culture ministry or grant structure to review and underwrite capital expenditures. The Guild needed sixty thousand dollars for an expanded headquarters — a hefty sum at the time — and just when it seemed almost within reach, it had a further setback when Eaton's asked it to withdraw The Guild Shop from its College Street store. Moving from the shelter of Eaton's was inevitable since the two parties had outgrown one another, but the timing was unfortunate. The Guild property committee now had to search for new retail space in the Bloor Street West area — considered the best place to be — and spend precious reserves on renovations. By the time the shop opened at 77 Bloor Street West in 1952 and a full-time office manager hired to put the Guild on a more business-like footing — retired banker Stanley Hazell, whose wife, Eileen, was a popular potter — dreams of an all-purpose centre faded. There's no question that its absence impeded the progress of handcrafts for many years.

The move to Bloor Street was an unqualified success, however, and The Guild Shop flourished. Retailing was a priority among many on the board of directors, who were successful retailers themselves, a fact which did not necessarily guarantee they understood how to market crafts. Under the terms of the constitution, a minimum of three craftspeople were also to sit on the board. The Guild began to send travelling exhibitions throughout

the province: to Fort William (now Thunder Bay), Midland, Oshawa, Orillia, Woodstock, and many other centres, and through these tours, it noticed a growing public interest in its work.

To take advantage of this and to introduce quality crafts to new markets, Guild directors tried to foster community craft shops. A Guild supervisor was to visit these retail affiliates regularly to maintain appropriate standards of design and workmanship, even though The Guild Shop itself was not exemplary in these matters and was sometimes criticized for its substandard stock. Huntsville, Bracebridge, Ottawa, Windsor, London, and the infamous Niagara Falls were high on the list of possibles, but after months of protracted discussions throughout 1950 and 1951 all that resulted was four retail partnerships of uncertain duration.[33] The Guild also recognized there was sales potential in Ontario's growing tourist trade, had it the wherewithall to take action. "One only has to look at the atrocities which are committed in the name of handicrafts and which are sold at border points particularly," Guild President C.J. Laurin wrote in 1953, "to realize that an outlet for Canadian handicrafts which are truly Canadian and which are truly crafts is an essential."[34] Unfortunately, the same could be said today as well.

Expansionism Fifties Style

One of the best-loved and committed craft advocates was Toronto native "Millie" Ryerson, owner of The Artisans.

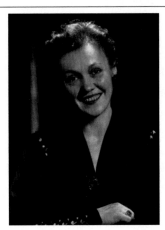

But it wasn't all doom and gloom on Toronto's retail scene; two new craft shops had arrived to brighten the picture. Occupational therapist Mildred "Millie" Ryerson unwrapped The Artisans late in 1949 at 51 Gerrard Street West, just south of Eaton's College Street, an uncompromising grassroots enterprise.[35] "I wanted to be able to work with people, to help them design, to develop, to earn a living, so I needed an outlet to sell their work," she explains. She had worked as a clerk at The Guild Shop for a few years in the mid-Forties and hostessed its shop at the Canadian National Exhibition. She was thus aware of who the studio craftspeople were and their need for more retail outlets; her premises she did not regard as competition for The Guild Shop, since it already had its own patrons and clients.

Without backing or supporters of any sort, Ryerson borrowed five hundred dollars to get started. Her rent was one hundred dollars a month,

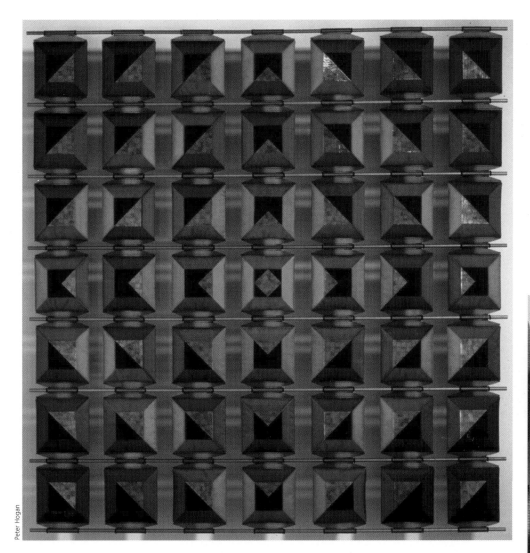

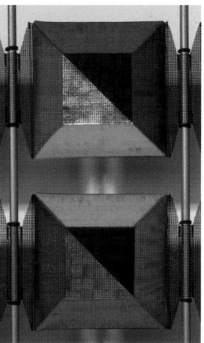

For her cushioned series of contemporary quilts, Judith Dingle isolates quilt blocks by treating them as separate units. *Refraction*, measuring 107 cm square, has pieced, stuffed, and painted silk, metallic fabric, screening, and wood. Here, Dingle has used the traditional "Spools" design to overlay and partially shape the "Barnraising" pattern.

Peter Hogan

Peter Hogan

85

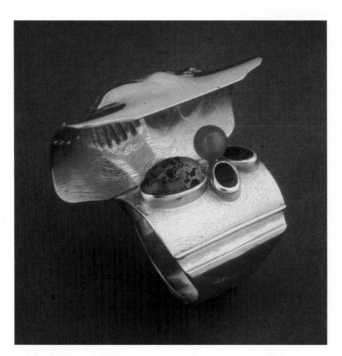

left: While still a jewellery student at George Brown College in Toronto, Andrew Goss fashioned a hinged gold ring set with turquoise, carnelian, and garnets, a 1973 prize-winner at the CNE.

right: Lyn Wiggins has perferred working in precious metals to create her jewellery. In this 1984 pin, she mirrored the stripes of an imperial jasper stone in a sandblasted silver framework.

Peter Hogan

Wendy Shingler used fabricated roller print and 18k gold and sterling for *Sentinal*, a 3.5 x 2.5 cm brooch selected for the Metal Arts Guild's *Magnum Opus* travelling exhibition in 1992.

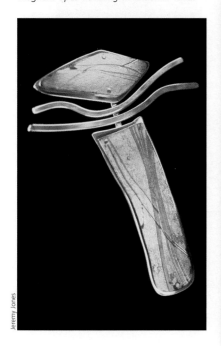

Jeremy Jones

John Dowding

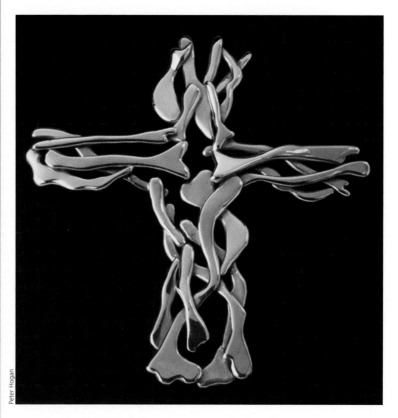

Peter Hogan

left: Combining silver with 18k gold, jeweller Van McKenzie fashioned his *Ivy Bracelet* in 1997.

above: One of the favourite commissions in 1967 of custom-jeweller John Pocock was a gold cross that hung from an elaborate chain attached to the base of a gold choker.

Earthenware vase with raised design, glazed in cobalt, executed in 1928 by Central Technical School graduate Nunzia D'Angelo, owned by her daughter Adria Zavi Trowhill.

This lidded jar was typical of Nunzia D'Angelo's work in earthenware in 1930. She presented it later to Alfred Etherington of Sovereign Potters in Hamilton, where her work was sometimes fired. It is now owned by Etherington's daughter, Lois Etherington Betteridge.

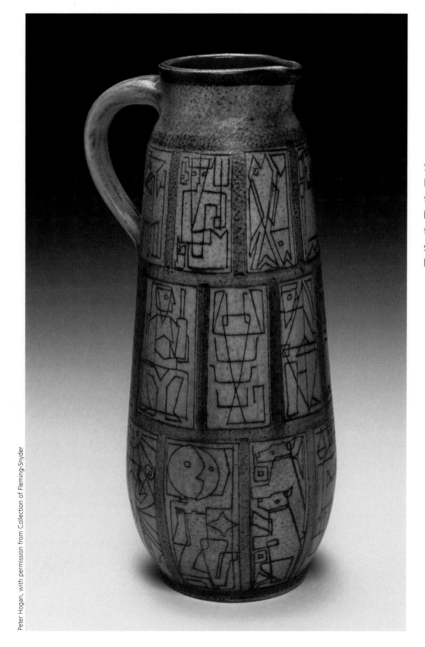

Susanne Harlander preferred red earthenware for her sgrafitto treatment of surfaces. Applying designs freehand, she then brushed in oxide-based paints, bisqued, applied a clear glaze, and fired again. For this 32-cm-tall pitcher made in the early Sixties, she used manganese and copper oxides to highlight the heavenly constellations.

Leather sculptor Rex Lingwood virtually grew up with leather and has earned an international reputation for his cuir bouilli or heat-hardening technique. This 28 x 19 x 18 cm bowl demonstrates his mastery of subtle colouring and original design. The work was completed in 1995.

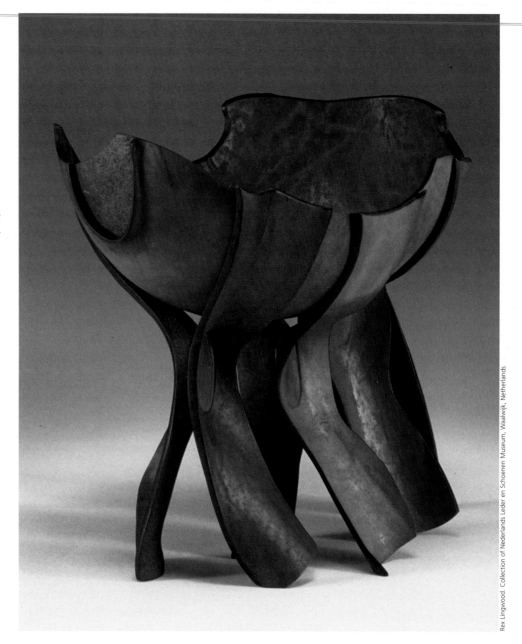

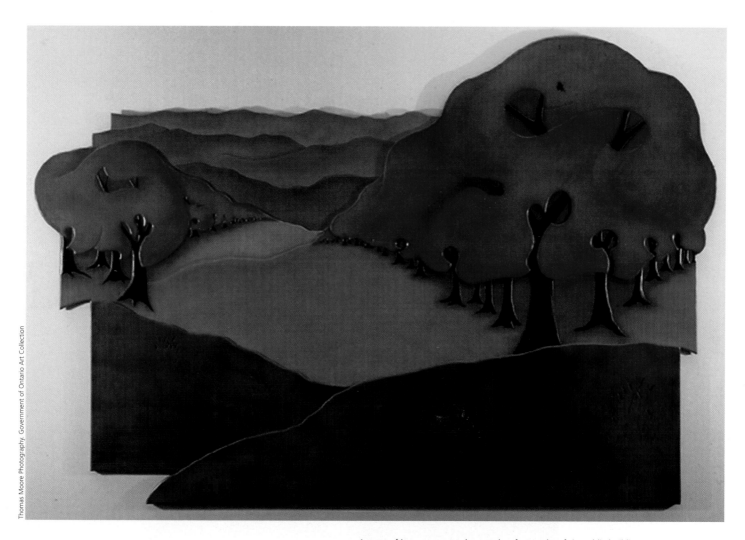

As part of its program to place works of art and craft in public buildings, the Province of Ontario commissioned Paul and Beverley Williams to execute a 300 x 182 cm leather-relief panel for the Michael Starr Building in Oshawa. Installed in 1982, *The Ridges of Durham* was made from vegetable-tanned leather applied in layers over carved wood sections.

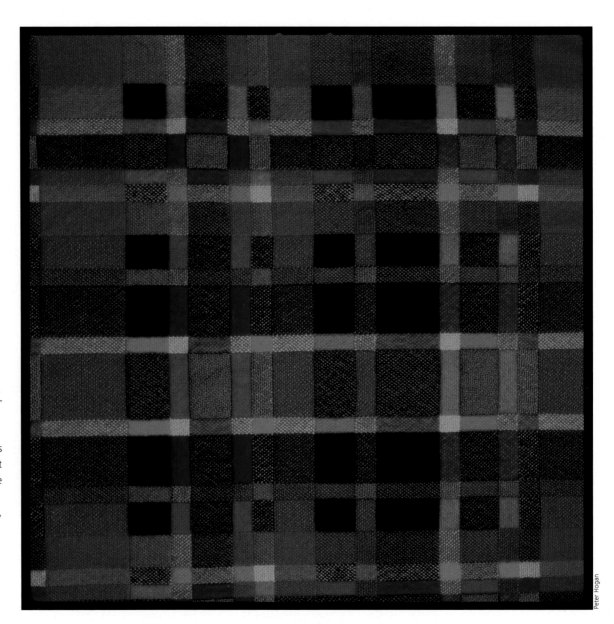

Woven by Barbara Torry on an eight-harness loom in the late 1970s, this multi-colour, double-weave wool became a jacket with knitted bindings at neck and cuffs. When modelled at a fashion show held at the residence of the University of Toronto's president, Torry received kudos for design, colour juxtaposition, and her technique of using interacting blocks.

92

Peter Hogan

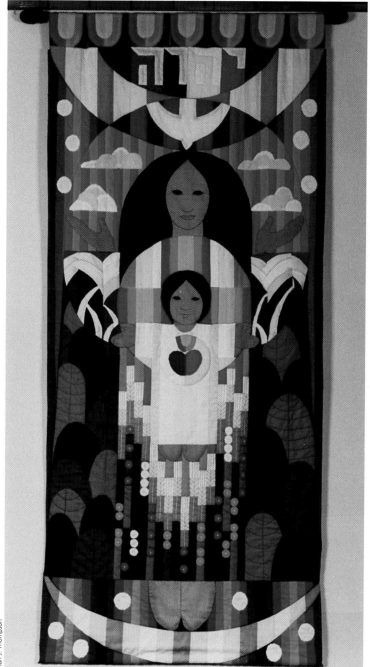

Brian J. Thompson

Waterloo textile artist and designer Nancy-Lou Patterson hand embroidered and appliquéd cottons in making *Our Lady of New Life* for St. George of Forest Hill Anglican Church in Kitchener in 1981. Spanning 180 x 120 cm, the banner appeared in *Art of the Spirit*, a 1992 book of contemporary liturgical work in fabric.

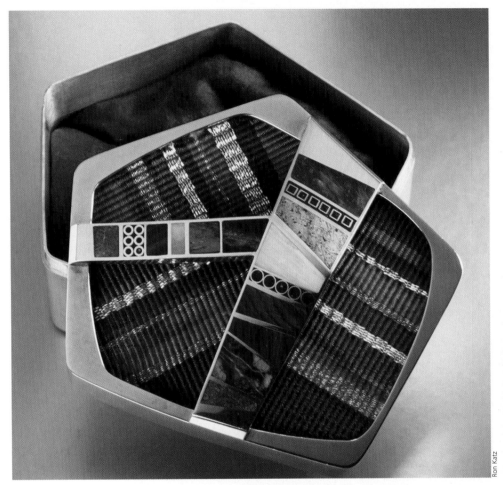

below: From her River Riders series of ceramic sculptures in the early 1990s, Ann Roberts has brought together a parrot, a rabbit, and a river-worthy boat.

above: While doing graduate work at the Rochester Institute of Technology in 1979, Donald A. Stuart explored new techniques. His sterling-silver ring box combines Stuart's own silk-thread tapestry work with delicate inlays of sodality, lapis lazuli, agate, copper ore, silver ore, walrus ivory, ebony, rosewood, and caribou antler.

Ron Katz

Peter Hogan

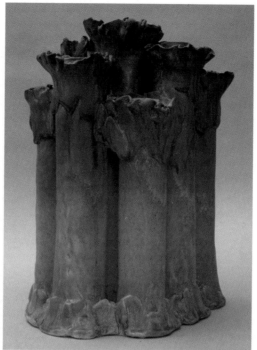

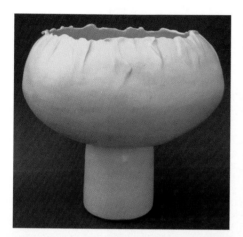

top left: One of Bailie Leslie's pieces in The Five Potters exhibition at The Craft Gallery in 1978 was a hand-built, standing, vase form in porcelain.

top right: Ceramic sculptor Marion Lewis hand-built this 38-cm-high stoneware candelabra, and decorated it with a transparent glaze accented with cobalt and manganese.

below left: Two porcelain vases by Mayta Markson were wheel-thrown, their edges altered, and uppers glazed with copper.

below middle: Using silk-screen images on white glaze porcelain, Annette Zakuta created bottle forms in a series inspired by remarkable women in American history.

below right: Dorothy Midanik's *Imari Chest* showed off an embossed design on porcelain with touches of yellow and orange.

After three and more decades as an enamelist, Alan A. Perkins continues to explore his medium, using new techniques while relying on the natural properties of glass and metal. For *Your Lips Were Like a Red and Ruby Chalice* from a 30-year retrospective in 1996, he has used vitreous enamel with 24k gold foil, and gold-plated the interior.

Pirak Studio

96

Based on emotions evoked from walking in the Ontario countryside, Tamara Jaworska wove a series of smaller, intimate tapestries which she called *Free Verse*. The one pictured is number ten and is from a series completed in 1990–91.

97

Sarah Hall silver-stained and sand-blasted leaded glass for her *Creation Window*, 1.8 m in diameter, which she completed in 1995 for the Immaculate Conception Church in Woodbridge. Almost imperceptible to the eye is a small child etched into the womb of Eve (r).

André Beneteau

Peter Hogan

Bill Lindsay

above: In the early 1980s, Toronto stained-glass artist Robert Jekyll created a series of autonomous panels that employed shapes within shapes and used mirrored and tinted window-glass, transparent, opalescent, and opaque stained glass, and lead, as demonstrated in *Enclosed Form #2* measuring 82 x 69.5 cm.

right: Memorial church windows were a continuous source of commissions for stained-glass artist Yvonne Williams. In 1963 she completed a series of four nave windows for St. Mary The Virgin and St. Cyprian Anglican Church in Toronto, using a palette of rich reds, blues, greens, and yellows. This detail shows Mary, Sister of Lazarus.

99

Latvian-born weaver Velta Vilsons supported herself and her two daughters on commission work. The two illustrated screens were made for Ontario Hydro in the mid-Seventies.

and at first she had to buy on consignment, since she didn't have enough money to purchase outright, which she would have preferred. "The Artisans played a very important role because Millie genuinely had real contact with craftsmen," says veteran Kleinburg potter Jack Herman. "Millie was interested in the whole idea of crafts as a way of life; she really cared about you as a craftsman and was a remarkable lady in the craft movement. We did very well in her shop and she led us to new ideas."

While The Guild Shop's management committee oversaw its every move, Ryerson was accountable only to herself and her bank manager. "She determined not to make money and chose pieces for the shop and priced them so costs would be covered," says Helen Weinzweig, a long-time friend who worked there in the mid-Fifties.

"I didn't like the idea of exploiting anyone, or making a lot of money out of other people's work so I didn't. It wasn't hard," Ryerson smiles. Was she a good business woman? "I don't think I was bad. I started with almost nothing and before I was through I was hiring four people to work there and I had to do a lot more work than they did."

"We despaired of the way she looked," Weinzweig remembers. "She wore hand-woven materials and hand-woven shawls with flat shoes — she was a hippy, in fact." Ryerson resists such a characterization. "No, I wasn't. I was very serious about what I was doing; hippies were more internalized." Soft-spoken and thoughtful, she still moves with a grace borne from years of dance training, with those inner reserves of determination and energy that dancers must have to survive.

A business partner of Ryerson's for a few years, Jewel Schwartz, opened a third shop on Bloor Street in 1955, an altogether more stylish and upscale craft outlet, Trade Winds, which she had professionally designed in contemporary colours — orange, green, and white — with mahogany. Before going out on her own, Schwartz took courses in jewellery and pottery so she would know what was involved. "I didn't have the hands for it but I wanted at least to have an idea what the materials were." In 1960 her building was torn down so she relocated to Cumberland Street, the first such store in Toronto's Yorkville area where she stayed until retiring in 1984. "They were wonderful years; lots of aggravation and heartache, but that goes with having a business like that." And she was prepared to be

Logo of The Artisans shop was a cockerell whose legs once formed the two strokes of the "A" in the shop's name. Mounted on a wooden board, Carl Rix's rooster linocut became synonymous with Toronto's Gerrard Street Village.

101

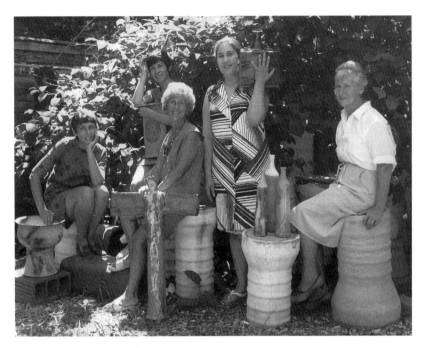

The Five Potters had a back garden with their first co-operative studio on Davenport Road in Toronto. Left to right: Mayta Markson, Annette Zakuta, Marion Lewis, Dorothy Midanik, and senior member Bailie Leslie.

a maverick. "I was awfully sick of the traditional. I liked the innovation and imagination that these people had and was thrilled to meet people who were so creative. Primarily I saw myself an educator and the people who came in developed a taste for the unusual."

Like Schwartz and Ryerson, other individuals and groups in the Fifties developed their own work spaces where they would have more freedom to follow creative instincts. Not long after industrialist Sir Ellsworth and Lady Muriel Flavelle retired in 1948 to Kingswold, their new country estate north of Toronto, Lady Flavelle threw open her home to a group of thirty local women to talk about developing a craft group. "Kingcrafts was born that day" and "never waned in vision and enthusiasm," Lady Flavelle was to write later.[36] Within six years the group raised enough money from sales of craft work and from local sponsors to erect its own headquarters in King City, built and completely paid for in eighteen months — an astonishing accomplishment when compared with the Guild's struggles to establish a centre. But then, smaller communities have demonstrated, more than once, that when they rally together they can often achieve results that seem beyond the reach of larger centres.

By the mid-Fifties, ceramic supplies had become more affordable and accessible largely due to the efforts of Ferro Enamels whose Canadian president, Brigadier Wilfred Mavor, was committed to the studio pottery movement and supported it wherever he could.[37] Potters like Evelyn Charles, Helen Duncan, Helen Copeland, and Molly Satterly, who were not engaged in volume production, could now combine home and work if they chose, but the juggling act didn't suit everyone. In 1957 five women pioneered in a studio cooperative that functions almost four decades later with four of the originals still active.

In forming The Five Potters, "We wanted more freedom than you could get in school [Central Technical], freedom to sell and display work, interchange ideas and so on," retired

senior member Bailey Leslie said. "It wasn't all that expensive when we split rents and costs five ways," Mayta Markson added, "and we had supportive husbands." Clay sculptor Marion Lewis agreed: "It was important for the studio to pay for itself, but we didn't have to make a living at it." Leslie, Lewis, Markson, Dorothy Midanik, and Annette Zakuta were married to professional and business men who understood that their wives needed to work undisturbed outside the home to fulfill their artistic ambitions. Although colleagues, they pursued individual careers and never critiqued one another's work. On occasion, however, they did collaborate on architectural commissions: murals for the Peel County Courthouse in Brampton and the Bayview Golf and Country Club in Toronto, a hundred hanging planters for a health centre in Sault Ste. Marie; and a fountain for an Edmonton shopping centre. All won their share of national and international awards and collectively staked out a niche on the leading edge of the ceramic scene. "Today young people are doing the more exciting things and probably look at us as we looked at the older ladies when we were young," mused Zakuta. "The best time is when you are young and starting out. We thought we were more avant garde when we started out, too."

When the five came together, they measured their progress and found their rewards through juried exhibitions. "The highlight was being accepted for the international showings where we had to compete, and we had to work toward being accepted," Lewis said. "Today you don't aim for the same things as we did then, the direction is different." And exhibitions were fortunately more common in the Fifties. Perhaps the most meaningful to the clay community were the juried biennials of The Canadian Guild of Potters held in Montreal and Toronto from 1955 to 1971, which, more than anything raised standards and provided encouragement to studio artists.[38] After previewing the second biennial, ROM curator F. St. George Spendlove wrote, "The national awakening of Canadians to the importance and beauty of their national heritage has affected ceramics as much as anything. Seldom has so much work been done by so few workers to benefit so many." The 1959 exhibition accepted work by all five of the studio co-operative, and its senior member, Bailie Leslie, was again a prize winner, an accomplishment she was to repeat again and again.[39]

The decade of the Fifties also gave birth to the Canada Council, an organization conceived in the 1951 Royal Commission on National Development in the Arts, Letters and Sciences under chairman Rt. Hon. Vincent Massey, whose name has become synonymous

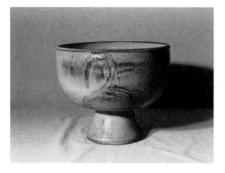

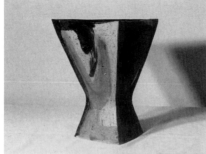

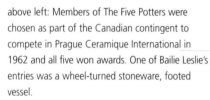

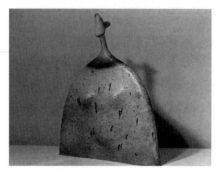

above left: Members of The Five Potters were chosen as part of the Canadian contingent to compete in Prague Ceramique International in 1962 and all five won awards. One of Bailie Leslie's entries was a wheel-turned stoneware, footed vessel.

above middle: One of Dorothy Midanik's contributions to the Prague International was a three-sided standing form with rubbed oxides and black glaze. She was also a gold medallist.

above right: Mayta Markson hand-built a stoneware form, encised the surface, and rubbed in oxides.

below left: Marion Lewis won a gold medal for *Contessa,* a white-glazed stoneware sculpture sprayed with coloured oxide.

below right: Annette Zakuta hand-built imposing cylinders.

with the commission's report. For all the decade's cultural optimism, Massey noted striking deficits: no national library or national cultural body, underfunded National Gallery and Canadian Broadcasting Corporation, and the list went on.

All that aside, the ebullient Fifties held out greater opportunities for self-expression and self-fulfillment than ever before. Craftspeople who would and did make the most of them had much to look forward to. From the professional perspective of the National Gallery's Donald Buchanan, when looking over the gallery's first invitational national fine-craft exhibition in 1957, the average level of craft and design was improving, but to find true excellence he looked to the touchstones, the "most supremely gifted workers in ceramics and enamels, in weaving and in silver." He was optimistic that those following these ambassadors now had the competence to rise to comparable standards.[40]

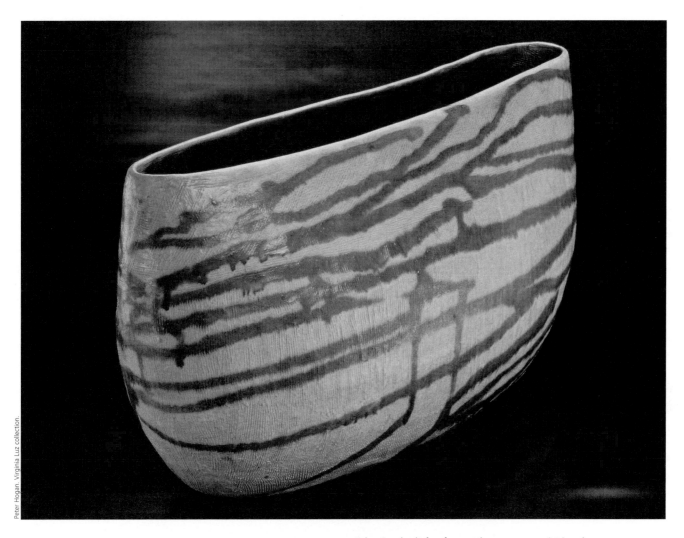

Helen Copeland's free-form earthenware vase so intrigued
Lawren Harris that he wanted to buy it when he first saw it at
the CGP biennial exhibition in Montreal in 1957. It was promised
to Copeland's pottery teacher, "Bobs" Howarth, who willed it to
colleague Virginia Luz. A companion piece won a silver medal at
a ceramic international exhibition at Ostend two years later.

Czech expatriate Jarko Zavi sculpted his *Mother and Child* in clay after he left Toronto in 1946 to live in Cobourg. Glazed with a decorative metallic finish of his own making, the work reflects his European training and sensibilities.

1961–1975

CHAPTER FOUR

THE CIRCLE WIDENS

THE CIRCLE WIDENS

For North Americans, the Sixties were a cultural watershed, a time of idealism, libertarianism, and social upheaval, which profoundly affected all walks of life. If the Fifties are remembered for their more adventurous approach to materials and the encouragement to individuals to have a go at self-expression, the Sixties and Seventies are memorable for the birth of a counterculture and a populist, free-wheeling, anything-goes attitude. Experimentation and creativity flowered in this permissive and accommodating climate, and craftwork was a barometer of the best and worst of the Age of Aquarius.

Among the positive achievements was the growth of craft activity itself: service organizations, craft schools, practitioners, collectors, consumers, exhibitions, and an infectious spread of regionally based media guilds. On the international scene, American philanthropist

Aileen Osborn Webb added to her roster of craft accomplishments the organization of the World Crafts Council in 1964, and five years later two continental media groups were formed: the Society of North American Goldsmiths (SNAG) and Handweavers Guild of America, Inc. In Canada, the Sixties and Seventies heralded an impressive range of creative enterprises, epitomizing what the Massey Commission had earlier called "a prevailing hunger throughout the country" for personal cultural experiences. Ontario minted an arts council in 1963, the Ontario Craft Foundation in 1966, and in the following year established community colleges, of which a school of craft and design in Lorne Park (now Mississauga) offered the most comprehensive craft programs. The province's cultural world finally seemed to be unfolding in a fashion appropriate to a

confident, vigorous, and increasingly wealthy province in a nation proudly mindful of its hundredth milestone.

By the early Sixties, Ontario had a population of six-and-a-half million, and Toronto was home to a large contingent of professional artists, craftspeople, and arts organizations. The times had become relatively affluent; there was high employment and general optimism. A rising middle class was prepared to spend: by 1967 annual craft sales had grown to fifty million dollars.[1] The province acquired a forward-thinking premier in 1963, John P. Robarts, and fathered at least two committed arts advocates: Maclean-Hunter publisher Floyd S. Chalmers, already a craft supporter, and businessman Arthur Gelber, president of an Ottawa-based lobby group, The Canadian Conference of the Arts.[2] Both men believed it was time that Ontario became more active in

encouraging and supporting the arts, that the public was probably ready for the adventure and would accept the expenditure with equanimity. Gelber himself was midwife at the birth of the arts council, with Robarts at his right hand. One of the council's priorities was to inject some muscle into the craft scene then "plagued with a field of problems,"[3] resulting, in part, from insipid government backing. An arm's-length arts council seemed a perfect vehicle to indirectly funnel government assistance to crafts and other arts programs and sidestep any public criticism for financing "frills," a straw man provincial politicians regularly fell back on to justify lack of support.

Robarts also saw the wisdom of making art and craftwork accessible to the general public, at the same time humanizing the severe Modernist civic buildings at Queen's Park and throughout the province, many of them

with empty forbidding walls.[4] The Department of Public Works coordinated an art-in-architecture program, firm in the belief that if we "put people in soulless surroundings we'll get sloppy work and a soulless work force."[5] Such initiatives became catalysts for private-sector projects by architects, businessmen, and developers who commissioned craft work for interiors of a variety of buildings. In 1964, the federal Department of Public Works had set an example by allocating one percent of capital costs of public buildings for a fine-art program that included mosaics, frescoes, tapestries, stained glass, ceramics, and wall hangings.[6]

Not only did crafts receive more attention and attract legions of new makers in the Sixties and Seventies, work itself underwent dramatic changes, especially in clay and fibre. Weavers, for example, discovered new horizons beyond fine linens and traditional fabrics for clothing, interior accessories, draperies, and room dividers.[7] As for potters, there were so many movements and sub-movements co-existing in America by the mid-Sixties that the ceramics field was totally transformed. There were essentially two camps: the functional (with two branches), and the sculptural with a myriad of splinter groups. Prominent among the latter were California radicals intent on challenging the norms, not surprising since the West was at the heart of the Sixties protest movement.[8] Consistent with Canadians' more cautious nature, Ontarians did not slavishly mimic the avant-garde, although they would have become familiar with main trends from reading craft magazines and exhibition catalogues, or by attending major U.S. exhibitions. Right on their doorstep was one of the alternative voices, however. For five years in the Seventies, a California maverick and widely exhibited American ceramist, David Gilhooly, taught at York University in metropolitan Toronto and directly influenced a generation of younger potters.

The metal and jewellery craft world did not experience radical mutations until the Seventies, but studio workers nonetheless faced troubling new economic realities. For one thing, the commission market for larger pieces was weakening, partly because of rising silver prices. As well, consumers were showing a decided lack of interest in acquiring and looking after silver holloware and flatware, choosing instead to use stainless-steel accessories. With one or two exceptions, Ontario smiths seemed to lack skills for developing new commission markets, and relied on teaching and jewellery making.

Whatever the medium, standards of craftsmanship varied widely in the Sixties and Seventies. Clay specialists in particular were encouraged to be innovative, to express themselves freely, take risks, hang loose, and work spontaneously to capture precious moments of creativity. Of secondary importance were dogma, convention, and a craftsperson's time-honoured respect for materials and tools. The act of making and the idea behind it had become more important than the results, the voyage more rewarding than what followed. It's evident now that with experimentation there can be complacent workmanship, poor finishing, and superficial craftsmanship. Some of the work from this period, consequently, gave crafts a bad name and threatened to vulgarize it.

Fortunately, throughout the period a corps of professionally committed craftspeople continued to produce and develop work of enduring quality, which came to prominence through a profusion of exhibitions. Some of these moved about the province to new community galleries and art centres; many were built as centennial projects. Beginning in 1969 and continuing through the Seventies, the Canadian Guild of Crafts (Ontario), grandchild of the Handcrafts Association of Canada, organized juried multimedia exhibitions on a scale not seen before. By all accounts the icing on the cake was the internationally acclaimed *In Praise of Hands* at the Ontario Science Centre, organized for the tenth anniversary of the World Crafts Council, which convened in Toronto in 1974. No doubt about it, the Ontario craft scene was on a roll.

A graduate of Central Technical School's ceramic program, Eileen Hazell was a popular exhibitor and award-winner. Her signature pieces were hand-built stoneware birds, such as this pair from the 1971 exhibition, *Make/Mak*.

Gordian Knots

Recalling the nuances of the Sixties and Seventies is somewhat like trying to catch a fluttering butterfly that eludes our attempts to examine it at close range. The images we have are rich but ephemeral: coffee houses, communal living, poetry readings, tie-dyeing, idealistic flower children, long hair, bare feet, macramé plant holders, and anything handcrafted. This last had an unsettling side-effect for Ontario's studio craftspeople.

The hard-won gains achieved by serious practitioners over a span of three decades were now undermined by a cult of amateurs caught up in their expressive urges, but not necessarily in fine design or quality. It seemed that anything handmade was generically labelled as "craft." This aesthetic thorn, fortunately, was offset by another group just as caught up in the optimism of the period, but who chose further education in craft programs, believing that something worthwhile would surely follow serious study: jobs in a design house, textile firm, studio, cottage industry, or a teaching situation. This latter group was to become a prominent generation. Economic prosperity in Ontario meant that government and private money was available to purchase, commission, or otherwise acquire craft work by a circle of established professionals and new graduates.

Crafts in general were a hot topic. They satisfied a public craving to own something that was unique and affordable. Their growing popularity also stemmed from increased leisure time, an encouraging press, and the rising cost of consumer products.[9] The good news was that the annual market value of craft products sold in the province had risen to fifty million dollars by 1967; the bad news was that Ontario-made work only represented a mere quarter of that.[10] Clearly, there was work to be done to encourage and promote increased production of quality craft on the home front and to develop a means for marketing it.

After its 1963 genesis, the Ontario Arts Council attempted to sort through a tangle of aggravations that vexed the provincial craft scene and to find solutions.[11] We can only

guess what the perceived difficulties were, because the Council's annual reports provide few details, and archival records are scarce. At the top of the list would surely have been inadequate craft-and-design educational opportunities, compounded by a scarcity of supplies, professional development, and selling opportunities for those struggling to earn livelihoods in more isolated areas.[12] Or put another way, as commendable as were the activities of the Canadian Handicrafts Guild's Ontario Branch — chiefly running a profitable retail operation in Toronto and organizing some outstanding exhibitions — its programs touched only a small segment of the province's craft community.

The Guild's board of directors was somewhat distracted by two major concerns in the Sixties: real estate and image. After three year's discussion, all branches of the national Handicrafts Guild decided to bury the outmoded "handicraft" moniker and function as Canadian Guild of Crafts. It was time to tell the world, as Ontario President Douglas Boyd explained in a February 1968 newsletter, that "handicraft" was no longer appropriate for an organization striving to have craft accepted as a valid form of art. And because 77 Bloor Street West was designated for redevelopment, a new location for The Guild Shop had become top priority. Rather than continuing to rent, directors gambled on buying property in the Yorkville district, even though some disparaged it as "hippiedom."[13] It became obvious that craftspeople themselves had to look to sources other than the Guild of Crafts for infusion of new ideas and energies.

The young Arts Council, together with "Bunty" Muff, craft officer with the Community Programmes division of the Ministry of Education, set to with a vengeance. To obtain a concensus for future action, they organized a pair of conferences by rounding up some two hundred craftspeople and laymen, plus world craft authorities Aileen Webb of the then American Craftsmen's Council and Cyril Wood of Britain's Crafts Council.[14] Extensive research preceded conference sessions so that unanimous accord was reached in a breathtakingly short time-frame, a feat impossible today given our penchant for protracted deliberations and political correctness. Key recommendations included forming a second organization to serve all the province's craftspeople through a range of programs, and establishing a centre to dispense training and marketing assistance. By June 1966, with an initial budget of $42,000, the Ontario Craft Foundation was off and running with a gloriously ambitious agenda designed to move mountains. Its goals had every semblance of a

Provincial Craft Advisor "Bunty" Muff met Arthur Gelber at a conference late in 1965 to lay the cornerstones of OCF. Gelber was then president of the Canadian Conference of the Arts and a board member of the new OAC.

pipe dream, but this was the Sixties when nothing was impossible.[15]

It's generally accepted that the person responsible for creating the Foundation was a practical visionary from government circles: "Bunty" Muff. "She saw exactly what was happening in Ontario or not happening," says Toronto stained-glass artist Gerald Tooke and a Foundation president. "She had been out there from the beginning, knocking on doors for decades, teaching weaving in church basements. She knew what was going on throughout Ontario's regions and she saw the larger picture, too. Very unusual."

In its ten-year existence and with limited government funds, OCF was able to make substantial inroads and scale at least some of the steeper mountain slopes. It produced and distributed a bi-monthly newsletter and a magazine, *Craft Ontario*, essential for communications; developed a library of visual and other teaching aids, catalogues, and directories; organized workshops and regional exhibitions; ran a sample showroom where it acted as agent; and laid the groundwork for a wholesale marketing enterprise. And it succeeded on a human scale. "I think the greatest accomplishment of the Foundation was that people became aware of other craftspeople in the province and help available to them," says Aurora fibre-artist Marie Aiken-Barnes, the Foundation's first northern regional director. "Gordon [Barnes] built kilns all over Northern Ontario as well as running the Foundation. In fibre arts, I was able to bring teachers to weaving groups in Timmins or Sudbury. Because I was a weaver, I was invited to the groups and became a trouble-shooter in the same way that Gordon became a kiln builder." The Foundation's structure was visibly democratic and included craftspeople, educators, and a brigade of regionally-based craft representatives; by 1975 its membership had grown to just over fifteen hundred, essentially the same as the Guild's.[16]

Almost more enduring than these tangibles was its role as educational catalyst. The establishment in 1967 of The Ontario Craft Foundation's School of Design in Lorne Park, now Mississauga — later to become Sheridan College School of Craft and Design in Oakville — was a pivotal achievement. Although community colleges began offering craft programs at the same time, and a handful still tender a limited selection, Sheridan's was the most extensive and, in the long run, the most influential. Craft graduates everywhere strengthened and enriched the studio scene, and if they did not pursue a career in crafts, at least they became knowledgeable and discerning customers.[17]

Edward Schreyer, governor general of Canada, conferred the Order of Canada on "Bunty" Muff Hogg in 1980 for her work in the craft field.

John Evans, Ottawa, National Archives of Canada

113

Peter Smith

Gordon Barnes

above: In the exhibition hall at the Stratford Shakespearean Festival, juried crafts from across Canada were brought together by CHG from 1959 to 1964. This display is from the 1960 exhibition.

below: Incorporated May 26, 1966, OCF attracted a roster of capable presidents. One was John Mather of Indusmin, a subsidiary company of Falconbridge Nickel Mines Ltd., here at a 1972 meeting in the foundation's offices.

The Foundation's dreamed-of resource centre never came to pass, and by the early Seventies, it found itself having to fight for survival in spite of its government-approved mandate. In his annual president's report for 1974, David Piper lashed out in frustration: "It is a strange position, being president of a provincial society with a worthwhile charter, having been started by the Premier of the Province when he was Minister of Education [William G. Davis], and finding great difficulty in serving the needs of the craftsmen in Ontario, as stated in the OCF charter, because you are not really listened to."[18]

By this time, the Foundation was no longer part of the Education Ministry but a ward of the Sports and Recreation Bureau of the Ministry of Community and Social Services, under whose stewardship it felt unwanted, misunderstood, and most certainly unloved. Piper thought the Bureau adversarial in its dealings with OCF and, indeed, departmental memos confirm that Director Robert E. Secord was opposed to furthering the Foundation's program of regional development, marketing for the professional craftsperson, and expansion of its magazine.[19] "One must bear in mind that the needs of the craftsmen are growing larger, not diminishing," Piper would argue. "The number of craftsmen is increasing, we are talking about a growth industry, not one on its way out," and "There is so much that is not being done for crafts that we should be worrying how we are going to do it." To be fair, there were many who agreed with Piper's predecessor in the presidency, John Mather, who believed that "craftsmen of the province will not receive the public support and acclaim they so richly deserve until there is a semblance of unity and a common voice."

In the intervening years between the Foundation's birth and its struggle to survive, the older service organization, the Canadian Guild of Crafts, turned a corner, became more professional, and expanded its operations beyond retailing and juried exhibitions. In 1970 it began publishing a magazine, *Craft Dimensions/Artisanales*; in 1972 it rented offices and gallery

space at 29 Prince Arthur Avenue and hired as executive director seasoned arts adminis-trator and gallery director, Paul Bennett. Under Bennett it broadened its scope, most par-ticularly in regional development, a field where affiliate membership had dropped to an all-time low. One of the Board, popular Toronto architect Raymond Moriyama, headed a Futures Committee and was asked to recommend long-term goals and immediate objec-tives.

Before looking into his crystal ball, Moriyama talked with a number of craftspeople and unearthed a litany of grievances and frustrations. Protesting the lack of economic aid available to them, most craftspeople whom he interviewed were naturally enough, preoc-cupied with selling work. Their main outlet, The Guild Shop, sold poor-quality mer-chandise in their opinion, did not promote them enough, or try to win over the public, whom they regarded as phillistines with poor taste and little sensitivity to their work. As for the magazine, they felt it should be more meaning-ful and print more technical articles. They also recycled some chestnuts: the art-versus-craft controversy, which Moriyama termed paranoia; the misguided notion of competing with the machine; and that you could survive without the Guild if you were good enough.

From all this he concluded the Guild had to re-evaluate its role as a catalyst and facilitator, and that, ideally, it would self-destruct when craftspeople had developed a natural interdependence and independence by accepting more responsibility and involvement in the decision-making processes. As for the here and now, he agreed with John Mather that the Guild and the Foun-dation must fuse into one multicraft provincial organi-zation to achieve harmony in diversity.[20]

Brian Willer Photography Inc.

above: In 1969, the Ontario Youth and Recreation Branch pro-vided funds for six travel-ling exhibitions of crafts. First in the series was *Contemporary Crafts #1*, coordinated by Judith Tinkl, shown here unpacking work crated in styrofoam blocks. Each display case also served as a self-contained shipping carton.

And so it came to pass that in 1976, the Ontario government presided at a marriage of convenience between the Foundation and the Guild, which collectively became the Ontario Crafts Council. In the next two decades their common voice and combined strengths guided the craft movement through heady peaks and deep valleys.

below: Raymond Moriyama served as juror for the 1971 exhibition, *Make (Mak)*, held at the Ontario Science Centre, where he congratulated two award winners: jeweller Reeva Perkins and enamellist Alan Perkins.

The Chemistry of the Times

above: Jurors for *Craft Dimensions* were American masters Glen Kaufman, textiles (left); Robert C. Turner, ceramics (right) and Ronald H. Pearson, jewellery and metalwork (centre). After discussing the merits of Ruth Gowdy McKinley's lidded jar, they awarded it a special prize.

below: *In Praise of Hands* exhibition coordinator M. Joan Chalmers with some of the craftwork on display at the Ontario Science Centre.

It is daunting, perhaps foolhardy, for a craft observer thirty years after the fact to read, or try to read, the pulse of the 1965 to 1975 period, a time when Canada's hundredth birthday was one of many milestones. This altogether remarkable decade gave life to a profusion of craft activities throughout the province which we're not likely to experience again. Two craft-service organizations with legions of volunteers now promoted the interests of craft makers; media guilds expanded their horizons, activities and effectiveness; and hundreds enrolled in craft programs or took courses at community colleges, at the Ontario College of Art, at high schools whose earlier influence was now eclipsed by the community colleges, or in special workshops and summer sessions run by Community Programmes.

Many of us recall the drama and wonder of Apollo Eleven landing man on the moon in July 1969. Two months later, Toronto and area experienced another kind of excitement as the Guild staged the first of its rousing biennial juried exhibitions, *Craft Dimensions Canada*, followed by *Make/Mak, Entr'acte, Art in Craft*, all held in prominent venues to attract maximum public attention.[21] In 1974 the Guild also helped co-ordinate the largest and most original craft exhibition ever seen in Toronto, or anywhere for that matter, *In Praise of Hands*. Toronto was host to the World Crafts Conference in June and the Guild was determined that this first worldwide craft exhibition make history. Provincial and federal governments and Benson & Hedges (Canada) Ltd. furnished the financial wherewithall, while WCC director and Guild Vice-President M. Joan Chalmers added the organizational clout and exhibition experience. "It was a happening; it was show business," Chalmers recalls. "My concern was to make crafts interesting to a wider range of people and that's why I was so pleased to get into a place like the Ontario Science Centre, because we exposed crafts to more people." Chalmers and her committee hoped that if those attending were craftspeople already, they would see a superior standard of weaving or ceramics, and would aim higher in their own work. "There were unique pieces and the best of everything was creating a market for excellence and an awareness that we were celebrating people from all over the world who work in three dimensions. Our mission was to knock their socks off." Local crafts received a boost from all this publicity. "That conference and exhibition had a big effect on helping us to make more money," says one of the Canadian finalists, Toronto

enamellist A. Alan Perkins. "It got us international exposure. After it, I remember the Massey Foundation gave my wife Reeva several large jewellery commissions."

June 10–15 was declared craft week in Toronto, but the entire month of June afforded the city a veritable banquet. No less than seventeen shows featured work in glass, clay, fibre, leather, metal, or wood, and the whirl continued to year's end. Throughout Ontario a dozen or so venues — from Thunder Bay to Ottawa — presented craft exhibitions, as did many Canadian galleries throughout the country. *In Praise of Hands* showcased six hundred pieces from fifty-five countries and drew more than half a million visitors during its three-month run — this at a time when an August transit strike bedevilled anyone who had to rely on public transit. Joan Chalmers's mother, Jean A. Chalmers, purchased all fifty-nine Canadian submissions and gave them to Ontario's Canadian Guild of Crafts for its permanent collection, which is now housed in the Canadian Museum of Civilization in Hull, Quebec.[22]

Along with all this, craft fairs popped up in town and country, and an urban version, One of a Kind, opened its doors in 1975 on the Canadian National Exhibitions grounds. Ontario's Youth In Action grants financed several summer student projects, which took craftmaking well beyond cities: workshops in Owen Sound and North Bay in 1971, and for two years, a workshop and sales co-operative called Suncrafts, in Bala on Lake Muskoka, followed by ones in Niagara Falls and Gananoque.

The summer at Bala furnished valuable experience to student jewellers Sandra Noble and Andrew Goss, now two of the province's enduring and respected professionals, who live and work in Owen Sound.[23] As well, for three summers Youth in Action funded Craft Truckers — six Sheridan students, who lived in tents, travelled in a converted delivery van and passed on craft basics to adults and children at Ear Falls, Rainy River, Longlac, Red Lake, Upsala, Vermilion Bay, and points northwest. Another Sheridan graduate, Sam Moligan, who claimed to be more of a businessman than a potter, invested between $15,000 and $25,000 of his own money to revamp a second-hand truck into living quarters and a mobile teaching studio. Operating on a freelance basis, he introduced a new procedure he had recently mastered at Penland in North Carolina — salt glazing.

below left: During Floyd Chalmers's term as president of the Stratford Festival Board in the mid-Sixties, his family lived in town at Chalmers House, 151 Douglas Street, in Stratford, a home Jean A. Chalmers decorated with Victorian antiques.

below right: Lois Etherington Betteridge's entry to *Art In Craft* at the London Art Gallery in 1975 was a raised-and-chased-sterling pitcher.

Selected from some 900 entries as a finalist in *Craft Dimensions Canada* in 1969, Donald L. McKinley's table and lamp of polyvinylchloride tubing and sheet plastic went on to take a top award.

In 1971 CGC staged the second of its biennial exhibitions, *Make/Mak*, at the Ontario Science Centre. Ontario's top designer-craftspeople were invited to participate, a group that included textile artist Kai Chan, who submitted *The Sea — Night & Dawn* of cotton and raw silk.

above: Toronto jeweller Betty Walton presents her production line of accessories at the One of a Kind retail show in the National Trade Centre, Exhibition Place, Toronto.

right: As his career took off in the mid-Sixties, Ron Roy received a large commission from the Woodbridge Board of Trade country club for massive planters. Each contained 54 kg of wet stoneware clay, left unglazed, which Roy threw on a kickwheel, then added the upper lip by hand.

Robert Tittle

His school-on-wheels project was so original and courageous it attracted considerable international attention. From his experiences, Moligan concluded what "Bunty" Muff and OCF already knew, that "People are crying for an individual to come in and show them how to do something concrete and constructive."[24]

Craft visibility grew in main centres, too, where public buildings began to resonate with commissioned fibre wall-hangings, ceramic murals, stained-glass windows, and works in wood, metal, and leather — generically known as "public art." At the Toronto offices of Industrial Minerals of Canada Limited, for instance, a craft collection of clay and glass, singular in Canadian corporate circles, had its beginnings in an initial purchase of mugs and ashtrays for staff.[25] Other businesses furnished their offices with craft-related accessories, some of which were designed and executed by A. Alan Perkins, who was associated with the architectural field for more than thirty years before striking out on his own. "In the early Seventies I got my big jobs for modular assemblages for walls which had an architectural quality about them," he recounts. "They were for collections owned by Crown Life, Cadillac Developments, Cochrane Murray, people like that. That was when the government allowed big business to invest in art and gave it tax write-offs," a commendable incentive that encouraged firms to undertake large-scale commissions.[26]

Beyond the Fringe with Walter's Web

Ontario's expanding craft horizons were considerably strengthened and nourished by a second government craft advocate who came on the scene from the world of art. A fine

arts graduate from the Ontario College of Art, Walter Sunahara had just returned from further studies in Japan when Community Programmes hired him in the fall of 1964 to work alongside "Bunty" Muff. Her field was craft, his was art, but division of responsibilities often overlapped. Like Muff, he travelled extensively throughout the province, taught, and organized courses and workshops for others to instruct.

"Consciously or not, he was a catalyst and promoter of the arts and crafts," says Marie Aiken-Barnes. "Walter was an enabler. He was responsible for many valuable training programs in this province. He had such sensitivity and enthusiasm, and we looked to him for inspiration and leadership." Aiken-Barnes was part of a large network of teachers, styled "Walter's Web," that criss-crossed the province on a regular basis, encouraging and educating those living in remote areas. Among the group were batik artist Joan Donnelly, Alan and Reeva Perkins, potters "Tootsie" Pollard and Donn Zver. When still a Sheridan student, Zver was asked to teach workshops, and he continued to do so after graduation, somehow balancing that sideline with the demands of starting up a studio pottery on his grandfather's farm at Troy, in the Hamilton region.

Walter Sunahara's first teaching assignment was a silk-screen printing course in 1964 at the Quetico Centre, 193 km northwest of Thunder Bay. He is shown here with Clara Paypompay.

"Bunty and Walter had the right idea," Zver says. "I think a lot of the concern at the time was that the craft movement was Toronto oriented, and what Bunty and Walter did was get craftsmen out into the hinterland. We went to outrageous places in snowstorms and everything else. We had these creative people, and it was a way to get them out to stimulate others all over the place: Dryden, Kingston, Kirkland Lake, Sault Ste. Marie, Sudbury, Thunder Bay, Timmins. Bunty was the grandmother; Walter the son and we were the grandchildren."[27]

Perkins also recalls with relish his experiences with the network, travelling to weekend workshops throughout Northern Ontario with his wife, Reeva, and Sunahara. On other occasions, "Marie Aiken and I would go for a week at a time, working for $125 a week. I did enamelling. Supplies were affordable, copper was cheap, enamels were cheap, and nobody was doing anything big. I was retailing enamels for four or five dollars a pound then, and they're now twenty-six to fifty dollars a pound." As potter Moligan had learned, many people in small communities were searching for a means to express themselves creatively. "We opened their eyes to something that was more than they were doing." Sunahara says.

Established in 1963, the Muskoka Arts and Crafts Association's July craft fair in Bracebridge continues to be a perennial favourite. One of the busiest booths is that of potter Jon Partridge.

"You could see gems among the stones. There were people who were sincerely looking for more than what they had, and blossomed."[28]

If the Sixties' bias for back-to-the-land living did nothing else, it encouraged younger craftspeople to believe that they could function creatively beyond urban confines, that there were rewards and advantages for studio craftspeople in rural living. "They realized that they didn't need all the material things, that the quality of life went with the thing that they enjoyed doing," Aiken-Barnes said in a 1975 radio interview. "More and more craftsmen are in competition with themselves, rather than with the guy next door, or the town, or the craft group. I think that's when a better quality of crafts started appearing on the market ... pride of good craftsmanship went with it."[29]

By force of circumstance, Aiken-Barnes herself always lived outside the mainstream after marriage: in Bracebridge, Gravenhurst, and Aurora, and realized early on that she was congenitally out of step with authority. Rebel, non-conformist, and you might say ahead of her time, she taught classes to other young mothers in her dining room when she herself was only twenty. With a representative from Community Programmes, she established night-school courses in the Bracebridge high school, defying men on the local school board who did not appreciate the extra expense, and thereby earning their undying displeasure. The nucleus of those students came together in 1962 as the Muskoka Arts and Crafts Association, a still vibrant, self-sustaining grass-roots organization.[30]

Aiken-Barnes moved to Gravenhurst and, once again, helped organize night classes where she first taught off-loom weaving techniques, a skill she learned growing up in the interior of British Columbia and a decided novelty in Muskoka. Even as a youngster, using a vocabulary of macramé, sprang, and bobbin lace was like breathing, and although the terms may sound exotic and impractical, Aiken-Barnes explains the results are anything but: Canadian snowshoes use bobbin lace techniques, and crosslink fencing is essentially sprang.

Her pupils in the Sixties were typical of many who were eager to experience the creative process by making their own wall-hangings and plant holders, even though their knotting anomalies hardly reflected the quality cultivated by Aiken-Barnes. "Macramé and jute are the things that loom large in my head," she recalls. "It always pained me because macramé was such a beautiful fine technique as I learned it, until it was abominated in heavy jute."

When Aiken-Barnes needed her own batteries recharged, she took a three-week weaving course from "Bunty" Muff at Danforth Technical School in Toronto, egg-tempera painting with distinguished painter and teacher L.A.C.Panton, and, later, summer courses at Penn State and Penland. "The Sixties just gave me wonderful incentive to see that women were out there beginning to do things. I came back from Penn State feeling like a reborn flower child from my Vancouver School of Art days, but I guess we were Bohemian in those days, weren't we, not flower children."

She also learned about one of the most influential American fibre artists and Bauhaus weaver, Anni Albers. "She was experimental in the same way I had felt when I had taken my first courses from Bunty. I would never earn my living from it, but the possibilities for experimentation in weave, colour, and design really intrigued me. She worked off-loom, took interlacement systems beyond the limitation of the loom — maybe that's where I got the interest in inter-relationship of interlacement systems," a corner of the fibre world where Aiken-Barnes is still regarded as an authority. Her American experiences also spurred her to "think big." When she was asked to make a balcony tapestry for Trinity United Church in Gravenhurst, she designed a brilliantly coloured abstract landscape some ten metres wide, appliquéd with embroidery by the women of the congregation, and completed in 1968. Four years later, the same group gave her a second large commission. Other orders soon followed. [31]

Even though exhibitions and the commissioning process opened doors for studio craftspeople, many had to fill fiscal chinks by teaching, which allowed freedom in off-hours to experiment, contemplate colour and pattern, create one-off pieces, and even go out on one's own. Marie Aiken Tower Studio Inc. opened in 1975, a renovated potash plant on the outskirts of Gravenhurst, soon a feature of the Muskoka landscape and her home, studio, and teaching headquarters.[32] Those years surviving outside a broken marriage, were

While an active teacher with Walter's Web, Marie Aiken was asked to give workshops in interlacement systems. In this 1972 publicity photograph, she modelled a vest for which she used multiple-strand knotting or macramé.

Gordon Barnes

123

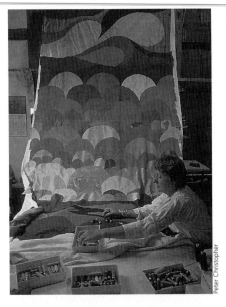

At her Tower Studio in Gravenhurst, Marie Aiken appliquéd silk to cotton in two large panels for *Solstice*, a 1977 commission for the Simcoe County Court House and Land Registry Office in Barrie.

tough going. "It is difficult to sort out personal survival from survival as a craftsperson," she reflects now. "It's almost like skating out on thin ice; it's a nice feeling when it supports your weight, because you don't have any indication that it's going to."

Teaching also sustained Aiken-Barnes emotionally, by "being able to give, being able to share, being able to feel that buoyancy out there. You can hydroplane on that buoyancy." Assignments took her as far away as Yellowknife and Coppermine and were very special. "It was a rewarding thing to be able to do for these isolated people what nobody had been around to do for me when I started out in Bracebridge, with the struggle to get night schools going, to get looms, weaving, information," she muses. "People were also just as hungry in Northern Ontario as the rest of us had been in Bracebridge."

Because she was so motivated herself, she infused pupils with her own enthusiasm. And hope. As mentor, she encouraged local teenage student Valerie Knapp to think beyond the confines of her small town. "She made me realize it was possible to have life as an artist," Knapp says. "Most people in Gravenhurst at the time thought that was a fantasy." Knapp went on to become a fabric specialist, establish her own textile printing and clothing company, Viverie, another line of wearable art under her own name, and, for a time, head the textile studio at her alma mater, Sheridan College, where she invited her mentor to pass along some of her know-how to younger generations.

Textile Tangents

By the Seventies, the world of fibres and textiles was extremely diversified. In one corner, the traditional spinners and weavers propagated a colony of venturesome tapestry artists who, like Aiken-Barnes, revelled in the excitement and challenge of working large scale. In another were textile printers and designers like Knapp and recent Dutch arrival, Gunnel Hag, who developed their own cottage industries, designing and printing yards of fabric and turning them into fashions. In yet another corner were devotees of interlacement systems, who often worked in sculptural modes or embraced a growing field of expression, basketry: in essence, small sculptural articles. A fourth branch found its niche in the precise demands of stitchery, embroidery, and quiltmaking. Still another group — the hookers — had a loyal following of one thousand members by 1975; the term "rug hookers" was no longer fitting because work encompassed far more than floor decorations. Their creative

sustenance and leadership came from Rittermere Farm Studio in the Niagara Peninsula, and, for most disciples, was a leisure-time pursuit. Work was seldom for sale but was exhibited regularly, and, in time, won respect for its finely detailed execution.[33]

Most tangents within the textile community experienced growing interest in their work and none more than quilting, in many respects the most approachable of crafts. Its rise in status from bedroom accessory to wall art stemmed from major American exhibitions of antique quilts presented to the public as design spectacles in an art context, rather than as historical curiosities. American critic David Shapiro compared them, not to post-painterly abstract work, but to Roman mosaics, because of their texture and patterning, superb technique and inherent grace.[34] In 1979, The Dairy Barn Southeastern Ohio Cultural Arts Center in Athens inaugurated its biennial *Quilt National* exhibitions, which rapidly became and still are influential milieus for promoting quilts as art forms for craftspeople around the world. An important milestone in Ontario occurred in 1975 when the Agnes Etherington Art Centre in Kingston toured *Tradition +1*, and encouraged others to organize exhibitions featuring quilts.[35]

Textile designer-printer Gunnel Hag sells a range of easy-wear clothing from her corner booth at the One of a Kind craft show in Toronto.

Remarkably, within just a decade, the quilting scene in North America had broadened, liberating newer generations from nostalgia, old techniques, and patterns — "padded rigamaroles of exuberant leftovers," as Shapiro has dubbed them. Using quilts as large canvasses, makers explored optical illusion, collage, visual effects, and new design concepts, communicated political ideologies, narrated stories. Quiltmaking, in other words, became a rich personal voyage and a forum for expressing contemporary ideas. Constructing quilts became easier, too. Polyester replaced cotton in quilt batts and made actual construction less onerous. Brightly coloured polyester fabrics also allowed quilters to produce work that was more vibrant, lively, and just as timeless as their predecessors had been.

The spinning and weaving camp was somewhat divided at this time, finding itself torn between mastery of sound techniques and the apparent lack of it in more nouveau, experimental pieces. Purists fondly recalled a superior exhibition of fine weaving in 1961 organized by ROM curator Betty Brett, and a showcase for the Toronto Spinners and Weavers Guild. Ten years later at the Ontario Science Centre, fine weaving and bold new work shared the spotlight in *Make/Mak*, an exhibition of Ontario's leading designer-craftsmen. "My first reaction … was one of surprise and pleasure at seeing so many gay colours and bold

designs," designer-weaver Eunice Anders wrote in the accompanying catalogue — she was weaving advisor to juror Raymond Moriyama. "Still some questions came to my mind: Why was it woven? Was it novelty for novelty's sake? What was the weaver trying to say? Has the far-out art become our guiding star, whether or not it has any inherent beauty?" Anders decried the entries that displayed a lack of technical knowledge and attention to detail. "Some of the rugs were so loosely woven that one could stick a finger through them, which is scarcely a functional quality for a rug. Some pieces, beautifully woven otherwise, had skipped threads or knots left either in warp or weft." But no one would deny they were arresting visually.

It was a proud day when Alan Jarvis officially opened the Pottery Shop and headquarters of CGP at 100 Avenue Road in Toronto in 1962.

Toronto Guild members Mary Ham and Florence Lloyd, able weavers with a robust spinning bias, share strong opinions about the heavily textured wall-hangings of the Seventies and their makers misuse of techniques:

The spinners were just tearing their hair out because here was the prostitution of all this wonderful material just hunked in and not spun at all. These weavers thought they were being creative, and we all stood back and said "God deliver us."

I thought they were the most atrocious things. All they are is a waste of good material. And dust catchers.

And what offended me so was that some of these fine beautiful rovings [slightly twisted strands of fibre] were not being used for the purpose for which they were intended. They were just slung in between coarse warps and thought to be beautiful.

Time has proven their point. Fine weaving has regained respect and is once again valued for its creative use of colour and texture and, above all, its superb craftsmanship.

Pots Without Precedent

The clay fraternity, local and national, was also flourishing. Toronto-based Canadian Guild of Potters, well into its second decade and four hundred strong, became the first media guild to own and operate its own retail and exhibition space at 100 Avenue Road in 1962. Good friends had made it possible. Dr. Franc Joubin, whose wife, Mary, was a dedicated potter, provided the building, and John Mather of Industrial Minerals, the first year's rent.

The superior calibre of work for sale — all of it juried — and the public's eagerness to acquire it made The Pottery Shop an immediate success, a case of being in the right place at the right time.

Satisfying ambitious potters, however, was another matter. The Shop strove to find that subtle balance between promoting pots of a high standard and fostering ceramics as an art, yet for a time it was accused of lacking vitality and only reflecting Toronto's relatively conservative buying public. As we've already noted, The Guild Shop at 77 Bloor Street West was labelled in similar fashion and, like its successor, 140 Cumberland, had to live down brickbats like frumpy, pedestrian, and undiscriminating from time to time. Retailers, it seemed, had to repair their image.

Potters chafed that clay was not accepted as mainstream art. Noting that galleries sometimes paid attention to clay in the form of sculpture, some clay artists believed that if they worked as sculptors they might gain entry to galleries and elite art circles. Without training as sculptors and a full understanding of the discipline, the wannabees often turned out work that was "abberated art," as editor and curator Anita Aarons described teapots that didn't work. Clay sculpture often did not fare well in juried competitions, where judges seemed to find the work tentative, with little feeling for sculptural space and form. "What was going on in the Seventies was an identity crisis of the craftsmen," Donn Zver explains, "a feeling that we are not 'artists,' that we've got to start making work that is going to be more art than craft. Even though the funky art was starting to happen in the States in the early and mid-Sixties, it did not catch on here until the Seventies."[36] This was the decade of the Super Object, ceramic historian Garth Clark writes, a time of slickness and superficiality, when pottery appeared in any number of conceits: cardboard, denim, burlap, wood, paper, metal, anything but what it was: clay.

Founding director of The Koffler Gallery in North York and a clay devotee, Jane Mahut remembers her disquiet about the potters' search for recognition by the art world. "I was concerned that they thought that pottery per se was not valuable as an art form in itself. They weren't satisfied that pottery could be handsome, or beautiful, or satisfying, or all the things that pottery is." Wiser heads understood, of course, that when you've matured as an artist, recognition follows. There was no hidden formula to it. Just possibly the disgruntled had the accent on the wrong syllable, or as an African delegate at a World

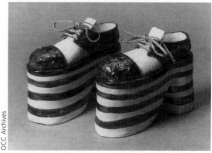

above: The Guild Shop at 140 Cumberland Street as it appeared in 1969, immediately after the move from Bloor Street. Later renovations changed the front and interior.

below: For its last biennial juried exhibition, held at the London Art Gallery in 1975, CGC chose the theme *Art in Craft*. One of the participants, Keith Campbell, used porcelain clay for his sculpture of *Young St. Shoes*, decorating it with a clear glaze, and red, blue, and silver lustre.

Crafts Council conference once put it, "The part you do with your hands is craft and the part you do with your head is art."[37]

Despite its inferiority complex, if that's what it was, the clay community seemed to be here, there, and everywhere in this fifteen-year period. Members took part in more than two dozen juried or invitational pottery exhibitions or ones that had a clay component within them. They also competed in international exhibitions in Florence, Geneva and Prague, Syracuse and Washington, where they frequently won awards. They helped Canada celebrate its one hundredth birthday at Montreal's EXPO in *Canada Crafts 67*. As they had in the previous fifteen-year period, the juried biennials of the Canadian Guild of Potters were noteworthy for the standards they set and the attention they brought to the field. Jurors — often with international reputations — spared no one in their critiques. When confronted with work they regarded as uninspired, vulgar, full of gimmicks, or mirroring the worst of the American excesses, they said so. When judging work they deemed sublime and timelessly beautiful, however, they didn't hesitate to praise and share a maker's passion, vision, and imagination.

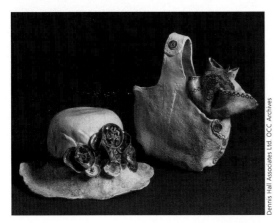

Belleville's Audrey Davies, who began working in clay in 1952, won an award for ceramic sculpture at the CNE in 1973 for her porcelain and fibre-glass hat and purse, glazed in off-white with pink, mauve, and green floral motifs.

Dennis Hall Associates Ltd. OCC Archives

Those same qualities consistently epitomized Toronto's clay quintet, The Five Potters. "They were inspirational and the best potters around when I was going to the Ontario College of Art in the early Sixties," says seasoned Scarborough potter Ron Roy. "Some of the things Dorothy Midanik was doing and winning prizes for were absolutely stunning pieces, full of imagination and creativity. They were big, too. She was a major influence. Bailey Leslie's work was beautiful, sensitive, and stunning but it was traditional. Marion Lewis has always been a great little sculptress, her work was stunning, too; it wasn't flashy, it was calm, it was warm, it was inviting, it was real, a natural quality to it. Mayta Markson and Annette Zakuta were the production potters and showed you could do both, you could make things that were natural and functional; they didn't have to be gussied up, shiny, and all that stuff. Anyway, they were a double or triple whammy. They were my first customers when I went into the clay supply business in the early Seventies."

In sheer numbers alone, the clay community, like the population itself, was growing by leaps and bounds, and now for the first time received more media attention than most other craft disciplines. Sales in The Pottery Shop went from more than $35,000 in 1965

to $88,000 a decade later. The Guild Shop, by comparison, had sales of more than a quarter of a million in 1965 and double that figure in 1976, with ceramics as its best-selling medium.[38] The other reliable barometer of clay activity, Jorgen Poschmann's Pottery Supply House in Oakville, reported that eighty percent of clay sales in 1978 was absorbed by institutions and schools, the other twenty percent by studio potters, double what this group had purchased a decade earlier. Even more telling was the fact that Poschmann's volume of business went from $61,000 in 1963 to $845,000 in 1978. Today it is inching toward two million. A second barometer, Tucker's Pottery Supplies Inc., opened for business in 1975 north of Toronto and has experienced even larger growth in two decades. Owner Frank Tucker observes that his increasing sales are no longer from institutions and schools but from individuals: professionals, serious amateurs, and hobbyists.

By the mid-Seventies, clay communities across Canada were well established, each having regional interests, perspectives, and problems. The forty-year-old Canadian Guild of Potters realized with the country so radically changed that its existing structure could no longer represent the whole. It seemed appropriate that provinces and regions control their own affairs, and as Waterloo ceramist Ann Roberts also makes clear, "There was a plethora of humanity joining all these guilds and a sense there needed to be layering." A committee set up to reassess the Guild of Potters initially recommended the Guild reconstitute itself into a "cohesive federation of regional bodies," but that concept soon gave way to an organization of those deemed to be "professional."

Under a masthead "Ceramic Masters Canada," letters asked individuals who thought they were qualified to submit slides for jurying as a pre-condition of membership. A mere baker's dozen passed the ill-defined litmus test, which is not surprising since ceramists, essentially a democratic group, have never agreed on who its crème de la crème are.[39] A two-tiered recruiting approach was tried next, Roberts recounts, and the name changed to Ceramists Canada/Céramistes Canada in 1978, because the former seemed too elitist and deliberately exclusive. Once accepted, members often neglected to pay the fifty-dollar-annual fee so there was a perpetual shortfall of operating funds. "What we decided to do was meet once a year at some place with an exhibition as the carrot," Roberts says, "which was how we could be sure people would come and pay their dues." The first was held at The Koffler Gallery in North York, the second at the Tatay in Toronto, and the third and final

Ann Roberts used glazed and unglazed ceramic in constructing *From Old Bones New Life Begins* in 1977, a 2 x 4.8 metre wall-relief commission for the Waterloo Country Court House and Land Registry Office in Kitchener.

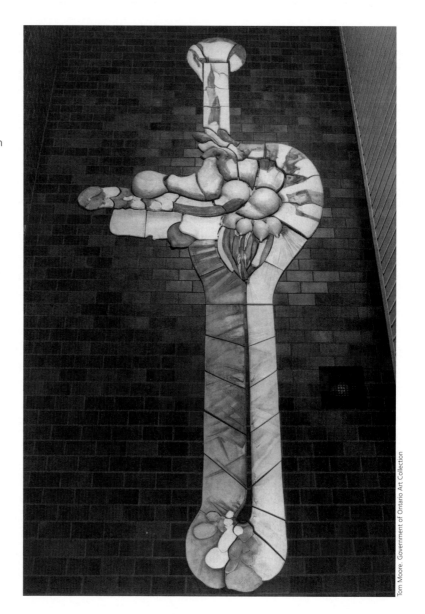

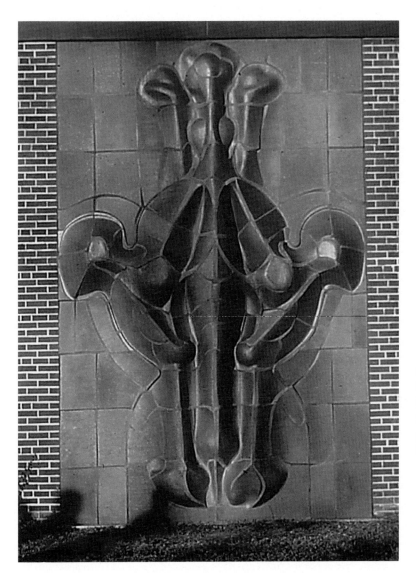

In 1969 Jorgen Poschmann hired OAC student
Timothy Rainey to construct a 3.4 x 4.8m mural
for an outside wall of his business. Using 12 plas-
ter molds and 1,814 kg of stoneware clay, Rainey
produced 133 pieces, which were then fired in
Sheridan College's gas kiln by student Donn Zver.

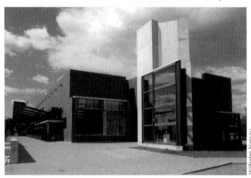

above: For the 1974 exhibition, *From Oven To Table*, at CGC's gallery on Prince Arthur Street in Toronto, Robin Hopper (left), offered viewers a pasta dish; Sue Hopper, a casserole, and Keith Campbell, a fruit compote.

below: Regarded as a fine building by any standards, the Canadian Clay and Glass Gallery in Waterloo was designed by Vancouver architects John and Patricia Patkau.

one in Regina in 1984. Presidents were well respected: indefatigable founder Robin Hopper, who had relocated to British Columbia from Georgian College in Barrie; Ann Roberts of the Fine Arts Department of the University of Waterloo; Franklyn Heisler, then with the Ceramics Department of the University of Regina; and career ceramist Alain Tremblay of Val David, Quebec, whose specialty was large architectural commissions.

After staging three exhibitions and producing one newsletter and masses of correspondence, Ceramists Canada/Céramistes Canada like Sleeping Beauty fell silent, unable to sustain a relatively small league solely on membership fees. Hopper also identified other difficulties: oversaturation of organizations, lethargy, lack of time and energy, and Canadian geography itself. By 1986, executive members voted the organization out of existence, but not before it had pledged itself to build a showcase and research centre for contemporary clay, glass and enamel arts, a project initially inspired by the premature death of esteemed master potter Ruth Gowdy McKinley in 1981. The vision now operates in Waterloo as the Canadian Clay and Glass Gallery.

Here in Ontario, the clay fraternity emulated Alberta potters by banding together provincially as the Ontario Potters' Association under president Donn Zver in 1975. "OPA was tremendously popular in the beginning," Ron Roy remembers, "and it had a lot to do with Donn Zver's personality. It had over one thousand members in a very short period of time, unheard of for a single craft organization at that level in Canada." It was a network waiting to happen.

Zver says that his group built its organization from the ground up, in which strong regional representatives from local guilds helped select OPA directors.[40]

Four years earlier, Zver and his Mohawk College students had formed The Potters' Guild of Hamilton and Region, and were in touch with similar associations in centres such as Burlington, Kingston, Ottawa, Simcoe, Stratford, Sudbury, Toronto, and Waterloo — all had organized within the previous eight years. By bringing them together, OPA was able to effectively harness grass-roots energy, commitment, and strengths.[41] "It was almost a cult with Donn as the guru," says Marion Maynard, a member of the Mohawk group and the Hamilton Guild's first elected president. "We all in our own way really adored this person. He was so gentle, very kind, very encouraging. He developed a real following of people who really felt good about themselves because he helped to make them feel good."

When the Canadian Guild of Potters no longer wished to run the operation at 100 Avenue Road, OPA took it over and ran it there for three more years before relocating to Yorkville. For economic reasons, OPA reluctantly had to continue buying some of the stock on consignment, an arrangement which disadvantaged those who couldn't afford to leave work for long periods, or who had the expense of shipping pottery from the other end of the country. That aside, it provided its membership with a magazine, *Ontario Potter*; organized workshops, lectures, and conferences; produced a travel guide to studios around the province;

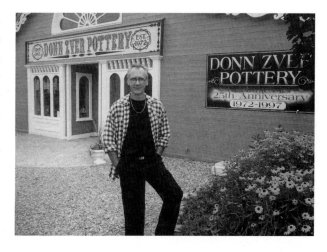

While Donn Zver was getting OPA off the ground, he was also trying to build his own business. Not only has the Donn Zver Pottery passed its 25th milestone, it now has spacious showrooms and a restaurant.

and established a permanent collection, now in the care of the Burlington Art Centre. By the time Zver turned over the presidency in 1980, OPA had just under fifteen hundred members and almost thirty affiliated guilds. In 1986, it became FUSION: The Ontario Clay and Glass Association.

Crafts, Public, and Politics

The new alliances, structural changes, and shifts in direction that absorbed the craft underground would hardly have held much interest for the general public. Far more fascinating were the makers themselves and their lifestyles — almost a new breed of anti-hero — and to observe them up close and personal while they worked. Given that many had homes and studios in the country, that wasn't always feasible, however. By now, the public had absorbed just enough about crafts to be intrigued by the making process: goblets emerging from glass, pots rising from wheels, furniture growing from wood, jewellery from raw metal, printed textiles from dye pots. The craft studio at Harbourfront brought public, makers, and studios together under one roof in a project that pitted idealism, innocence, and creativity against political opportunism and ambitious administrators.

It's hard to imagine a less congenial spot for developing a cultural camelot than the Harbourfront lands of the early Seventies: eighty-six acres of industrial wasteland on a

above: Potter Judy Lowry designed a business card for the first season at Harbourfront.

below: Much of the first summer was spent building a kiln at Queen's Quay, under the leadership of Sietze Praamsma (third from right).

dismal stretch of lakefront comprising girders, warehouses, and decrepit docks, much coveted for redevelopment by various interest groups. All were outflanked in the land grab by Prime Minister Pierre Elliott Trudeau, who bought the properties in hush-hush negotiations and presented them to Toronto citizens as an election bribe in the fall of 1972. While admitting the government had no plans for the site beyond the gift itself, venerable Liberal spokesman Mitchell Sharp, then MP for Toronto Eglinton, claimed the donation "the most imaginative action in the field of urban affairs." And it was — in urban culture — but that had little to do with political foresight.[42]

The federal government allocated three million dollars for Harbourfront's initial 1974 season, forty thousand of which was earmarked for the craft area. Advertising executive Joe Hatt-Cook of Folio Creative was hired as program manager, and he envisioned highly visible studios, convinced that craftmaking in public view would lure hundreds to the lakeshore. His original plan was to hire established craft professionals as pied pipers, but budgetary limits forced him to settle instead on sixteen third-year students from Sheridan College's school of craft and design. Not realizing what lay ahead, they eagerly agreed to commit to twelve-hour days for three months at a hundred dollars a week.

The facilities assigned to Sheridan Harbourfront '74 were a 1918 foundry, last used to build minesweepers during World War II — without walls, electricity, running water, toilet facilities, or a durable roof. With good reason, the federal Public Works Department was openly hostile to anyone in such an unsafe area and made existence doubly difficult for the little craft colony struggling to build and install equipment with limited funds, to get on with printing textiles, or making pots, jewellery, glass, and wooden objects. It was a summer of red tape and challenges for everyone: makers, Hatt-Cook, and Harbourfront administration. The studios were barely functional when a freak storm in August collapsed the makeshift roof and canvas walls, and ended the pilot project. Participants scarcely had a chance to show what they could do but did prove that the concept had potential and that an open studio was a superlative tool to make the public aware of the value and essence of crafts.[43]

The following summer, federal coffers provided only enough funds to hire six crafts-people, but others joined on a freelance basis: at their disposal were studios and equipment they could not afford for themselves. Some twenty individuals banded together as Harbourfront Crafts under geologist-turned-potter Sietze Praamsma, a survivor of Sheridan Harbourfront '74. Prior to that, he had worked as studio technician at Sheridan College and at the University of Wisconsin, where he and his wife, Saskia, were part of a communal pottery studio. "To me that was a period of great creativity and renewal," Praamsma says. "It was extremely exciting, very inspiring. People were doing the craziest things. Everything was possible. Nothing was ridiculous."

The Praamsmas were utterly persuaded the only way to run craft studios was co-operatively. "It's funny with these co-operative ideas," he reflects. "Lots of people have lots of ideas and so you end up with an enormously ambitious program." Home base for Harbourfront Crafts during the summer of 1975 was the old loading bays of the Direct Winters Transport Company at 235 Queen's Quay West, where present-day studios are still housed. There, the group taught, gave demonstrations, ran workshops, and staged an autumn craft festival, *A Gathering of Friends*. Featuring films, demonstrations, and sales of work by residents and other craft professionals, the gala was deemed "pleasant, productive and appealing" by *The Ryersonian* while a team of French government officials "were impressed how we had worked it out with limited means, because it was very primitive," Praamsma recalls.[44]

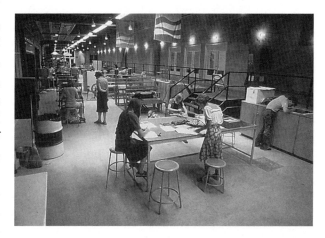

Moving indoors under a competent roof was a big improvement for the craft studios at Harbourfront, pictured here in year two, 1975.

Its summer contract at an end, Praasma's circle continued operations for another few months as an independent collective, The Crafts Community. "Basically, we wanted to create a place to work together, to create something bigger than the individual craft items. The idea was that you would get a pool of ideas by having craftspeople together generate new ideas and new work," Praamsma muses. "You have to remember this concept came out of the Sixties, and the working-together theme was pretty important even in the mid-Seventies." As far as Ottawa potter Kathi R. Thompson was concerned, Harbourfront then was the best of all possible worlds. "The mid-Seventies was a wonderful time. The passion of the Sixties and the desire to make wonderful things was paramount as was an earthiness, lack of pretension, artifice, and

above: Anita Aarons generated excitement at Harbourfront and bristled with energy even when giving a slide presentation.

below: By 1979 the craft studio complex at Harbourfront had been renovated and included a much-improved metal studio.

anti-materialism." Although some participants were absorbed with making a living and worried by erratic incomes, Thompson felt differently. "I didn't want to look at the 'business' of crafts, didn't make an attempt to sell work, to sell myself, didn't want my own studio. I wanted the inspiration of working with a group. Harbourfront was a foundation for the way I work now."[45]

The summer of 1976 saw sweeping changes in the Harbourfront organization, especially in the craft area. That year, flamboyant Australian-born Anita Aarons took charge of the visual arts area. Although an accomplished jeweller, she was more familiar with the world of galleries than with rudimentary craft studios, and was aghast after her first visit. "I first saw that dreadful building with its bare ceilings and pipes everywhere," Aarons remembers. "There were lots of problems in the craft studios. There was no way to show the work, there were hardly any [display] stands, and craftspeople had to sell their goods from their work stations. So I first had to see there were proper jewellery equipment, proper wheels, proper glass facilities to work with."

Like the proverbial new broom, she tackled her mission with zest, conviction, tenacity, and singlemindedness. Her reputation took on mythic proportions as she battled management and wheedled for her visual arts constituency. In so doing, she would brook no vision but her own. Since an independent craft collective such as Praamsma's would not have been answerable to her, it had no future at her Harbourfront and had to go. With it went a delicate counter-culture sensibility that typified the Sixties and Seventies. Ceramics resident Jim Miller recalls that "the craft studio by then had its own momentum and carried on despite the fact that we saw ourselves becoming more bureaucratized." Nonetheless, under Aarons, the studio gained a higher profile with press and public, and its facilities were given a much-needed overhaul.[46]

Life with Aarons was always a roller coaster. She replaced Praamsma with a series of coordinators: architect-turned potter Oz Parsons; fibre artist and sculptor Susan Schelle, still active in fine art circles; Brian Stratton and Shar Tikkinen, whose stays extended from six weeks to a year. Some left. Some were fired. The daily struggles exhausted and exasperated them all, and upset many craftspeople who were relocated to another building during renovations or stripped of studio space altogether.

In June 1979 Aarons hired Jean Johnson as craft coordinator, and her first day on the job was as discouraging as Aaron's had been earlier. "It was chaos, total chaos. Across the road at 222 Queen's Quay, torn down since, were all these craftsmen on the second floor with potter's wheels and whatever, very unhappy. I remember going back and forth umpteen times. We gradually got moved out of there and brought stuff over [to 235 Queen's Quay West], but a lot disappeared. Morale? The craftspeople were paranoid. My mandate was to run the studio, but I didn't know then that I was going to be responsible for running kilns that I knew nothing about."

From those inauspicious beginnings, Johnson has overseen the modernization of the facilities, expansion of supplementary activities, notably high-calibre lectures and workshops, and formalization of the residency programs.[47] To work in one of the four studios — clay, glass, metal, and textiles — participants are juried, sign contracts for renewable one-year terms, pay monthly studio and equipment rent, teach and demonstrate on weekends, and develop lines of work that will sustain them eventually. Each studio has volunteer professional craftspeople and teachers attached to it as advisors, whom Johnson regards as necessary bridges between student life, studio experience, and the outside world. "It's taken us many years to learn to look for people who believe it is important to educate the public," Johnson says. "Otherwise, they will find it very difficult to work down here. We know from experience it can affect them very badly if they are not outgoing and do not have a missionary thing about working with the public." Skye Morrison, a textile studio resident in 1977 before Johnson's arrival and now Dr. Morrison and Sheridan professor, recalls coming to the same conclusion. "All those horrible comments you think people would never dare to say, I had every one of them in my Harbourfront experience. You have to be a certain type of person to handle the invasions. I did resent the attitude held by public and Harbourfront administration that we were a 'bunch of dumb craftspeople'."

Since that time, much has changed. Public, craftspeople, and the studio system have all matured; it's taken for granted that residents must be able to function in front of the public. "People coming to the studio now are much more professional, serious, self-motivated, and committed to craft as a lifetime profession," Johnson says. Some even have university degrees. "They can see there is somewhere to go from here. There is far more potential and variety of opportunity for them than there was fifteen to twenty years ago."

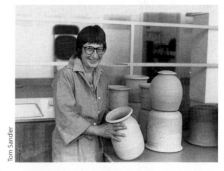

above: Fresh from her work at the Merton Gallery, Jean Johnson admired work by studio-resident, potter Jorgen Sommerer.

below: Glassblowing demonstrations always fascinate the public, as John Kepkiewicz learned during his Harbourfront studio residency in 1982–84.

137

Sgt. Bertrand Thibeault, Rideau Hall

In 1993 Jean Johnson was accorded membership in the Order of Canada by Ramon J. Hnatyshyn, governor general of Canada.

Many who spend time at Harbourfront set up studios together when they leave, so for them, the co-operative model remains a practical means of functioning as a studio craftsperson.

In its twenty-four years of existence, Harbourfront's craft studio has nurtured in excess of two hundred residents. It's widely recognized as a cultural incubator that provides college graduates and experienced apprentices with time and subsidized workspace to develop the skills they will need once they leave Harbourfront's hothouse. Hatt-Cook's sapling had matured into a resilient evergreen, as he hoped, but the inconstancies of public funding continue to menace its survival. Fortunately, the legacy left by its resident craftspeople endures after political strategms are long forgotten.

What makes the Sixties and Seventies so compelling and such a rewarding field for study are their quickening pulse-rates and intricate diversities. Like a fireworks display, creative sparks went off in every imagineable colour and configuration. Crafts earned a larger stake in the art world and drew to its bosom many men and women once attracted to painting or sculpture as careers; government accepted a degree of leadership in craft education; galleries and shops increased in number and exhibited and sold to a receptive public; large-scale craftwork became civilizing agents in urban, corporate, and domestic settings; craftmaking itself spread well beyond cities and towns. This was not unique to Ontario, and by 1975 in Canada, there were reportedly ten to twelve thousand full-time craft producers, who accounted for estimated retail sales of a hundred-and-fifty million dollars.[48]

Respected British studio potter Elizabeth Fritsch once said that making art of any kind in our society defies "economic pressures and psychic repressions" by insisting on some measure of freedom for the makers. Craftspeople — an unyielding and independent troop — have always preferred to control what they produce and how they produce it. In doing so, they are prepared to tolerate difficult working conditions and a hand-to-mouth existence, if that is what is exacted. In the next two decades, many more of them accepted that challenge and stepped to culture's front ranks.

138

1976–

Present

CHAPTER FIVE

ALL THE WORLD'S A STAGE

All the World's a Stage

After the growth spurt of the Sixties and Seventies and the advent of postmodern's diversity and pluralism, the Ontario craft scene seemed to gather a head of steam in the mid to late Eighties, outwardly confident, exuberant, even sophisticated. A glorious hereafter beckoned, which inspired futurists and marketers to predict larger and more buoyant markets. Then, inexplicably, fortunes changed to undermine the bold course that craft had charted for itself at a time when "it had the potential to make a far greater contribution to the spiritual, cultural and economic life of our communities than for many decades."[1] As with so many reversals in fortune, at play were a cluster of circumstances that Ontario shared with the rest of North America's craft world.

The most obvious culprit was a tenacious economic recession in the Nineties — far worse than a smaller one in the early Eighties — whose severity caught most producers offguard and ill-prepared for the outcome. Without secure jobs or disposable incomes, the buying public was in no mood to acquire what were perceived as luxuries. Especially hard hit were jewellery makers, not altogether surprising since jewellery is generally craft's most dependable gauge of fashion, status, and change. It was then leading the craft field in sales, with ceramics a close second, and blown glass not far behind. For service organizations like the Ontario Crafts Council and the Ontario Potters' Association (since 1986 known as FUSION), dependent on profits from retail operations to run programs, such economic downturns were crippling, and, in the latter case, forced closure of its shop in 1990 even before the recession's worst moments.

There's no question the public purse became leaner and meaner for the cultural sector, with the result that government support of craft organizations continued to diminish. The Canadian Crafts Council in Ottawa, for one, lost its operating funds and administrative roof, as did OCC in Toronto, which currently exists on its own resources outside the very building it purchased and so stunningly renovated in the late Eighties. The dislocations of the Nineties, when compared with the Depression of the Thirties, seemed far more disruptive, widespread, and chaotic for the craft community. There was, after all, so much more at stake. After six decades of growth, the craft community had become complex, even unwieldy, and increasingly dependent on outside funding to carry out programs that its public had come to expect. Individual craftspeople accustomed to living on the margins were able to tough it out as long as there were enough buyers for their work, and for a time, there weren't.

Even before the recession hit, student enrollment in craft programs throughout North America began to sag because fewer young people were attracted to a career that guaranteed unpredictable income levels, perhaps a net of fifteen thousand dollars a year.[2] Especially alarming to them were soaring costs of living, increased property taxes and, for Canadians, the detested federal Goods and Services Tax in 1991. As a result, many college courses were dropped and teaching positions for craftspeople eliminated or put on a part-time basis. While Ontario in the Seventies had a handful of universities, the Ontario College of Art, and twenty-two colleges committed to a range of post-secondary craft courses, by the Nineties only some universities, OCA, and a half dozen colleges offered even a limited selection.

Of those, only Sheridan in Oakville has kept a commitment to provide an integrated craft program and, even there, honouring it has been an unrelenting challenge. Costs of running craft studios anywhere in the province have always been high, and today's staff are usually forced to find sources of supplementary funding.

If anything defines the past twenty years, it is striking contrasts: on the one hand, severe dislocations, and on the other, genuine triumphs. Since 1974, ten Ontarians associated with the development of crafts have received vice-regal honours: one as Companion, two as Officers of the Order of Canada, and seven as Members.[3] Craft is said to have an economic impact of some three hundred and fifty million dollars in Ontario,[4] whose population by 1996 had topped eleven million, half living in and around the greater metropolitan Toronto area. Toronto city welcomed five new craft or design-related buildings within the past decade or so: the George R. Gardiner Museum of Ceramic Art (1984); the Museum for Textiles and Chalmers Building (home of

OCC) (1989); the Design Exchange (1994); and the Bata Shoe Museum (1995). In Waterloo, the Canadian Clay and Glass Gallery opened its doors in 1993.

Furthering a wider profile for crafts were a variety of other ventures. Major commissions for Rideau Hall came from the governor-general and his wife, from public sources such as Toronto's Metro Hall, Ottawa's City Hall and its regional headquarters, and corporate circles and sports venues such as Toronto's SkyDome. Individuals and professional associations continued to collect craft for their offices. Large corporations such as Imperial Oil Limited established craft gift programs to honour clients, retiring personnel, and those who merited long-time service awards; and General Foods Inc. held a national competition for fine coffee-service sets to be added to its permanent collection. Craft work went abroad in exhibitions or as gifts to dignitaries. Toronto played host to three North American craft conferences never before held in Canada, the largest of which, Convergence in 1986, brought

more than two thousand for the biennial get-together of the Handweavers Guild of America. And a memorable cultural exchange between the German province of Batten-Württemburg and Ontario in the early Nineties paired craftspeople in a working-living-exhibiting program. So many benchmarks characterize the accomplishments of the decade, a paragraph hardly does them justice.

Many of these and other initiatives were orchestrated by OCC, which adopted an aggressive posture from its inception in 1976. With a commitment of $42,000 from the Junior League of Toronto, it established the first comprehensive craft library and resource centre in the country. It professionalized exhibitions, published a newsletter and magazine, continued its retail showcase, and became a forceful lobby group. Its commitment to furthering contemporary craft at home and abroad led to expansion and to undertakings that, in time, were beyond its resources and, by the early Nineties, proved its undoing. For the OCC, this final period represents the best and the worst of times.

Peter Hogan. OCC Archives.

The Ojibwe Cultural Foundation organized an exhibition in 1984 of native quillwork that was toured by the OCC. Both baskets are 10 cm in diameter and constructed of birchbark, sweetgrass, and natural quills. Amelia Kimewon Trudeau made the one above, and Rose Williams the one below. Williams has added a decorative tufted star pattern to her lid.

Facets of Promotion

I n sharp contrast to the scarcity of documentation for the beginning years of this book, the last twenty-five offered enough material for several volumes. Never was a period so studied, analysed, and chronicled in an attempt to raise the profile of crafts in Canadian culture. Throughout the Eighties four major cultural inquiries and a fifth on the economy received briefs from the Ontario Crafts Council and related groups. By participating, they hoped to focus attention on the contributions of craftspeople to the country's cultural, social, and economic jigsaw puzzle.[5] In the Nineties, lengthy briefs gave way to navel-gazing conferences, think tanks, and statistical surveys of the cultural sector. Behind the earnest resolve of these initiatives was a sense that, for all their advances, crafts were still mired on the sidelines of contemporary Canadian culture.

For those of us advantaged by hindsight, there had been substantial inroads, however, at both national and local levels. Beginning in the mid-Seventies, members of Montreal's prominent Bronfman family commemorated their mother Saidye's eightieth birthday in 1977 by establishing a prestigious craft award in her name — and creating at the same time an incomparable arena for contemporary craft.

The Saidye Bronfman Award for Excellence in the Crafts (now Saidye Bronfman Award) is peerless, equivalent to a craft oscar or academy award. Providing a sizeable amount of money to recipients, it enables the Canadian Museum of Civilization to acquire examples of the recipients' craft for its permanent collection and produce a video of their studio activity. In addition to celebrating distinguished individuals and their contribution to the development of craft, the award is a wellspring of encouragement and a stimulus to the entire field.

An impressive national touring exhibition with colour catalogue, *Masters of the Crafts*, showcased the first ten recipients, and they and the second ten appeared in *Transformation: Prix Saidye Bronfman Award 1977–1996*, which made the rounds of Canadian galleries and

One of the gatherings to consider Canadian crafts in the twenty-first century met at Banff in 1991. Taking a break from sessions were (left to right) Marilyn Stothers, Winnipeg quilter; Julia Kunovska from Czechoslovakia, wearing a Rachael McHenry knitted hat given to her by M. Joan Chalmers, craft patron and activist; and Diane Codére, Quebec arts administrator now living in B.C.

museums. The award's genesis foreshadowed a period of unprece-
dented growth and maturity for crafts in Ontario, palpably demon-
strated by the fact that, among recent Bronfman recipients, a number
are from Ontario.[6]

At the same time the Bronfman arrived on the national scene,
crafts were developing a cult following at the grass-roots level through
the medium of autumn studio tours, today numbering more than
two dozen. Conceived in 1979 as an educational and public rela-
tions tool, the fall tour was meant to encourage the buying public to
share the rural life many craftspeople had chosen for themselves and
to view demonstrations of work-in-progress. It soon evolved into a
successful marketing tool beyond the utopian visions of its origina-
tors. In cottage areas like Muskoka, where the idea was born and
where the seasonal tourist population doubles or triples that of per-
manent residents, fall tours have single-handedly won over an addi-
tional market of purchasers. Although many of them are urban dwellers who have
become knowledgeable and faithful converts, few tour followers would think of visit-
ing formal craft galleries. To them, rurally based craftspeople are synonymous with
attractive and inviting environments, as Hart Massey has pointed out in *A Craftman's
Way*, because they appear to lead more creative and integrated lives, which outsiders line
up to share, even for an hour.[7] Increasingly, open houses in spring and fall have been
adopted by inner-city neighbourhoods, where they represent low-cost, collective sales
ventures that sidestep wholesale and retail overheads and keep money in the hands
of makers.

above: In the village of Salem outside Elora, not far from where the Irvine River meets the Grand, Sarie Marais occupies a century home that doubles as her showroom. Working mainly in metal, she fashions furniture, sculpture, and jewellery, all on display at Elora's fall tour, the first weekend in October.

below: Barrie's Sandra Orr presented an array of stunning hats at her home during the fall studio tour in 1997. When not making hats, Orr runs a successful craft shop.

The Retail Alternative

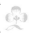

In mid-sized Ontario centres, co-operative retail operations filled another niche of the craft
market. Only a handful of Sixties and Seventies pioneer co-ops survived because most
were not able to work out realistic cost-sharing and management details. Those who have
succeeded are thriving: Riverguild in Perth opened in 1975; Cornerstone in Kingston, 1981;
Snapdragon Fine Crafts in Ottawa 1982; Fireweed in Thunder Bay, 1984; and a newcomer,

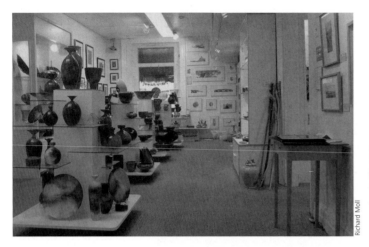

Richard Moll

left: In a heritage building at the corner of Princess and Ontario Streets in Kingston, Cornerstone offers a wide range of handcrafted work.

right: Wholesale purchasers converge twice yearly on the Toronto Gift Show held at Exhibition Place. A new feature, Uniquely Ontario, has been designed to showcase the province's first-time and newer exhibitors.

The Owen Sound Artists' Co-op, 1994. Whether co-operative or privately owned, only a couple of craft shops have had the longevity of Sandra Orr's Artifact in downtown Barrie, operating since 1973 on a will and a prayer. Orr herself is the sum of many parts: milliner, stitchery artist, sometime weaver, risktaker, and local entrepreneur. By being flexible, diversifying merchandize, changing the direction of the shop when necessary, Orr has been able to correct small mistakes before they overtake her, weather competition and economic bad times, and satisfy her loyal client base.[8]

When the Ontario Crafts Council first surveyed the province's shops and galleries for a booklet it was preparing for publication in 1990, it tallied some 250, which represented only the number of completed questionnaires it had to work with. From them, we learn that about two-thirds of the retailers had their beginnings in the vibrant Eighties, another third in the decade before. The recessionary Nineties may have spelled the end for some, but by 1996 the OCC tabulated more than 400 shops and galleries, which seemed to signal a rekindling of consumer interest in craft purchases. At the biannual Toronto Gift Show, Canada's largest wholesale venue, by 1997 craftspeople accounted for forty percent of exhibitors. Orders came from fifteen thousand retail representatives purchasing on behalf of some eight thousand Canadian sales outlets in cities, towns, villages, and for museums, galleries, hotels, and everything in between.

Galleries Join the Bandwagon

Of all promotional vehicles for studio crafts, without question the most effective and enduring has been the exhibition, as the founders of the Handcrafts Association of Canada had appreciated many decades earlier. From the mid-Seventies, there was marked improvement in standards: shows were stimulating, varied, leading edge, sometimes controversial, and professionally curated. Perhaps because of the buoyant Trudeau years, the nation's capital had its rush a bit earlier than Toronto. Retailer Jack Cook of Canada's Four Corners craft shop, which he began in 1963 and still operates, could claim with some plausibility that Ottawa in the early Seventies had Canada's largest complex of shops selling Canadian handcrafts. The city had also attracted a triad of specialist galleries to the Sussex Drive area: Barbara Ensor's Wells Gallery, Vicky Henry's Ufundi, and Martha Scott's Hibernia.[9] A decade later, Lynda Greenberg opened a fourth on Murray Street, a lone craft survivor in Ottawa's much altered and sorry economy.

Overlooking Lake Ontario, the Burlington Art Centre, with its Hayden Davies aluminum sculpture *Space Composition for Rebecca*, houses an extensive collection of contemporary Canadian ceramics and provides working studios for artists and craftspeople.

By the end of the Seventies, a new breed of craft apologist surfaced in Toronto: Dexterity under Jim Wies and Ross McGill (1978); Glass Art Gallery under Janak Khendry, and Prime Canadian Crafts under Suzann Greenaway (1979). "The whole art scene was really bursting, absolutely flourishing," Prime's Greenaway remembers. "It was just a vital, vital time for arts in Canada, the whole marketing thing was really taking off. It was a boom time." Greenaway had managed the Ontario Potters' Association retail outlet and gallery on Avenue Road in Toronto for two profitable years, but had never operated or owned a fine-craft gallery. Undeterred, she was confident the bullish market would not fail her. It did, but she and Khendry managed to wade through the shoals thrown up by a weakened economy. Greenaway, in particular, has become a resolute and indispensable presence in Ontario's craft landscape, one of only a handful of such individuals in the country.

Other than the committed craft gallery, exhibition spaces for fine crafts appeared within institutions such as universities, Burlington Cultural Centre (now Burlington Art Centre), Toronto's Harbourfront, and North York's Koffler Centre, to name a few.

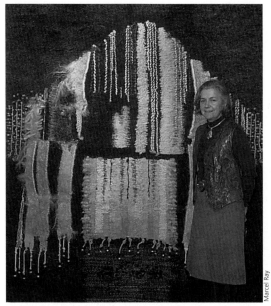

Marcel Ray

One of the pieces at the Merton Gallery's 1970 exhibition of Tamara Jaworska was *Night IV* of wool, linen, sisal, with metal bells. It covers an entire wall of Jaworska's hallway today.

Collectively, they, too, helped broaden and legitimize craft's reputation by generating articles, critiques, catalogues, and reviews, and what Peter Dormer calls "a web of theoretical contexts."[10] By this time, Ontario also had a lively network of some two dozen community galleries housed in small museums, public libraries, and cultural centres, venues eager to receive touring exhibitions circulated by organizations such as the Ontario Crafts Council, or, on occasion, to curate their own. Crafts were becoming so popular, respectable even, that private, fine-art galleries were prepared to introduce craftmakers to their preferred clientele. Conspicuous throughout the Seventies was Toronto's Merton Gallery, under the aegis of Jean Johnson. "Jean made things happen when no one was prepared to do it," says William C.G. Hodge, a Toronto weaver and faculty member at the Ontario College of Art. "She managed one of the first legitimate galleries in Toronto that showed craft as a full-fledged entity alongside drawing and painting shows. She made no differentiation between them."[11]

One of Johnson's early successes was a two-week exhibition of tapestries by a new arrival from Poland, Tamara Jaworska. "No one had ever seen tapestries like that," Johnson recalls. "Word had got round that this was something really special and on the last Saturday the gallery was absolutely packed all day." From that experience, Johnson ventured into other facets of the textile and fibre-art field, and to other craft media, unveiling talents in solo and group exhibitions. "It was all new work that I had never seen before that had the kind of ideas, the kind of use of material that was very fresh, very well done and very exciting."

The OCC's Approach

In downtown Toronto, the Ontario Crafts Council's compact new gallery at 346 Dundas Street West, opposite the Art Gallery of Ontario, was a showcase of another sort. Inaugurated in 1976 with *Crossroads*, a multi-media invitational show of leading Ontario makers, it offered as rich a smorgasbord of juried, solo, and group exhibitions as limited finances would allow.[12] Some featured work from group members such as the Metal Arts Guild, Ontario Handweavers and Spinners, Surfacing, Ontario Potters' Association, and the Ontario Hooking Craft Guild; others introduced student work from Georgian College in Barrie

and Sheridan College in Lorne Park. In co-operation with its six regions, OCC for a time sponsored annual juried district exhibitions, brought the choicest pieces to Toronto for further jurying at the provincial level — yearly yardsticks they were called — took the composite show to the Canadian National Exhibition or other public venues for maximum exposure and then toured it throughout the province.[13]

Guiding the OCC's exhibitions committee for a time was OCA's Hodge, who regarded the gallery as a tutorial agent. "We wanted to educate craftspeople around the province to what others were doing, to show not just the top of the pile but a mix of all types of craft work," he explains. "We also wanted to show the public the spectrum of what was possible from the functional to the fine craft because we felt people didn't know what craft was or that there was, in craft, the equivalency of fine art."[14] To that end, OCC commissioned thirty mini-exhibits by leading craftspeople and circulated them to rural communities in a project tagged *Craft Packing*, made possible by support from the federal Museums Assistance Program. The concept of taking OCC-organized exhibitions to smaller communities was revived in Ontario's bicentennial year, 1984, and continued for another eight years under the logo "Handcrafted/Fait à la Main."

To further craft's visibility, promote professionalism, and document the best contemporary work, the Council in the mid-Eighties staged three slide competitions, *Craft Focus I, II, III*. Entries came by the hundreds from across the country, and finalists were featured in colour catalogues distributed within OCC's quarterly magazine, *Ontario Craft*, which had an ever wider circulation and now sported colour covers.

OCC president and then executive director throughout most of the Eighties, Joan Tooke, particularly remembers a landmark project with the American Craft Museum and

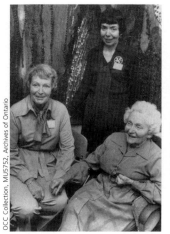

OCC Collection, MU5752, Archives of Ontario

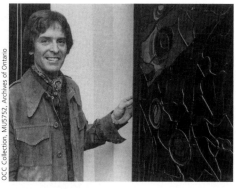

OCC Collection, MU5752, Archives of Ontario

above right: Robert Jekyll's entry for OCC's opening exhibition in 1976, *Crossroads*, was a stained-glass panel, *Rosary Light*.

above left: On hand for the official opening of the OCC's headquarters at 346 Dundas Street in 1976 were founding president M. Joan Chalmers; her mother, craft patron Jean A. Chalmers, and (standing) textile-designer Jean Burke of Sault Ste. Marie, founding vice-president.

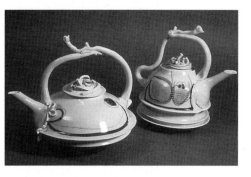

left: Among Ontario's top craftspeople selected in 1978 to participate in a touring exhibition called *Craft Packing* was potter Kayo O'Young of Kleinburg, whose work in porcelain continues to enjoy a large following.

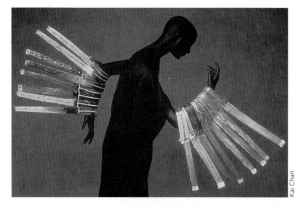

To honour Ontario's 200th birthday, *Celebration 84* brought together American and Canadian work for the first time at Harbourfront. One of the arresting images was *Sunshine — white sand — blue*, Kai Chan's arm bands of folded palm leaves and mixed threads, which he painted with acrylic.

the Harbourfront galleries, *Celebration '84: A Sense of Occasion*. Blending costume and contemporary jewellery, the eclectic exhibition was an international partnership that had never been attempted before, and as *Toronto Star* critic Christopher Hume put it, confirmed "that the dividing line between art and craft is no longer as clear as it once was."[15] Many collaborative exhibitions between OCC and other organizations characterized the period, schemes that pooled the Council's expertise and someone else's money. OCC operated within tight budgets, yet Tooke says it somehow found sponsors to enable it to stage twelve exhibitions a year in its own gallery, as well as send a number on tour. Mirroring the decade's growth and move to internationalism, the Council seemed to be everywhere at once, propelled by strong volunteer committees and a professional staff who shared a collective vision. That vision eventually hit a brick wall, as we will discover.

Messages from the Mediums

Jewellery

By the time the Eighties were in full swing, it was unmistakeable that the public's appetite was whetted for viewing and buying crafts. The first generation of Canadian craftspeople trained at community colleges were now producing a volume of saleable work, having weathered hardships that had tested their mettle, optimism, and naiveté — as their Thirties forebears had also experienced. "More and more galleries and shops were opening up. Craft stores developed because we were there, and it seemed very easy to sell," recalls jeweller Sandra Noble Goss of Owen Sound. Although she and her husband Andrew lived in the country, grew their own vegetables, were often snowed-in for days, and ingenuous about marketing, "somehow the stores found us. By the late Eighties one felt you could sell almost anything if it hung from an ear and was big. It was indiscriminate. People couldn't seem to get enough."

During the Seventies and Eighties two European influences had dramatically altered the contemporary jeweller's world: one was related to design, the other to materials. The new

jewellery movement encouraged experimentation and egalitarianism — fashioning work from non-precious metals and materials sensitive to colour and pattern. Further, Texas billionaires Bunker and Herbert Hunt spent the Seventies speculating in silver bullion and futures through a byzantine series of manoeuvres, gradually driving prices up to a 1980 high of fifty dollars an ounce, by which time silver supplies were almost unaffordable for students and smiths who preferred to die rather than switch. Fortunately, many rising professionals like the Gosses discovered "it was really interesting and exciting to work with other materials and colours."

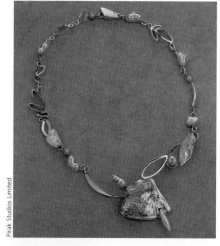

The new jewellery was expressive, colourful, witty, satirical or even defiant, on occasion beautiful, and invariably showy. Its theatricality and unorthodox personality captivated the fashion world, and numerous exhibitions featured marriages of the two. Contemporary jewellery became a favoured commodity and was accorded respect and adulation in newspapers, magazines, galleries, and juried exhibitions. It was indeed a heady time. "The public at last gave up the idea that unless it was in silver, it didn't have any value," Andrew says. "What was important were ideas and design and our labour."[16]

As a result, the Eighties and early Nineties attracted many aspiring jewellers to enroll in college programs — there are presently three full-time ones in Ontario — believing public interest in buying the new designs would remain strong indefinitely. Then the recession hit. By the mid-Nineties, Andrew observes, "You have an incredible number of professional jewellers out there competing with one another. Not only did the Nineties market shrink for a time, precious metals are coming into vogue again to raise prices, so it has suddenly got very tough."

above: Aggie Beynon made this commissioned neckpiece in 1997. Elements of the chain employ 18k gold, sterling silver, and natural Chinese pearls, while the centrepiece uses fine silver, fine gold, and pure copper.

below: Harbinger Gallery in Waterloo celebrated its tenth birthday in 1997; its founder, Aggie Beynon, now has a roster of some 175 craftspeople.

The new realities have had an impact on gallery owners, too. "All this competition requires that quality be better than it was, so jewellery is not the easy sell it was in the Seventies and early Eighties," says Waterloo gallery owner Aggie Beynon. A fine jeweller herself, Beynon finds it harder and harder to find precious designer jewellery for her Harbinger Gallery, because the demand is higher. "The market in the late Nineties has changed quite a bit. On the one hand, clients today seem to go for more elegance and refinement and demand better work, while on the other, artists need more time and money to produce

this work. For the first time in ten years, I've had to ask my artists to work small. It's not even a price issue, it's a size issue. The trend some of my artists are moving to is using more precious metal, hence more money for them when they do sell." It's clear that jewellers will have to adapt to many challenges and unknowns as they move into the next millennium.

The situation is upside down from the Eighties, Sandra Goss affirms. "Some of us older jewellers and craftspeople who once had it easier have to learn how to market. I feel the younger people know much more about marketing; they've gone into it more as a career. We didn't think of it as a business, but more as artists trying to make our life in the country, being independent, generating our own income, creating something from nothing." Whether baby boomers or younger, today's production jewellers have had to shift gears and, in some cases, create alternate lines of work in metal, such as garden or table accessories, to sustain them while the jewellery field undergoes yet another transformation. Some are exploring computer technology. Andrew Goss has hope for a website he is developing on the Internet, a vehicle he sees as a natural fit for craftspeople. "Because so many of us like to do everything ourselves from the making to the marketing," he explains, "the Internet fits into the marketing end of things, somewhat like a cross between a brochure and a telephone." Goss is currently hosting and designing websites for artists and craftspeople to function as online portfolios or catalogues, containing prices, shopping costs, and order forms.

The Goss studio today in downtown Owen Sound.

Taras Slawnych

Hot Stuff: Blown Glass

Apart from jewellery, a craft field that has luxuriated in popularity in the last two-and-a-half decades is blown or hot glass. First taught by Robert Held in a rude quonset hut at Sheridan's Lorne Park Campus in 1969, the college's program is now run in state-of-the-art facilities in Oakville under Daniel Crichton, who modelled them on the Steuben Works in Corning, New York. It took a full decade for glass activity in Ontario to mature to what historian and curator Rosalyn J. Morrison deems a golden age, a time when teachers and pupils began to master techniques and borrow concepts from other disciplines, often venturing into large sculptures and constructed works intended as installation pieces. Many of Ontario's young glassmakers chose to remain within more traditional forms because they appealed more readily to buyers in fine shops and galleries. The overnight popularity of blown glass was, to invoke a pun, quite breathtaking, and drew two more glass specialists to Toronto: DuVerre Glass (1981) and Sandra Ainsley Gallery (1984).

Not only is glassblowing an unforgiving medium — demanding and physically draining — its studios are notoriously expensive to operate. Consequently, it costs more to produce glass objects than most other studio objects, a reality reflected in price tags. "Prices for glass went up, up, up," Prime's Greenaway recalls. "I would have a piece of glass sitting beside a piece of ceramic and it would be three times the price, and the ceramic would be by someone who had been working for twenty years, an extraordinary work, while the glass would be quite captivating for its colour, but might have little content or idea. But there was real patronage for it; it was magic." It was and is a seductive medium and there are times, Crichton has admitted, "when the beauty of the material can overwhelm the art of creation itself." [17]

To study glassmaking in the Eighties and Nineties, students had the option of working with the adventurous and imaginative Karl Schantz in rather limited facilities at the Ontario College of Art in a now-discontinued program, or with classical vessel-maker Crichton at Sheridan. Its craft and design school was relocated to its Oakville campus in 1988 and thoroughly modernized. The new 465-square-metre studio includes a 454-kilogram furnace, four glory holes, ten annealers, a 136-kilogram casting-furnace, sandcasting area, complete range of supplementary equipment, and resource centre. Under Crichton's generous stewardship the program has broadened beyond blowing to encompass a variety of innovative approaches to glassmaking. His own elegant, textured forms and mentoring of students at home and abroad were recognized with the Saidye Bronfman accolade in 1994.[18]

Sheridan's Furniture Domain

In addition to Sheridan's leadership in the glass field, it has produced a network of extraordinary designer-furniture makers, or rather, Donald L. McKinley has. During his twenty-eight-year career at the helm of the college's furniture-design studio — the first five years of which he also directed the school of craft and design — McKinley instilled an uncompromising commitment to excellence. One of the reasons he was hired, he maintained, was because of his training in industrial design (in the United States) and his belief that neither a fine-arts or industrial approach was the way to go at Sheridan. Rather, he espoused the notion that the program, from its inception, should promote links between art, technology, and industrial design. Time has confirmed his judgment.

"That wood program is outstanding," says craft patron M. Joan Chalmers, who has

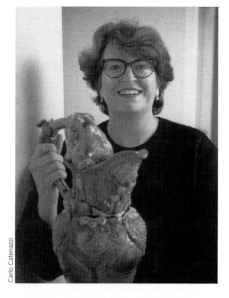

Carlo Catenazzi

At Prime Gallery, owner Suzann Greenaway promotes and nurtures top talent from all parts of the country, seen here setting up an exhibition of work by ceramist Wendy Walgate.

151

commissioned a great deal of it for her home. "Think of two generations of 'woodies' who have come out of there. The emergence of wood craftspeople is astounding as is the work some of them have done." Gallery-owner Greenaway, whose clients include some McKinley graduates, says that "while McKinley's own work is very forward and intelligent, he has created a legacy that is unbelievable; when people come out of there, they don't look like a McKinley clone. There is incredible diversity." One of the people responsible for bringing him to Ontario in the mid-Sixties, "Bunty" (Muff) Hogg, then with Ontario's Community Programmes Branch, maintains that "no one taught as he taught. He has devoted his whole life to helping wood craftsmen. He is one who has contributed more than anyone else to crafts in Ontario."

McKinley protegés have spread their wings from coast to coast: Tim Angel (now in Newfoundland), Robert Diemert, Scott Eckert, Paul Epp, Peter Fleming, Michael Grace (now in B.C.), John Ireland, Patty Johnson, Randy Kerr, Tom MacKenzie (now in B.C.), Sherry Pribik, Joel Robson, Tim Rose, Don Stinson, Stefan Smeja (who took over from McKinley), and senior graduate Michael Fortune, honoured with a Bronfman Award in 1993."[19] Most of them work on a commission basis, teach, or appear in galleries, or all three. Fortune is probably the most widely recognized and the most versatile. As well as operating the Michael C. Fortune Studio in Toronto, he has taught, served as a design consultant for a not-for-profit employment venture in Toronto, and lent his expertise to Third-World initiatives.

Sharing Good Fortune

It's a fine irony that just at the point when craftspeople were finally on their feet after some very lean years, they were viewed as successful enough to become resources for struggling craftspeople in poorer countries. A number of organizations sought out established craftspeople with a humanitarian bent, asking them to put their careers on hold for brief periods to work with the less advantaged. Fortune, somehow, juggled things at his studio to answer the call. Working under the auspices of the Commonwealth Fund for Technical Cooperation, he assisted five large furniture companies in Trinidad to focus on manufactures for export. Putting in gruelling three-week time periods over eighteen months, he carried out research, designed a line of marketable furniture from sustainable Trinidadian wood, trained workers to use mechanical drawings and prepare templates, oversaw machine

D. L. McKinley

Furniture-master Donald L. McKinley framed himself in a mirror made from a single strip of sugar pine, band-sawed with an undulating pattern along its length.

set-ups and fabrication of prototypes, and then helped to introduce the products to the United States.

He followed that venture with a similar design and technical-consulting assignment in the Yucatan district of Mexico, working for American-based Aid to Artisans and the United States Department of Agriculture. Enduring incredible heat and humidity and communicating in sign language augmented by pencil sketches — he had but three Spanish lessons before leaving — Fortune managed to develop a line of furniture from local woods for use in the area's tourist resorts and thus help to invigorate Yucatan's economic development. Designer-craftspeople can offer the best of both worlds, he believes. They have design training, which allows them to be both creative and realistic, as well as the technical know-how to ensure that their designs are properly implemented within the limitations of the project. In 1996, Fortune began a new adventure in Nelson, British Columbia, where he has helped to pioneer The Wood Products Design Program within the Kootenay School of the Arts while maintaining his Toronto studio and consulting for a furniture manufacturer in Belize, Central America.[20]

Alberto and Jose were among the Mexican carpenters that furniture designer-maker Michael Fortune mentored in the village of Tres Garantes.

Alternate Voices

Leather and Bookbinding

It would be misleading to suggest that the only branches of craft that grew in stature were those taught in college diploma courses. Musical instrument makers, leather sculptors, bookbinders, stained-glass artists, woodturners and carvers, although not as well served by post-secondary education as glassblowers, jewellers, and potters, also had an honoured pedigree. The lack of full-time courses available to them, with the exception of token offerings in the Seventies, did not suppress their growth but merely threw would-be practitioners on alternate resources such as overseas study, apprenticeship, evening courses, workshops, and seminars. Five Bronfman juries, in fact, have seen fit to honour the accomplishments of a variety of Canadians who followed other educational paths, among them Ontario guitar-maker William "Grit" Laskin, who is largely self-taught, and bookbinder Michael Wilcox, trained in England, and considered among North America's finest practitioners. From his studio in the Kawartha Lakes area, Wilcox ekes out a livelihood solely from design bindings, one of the few in the world to manage such a singular feat.

Although numerically challenged throughout the time-frame covered here, book-binders have compensated for their small numbers through the superior quality of their craftsmanship. Notable in the Thirties was Toronto gallery-owner and art patron Douglas Duncan, who also ran a small business as a custom book-designer and binder, a skill he learned while living in France in the late Twenties. A member of the Handcrafts Association's executive for a time, he had some of his pieces selected for the Paris Exposition of 1937.

Robert Muma: Binding Godfather

The acknowledged father of Canadian binding, Robert Muma of Coldstream and Toronto, got his start after World War II when he and his wife operated a leathercraft school, Mumart, from their Hazelton Avenue home, which drew students from Canada and northern United States. Mainly hobbyists, his pupils learned how to fashion handbags, wallets, belts, book-marks, picture frames, and other accessories that were then all the vogue. Leather courses, in fact, were for a time a veritable staple of night-school programs. With a circle of more serious enthusiasts, Muma formed the Canadian Society for Creative Leathercraft in 1950 to improve standards of craftsmanship and promote more original design concepts.

The craft of bookbinding had always fascinated Muma, and he had worked briefly in a binding factory, but it was not until he acquired the requisite set of European tools that he was able to become a full-time hand-binder and restorer, eventually one of Canada's finest in private practice. While building his clientele, he continued to teach small classes of sea-soned leathercrafters who had also become intrigued with quality bookbinding. At the rel-atively senior age of fifty-two, Muma received the first scholarship established by the Canadian Handicrafts Guild's Women's Committee to assist with further study. He used the thousand-dollar stipend — an amount made possible by Douglas Duncan's matching donation — to gain mastery of the exacting technique of gold-tooling and gilt-edging at Columbia University, New York City. In North America's bookbinding field, gold work was an uncommon hand-specialty, because procedures were not written and could only be learned orally from experts. On his return to Toronto in spring 1960, Muma savoured a heightened reputation for what Michael Wilcox terms his inventiveness and artistry, not to mention his contagious enthusiasm. Now more refined, his hand-bound volumes were sought after as gifts and commemorative pieces for corporations, institutions, and royal visitors. Assisted by occasional apprentices, and Michael Wilcox for a spell in

Completing a commission in his Hazelton Avenue studio, bookbinder Robert Muma, by 1977, was ready to retire from the limelight after more than thirty years as a pioneer in restoring and binding books.

1963, Muma continued in the profession until the late Seventies when he sold his equipment and returned to a first love, botany, combining it with watercolour painting.

About this time, experienced bookbinders from overseas began to take up posts as preservation specialists at universities and libraries, and in their spare time, passed on binding and related skills through evening courses or, briefly, at Sheridan College. One of them, John Holmes of McMaster University's Library in Hamilton, organized a first-ever exhibition of contemporary work, *20th Century Bookbinding*, at the Art Gallery of Hamilton late in 1982. The public was fascinated, and the die was cast. What had existed substantially as an underground movement soon coalesced into the Canadian Bookbinders and Book Artists Guild (CBBAG), which made Robert Muma its first life-member in recognition of his role as foster parent. The time had arrived for bookbinding, paper decoration, and box making to be recognized as separate entities within the craft constituency. The new organization devised an ambitious program that it still maintains: education for members through workshops, seminars, courses, lectures, and dozens of videos; juried and touring exhibitions; and a quarterly newsletter to five hundred members clustered in its five urban chapters across the country. A thoroughly modern organization operating in the context of the most traditional of crafts, CBBAG has embraced the computer world and through its website handles queries and dispenses information to an even broader audience.[21]

Magazines such as *Canada Crafts* and *Craftsman* by the late Seventies, had also begun to feature didactic articles about leather to illustrate its expressive possibilities and to explain techniques to unfamiliar readers. Den mother Daphne Lingwood of Caledon East, otherwise known as Daphne of Canada, had long since confirmed that leather was a most-exciting and sensuous craft medium. During her exceptionally durable career, she has produced what Robert Muma once described as a "bewildering parade of creative ingenuity in coloured leather flowers, masks, bags and wall hangings."[22] Leather sculpture, boxes, bowls, murals, and masks have now attained exhibition status and become part of private and

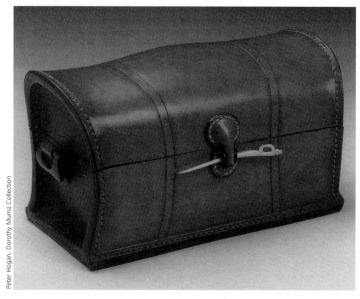

Peter Hogan. Dorothy Muma Collection

Made by Robert Muma in the late Seventies, for his own use, this replica of a pirate's treasure chest is 26 x 14 x 14.5 cm of molded and baked cowhide, hand-stitched, hinged, and latched with a miniature bone sword.

corporate collections around the world, in the hands of Ontario's leading exponents: Paul and Beverley Williams of Bethany, David Trotter of Whitby, and Rex Lingwood of Bright, widely considered a global authority and innovator in the world of creative leather art.[23]

Rekindling the Fires of Stained Glass

The Seventies also marked a renewed interest in stained glass. More than anything, the North American revival of stained glass — essentially a spiritual and material medium — mirrored the Age of Aquarius with its curious mix of pseudo-religious spirituality and secular worldliness. Even so, stained glass remained a most perilous craft medium within which to function as a professional. Large-scale ecclesiastical commissions were fewer in number by this time and generally monopolized by religious-trade studios whose ultra-conservative clientele was uneasy with change. The opposite was true in post-war Germany where artists designed striking non-traditional windows in an aesthetic that was to profoundly influence North American work. The Germans were prepared to make a fresh start and break with the past after World War II, whereas our culture had not undergone the same experience, was not as ready to give up the past, and was assuredly not as oriented to expressions in art as Europeans.

Architects, designers, and stained-glass artists viewed Canadian commercial stained-glass studios as moribund and standoffish. "They had never maintained an interest in, or sought to establish a relationship with, the directions and developments in fine art or architecture," Sarah Hall wrote in 1978 while completing her overseas studies in stained glass.[24] Because trade studios employed production-line techniques and regarded their windows as products rather than art, Hall said they usually avoided relationships with the outside world of art and new trends in design, colour, and architecture. "Their contribution to the design of modern windows," she went on, "consisted of little more than an alteration of the backgrounds of their standard Victorian designs into meaningless assemblages of coloured glass." By contrast, the German work, which was and is funded from taxes, was refreshingly modern and abstract, dynamic and stirring.

By 1975 a dozen or so restive Canadian artist-designers had had enough and counterattacked by forming a lobby group, Artists In Stained Glass. The catalyst that transformed them from informal salon to formal guild was their commitment to politick for establishment of national competitions for important federal commissions, such as proposed windows for the Senate chambers. Through AISG, the group also hoped to weaken

the stranglehold of the trade studios, restore the mediaeval values of art and good design and to promote independent pieces, accessories, and installations for residential settings. They regarded their work in the same light as contemporary painting, sculpture, printing, or photography. Just as the world of clay had been transformed by abstract expressionism and highly coloured and patterned fine art, so stained-glass designs now reflected a move from the figurative to the abstract, work which could be displayed, like paintings, in a number of settings.

From its modest beginnings, AISG staged yearly displays of members' work and, in 1978, organized a two-week Master Stained Glass Workshop at Harbourfront, conducted by English modern mediaevalist Lawrence Lee. At the same time, the Art Gallery at Harbourfront whetted the public appetite with the first exhibition of architectural-scale stained glass in more than a decade, *The Magic of Glass*. AISG and its provincial affiliates today collectively represent a membership of some three hundred and its programs include exhibitions, conferences on contemporary issues, and newsletters. AISG'S own organ is the quarterly bulletin *Flat Glass Journal*, which has taken over the role of an older publication, *Leadline*.[25]

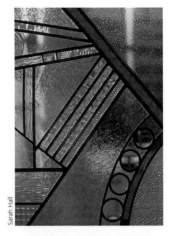

Since the American craft movement of the Sixties, with its California base, also encouraged a do-it-yourself ethic, small glass-supply stores sprang up throughout Ontario in the Seventies to provide glass, lead, tools, books, and lessons to hobbyists and independents. Previously, supplies had to be brought in from overseas and only sizeable studio operations could afford the expense. Most of us have seen enough mock Tiffany lamps and sun catchers to last a lifetime, but the advent of this change recast a once highly structured medium into an accessible, affordable, and intimate activity. By the late Seventies, it was estimated that there were more than a hundred thousand devotees in the United States, whereas a decade earlier there had been fewer than a hundred.[26] We can be sure a good number of stained-glass converts also lived in Ontario.

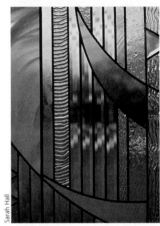

There are no yardsticks for measuring hopes and dreams and whether AISG achieved what it set out to do. It did at least succeed in introducing new design concepts, in wresting a share of commissions from the trade studios, and in promoting commissions for autonomous stained-glass panels, although this last had inherent limitations. "A two-dimensional piece that hangs in a window is not as powerful as something built into a site," Hall explains. "There is a relationship between the mass of a building and that interpretative light, which is what we design for." Since 1980 Hall has operated her own highly

Sarah Hall often uses leaded glass, lenses, prisms, and bevelled glass when she wants to achieve arresting graphic details. Two of her favourite commissions were nursery windows for Jessie's Centre for Teenagers in Toronto (above) shown here in detail, and (below) a segment from a tower window for the First Unitarian Church in Toronto.

successful studio in downtown Toronto. Having trained in the United Kingdom and apprenticed with Lawrence Lee, she learned to work on massive pieces and still prefers king-sized commissions. On her return to Canada, she "was fired with a tremendous need to educate and to help change the ideas of people in what they put in their churches. I wanted to do liturgical work and I wanted to do things that I felt were real. I found our churches full of gloomy saints, stereotypes, and commercial images. I don't mind them in restaurants but I don't like to see them in churches."

Selling modern design ideas to cautious clients is intimidating, however, the outcome unpredictable and often stifling to budding careers. "You can do all sorts of great art work, but if you cannot present it and have people feel confident and comfortable, it won't get made and you won't survive," Hall soon learned. "When I go into a presentation, I know every single time it is going to be hard work to help them understand what I am presenting and why I have designed it this way, the fact that it looks different from what they thought, from what they know. I don't think it's ever going to be an incredibly easy sell." She once asked Yvonne Williams if she ever got to the point where she never worried when she was presenting a design and the answer was, of course not. "Presenting something new that people have never seen which looks nothing like glass — that's a big part of our problem — our sketches don't look anything like glass." And yet, when Hall looks back over some "financially excruciating" years, she sees what she has accomplished as a designer-craftsperson — more than one hundred and fifty commissions in Canada, the United States, and overseas. It's clear she has made stained-glass history in a notoriously difficult field, just as Williams had managed to do in the Fifties and Sixties.[27]

Soaring costs cast dark clouds over studio operations, however, even those as successful as hers. For generations, stained-glass studios purchased antique hand-made glass from German and French factories, but at present, only two remain in business and both are threatened by escalating labour and energy costs. Because Hall's work relies on an exuberant range of colours, she worries that "If we lose our hand-made antique glass I don't know what I would be designing for. I think there will still be enough in my lifetime but I am concerned about it, because it is a rather precarious thing." Working with stained glass has always resembled a mediaeval method of manufacture, a most labour-intensive craft that is increasingly expensive for clients to afford. "Even when you work as quickly and as well as

Stained-glass designer-maker Sarah Hall of Toronto stands before some of her window sketches.

André Beneteau

158

you can," Hall says, "new work is threatened by the very high costs that are necessary to produce it." To appease clients, she foresees a move to less-expensive techniques such as sandblasting, so that leaded stained glass as we've known it could disappear.

Changing Priorities

Beneath the showy patina of the Eighties, a cultural historian might have detected signals that things were not as robust as they seemed. Well before the big recession, the economy yawed up and down, and in the early part of the decade, the federal government imposed fiscal restraints that affected project grants to arts organizations, although the Ontario Arts Council's new grants program to individual craftspeople was a small triumph.[28]

Far worse was that college enrollments, so buoyant for fifteen years, began to drop alarmingly in some craft subjects, paradoxically at a time when the craft community was beginning to thrive. Mature students who once filled part-time courses seemed to prefer to look and buy rather than make, and the younger generation wasn't turned on by prospective hardships associated with becoming self-employed. "By the Eighties, everyone had to be cool and have good cars. Being a potter or a weaver didn't fit that category," recalls potter Keith Campbell, a ceramics instructor and long-time visual-arts administrator at North Bay's Canadore College. "The bubble burst. The community colleges took a real beating because we hit a point of saturation."

Barrie goldsmith and teacher Donald A. Stuart works on a commission from a crowded studio in his home.

Craft programs were suspended in many of the twenty-two community colleges, and individual courses axed permanently. Especially disheartening was the demise of the once-vibrant studies at Barrie's Georgian College, which today has one full-time craft program — jewellery and metals under Donald A. Stuart. The craft community was further outraged when Sheridan announced it was terminating its weaving and metal programs in 1984, the latter particularly puzzling and myopic in the face of a growing interest in jewellery studies. The issue galvanized many media guilds, administrators, organizations, journalists, teachers, and students to write letters of protest but to no avail.[29]

Apart from a steady decline in their numbers, the priorities of students had also changed; often older and with life experiences behind them, the newer generation was and is less adventurous and more conservative than its Sixties counterparts. "They want hard, cold, practical information, and trying to get through to them that that is not going to help

them ultimately in their career — they just don't get it," says OCA's Hodge. "It's almost the reverse of the students I had back in the Sixties. Now trying to get them to experiment is very difficult. They are all looking for 'jobs' and I point out to them that 'jobs' are dead, but there is going to be oodles of work."

Because Hodge is constantly redefining himself in his fibre field, he resolutely espouses change, technology, and new directions, and he challenges students to do likewise. "The big thing now and in the foreseeable future is custom work. This new generation is going to free-float from position to position, work to work, some might never leave their own studios, many are going to get attached to modems and work that way. I tell my students they will keep coming back here or to other institutions, because they are going to have to keep upgrading. That's the world they're going into, a world that requires continuous education: workshop here, seminar there, course here, program there."

Pared to the Bone

For the half dozen craft programs that are left in Ontario, a haunting spectre is continued reductions in provincial funding. Because government support has been eroding for some time, OCA (now OCAD) and community colleges have had to reduce teacher-student contact hours, some more dramatically than others. "The challenge for faculty," says Hodge, "is how to cut faculty-student contact but increase the learning experience." And the challenge for colleges is how to keep the doors open; more and more of them have to supplement operating grants with fundraising efforts at a time when they could be enriching and expanding craft education to include master-level studies.

It has become increasingly clear that a post-secondary degree is a prerequisite if students aspire to a serious exhibition and teaching career. Those pursuing graduate training in craft subjects have always had to leave the province and, if they could afford it, the country. "The community colleges have been doing quite a good job at their niche of the marketplace," Hodge feels, but "because of the length of their programs they can only take the student so far. We need the post-secondary school legitimized, which a degree would do." Harbourfront's Jean Johnson puts it even more strongly. "In my opinion, the fact that we don't have at least a BFA in crafts in this province limits the development and growth of the craftsperson and of the community because it deprives us of that basic education."

The Crafts Council had become so concerned about the quality and depth of craft education in Ontario that in the late Eighties it commissioned a year-long examination of issues and problems, results of which it presented to the Minister of Colleges and Universities, together with recommendations for change, but again, to little avail.[30] One of the participants in the inquiry, then Sheridan College administrator Betty Kantor, believed the issue reached far beyond programs and degrees. "Culturally, I think there needs to be more recognition of what the crafts contribute to Canada and Ontario," she said, "and I think there needs to be a recognition of the financial contribution that crafts make to the economy." With that in mind, the Ontario Arts Council recently published a statistical study showing the economic impact of the arts organizations it funds, a group that had included OCC and craft media guilds. Its findings illustrated how the not-for-profit sector paid its way, and debunked the perception the arts were a luxury and drain on the economy. Every dollar spent in the cultural sector resulted in total economic activity of one dollar and twenty-three cents; in the time-frame under study, in fact, the provincial government contributed forty-two million dollars to arts groups and received back fifty million dollars in taxes.[31]

The Yellow Brick Wall

By the mid-Eighties, the Ontario Crafts Council was, in the words of one of its presidents, Adam Smith, a dynamite place with an active membership of three-and-a-half thousand. A large staff, with a complement of volunteers, had guided the organization well beyond the ill-defined nether world that characterized its early years. Complacency was out; forward thinking was in.

OCC embraced a business procedure called KRA, or Key Results Area, in which it defined short- and long-term goals to keep itself on track and accountable to membership and funding agencies. By committing itself to ambitious five-year plans, however, the Council placed enormous pressure on staff. Functioning in little less than five-thousand-square-feet of administrative and gallery space, they were shoe-horned into four floors of a charming Victorian semi-detached building. Experts in space planning advised the Council that to carry out its program

from a 1978 drawing by David Crighton. OCC Archives

Ontario Crafts Council - 346 Dundas Street West - Toronto DAVID CRIGHTON 1978

161

above: The OCC committed 2% of capital costs to built-in art at 35 McCaul Street. John Ireland received the commission to design the second-floor atrium railing in which he used curly maple, cherrywood, glass balls, and cold-rolled steel.

below: While on a sabbatical break in Maui, ceramist Ann Mortimer created a new series of spherical work using paper pulp.

goals it needed more than double that — almost twelve thousand square feet. "It was very very hard circumstances for the staff and I felt we were asking a lot of these people," Smith recalls of his presidential years between 1986 and 1988. "They were working ridiculous hours for ridiculous money, and asking them to do that in ridiculous circumstances was one straw too many. If we weren't seen to be acting to alleviate the space problem, we were going to lose staff that we could ill afford to lose. And so, we launched into the process of what we were going to do about it."

Initially they looked for additional rental space but, in time, outright purchase seemed more realistic and responsible. "What we paid for 35 and 37 McCaul was what anyone would pay for those buildings, essentially thirty-four thousand square feet," Smith says. "One building was not an option; we had to buy both."

To help underwrite expansion, OCC sold its cramped Victorian quarters at 346 Dundas and shop premises at 140 Cumberland. A generous grant from the Ontario government in recognition of "the tremendous contribution the Ontario Crafts Council makes to crafts in Canada," helped its capital fund grow close to five million dollars. That left approximately another two million to be raised publicly to renovate the yellow-brick twin industrial towers. President Smith, Executive Director Tooke and patron Chalmers were convinced the public would rally to support a new home for the Council and put contemporary crafts in a showplace like no other in the country. Others thought so, too. Newmarket ceramist Ann Mortimer, who took on the presidency in 1992, remembers that "we were just one of thousands who made the assumption that the good times, the bubble would go on forever, that all of this was possible." North Bay's Keith Campbell thought the move was brave and brilliant. "It was gutsy for them to say let's go for it, let's try. But the world economy was poor and for the OCC, the timing was bad."

Aside from the recession that swooped down on the early Nineties, it's apparent now OCC did not understand the basic nature and subtleties of a major fundraising campaign, and at a time when it was competing with other arts groups also looking for capital. The move to Chalmers Building on McCaul proved too big a project for a mid-sized service

162

organization whose focus was not its own profile but the work of craftmakers and its core programs. It was, as Chalmers said later, "an experiment that didn't work." Unable to raise sufficient funds to cover purchase and renovations, OCC was eventually saddled with a bankrupting mortgage, and now rents rather than owns, surviving as best it can with a much-reduced staff. "The OCC will stabilize and will rebuild again," Campbell is persuaded. "We as craftspeople just have to ride this out. We are strong enough; we're resilient. We're not going to die."

G. A. Crawford

A brave but short-lived venture was the OCC's satellite shop at Terminal 3 at Pearson Airport, which had to close its doors after only ten months.

The Future

In the sixty plus years covered in this volume, Ontario's studio craftspeople have come a long way, numerically and aesthetically, especially when we recall humbler studios and equipment of the Depression and war years. The current economy and societal priorities may no longer wish to support craft-umbrella organizations that nurture, lobby for, and provide forums for discussion and communication. Even a recognized necessity of the Thirties — a mother organization to assist craftspeople to make it at the professional level through retailing and exhibitions — is proving difficult to sustain six decades later. This state of affairs makes no apparent sense in a province as well endowed as Ontario, and doubly challenges its craftspeople.

For the first time in their history, however, studio craftspeople have an organization at their disposal that they can shape to their perceived needs, without having to follow outside agendas and priorities. Without grant support, OCC at present is no longer beholden to bureaucrats and government administrators. As architect Raymond Moriyama suggested two decades earlier, this may be the time when craftspeople will become interdependent on one another and thereby independent. They face not only their own survival but change, change, change. Cultural protectionism will be an issue; incessant down-sizing will continue; as jobs disappear, production crafts will multiply as people turn part-time interests into full-time careers to replace lost incomes.

At the conjunction of the twentieth and twenty-first centuries, studio craftspeople need

suffer few aesthetic constraints. They have the freedom to move seamlessly into "fine art" circles while working within a craft medium, should they so choose. Some incorporate

above: To mark the OCC's 15th birthday in 1991 in a partly renovated gallery space at 35 McCaul Street, M. Joan Chalmers provided $15,000 in prize money to honour excellence in the craft profession. Winner was Guelph metalsmith Lois Etherington Betteridge.

below: 1997 winner of the Jean A. Chalmers National Crafts Award, Lonsdale porcelain artist Harlan House, received congratulations from M. Joan Chalmers.

sociological content, social issues and commentary into their particular medium of expression. Isolation is no longer an issue. Most major centres have retail and exhibition outlets where craft work is sold; country and city studio tours allow interaction between maker and buyer. Their progress over the span of six decades mirrors a cultural sector that is increasingly confident and mature.

In a recent article in *Ontario Craft*, stained-glass artist Robert Jekyll urged colleagues "to set aside uncertainty, insecurity and denial" and "take our collective future into our own hands as craftspeople and not wait, as we have so often in the past, to be invited to do so by others."[32] Thus, the question before Ontario's craft sector is whether it is resilient, confident, and aggressive enough to assume direction of its own affairs, overcome the present reversals and, armed with Herculean resolve, stride forward to seize the next millennium.

Before them is another of those fine lines that exist between survival and a respectable livelihood, an irony at a time when studio crafts are such an integral part of our cultural landscape. But, then, craftspeople have always existed on the edge, on a limb, without assurances that their livelihoods are secure. A fine line haunts them, follows them, reasserts itself and, ultimately, dominates their very existence. They would have it no other way.

164

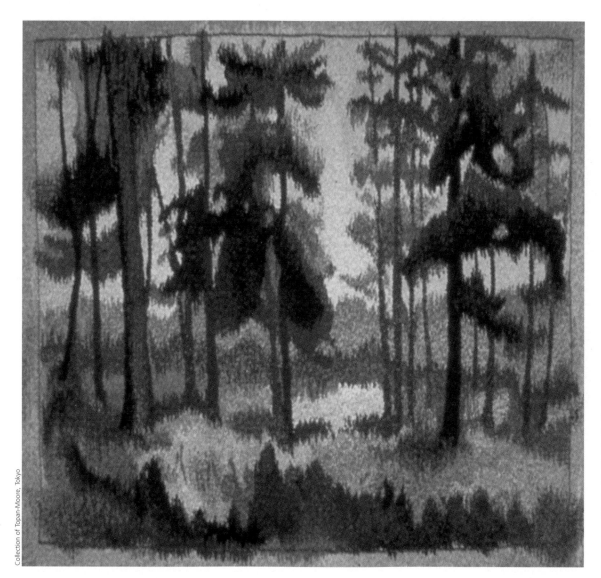

To achieve the desired subtleties, weaver William C.G. Hodge wound wool, rayon and linen threads together to blend colours before weaving. Measuring 183 x 173 cm, *Thunder Bay Clearing* stems from his 1982 series based on Canadian landscapes and demonstrates his identifiable style of tapestry making.

Toronto weaver Judith Fielder's colourful silk jacket, *Granny's Patch*, won Best in Show in the 1991 OHS exhibition, *From The Source*. Fielder assembled overshot squares of different wefts and treadlings to emulate a patchwork quilt.

Gernot Dick

Head of OCA's textile department for many years, Helen Frances Gregor, used a gobelin weave and wire construction to create *Sarabande*, a wool-and-linen 3-metre-tall hanging, exhibited in 1973 at the AGO in *Weaving-3D*.

right: Exhibition curator Connie Jefferess of London fashioned *Cape For Charles Rennie MacIntosh* in 1984, measuring 132.1 x 228.6 x 51 cm and shown here in detail.

below: Veteran quilter Judith Tinkl's contribution to *The Uncommon Quilt* was a 173 x 208 cm hexagon called *Snowflake*, shown here in detail.

Steve Kerr

Steve Kerr

Steve Kerr

Steve Kerr

left: Quilted in cotton and polyester with bells,
Diane L. Robinson's circular *Cherokee Raindance*
has a diameter of 165 cm.

right: Detail of John Willard's 200.7 x 198 cm
quilt *Ribbon Dancer Once Removed* shown in *The
Uncommon Quilt* exhibition held at the University
of Western Ontario in 1985.

169

In the mid-Eighties, woodturner Ted Hodgetts achieved a
sensuous quality in this 13-cm-high hollow vessel through the
use of silky oak, purpleheart, wengé, holly, and ebony.

172

For a solo exhibition at Dexterity gallery in Toronto in 1988, John Ireland explored the sculptural qualities of the table form. For *Lotus Table* he chose to combine pomelé mahogany and wengé, because of the dramatic interplay between the constrasting woods.

Jeremy Jones

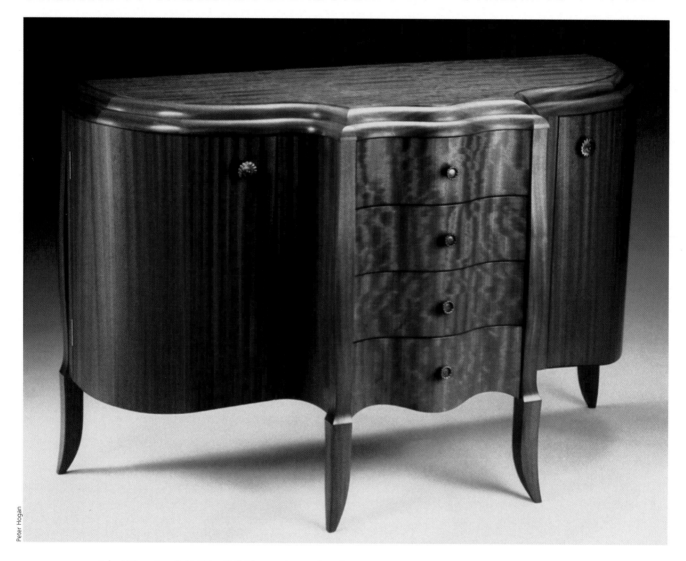

Robert Diemert made his *Wave Buffet* from makore and sapele
African mahoganies, commonly known as ribbon-striped
mahogany, and then finished with clear lacquer. The buffet
was one of series in the mid-Nineties in which Diemert worked
with curved laminations to create classic furniture forms.

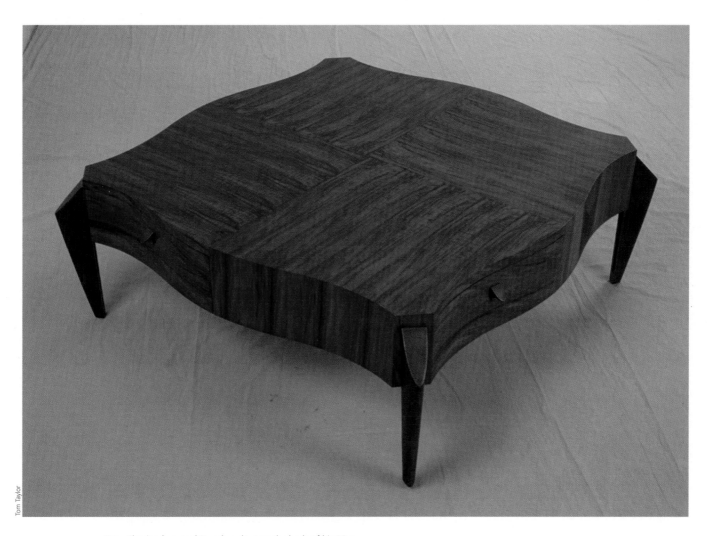

Peter Fleming has used French walnut on the body of his 38 x 100 x 100 cm coffee table, *Tortoise*, and patinated sand-cast bronze for the legs. The pinwheel position of the drawers allows maximum use of space. Fleming completed the table in 1996.

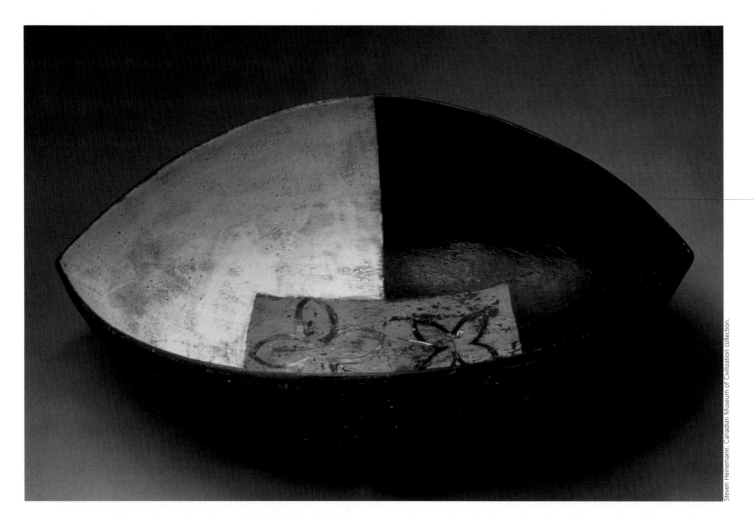

Before receiving a Saidye Bronfman Award in 1996, ceramist
Steven Heinemann's slip-cast and multiple-fired earthenware
bowl won an Award of Merit in New Zealand's Fletcher
Challenge Ceramics Competition in 1995.

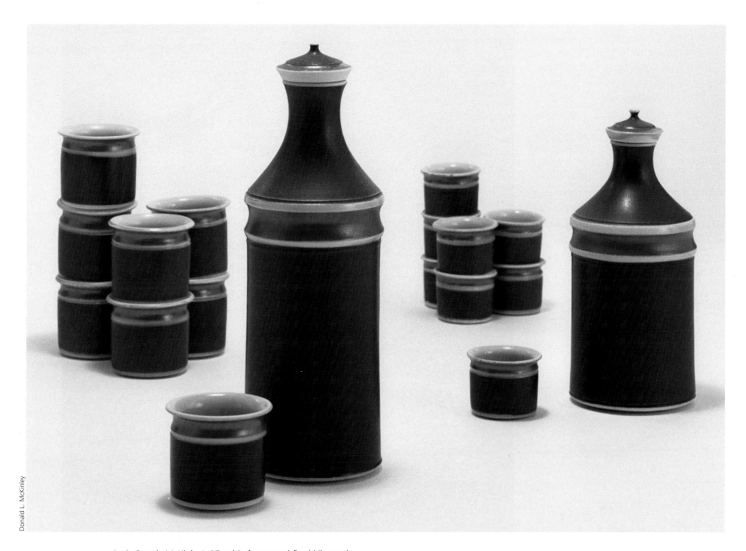

Ruth Gowdy McKinley's 25-cubic-foot wood-fired kiln on the
Sheridan Campus was legendary for the sublime porcelain pots
it produced. In 1977 McKinley made a "Faenza Wine Set,"
consisting of two stoppered bottles with cups in black, brown,
and white with a matte finish sent later to Italy for a ceramic
international.

177

Enamelist Fay Rooke of Burlington has earned an international reputation for achieving poetry in cloisonné. Her *Hosta Story* (1992) is a raised copper-bowl form enhanced with two-sided cloisonné enamel and fine silver. She has high-fired the interior and given the exterior a hand-polished matte surface.

Terry Robertson

178

Peter Hogan

Jeremy Jones

above left: Since 1979 David McAleese and Alison Wiggins have perfected the technique of anodizing titanium, which they used in earrings, necklaces, and bracelets. One of their showpieces was this earring-and-necklace set made in 1990.

above right: A graduate of the Alberta College of Art and Design, Toronto jeweller Ken Vickerson is active as both a craftsperson, exhibitor, and teacher. His *Boutonniere Series* of pins in 1991 combines sterling with 14k gold.

right: Arthritis may have ended George Dancy's career as an auto mechanic, but physiotherapy sessions taught him jewellery making, which became his second career by the 1950s. Featured at The Guild Shop was this choker in which he combined silver and a blue-and-beige banded agate.

Peter Hogan

Peter Hogan

above: During the alternative materials movement in jewellery circles during the 1980s, Owen Sound's Andrew Goss experimented with laminated paper using photocopies of words and images, coloured pencil and ink. He held the laminations onto an acrylic back with painted aluminum frames.

179

In the late Eighties Newmarket ceramist Ann Mortimer turned to working with illusion and low-fire white clay in a series of low-relief, two-dimensional wall plaques. In this late-Eighties variation, a grey cloud moves across a rectangular box of abstracted blue flowers.

Peter Hogan

180

A FINE LINE

APPENDICES

Angelo DiPetta used 7 dozen tiles, each 38 sq. cm, in constructing his ceramic mural *Canadian Allegory* for C-I-L House in Toronto. Installed in 1982, the work uses both primary and earthy, organic colours to highlight the relief elements intended to evoke both the Canadian landscape and technical world.

Endnote References to Chapters 1–5

Chapter 1

[1] Alison Britton, "Craft: Sustaining Alternatives," Introduction to *International Crafts*, p. 9. A variety of craft writers have written eloquently about the various faces of craft: Britton's whole introduction to *International Crafts* (1991); Adam Smith, "Making the Case for Craft," in *Ontario Craft*, Summer 1985; Susan Eckenwalder's "The Well-Crafted Object," in *Ontario Craft*, Winter 1984; Sue Rowley's broad disciplinary "Warping the Loom: Theoretical Frameworks for Craft Writing," in *Craft in Society* (1992); Janet Kardon, "A Centenary Project: Stage One — The Home as Ideological Platform," and John Perreault, "Starting from Home: Twentieth Century American Craft in Perspective," both from *The Ideal Home: The History of Twentieth Century American Craft* (1993).

[2] Britton, p. 15.

[3] Martina Margetts, Preface to *International Crafts*, p. 8. Margetts was keynote speaker at the Decorative Arts Institute's seventh annual symposium, Toronto, April 1997.

[4] Quoted by Lloyd Herman in his introductory essay to the catalogue *Art that Works*, p. 24.

[5] Virginia Watt, "Profile of a Professional Craftsman," *Artisan News*, Mar./Apr. 1978, p. 7.

[6] Warren Seelig, "Commentary," *American Craft*, Apr./May 1987, p. 27.

[7] John Perreault, "Craft Is Art," *Eloquent Object*, p. 201. Bruce Cochrane's curatorial comments for *Useful Intentions*, 1996, also discuss balancing artistic expression and sensitivity to functional design.

[8] Ron Roy interviewed by author at his Scarborough home in 1996.

[9] John Bentley Mays, "Commentary," *CraftNews*, July 1986, p. 4. In 1992 the Institute for Contemporary Craft was formed in Toronto to encourage dialogue about critical issues facing today's craft community. In two symposiums, 1993 and 1997, it has attempted to explore some of the issues Mays refers to.

[10] Grant McCracken, "Commentary," *Ontario Craft*, Spring 1995, p. 30. McCracken has been associated with the Department of Anthropology at ROM.

Chapter 2

[1] In 1931 Toronto's population was officially 631,000; that of Toronto and its outlying suburbs was 818,000. By 1933, 30% of Torontonians were jobless; by early 1935 one quarter of Toronto and suburbs was on relief. James Lemon, *Toronto Since 1918*, Toronto, p. 59 and Appendix, p. 195.

[2] For more details see Watson Thomson, *Pioneer in Community.*

[3] Kenneth McNaught, *A Prophet in Politics*, p. 257–59, and Michiel Horn, *The League for Social Reconstruction*, Preface, p. 55, 78.

[4] Lemon, p. 79.

[5] Among them *Canadian Geographical Journal, Canadian Home Journal, Canadian Homes and Gardens, Canadian Magazine, Chatelaine, Gossip, Curtain Call*, and *Saturday Night*.

[6] Col. Wilfred Bovey, "Canadian Handicrafts," and a memorandum dated Aug. 29, 1939, by Floyd S. Chalmers, Ontario Archives, OCC Collection, MU 5752, Adelaide Marriott Papers, file CB2.

[7] OCC Collection, MU 5752, file CB, Archives of Ontario. Translated from the Italian text. Much less familiar to North Americans than colleague Georg Jensen about whom I need add nothing, Ibe Just Andersen deserves a word. Born in 1884 to Danish parents then living in Greenland, he moved to Copenhagen with his family when he was 10. He first studied painting and sculpture, and from 1914 onwards worked as a goldsmith in collaboration with his wife, expanding his repertoire to include silver, bronze, copper, pewter, ivory, mother-of-pearl, and wood. By the late Thirties he had almost a cult-like following, and many Scandinavian families could claim they owned a "Just." "I don't like to call myself modern," he once said, "but I would like to give my best works an understandable form. With every new problem which I encounter I try to provide a natural solution with simple lines and happy proportions."

[8] Little published literature exists about Edna's venture; my one source is an article by her brother Paul T. Breithaupt in

the magazine *Etcetera*, Sept. 1930. Grange Studios existed from 1929–1934, and we can only speculate as to why it closed. Much has to be researched and written about Edna Breithaupt herself, a mold-breaker if ever there was one.

[9] All the Shenstone material is extracted from three articles he wrote in the latter part of his life: *Craftsman*, Oct. 1979; *Canada Crafts*, Mar./Apr. 1980; and *Ontario Craft* Spring 1989. He was educated at Appleby College in Oakville and at University of Toronto Schools in Toronto. After serving in World War II, he found supplies of pewter unavailable, so he worked for the federal service in Ottawa, only returning to his beloved pewter in retirement. Before he died he authored a book on Canadian peweters, *For the Love of Pewter.*

[10] Existing in Germany from 1919 to 1933, the Bauhaus School influenced North American architecture, painting, design, and crafts for decades. Stressing purity of line and form, the School championed that function and natural materials should dictate design. In the Thirties many of its practitioners emigrated to North America to shape the vision of generations of craftmakers, notable among them Anni Albers in weaving and Marguerite and Frans Wildenhaim in ceramics. In time, the Bauhaus perspective in clay was modified by the Zen Buddhist aesthetic of Japanese potters, introduced to this side of the Atlantic in the 1950s by British ceramic godfather Bernard Leach.

[11] Organizers were Frederick Robson, then with Ridpaths; Peter Howarth, Central Technical School; "Bobs" Howarth, a pottery teacher there; John deN. Kennedy, lawyer; Herbert H. Stansfield, OCA teacher and craftsperson; and Hephzibah Stansfield, professional weaver. The exhibition ran from Jan. 26 – Feb. 14, 1931. One of the sponsoring organizations was the Junior League of Toronto, then 303 members strong.

[12] Questions posed and still valid: Should Canadian craft work be encouraged as it is in other countries? If the various crafts were encouraged as an occupation, could the work be marketed and how? Will people buy and appreciate Canadian craft work? Why do people buy original paintings and not original handwoven fabrics? To what extent does craft work build character and reflect national spirit? How can craft work develop industries? (*Etcetera*, Apr. 1931, p. 9.)

[13] Frederick Robson was variously identified as Frederick E., Frederick C. and in official HAC documents as Frederick Lithgow. The *Globe and Mail*, Jan. 16, 1950, said that Frederick Robson (1884–1950) was president of Robson Oil Co. of Bowling Green, Kentucky, when he died. Awarded the Coronation Medal in 1937 for his public service, he founded the Big Brother organization and was president for five years. He also founded the Men of the Trees Society in Canada (Jack Ridpath also made this possible) and was president for six years. At the time of his death he was president of the English Speaking Union and active in other organizations in Toronto, although no longer associated with the craft movement. His wife was a member of CGP for a time. He was President of HAC from its inception in 1931, resigning in Dec., 1933.

[14] Eaton Collection, F229, Series 138; Box 1, Archives of Ontario. The exhibition ran from Apr. 25–30, 1932.

[15] Ibid. For the June 5–10, 1933 venture participating organizations included Imperial Order Daughters of the Empire (IODE), JLT, WAAC, Local Council of Women, United Empire Loyalists, University Women's Club, Historical Society. Prominent sponsors were Lt. Gov. and Mrs. Herbert Bruce, Mr. and Mrs. C.T. Currelly of the ROM, Mr. and Mrs. R.Y. Eaton, Mabel Adamson, Lady Kemp, Lady Baillie, and others.

[16] O. D. Vaughan in an Aug. 1, 1935 letter to W.J. Kernohan, manager of Eaton's College Street store. All material on the Guild Shop at Eaton's in the Eaton Collection, F229, 69, Container 13: Housefurnishings: General, Archives of Ontario. Eaton's calculated it was only earning twenty cents a square foot from the space, far below other departments. It continually rationalized such a poor return by acknowledging it was gathering goodwill from the well-connected Guild board of directors and shop customers. Nonetheless, it chafed at the Guild's approach to merchandising, and Vaughan could never understand why "The Guild never seemed satisfied to be submerged in the system of our store."

[17] For an overview of The Guild Shop see my article in *CraftNews*, Apr. 1992, p. 1.

[18] Sovereign Pottery Limited was established in 1933 at 282 Sherman Avenue North

in Hamilton, premises formerly occupied by Atkins Saw Company. Founders were W.G. Pulkingham, president; Alfred Etherington, sales manager; and Harry M. McMaster, plant superintendent to 1939. They owned 50 percent of the common stock. In 1947 the firm, Canada's largest and most successful dinnerware manufacturer, was sold to Johnson Brothers (Hanley) of England, who kept the management team intact until 1952. The English company said it was "impressed by the enthusiasm, keenness and ability of the executive and employees and the great achievements and high quality of ware." Their work was purchased by airlines, Canadian Westinghouse, Montreal's Queen Elizabeth Hotel, and the railways. One of the original partners, Harry McMaster, went to Dundas to begin McMaster Pottery Limited, and developed a line of "art pottery" intended to appeal to the tourist and florist market. In 1941 he reported expansion and purchase of new equipment to meet the demand.

National Sewer Pipe had several branches at the time. The one in Swansea would have been closest to Mabel Adamson's home. Swansea was incorporated as a village in 1926 and annexed to Toronto Jan. 1, 1967, at the time of the reorganization of Metropolitan Toronto.

[19] Sandra Gwyn in *The Private Capital*, p. 347, tells us that Mabel Adamson's family, the Cawthras, were Victorian merchant princes, whom her son Anthony termed the "Astors of Upper Canada." A society belle in 1890, Mabel Cawthra (1871–1943) is a prominent player in Gwyn's *A Tapestry of War*. Anthony, a noted town planner and architectural historian, described her many artistic interests in chapter 7 of *Wasps in The Attic*. Rosalind Pepall in *The Earthly Paradise*, p. 28, also details Mabel's early involvement with the Arts and Crafts Movement in England and her time (1902–03) at C.R. Ashbee's Guild of Handicrafts in Chipping Camden in the Cotswolds, a school noted for enamelwork and metalcraft. From 1912 to about 1920 (although she was absent from Canada during World War I) Mabel represented the Canadian Society of Applied Art on the board of the OCA. The kiln she gave to OCA may have been the one she purchased in England for her earlier work in enamel. Her pottery was included in an exhibition of applied art in 1930 at the Graphic Art Building of the CNE, a place of considerable esteem at the time. She joined the board of directors of HAC in 1934. Her diary covering 1934–36 has been donated to the Toronto Reference Library special collections although I read it in her son Anthony's attic library.

[20] Alan Jarvis, *Douglas Duncan A Memorial Portrait*, p. 12. Duncan was born in 1902 and died in 1968.

[21] Robert Stacey, *Metalsmith*, Spring 1985. More about Stacey (1911–1979) in the next chapter.

[22] Breithaupt Hewetson Clark Collection, Series 6.4.4. The Guild — History — General Files, University of Waterloo Archives. The BHC Collection is the main source of information cited although the interpretation is the author's. Just prior to his marriage, H. Spencer Clark had worked in Toronto with Henri Lasserre at the Robert Owen Foundation, a non-profit organization that used Lasserre's inherited fortune to assist organizations that were committed to sharing profits with employees. The Clarks spent part of their honeymoon visiting Roycroft arts and crafts community in East Aurora, N.Y., and Rosa's father visited there on several occasions so they were well aware of how a community of artists might function. Roycroft had to close its doors in 1938, victim of the stock market crash of 1929 and the Depression that followed. Clark later described the period to Jerry Amernic for *Key to Toronto*, Sept. 1978, p. 13.

[23] Although voluminous, H.S. Clark's records are not impeccable, and one cannot be certain who the craftspeople were that worked there in the studio heydays 1932–41. His records mix names of talented craftspeople he hoped to lure there with those he actually did. The most valued and longest employed was Bavarian Herman Riedl, not so much a studio craftsperson as an industrial furniture maker and restorer. Also in the wood studios for short periods were English woodturner Frank Mildred and cabinet-maker Frank Carrington, both there in 1933; Carrington by 1936 had his own furniture business in Toronto; he taught at OCA and served on the board of CHG. Woodcarvers for a time were Dane Aage Madsen and Alfred Perry. Although not the first weaver, English-born and

-trained William C. Dawson was apparently without parallel and demonstrated at the CNE as early as 1935; salary $10/week. He trained his successor, Alex MacDowell. Others included Margaret "Migs" Heartwell and a former technical school instructor, Anne Burns, on site in 1933 and who relocated to Kingston. The A.E. Freeman family provided wrought-iron work for a time and continued business on Yonge Street for years. Batiks and printed fabrics were executed by a succession of people including Alice McCabe, a 1928 graduate of Central Tech's art course and classmate of Nancy Meek, who also spun; she was a fixture on the Toronto craft scene. Ceramics seem to have been a problem area for the Guild. Started by an elderly Staffordshire potter, J.H. Eardley, who built the coal-burning kiln in 1937 (still on the Guild property) and died shortly after, the facilities did not entice potters to stay long. Spencer Clark wrote to CGP in 1938 inviting one of its members to make and sell work at the Guild in the summer of 1939. CGP's executive minutes of Dec. 19, 1938, affirm that they "could not recommend the situation to anyone judging from facts and the Guild's business relationship." Keith Heartwell in 1933 undertook to provide metalwork with his apprentice nephew Fraser. Classic English silversmith Arthur Neville Kirk came with his family in 1934 but his stay was short-lived. Austrian Franz Kral was metalshop manager in 1941, before the war closed the shop, and he seems to have provided jewellery to the shop offsite after that.

[24] *Gossip* magazine Nov. 15, 1937, BHC Collection, Series 6.3.6. The Guild — Operations — Looms and Weaving, Box 95, University of Waterloo Archives.

[25] BHC Collection, Series 6.3.6. The Guild — Operations — Looms and Weaving Correspondence, Box 98, University of Waterloo Archives. The history of the Thackeray loom in Canada is a tortured story. Mr. and Mrs. Thackeray were jointly granted a patent in England in 1925 and 1934. Frederick Robson of Ridpaths appeared to hold an unofficial patent for North America, applying for the rights on May 4, 1934, which were never legalized. The Clarks acquired it legally in August 1936. Litigation between Clark and Robson followed. Between lawyers' fees to patent agents, Ridout and Maybee, until 1947, and royalties on sales to Mrs. Thackeray, it is doubtful if the Clarks ever made a profit on the production of the Thackeray looms. The looms were named after their inventor, a Mr. Thackeray, who developed them for his invalid wife.

[26] Ibid Box 92. This is not to suggest there were not accomplished professional weavers in the Thirties; there were, and some had studios from which they sold work. A few banded together with other enthusiasts in 1939 at WAAC in Toronto to form the SWO, which will be detailed in the next chapter. The Guild's first librarian was professional weaver and teacher Nadine Angstrom, who also had weaving and yarn shops on Bloor Street West in Toronto and "The Shuttle" in Oakville, which she began in 1929 or 1930 and sold in 1960. It carried woollens and yarns, woven garments, skirt lengths, placemats, scarves, and curtaining. Angstrom died in Toronto in 1988, age 95.

[27] Ibid. Clark had proposed in a letter to C.L. Burton, president of Simpson's, on May 27, 1935, that Simpson's provide space on its sixth floor for a weaving school and headquarters of an organization he was forming with the backing of Ridpaths Limited: The Ontario Association of Hand-Loom Weavers, whose membership at that point was comprised of Guild staff, family members, and interested friends. Simpson's never bought into the plan, the Association remained on paper and the Simpson School on the third-floor needlework department was the only tangible result of the initiative, and it may have been no more than a temporary sales promotion.

[28] H.H. Stansfield came to Canada in 1922 and spent a decade at OCA, retiring in 1933 when his department was dismantled, after which he and his wife moved to Limberlost, near Huntsville. For a time, he was an associate editor of *Etcetera* magazine and stalwart supporter of HAC. In 1935 he and his wife, Hephzibah, a professional weaver, came back to the city, renting the Renzius studio premises at 65 Gerrard Street West. He taught art metalwork at Northern Vocational, to fill the void left by Rudy Renzius. Always frail, he died suddenly of an embolism in May 1937 in his early 50s. It seems likely that Hephzibah returned to her native England.

[29] Nancy Meek's comments and insights stem from a series of taped interviews with the author over a period of three years. She had saved photographs, order books, sketches, letters, and memorabilia, and on her death in March 1998 her daughter Judy Watson unearthed a wealth of additional material, which she shared with the author. In her wartime letters to her husband, John Pocock, for instance, Meek expressed her "non-violent beliefs," provided word sketches of Gerrard village life and of her struggles as a rising professional. Her work schedule for the first week of June, 1943, for instance, included making silver earrings, gold pendant, amethyst and silver ring, goldstone and silver ring, silver pendant, silver buttons, as well as designs for wedding rings. From her letters, we learn that although money was tight, she and her friends were able to go to movies, operas, concerts, plays, readings, enjoy meals out, and entertain on a modest scale. Support life in Toronto's Greenwich Village was clearly exceptional. Her accomplishments were chronicled in the *Globe and Mail*'s "Lives Lived" column April 10, 1998.

[30] *Globe and Mail*, Dec. 17, 1937. From the *Globe and Mail*, Sept. 6, 1948, we learn Adelaide Plumptree (1874–1948) was born in Surrey, England, and was a scholarship student at Oxford. A born organizer, since coming to Canada with her husband Rev. H. P. Plumptree, who eventually became a canon of the Anglican church, she founded the Canadian Girl Guides, was secretary of the Canadian Red Cross, chairman of the Toronto Board of Education, alderman of Toronto City Council, and author in 1935 of a major report to David Croll, recommending reforms in slum clearance, town planning, and annexations. She received a CBE in 1943 for her work organizing the Red Cross transport service overseas during World War II.

[31] There were several venues where craft and applied art were shown at the CNE at different times and under different sponsoring organizations: the JLT, The Guild of All Arts, The Federated Women's Institutes, WAAC and CHG, national and provincial. WAAC was the first organization to send a woman representative to the male-dominated CNE board of directors, while HAC/CHG/CGC had the longest-running association with the CNE. As for the locations on the CNE grounds, The Graphic Art Building (1908–1954) was decidedly more "art" oriented and the building was replaced by the Queen Elizabeth Building in 1957 where craft work was exhibited for a brief period. A wide range of craft work was shown throughout the Thirties in the Women's Building (1908–1961). Fire ended its usefulness. After 1970 craft work appears in the Arts, Crafts and Hobbies Building.

[32] Known Ontario craft participants to the Paris Expo of 1937 beside Meek were bookbinder Douglas Duncan and metalsmiths Andrew Fussell and Harold Stacey. Most would have been too impecunious to attend. The exhibition also included work selected from an exhibition at ROM Mar. 29–Apr.4 of CGP, shortly after it was formed in 1936. Little coverage of this exhibition has survived except for general reviews in *Saturday Night*, May 14, 1938; *Journal*, Royal Architectural Institute of Canada, Vol. 14, #10, 1937; *Canadian Geographical Journal*, Aug. 1937, and *The Curtain Call* Dec. 1936. Meek wore her gold wheatsheaf pin when she was invested with the Order of Ontario in 1992. An Eaton's vice president, O.D. Vaughan, stated in a 1964 interview that "the first launching of modern furniture was in the Paris Exposition of 1937." Eaton Collection, F229, Series 162, Box 18, Archives of Ontario.

[33] Elaine Levin tells us on p. 171 of her comprehensive *History of American Ceramics* that cash-strapped American universities in the Thirties and Forties first employed the bases of Singer sewing machines and their foot treadles to make potter's wheels. This adaptation forced potters to work small scale, but proved an invaluable assist in trimming press-molded work.

[34] "Millie" Ryerson's comments are from personal interviews conducted in Toronto in 1994 and Montreal in 1995.

[35] Space does not allow a full chronicle of the stalwart support to crafts made by the Howarths. They were founders of HAC (he was the first vice-president) and she was in on the ground floor of CGP in 1936. He received his training at the Royal College of Art in London, England, where he met his wife Zema Coghill, then a young South African furthering art studies in England. He was a well-known stained-glass designer throughout the Thirties and retired as director of art at

Central Technical School in 1955. Both were prominent members of the Ontario painting community and were active until they died: he in 1986, age 97, and she in 1987, age 87.

[36] Elizabeth Wyn Wood (Mrs. Emanuel Hahn) was speaking before the National Arts Club in New York City, Mar. 21, 1945. A partial text of her remarks was run in the 1945 summer issue of *Canadian Art*, p. 188–225. Some of her statistics are unreliable, but the general thrust of her remarks are of merit. Wyn Wood and her husband were subjects of a retrospective exhibition, *Tradition and Innovation in Sculpture*, at the McMichael Canadian Art Collection in summer 1997.

[37] As Teresa Casas explains in an unpublished University of Toronto graduate paper in 1986, Prof. Montgomery was a tireless advocate of research and development in order to build a strong national ceramic industry. In the mid-Thirties, Montgomery and colleagues were excited about the potential of the red and buff-burning fire clays of the Mattagami and Missinaibi Rivers in Northern Ontario. As it transpired, this red clay proved not satisfactory for potting without blending.

[38] CGP, MG 28, I III, Vol. 1, Minutes of Mar. 20, 1936 meeting, Ottawa, National Archives. The actual name was not adopted by vote until Feb. 6, 1937. Fee to join was 25 cents.

[39] For forty years the Ceramic National provided the major platform for ceramic artists in the U.S. and a springboard for younger artists. It was a distinct honour for Canadians to be asked to participate.

It had grown so large and successful in succeeding years that by 1972 it had become unmanageable and was discontinued.

[40] Reported in *Clay Products News and Ceramic Record*, August 1941.

[41] Nunzia D'Angelo Zavi died of cancer in 1968, a disease she battled for many years; Jarko Zavi remarried in 1976, lived at Brighton, and died in 1987 of a heart attack while fishing, a hobby that was one of his obsessions.

[42] For a history of MAG, see Anne Barros, *Ornament and Object: Canadian Jewellery and Metal Art 1946–1996*.

[43] Material from Doris McCarthy obtained in a personal interview at her Toronto home in 1992. Fussell taught at Central Technical School until 1977, and he died in 1983.

[44] Eric R. Arthur, M. A., A.R.I.B.A., was an architect with a special interest in restoration and preservation. He is best known for his book *Toronto: no mean city*, (Toronto: University of Toronto Press, 1964). Edward "Ned" Corbett (1887–1964) was a mover and shaker in many circles and was director of the Banff School of Fine Arts before coming to Toronto, where he pioneered the field of adult education and authored several books. Craftspeople remember him as warm, open, and so interested in the creative process that he made the rounds of local craft studios on a regular basis. His lifelong interest in crafts began while recuperating in a London hospital during World War I, where he learned to knit; later at a sani-

torium in B.C. he developed skills as a basketmaker.

[45] *Globe and Mail*, Apr. 29, 1942, pp. 5 and 8; *Evening Telegram*, Apr. 29, 1942, p. 16.

[46] *Design in Industry*, RG 107, Box 1, File 5, ROM Archives, Toronto. Ontario's pre-eminence in ceramics and metal crafts were mentioned by Wilfred Bovey in "A Survey of Domestic Art and Craft in Canadian Intellectual and Economic Life," in 1938, and by Elizabeth Wyn Wood in *Canadian Art*, Summer 1945.

[47] *Canadian Art*, Vol. II, #5, Summer 1945, p. 207

Chapter 3

[1] In 1947 OCA also established an industrial design department, the country's first school to do so. The federal government was then fostering peace-time uses for technologies developed in the war effort for which industrial designers were essential. In 1948 the federal government created the National Industrial Design Committee (later Council, an extension of the National Gallery of Canada) which, in turn, opened a design centre in Ottawa in 1953 and, in the Sixties, a Toronto subsidiary. Located in The Colonnade shopping centre, a short walk west from CHG's shop at 77 Bloor West, it existed until 1968.

[2] The Royal Ontario Museum Act of 1947 had a new clause (e) which added to its purposes "the co-operation with manufacturers or industry in Ontario for the

purpose of improving or expanding industrial design." It is not clear who initiated the new clause, ROM or the provincial legislature. Either way, it reflected the prevailing commitment to develop industrial design. Comments on this particular thrust are contained in an article by Robert Fulford, "They're Putting the Craftsman Back in Business," in *Mayfair*, May 1955.

[3] *Canadian Art*'s figures were in line with a 1950 report by Joseph Banigan of Ontario's Community Programmes Branch, who conducted a personal survey. In the face of no hard evidence because it just wasn't available, Banigan also concluded that craftspeople enriched the economy, buying about seven times as much in supplies and raw materials as they sold in finished products. Craftspeople and hobbyists, made for home or personal use, about twenty-two times as much as they sold finished products. *Canadian Art* magazine merits a brief look, especially when it broadened its mandate to include commentary and news of the fine craft scene in the hands of Alan Jarvis, who assumed the editorial mantle in 1959. Under him, the magazine ran a short-lived Canadian Fine Crafts section with portraits of craftspeople, reports of visits to various studios, profiles of craft organizations such as the Canadian Guild of Potters, and discussions of issues relevant to the professionally oriented.

[4] James Lemon, *Toronto Since 1918*, pp. 113 and 195.

[5] Kidick's comments originate from personal interviews in 1994 and 1995. In 1950 many potters continued to work with earthenware, a less expensive but more perishable low-firing clay that conventional electric kilns with less powerful elements could accommodate. As for her colleagues, Ross died in 1967 of cancer by which time she had established a solid reputation for superbly executed stoneware. Ross had a year's work and study with Kjeld and Erica Deichmann in New Brunswick and ten years at Coboconk before relocating to Toronto. For a time, she and McKillop taught pottery at Mooredale House in Toronto's Moore Park district.

[6] Material on the Burnhams acquired during a 1992 interview with Dorothy Burnham in Ottawa and from *Rotunda*, Summer 1986, and the *Globe and Mail*, Apr. 23, 1992.

[7] Harold Burnham, "What Is a Professional Craftsman," *Canadian Art*, Vol. XVI, no. 4, Nov. 1959, pp. 248–9. Four years earlier, potter Nunzia d'Angelo Zavi had written the CHG executive from her home in Cobourg, defining what she meant by the word "professional" and concerned about the quality of work for sale in The Guild Shop made by amateurs. See also end note 34, below. No more passionate advocate for the professional designation "artist-craftsperson" existed than Toronto metalsmith Harold Stacey, who had an uphill struggle all his career since the term appeared infrequently in Canada during his lifetime.

[8] The Kingston Hand-Weavers Club (in 1951 renamed Kingston Handloom Weavers) was one of a number of early weaving guilds that sprung up in Ontario in the Forties. The first was the SWO, begun in 1939; the second was in Ottawa where a group functioned from 1943–46 under the Ottawa Civil Service Recreation Association. In 1947 the Bytown Weavers' Guild began and two years later became the Ottawa Valley Weavers' Guild. Also in 1947 the Thunder Bay Weavers' Guild came together. Hard on their heels was the Arachne Weavers' Guild in St. Catharines [now defunct], Hamilton Weavers' Guild, Niagara Weavers' Guild (now known as the Niagara Handweavers and Spinners Guild), the London District Weavers, and the Nipissing Handweavers Guild. Most became affiliates of CHG and grew out of weaving classes conducted by the Home Weaving Service. The Kingston group begun by "Rie" Bannister was particularly distinguished. Its first president, Cora Reid, was also the first president of the OHS when it was formed in 1956. She and her husband, George, were expert weavers and teachers.

[9] Material on Mary Eileen "Bunty" Muff Hogg gathered in interviews in 1994 and 1995.

[10] About the singular Karen Bulow, "Bunty" Muff Hogg commented, "No one I've ever met had her way of putting colours together. Karen never designed anything to be woven with one colour thread; you had to have two or three. There would never be a straight red thread but red tempered with orange, dark crimson, etc." "Slatey" tones with subtle grey effects were Bulow's favourites, however. One of her employees in her Montreal studio

workshop was Latvian-born weaver Velta Vilsons who came to Montreal in 1952 and worked for Bulow at a dollar an hour for two-and-a-half years prior to setting up her own business in Toronto, where she became well known to decorators for her fabric yardages. Although long in retirement, Vilsons still executes striking wallhangings.

[11] Oscar Bériau letter Dec. 15, 1945; Ontario Dept. of Education, RG2, Series S-6, Box 1, Archives of Ontario. Bériau was director of home economics and handicrafts for the Province of Quebec, and at the time of his retirement in 1943 was considered a Canadian authority on all crafts. The wording of a letter Bériau received from Trade and Industry Branch Director C.H. McL. Burns on Dec. 8, 1945, is interesting and illustrates the lack of comprehension in government circles about the length of time it takes to develop into a competent craftsperson with an understanding of good design principles. As were so many in government service, Burns was a World War II veteran.

Burns wrote: "This department has had under consideration for some time the development of handicrafts in the rural and northern sections of the Province of Ontario, as an industrial development, rather than just a spare-time or part-time job for women folk in isolated districts.

"The Canadian Handicrafts Guild is sponsoring the organization of training centres or groups in various urban and rural sections of the province with the idea of creating social activity for women folk in isolated districts, giving housewives and other women something to occupy their spare time, and a means of earning a small part-time income.

"From our point of view, this is a very good idea and has much to commend it, but we are thinking more of small communities in rural sections of Southern Ontario, and particularly the small communities of the North Country, from which particularly female help must of necessity leave home and go to large urban centres in search of employment. We have been thinking that possibly we might establish in some of the smaller communities small handicraft industries, if you like, where from five to fifteen girls or women might be employed full-time, manufacturing homemade mats, carpets, weaving homespun scarves, neck ties, curtains, etc. and where some old men or women who are incapacitated for work in the mines could be employed in the manufacture of wood or metal products …" Ontario Department of Education, RG 2, Community Programmes Branch, Series S-6, Box 1, Archives of Ontario.

[12] Joseph Banigan to E.C. Cross, director, Community Programs, Dept. of Education, Dec. 16, 1948. Ontario Dept. of Education RG2, Series S-1, Archives of Ontario. At this point forty-eight looms were used for teaching, five courses were in operation, and 300 pupils had received instruction. Cross had been a wing commander in World War II and was one of the few bureaucrats enthusiastic about crafts. He died a few months after attending a conference in Britain. By 1951 Banigan reported that his department had taught basic weaving to 730 Ontario citizens in forty-five communities. Ibid, S-2, Box 1.

[13] Although "Bunty" Muff frequently received requests that said "I have cut down a tree, dried out the wood, how do I build a loom and learn to weave?" it would seem that many pupils somehow afforded a new loom. The LeClerc company of Quebec, the largest supplier of handlooms in Canada, reported in 1951 that it manufactured 2,500 looms per year and had 800 recent customers in Ontario. In a speech in 1973, Muff told her audience that a Native pupil, Agatha Naponse, was so determined to have her own loom that she and her family picked blueberries one whole summer to earn enough money to purchase a loom, continue lessons, and work at home. It was Naponse's prized possession.

[14] It's worth noting that among the best weavers in Canada in 1953 were Ontario's redoubtable Signe Lundberg, who won in three categories (linen placemats, drapery material, and upholstery) and Harold Burnham in two (linen towels and tweed-apparel fabric.)

[15] Jessie A. Norris, *The Book of Giving*, p. 12.

[16] Ibid, p. 13.

[17] Harold Burnham, "Crafts Give Me The Creeps," at a craft seminar held at OCA, Feb. 18, 1959. Private papers of Dorothy K. Burnham and also in *Canadian Art*, Vol. XVI, #4, Nov. 1959. Author Chloe Colchester, in *The New Textiles*, comments (p. 105) that "craft weavers reacted against the mechanical perfection and smooth finish of industrially produced

cloth by creating rougher, 'wholesome' cloths that proclaimed the fact they were hand-made. It is possible that in its imitative tendencies and capabilities, industry drove crafts towards the exaggeration of the hand-made aesthetic."

[18] In a memo dated Jan. 14, 1955, K.L. Young, then director, Community Programmes Branch, wrote that "it is apparent that we cannot accept the responsibility for teaching weaving skills to all of the people in Ontario who wish to learn them." Ontario Department of Education, RG 2, Community Programmes Branch, S-2, Box 1, Archives of Ontario.

[19] John Pocock letter, MAG Archives, Minutes 1947-48. This controversy was also discussed by Blodwin Davies in *Saturday Night*, Nov. 20, 1948, pp. 18–19. She suggested that one answer was to establish subsidized ateliers where quality teaching could go on. The CHG executive, in fact, was all too aware of the superficial approach of communities to craft courses. In her annual report for the year 1947–48, stalwart executive secretary Ruth M. Home said, "we are balked by finances. The communities do not see the value of quality in instruction and the necessity of adequate equipment. They will not pay the fees asked by the good craftsmen nor do they consider a lengthy period of instruction necessary for their instructors. Until this attitude changes, the Guild's services to the communities will also be restricted." Weaving was the most expensive program to operate since classes had to have small numbers in rooms large enough to hold all the floor looms. Other than weaving classes, the Guild said its craft programs paid for themselves from fees charged.

[20] OCA also offered veterans furniture and cabinet making with Frank Carrington and Gordon Yearsley, weaving with Wanda Nelles, pottery with Gladys Montgomery, Grant Wylie, and John McLellan, in that order, bookbinding with Amy Despard, leathercraft with Frances Neil, and museum research studies with Ruth Home. By the mid-Fifties such courses had become electives or dropped altogether when the college reorganized its programs, something it seemed to do on a frequent basis.

[21] A valued source of information about "Mackie" Cryderman and her community is contained in *The Art of London 1830–1980*, by Nancy Geddes Poole (London: Blackpool Press, 1984).

[22] Bill Reid in *Ryerson Rambler*, Issue 28, Fall 1985, p. 10, Ryerson University Archives. Reid was one of Canada's most distinguished and honoured craftspersons. Born in Victoria, B.C., in 1920, he was made a Fellow of Ryerson in 1985 and received the Saidye Bronfman Award for Excellence in the Crafts the following year. He is profiled in Doris Shadbolt's *Bill Reid* (Vancouver: Douglas & McIntyre, 1986). Reid died in 1998.

[23] Substantiated by Dormer & Turner, *The New Jewelry*, p. 7.

[24] Anecdote related by Donald L. McKinley in an interview with the author in spring 1996, talking about the period when he directed OCF's School of Design in Lorne Park, a community now part of the the city of Mississauga. McKinley died suddenly in 1998, and an appreciation of him appeared in the *Globe and Mail*'s "Lives Lived" column Feb. 5, 1998.

[25] The MAG submission was one of forty-four from the craft area to The Royal Commission on National Development in the Arts, Letters and Sciences, chaired by Rt. Hon. Vincent Massey, whom Prof. Robert Bothwell dubbed "the most apparently cultured Canadian of his day." In the official Massey report of 1951, handicrafts were viewed as "the practical arts," and the responsibility not of the federal government, but of the provinces and various voluntary organizations. When Massey became governor-general in 1952, he saw first-hand what one branch of "the practical arts" was all about. He attended the annual MAG exhibition in Toronto accompanied by president Nancy Meek attired in her only good pair of shoes, which had flapping soles held on with rubber bands. She recalled Massey's amazement: "I had no idea that Canadians did work like this or had craftsmen like this. This is beautiful work and very professional."

[26] We are indebted to Stacey's daughter Callie and son Robert for insights into his career and temperament. After Stacey's death from cancer in March 1979, age 68, Robert wrote two articles: for *Canada Crafts* Jan./Feb. 1980, pp. 4–7 and for *Metalsmith*, Spring 1985, pp. 11–15. At about the time Stacey left Canada and went to Corning, an informative article appeared in *Mayfair*, Vol. XXV, no. 4, Apr. 1951, pp. 55–56. The unidentified

writer commented that Stacey "is dedicated to no school or period of the past; he strains for no radical effects, no self-conscious modernism, no tortured originality … With a true artist's individuality he has construed grace and beauty in his own terms, insisting always on forms appropriate to the materials used, and on practical suitability of the article to the purpose for which it is designed and made." American Margret Craver Withers, herself a metalsmith, knew Stacey from his work with Baron Fleming, and commented to Callie Stacey in 1991 that "I always thought of him as a talented silversmith, innovative and industrious as well as an especially fine person."

27 Pearl McCarthy, "Art and Artists," *Globe and Mail*, Nov. 1, 1958. The tax exemption issue is vexing and not altogether clear. It seems Stacey's modest victory was rather short-lived. Craft taxation authority Peter Weinrich, then executive director of the CCC, says that rates varied over the years. Toronto stained-glass designer-maker Gerald Tooke successfully lobbied federal finance authorities in the 1960s to have stained-glass work of all kinds exempted. Lobbying of one sort and another was carried out in a desultory manner to have taxes removed from crafts, but there was not much success until the CCC took up the issue in 1975–76. Weinrich says that in 1977–78 two federal orders-in-council were produced; the first exempted bona-fide crafts from the federal sales tax, although not from the excise tax; the second increased the minimum tax level to $50,000 and then to

about $75,000. The Excise Tax remained despite CCC's forceful presentations that classing gold and silver as "luxury" goods was absurd in the 1970s. The advent of the GST allowed no exemptions.

28 Graham McInnes, *Saturday Night*, June 25, 1938.

29 The PreRaphaelite Brotherhood was founded in England in 1848 and members demonstrated a love of literature and history together with a deep interest in the art that preceded Raphael and other Renaissance masters. The Brotherhood fought against indifference, smugness, and an increasingly mechanized society, and encouraged artists to work against popular expectations and norms.

30 *Artisan*, Vol. 2, #3 May/June 1979. Other material on Williams appeared in *Canada Crafts*, Oct./Nov. 1978, and *Ontario Craft*, Winter 1984, *Mayfair*, Dec. 1954, p. 23–50, and many others. She is the subject of a 1994 York University research paper by Judith Baldwin, *Industry Into Art: The Yvonne Williams Studio 1932–1971 and Beyond*. Born 1901 in Port of Spain, Trinidad she retired to Parry Sound where the author interviewed her in 1992 and 1994. A retrospective of her smaller pieces was staged at the inaugural exhibition of C₂G₂ in Waterloo in 1993. Her extensive papers and records chronicle more than 400 commissions and reside in the Baldwin Room of the Toronto Reference Library. Her contribution to her medium was recognized in a "Lives Lived" column in the *Globe and Mail*, Dec. 24, 1997.

31 The Toronto freelance stained-glass com-

munity included Gerald Tooke, who arrived from England in 1954 and worked for Luxfer Studios on Parliament Street before going out on his own; he was elected to RCA in 1966. Others were Stephen Taylor, who had also come from England and worked alongside Yvonne Williams in her studio for some years; Jim Meeken from Scotland; Esther Johnson, Grace Allen, Marjorie Nazier, Russell Goodman, who also worked at Luxfer for a time and received a Membership in OC in 1988, and Peter Howarth, who retired from Central Technical School in 1955.

32 1949 Annual Report of CHG, fundraising literature, OCC Archives.

33 The associate groups were represented by: Mrs. Gordon Garrow, Garroway Farms, near Brockville; Mr. and Mrs. John Aird for the Mary Mundell Shop in North Toronto; Mrs. T.L. Armstrong and Mrs. H.E. Martin of the Sherwood Shop in North Toronto; and Mr. and Mrs. Eric Warrington, London. McDairmid's in Oakville tried it for a few months. The Guild never had sufficient capital to expand its retail capacity. It was ironic that the board promoted what was sold in The Guild Shop as setting the standard when craftspeople thought otherwise. Potter Nunzia D'Angelo Zavi, for instance, wrote in 1955 that Guild Shop buyers did not seem aware that some amateur craftspeople were using manufacturing methods in their craft work, and by accepting such work for sale in the shop, the standard of craftsmanship was lowered. In May that same year, potter

Bailie Leslie who represented CGP on the CHG board, reported on the issue of appraising work for sale in The Guild Shop and suggested experienced members, from the affiliates, spend time at the shop to help new staff. Clearly standards of work for sale in The Guild Shop varied widely. A survey history of The Guild Shop by the author appears in *CraftNews*, April 1992.

34 C.J. Laurin, 1953 Annual Report of the President, OCC Collection, MU5749, bt, Archives of Ontario. Danish-born B.A. Oil executive and craft champion Thor Hansen affirmed Laurin's thoughts in a 1957 speech, one of many he made lamenting the fact that tourists could not buy Ontario-made souvenirs in Ontario. His analysis was that "most Canadian producers of high quality crafts are not producing to supply any market. They are producing to satisfy their own aesthetic needs." He identified three obstacles to developing a Canadian souvenir market: lack of good design, lack of volume production, and lack of organized distribution. OCC Collection, MU5780, Fu, Archives of Ontario. In 1957 *The Financial Post*, too, claimed there was a twelve million dollar tourist market waiting to be developed.

35 "Millie" Ryerson was interviewed by the author in Toronto and Montreal in 1994 and 1995.

36 "The Kingcrafts Story," by Lady Flavelle, OCC Collection, MU5757, CL6, Archives of Ontario.

37 Ferro Enamels (Canada) Ltd. established a branch in Oakville in the 1930s and supplied kilns, wheels, glazes, frits, etc. Mavor was determined to develop a Canadian product, and in the early Fifties hired Danish-born and European-trained Jorgen Poschmann and accomplished potter Molly Satterly to produce a catalogue of supplies available from Oakville, illustrated with work by leading Canadian potters. Mavor sat on the board of CHG, gave annual prizes in pottery competitions, and offered to outfit the hapless Ontario Handicraft Centre's pottery section when it was completed. He also equipped private schools in Ontario with kilns at a time when work with clay was centred on hand-building.

38 Some of the established Ontario personalities in CGP by 1957 were "Bobs" Howarth who had 125 to 150 day students in her pottery classes at Central Technical School and 200 at night; Evelyn Charles, Norine Rive, Helen Duncan, Eileen Hazell, Helen Copeland, Cay Lloyd, Mary Dickenson, Molly Satterly, Kathleen McKim; and Konrad Sadowski, head of pottery at OCA since 1953. Up-and-comers included Merton Chambers, Joseph Barfoot, Don Wallace, and Roman Bartkiw. The list would certainly have included clay sculptor and activist Dora Wechsler, had she not died of cancer in 1952.

39 Remarkably, only five years after their studio was formed, all five of the potters were honoured at the 3rd International Ceramic Exhibition in Prague in 1962 — two golds and three silvers.

40 Buchanan, as associate director, was responsible for the National Gallery's fine-craft exhibition from which fifty outstanding pieces by the "touchstones" were selected to represent Canada at the Brussels Expo in 1958 in the fields of ceramics, enamels, jewellery, silverwork, weaving, and wood. Of these, sixteen were from Ontario: potters Evelyn Charles, Mary B. Dickenson, Bailey Leslie, Konrad Sadowski, Donald Wallace, Tess Kidick, Kit Ross, and Molly Satterly; jeweller Nancy Meek Pocock; weavers Eunice Anders, Harold Burnham, Esther Hansen, Krystyna Sadowska, Mrs. E.L. Stolfe, Velta Vilsons; and woodcarver Victor Tolgyesy.

Chapter 4

1 Letter to Hon. William Davis from OCF President Murray Wilson, Mar. 1, 1967. Ontario Department of Education, RG2, OCF, P3, Box 454, 2-906-0, Archives of Ontario.

2 The Canadian Conference of the Arts, a non-profit organization, grew out of the Canadian Arts Council, formed in 1945, and acquired its present name in 1958 to distinguish it from CC formed in 1957. Also serving craftspeople in a broad context was the Ottawa-based Canadian Craftsmen's Association begun in 1965. After nine years it amalgamated with the venerable Canadian Guild of Crafts (national), based in Montreal, to form CCC in 1974; lack of government funding has altered the nature of CCC's work. Arthur Gelber played a distinguished role in Canadian cultural circles as

philanthropist and culture vulture, whose essence was caught by Mavor Moore in the *Globe and Mail*'s "Lives Lived" column Jan. 13, 1998.

3 Roy MacSkimming, *For Arts' Sake: A History of the Ontario Arts Council 1963–1983*, p. 25.

4 For more details, see Fern Bayer, *The Ontario Collection.*

5 Reported by Arnold Edinborough in *The Financial Post*, Feb. 13, 1971, p. 18. Mr. Edinborough's arts column first appeared in Dec. 1969, and it reflected his commitment to bring the business and arts communities closer together, and through CBAC (Council for Business and The Arts in Canada) to encourage the private sector to invest money in cultural projects and organizations.

6 *Craftsman/L'Artisan*, Vol. 5, #2, 1972.

7 Chloé Colchester in *The New Textiles*, p. 139 says that fibre art became a standard solution for enlivening stark interiors built in Modernist style, since it was one of the few decorative forms approved by the Bauhaus and Corbusier and thus acceptable to architects. Lloyd Herman in his introduction to the catalogue for *Art That Works* (1990) also provides a neat summary of this point.

8 Garth Clark, *American Ceramics 1876 to the Present*, has revealing insights on this period. For another perspective on changing values, read Rose Slivka, "The New Ceramic Presence," *Craft Horizons*, Aug. 1961. Toronto lawyer and ceramic collector Aaron Milrad also has put his spin on collecting work from this period in the catalogue for *The Collector's Eye.*

9 "Report Prepared for the Province of Ontario Conference on the Arts meeting with Community Programmes Branch, Department of Education, March 20, 1964, Westbury Hotel, Toronto," Archives of Canadian Craft, OCF, MU5746 (3140/21), Archives of Ontario.

10 Murray Wilson, OCF president, to Hon. W. G. Davis, Mar. 1, 1967, Ontario Department of Education, RG2, OCF P3, Box 454, 2-960-0, Archives of Ontario.

11 Roy MacSkimming, *For Art's Sake.* p. 25.

12 Undated brief prepared by George Hancock, ed., *Canadian Homes Magazine*; G. Geldard Brigden of Brigden's Limited; and Hero W. Kielman of the Provincial Institute of Trades, Archives of Canadian Crafts, MU5746 (3140/21), Archives of Ontario. The trio pointed out that Community Programmes had "succeeded almost too well in its aims" for it has "created a groundswell of interest in the craft arts, has turned up some fantastically talented people, yet is unable to carry these people into what must become the next step of their training: an advanced study of both the techniques of their craft and an understanding of the pedagogy necessary to train others in their art."

13 CHC/CGC wisely decided to stay in the Bloor–Avenue Road area where, in 1966, the Bloor subway line had opened, making the district much more accessible to the buying public. A shop at 140 Cumberland, formerly owned by interior designer Freda James, was duly purchased for $105,000 and The Guild Shop re-opened there in 1969, where it remained until 1996 at which time it relocated a few doors east.

14 Aileen Webb (Mrs. Vanderbilt Webb) was a matchless figure in craft circles at this time. In addition to her seminal work in the American Craftsmen's Council (later the American Craft Council) and *Craft Horizons* magazine, she staged the founding meeting of WCC at Columbia University in New York in 1963, an organization that many Ontario craftspeople supported. Mrs. Webb came to Canada again as closing speaker for a conference in Kingston organized by the Canadian Craftsmen's Association in 1967, and for the WCC conference and exhibition in Toronto in 1974. She died four years later, age 87.

15 OCF had a very strong founding board of directors, who were hardly dreamers, however. President was Murray Wilson, who had been president of CGC just prior to taking on the OCF mantle. Vice-president was metalsmith Harold G. Stacey, and directors were Anita Aarons, Douglas Boyd, Evelyn Brownell, Jo Carson, Helen Copeland, Arthur E. Gelber, John C. Thorsen, and R. Michael Warren. It had, in addition, an advisory board of representatives from many disciplines, and six regional directors, so it covered the province.

16 The Archives of Ontario houses some OCF material under MU5746-9, OCC Collection. Gordon Barnes, a 1962 MFA graduate of Alfred University, New York, came to Toronto to succeed "Bobs" Coghill Howarth as pottery instructor at Central Technical School. In 1968 he became administrative director of OCF until 1972 when he moved to the King

Campus of Seneca College to direct its visual arts centre.

[17] For its first year in 1967–68, OCF's design school had fifty students and a projected budget slightly above a quarter of a million dollars to cover salaries, rent, light, heat, gallery operations, and travel. Cost per student in 1967 was $4,780. Sheridan's School of Craft and Design has a budget several times that figure today. Other colleges to survive budget cuts, downsizing, and changing priorities and still offer limited craft programs are Georgian College in Barrie, Cambrian in Sudbury, Canadore in North Bay, George Brown in Toronto, and Northern in South Porcupine. There are those in the craft community who believe it would have been better if the OCF Design School had remained outside the community college system, kept its separate location, and been given its own constitution and funding — the original intentions of OCF.

[18] David Piper to the annual general meeting of OCF, June 15, 1974.

[19] "Letter to T.M. Eberlee from R.E. Secord, May 9, 1973, Archives of Canadian Crafts, MU5746 (3140-21), File BH2, Archives of Ontario. Once William Davis became premier in 1971 he broke up his education ministry and OCF was re-assigned to Community and Social Services.

[20] Raymond Moriyama, Future of the Guild Report, as given at the 43rd annual general meeting of CGC (previously CHG and HAC) at Canada Life Place, Toronto, Apr. 25, 1975. His entire report has

cogent observations and a sensitive analysis of issues.

[21] It would be a grievous omission not to add that the success of these exhibitions, their predecessors and those at the CNE would not have been possible without CHG/CGC's volunteer detachment and the Women's Committee. Both deserve a chapter of their own. Formed in 1953, the Women's Committee soon organized visits to craft studios in Southern Ontario — which it still does — and in 1958, established a scholarship fund for advanced study for professionals. First recipient was bookbinder Robert Muma. That commitment continues. For years the Committee also donated prize money to the CNE. Members have always served as gallery hostesses, and their annual brochure *Canadian Crafts in Toronto* is a fixture of the hotel and tourist business. The group has donated at least 250 person hours each month to OCC programs. In the late Sixties, the Exhibition chair was the incomparable Marjory Wilton, whose magnetic personality and inspiring leadership made the most complicated undertakings a success. After her swansong, *Craft Dimensions Canada*, she replaced herself with an energetic newcomer, M. Joan Chalmers, who later turned over the reins to Alan Campaigne, director of design marketing for Arthur Sanderson Canada, when she shouldered heavier responsibilities for CGC.

[22] Ontario finalists for *In Praise of Hands* included potters Bailey Leslie, Mary Keepax, Ruth Gowdy McKinley; glassblower Robert Held; jeweller Haaken

Baaken; fibre artists Elin Corneil, Heidi Roukema, and Hilde Schreier; enamellist A. Alan Perkins. The other Canadians were William Reid of Montreal, Richard Hunter of Victoria, and Winnie Tatya Putumiraqtuq of Winnipeg. The actual attendance figures tabulated by the Ontario Science Centre were 667,053, impressive when compared with the King Tut exhibition at AGO in 1979, three-quarters of a million, and the Renoir exhibition at the National Gallery in 1997 which drew some 300,000. Word has it that the chair of CGC's Women's Committee, Ruth Markowitz, refused to allow a transit strike to prevent her from manning a CGC booth at the Science Centre, so she hitch-hiked.

[23] Don Smith, "Proving It Can Be Done in Muskoka," *The Muskoka Sun*, July 6, 1972, p. 21, and "Suncraft," *Craft Dimensions/Artisanales*, Aug. 1972, p. 8. In the same issue, on p. 31, the latter publication pointed out that in 1971 there were 37 craft projects receiving government support totalling $342,707. Arts-related projects, in general, received just under 10 percent of all government allocations.

[24] Moligan also received a $1,000 grant in May 1974 from CGC, and suppliers also assisted. You can read about him in "Moligan Pottery Workshops," *Craft Ontario*, Vol. 9, #2, Feb. 1975, and "Moligan's Mobile Workshop," *Craft Dimensions/Artisanales* June/July 1974. For background on the Craft Truckers project read *Craft Ontario*, Vol. 6, #5, Sept./ Oct. 1972 and Vol. 7, #4, Oct./ Nov. 1973. This was not all. CGC also

administered a Craftmobile project in which craft objects, prepacked in plastic cases, toured smaller centres. There were other local initiatives too numerous to mention here.

25 Read "The Indusmin Collection," *City and Country Home*, Apr. 1984, and "Handcrafts Humanize a Toronto Office," *Craft Ontario*, Vol. 9, #4, Apr. 1975. The company was better known as Indusmin Limited, a name it did not acquire until 1968. From 1964–68 it was Industrial Minerals of Canada Limited, and from 1946–64 American Nepheline Limited. Indusmin became a subsidiary of Falconbridge Nickel Mines Ltd., who sold it in 1990, at which time its prized craft collection of 173 pieces was given to the new C_2G_2 in Waterloo. Indusmin and its presidents, John Mather and Kelly Woodruff, were exemplary in their support of clay and glass. Their company donated prize money to juried craft competitions at the CNE for many years and paid the first year's rent for The Pottery Shop when it opened at 100 Avenue Road in 1962. Mather was a president of OCF and founding treasurer of OCC in 1976. He died in a plane crash in 1977, and his name is perpetuated in the annual John Mather Award at the OCC from funds provided by Falconbridge through Indusmin.

26 In addition to government buildings and major corporations, a legion of other sources commissioned work from craftspeople working in the clay, fibre, glass, leather, metal, and wood mediums. The range of clients was too varied to detail

here but would have included educational institutions, churches, theatres, hotels, libraries, athletic clubs, shopping centres, auditoriums, court houses, law offices, banks, and restaurants. For more details, read Jeanne Parkin's *Art in Architecture: Art For The Built Environment*. Many other commissions obtained through private art consultants were not recorded, unfortunately.

27 Mary Eileen Muff married Frank Hogg in 1971 and retired in 1975. Walter Sunahara continued his outreach work at OAC, especially in the Native and folk art fields, from 1977 to 1993, when he retired.

28 Comments by A. Alan Perkins, Walter Sunahara, and Donn Zver emanate from conversations and recorded interviews with the author over a three-year period, 1993–96.

29 Aiken-Barnes, when a resident of Gravenhurst, made these comments in a 1975 interview for the radio program "The Artisans," hosted by potter Bonita Collins, a copy of which is in OCC's Craft Resource Centre. Her other comments stem from interviews with the author in 1993 and 1996 at her home in Aurora.

30 Today with 300 members, MAC offers an extensive program of monthly exhibitions, workshops, newsletters, and guest speakers. Since 1963, it has also held a July show and sale in Bracebridge, which has become a staple of Muskoka summer events, attracting 35,000 to 40,000 people. In addition, it holds a Christmas show and a spring members' exhibition. It became incorporated in 1981, and in 1989 began operating with a curator in

The Chapel Gallery, Bracebridge. In its early days, it made annual donations to the local hospital. Today, it gives a $1,000 bursary to a graduating Muskoka high school student pursuing a post-secondary education in visual arts. MAC has calculated that its presence in Muskoka now generates half a million dollars in revenue for the community.

31 The 1968 tapestry is pictured and described in detail on page 14 of *Art of the Spirit: Contemporary Canadian Fabric Art* by Bradfield, Pringle, and Ridout. In her introduction to the book, Prof. Nancy-Lou Patterson says that Aiken-Barnes, assisted by OCF, organized a series of five annual exhibitions of liturgical textiles by Canadian artists. With one exception, they were held in Gravenhurst between 1970 and 1974. Patterson maintains these were important showcases for bringing liturgical textiles into the public eye and greatly encouraging their production. A crop of liturgical exhibitions by textile artists has occurred since, the most sweeping staged at The Cathedral Church of St. James in Toronto in 1989, *Liturgical Arts Festival: Contemporary Liturgical Art in Fabric*, organized by the above-mentioned writers whose contribution to the whole field of textile liturgical expression is exceptional. Bradfield estimates there are some ninety outstanding textile artists in Ontario presently engaged in liturgical art projects, which probably represents about three-quarters of the Canadian total, although Bradfield cautions that firm figures are impossible to establish.

32 You can read about Aiken-Barnes's project

in two articles: "Tower Studio," by Joan Carter in *Craft Dimensions* June/July 1975, and *Craft Ontario*, Vol. 9, #4, Apr. 1975, p. 13–14.

33 See *Ontario Crafts*, Spring, 1991, p. 7, "Hands Across the Border." The interests of the fibre world were gradually represented by several guilds: OHS formed in 1956; OHCG in 1966; Embroiderers' Association of Canada in 1973; SUR 1979; CQA 1981; The Basketry Network 1988; Ontario Quilting Connections 1988. Ontario Quilting Connections is a grass-roots organization, which has more than sixty member guilds representing some 5,400 individuals, who receive its newsletter and attend its workshops. There are many others who quilt outside a guild structure and who defy enumeration.

34 Influential quilt exhibitions were: *Optical Quilts* at the Newark Museum in 1965, and *Abstract Design in American Quilts* at the Whitney Museum of American Art, New York, 1971, organized by Jonathan Holstein and Gail Van der Hoof. The latter was reviewed by David Shapiro in *Craft Horizons*, Dec. 1971. For an authoritative and compelling review of the contemporary quilt's rise in favour, read *The Art Quilt* by Penny McMorris and Michael Kile. In Ontario, Ann Bird provides a good overview in "Quilts Today," *Ontario Craft*, Winter 1986.

35 *Craft Dimensions/Artisanales*, Dec./Jan. 1975, was devoted entirely to contemporary quilting in Canada to complement *Tradition +1*. Some but not all of the exhibitions that followed it were *More Than Comfort* at BCC (now BAC) in 1982;

Breaking With Tradition at Oakville's Centennial Gallery in 1983; *The Quilted Statement* in 1984 and the *Contemporary Canadian Quilt* in 1985, both by OCC; *The Uncommon Quilt* at the McIntosh Gallery in London in 1985. Of particular interest is Mary M. Conroy's article "Canada Quilts Today," which appeared in the Dec. 1974/Jan. 1975 issue of *Craft Dimensions/Artisanales*. *Canada Crafts* Aug./Sept. 1977 also ran an article by Rena Szajman, "Beyond Comfort Quilting." For fascinating broader perspectives, read two chapters from Chloë Colchester's *The New Textiles Trends + Traditions*: "Craft Textiles" pp. 105–112 and "Textile Art" pp. 137–144.

36 Ontario potters were reflecting a North American concern. Of this period, ceramic historian Garth Clark, on p. 136 of *The Potter's Art*, talks about the "schizophrenic polarities of the modern potter, torn between the practical, artisanal world of craft on the one hand and the subjectivity of the fine arts on the other. The divide remains even today," he says. On p. 177 of his *American Ceramics*, Clark also discusses the question through the eye of American critic Clement Greenberg.

37 Quoted by Gordon Barnes in *Craft Ontario*, Vol. 9, #12, Dec. 1975. American pottery guru Daniel Rhodes provides a lively and thoughtful discussion on the canons of taste in "Pottery Design," in *The Clay Products News*, Vol. XXXII, no. 7, July 1959. Comments from Mahut in this and the next chapter stem from a recorded interview in 1993, just before she retired after eighteen years of directing The

Koffler Gallery in North York. Although fond of all crafts, she was particularly sensitive to works in clay and glass.

38 By carrying Eskimo carvings, prints, and weavings in a separate section of the shop, which The Pottery Shop did not, The Guild Shop was able to enhance its profit picture considerably. Its 1976 sales total of $552,389, representing pottery sales of $6,766, for instance, netted a profit of $112,130. The Guild Shop also did not jury what it accepted for sale, as did The Pottery Shop, a procedure some of its members consistently urged it to adopt.

39 *Ceramics Monthly*, Sept. 1978, pp. 43–52 carried an article by Luke Lindoe and photo coverage of the work of the members of Ceramic Masters Canada: Keith Campbell, Ont.; Georget Cournoyer, Que.; Walter Drohan, B.C.; Jacques Garnier, Que.; Robert Held, Ont.; Jack and Lorraine Herman, Ont.; Robin Hopper, Ont. & B.C.; Roger Kerslake, Ont.; Luke Lindoe, Sask.; Ruth Gowdy McKinley, Ont.; Ann Mortimer, Ont.; and Maurice Savoie, Que.

40 OPA's founding board of directors consisted of president Donn Zver, Hamilton; first vice-president Joan Walsh, Kitchener; second vice-president Chris Bell, Timmins; secretary-treasurer George Erenburg, Simcoe; exhibition and sales Anne Sneath, Dundas, and Ingrid Levine, Ottawa; education and workshop Bill McCauley, Toronto, and Barbara Sharp, Burlington; and publicity and newsletter Mavis Bland, Newmarket. Other directors were John Hatashita, Waterloo; George Harrison,

Hamilton; Sandra Silcox, King City; and Minnie Hoffman, Waterloo. *Tactile*, May/June 1975.

[41] It's no accident that many guilds formed after community colleges opened in 1967, often under the ceramic teacher, and a decade or so after many students had their start in weekend workshops and courses organized by Community Programmes Branch. By way of illustration, Burlington potters came together in 1969, Hamilton and Region 1971, Kingston 1967, Ottawa 1974, Stratford 1972, Sudbury Basin 1970, and Waterloo 1967. Thunder Bay formed its potters' guild in 1976, although a multi-craft organization including potters had existed since 1971. Toronto potters formed a co-operative, The Potter's Studio, in 1972. Hamilton and district potters would have been well aware of centres of clay activity outside Toronto by 1975, through meetings. Studio potters thought nothing of travelling considerable distances to take refresher courses; attend workshops given by visiting international experts, usually brought in by CGP and held at community colleges; or to participate in meetings and conferences of OCF, for which some potters like Zver served on subcommittees. OCF publications regularly provided readers with regional news, and *Craft Dimensions*, April/May 1975, gave background on some CGC affiliates, reflecting that organization's new resolve to strengthen its activities in the regions. It's also no accident that OPA began in Hamilton. The area had a long-standing interest in craft development. The Hamilton Handicraft Guild began in 1961, eventually renaming itself The Artisans' Guild of Hamilton. To go back even further, an arts and crafts association was founded in Hamilton in 1894 which is, in all likelihood, the province's oldest.

[42] The Harbourfront story is convoluted and full of contradictions, too detailed to unravel on these pages. Toronto's Urban Affairs Library has a clipping file of newspaper articles on the subject. The less intrepid may elect to read my summary article "From Limited Means to Unlimited Success" in *CraftNews*, Jan./Feb. 1994. A great deal of background on the early years stemmed from minute books kept faithfully by the craft colony and privately held by Sietze Praamsma, who now lives in the Ottawa area. Praamsma gave the author free access to his records.

[43] At exactly the same time in Old Town Alexandria on the Potomac River in Virginia, an old torpedo factory was turned into an art centre with open studios. Housed in a much more sound building than those at Harbourfront, it opened to the public in Sept. 1974. Craftmaking in a public forum was clearly on the leading edge. Today, Torpedo Factory has a high percentage of visual artists, and those craftspeople who rent studio space have rather limited facilities for public demonstrations and function with a different mandate from those at Harbourfront.

[44] *Craft Ontario*, Vol. 9, #10, Oct. 1975, provides a publicist's overview of the studios in action. *CraftNews*, Aug. 1986, has a well-considered "Viewpoint" by glass-blower Tim Laurin on his experiences working in goldfish-bowl studios. Leisure activities initially devised by Hatt-Cook included more than crafts, of course. The same year the craft program was begun, poetry readings and music occurred at The Bohemian Embassy, reconstituted at Harbourfront during the summer. Eventually its strong literary associations metaporphosed into the prestigeous International Festival of Authors, directed by Greg Gatenby, who began working full-time at Harbourfront in mid-April 1975.

[45] Thompson operates her own studio and shop on the main street of Mahone Bay in Nova Scotia, where she is a successful entrepreneur in provincial clay circles.

[46] Anita Aarons was a steely presence in Toronto's cultural community for two decades. Born with a self-confessed sense of outrage, she made sweeping changes in whatever milieu she found herself. She arrived in Toronto in 1964 and first taught sculpture and design at Central Technical School, and the following year became allied arts editor for *Architecture Canada*, a post she held for six years. Among her many accomplishments were designs for stained glass windows, lighting, furniture, and embroidered tapestries; making jewellery — a silver neck ornament was selected for the Canadian exhibition at EXPO 67; and curating a number of significant exhibitions, the first being *Art in Architecture* at the University of Toronto in 1974. She directed the visual arts activities at Harbourfront from 1976 to 1984 when she retired and

returned to Australia to live. In 1983 she received an Arts Diplome d'honneur from the Canadian Conference of the Arts. She was interviewed by the author on a return visit to Toronto in 1994.

[47] Space does not permit a full discussion of the wealth of program activities organized over the years at Harbourfront Centre. Today's budgetary restrictions have forced retrenchment, but throughout the Eighties and early Nineties a summer craft fair was a headliner, as were fashion shows and Designed by Commission. There are ongoing conferences on leading issues, silent auctions, special exhibitions, and the annual studio residents' exhibition. Other constants are the International Creators Lecture and Workshop Series, informal lectures by visiting specialists, high-school and student workshops, and craft display showcases called Uncommon Objects. In fall 1979, Harbourfront opened a retail shop beside the studios to expose students to the mercantile world. First called Proud Possessions by Aarons, it was renamed Shop 235, and in 1987 became Bounty, now located on the northeast corner of the building and triple in size. Jeweller Melanie Egan has taken over coordinating the studio program, which she has detailed in an article in *Glass Gazette*, Fall 1996.

[48] *Crafts and Craftsmen in Canada: A Report of a Survey on the Views of Craftsmen, Their Background and Present Circumstances*, p. 10. Fibre and clay accounted for most craft activity: 41 percent for fibre and 32 percent for clay. Activity varied from province to province. Ontario's fibre workers accounted for 48 percent of the Canadians surveyed; its clay artists were numerically behind the West, which favoured clay activity over other mediums. A craftsperson who did not supplement income by teaching earned an average of $8,680 a year in the Seventies.

Chapter 5

[1] Overview of Banff Conference, *Canadian Crafts in the Twenty First Century, The Visioning Workshop*, p. 15.

[2] Reported in *Work In Progress: Human Resource Issues in Visual Arts and Crafts*, p. v.

[3] OC recipients: 1974 Dora de Pedery-Hunt (Officer) medallist; 1975 Pearl B. Whitehead (Member) volunteer; 1979 Mary Eileen "Bunty" Muff Hogg (Member) administrator; 1982 Joyce Wieland (Officer) quilter; 1987 M. Joan Chalmers (Member) patron, elevated to Officer in 1992 and to Companion in 1998; 1987 Helen F. Gregor (Member) weaver; 1988 Russell Goodman (Member) stained-glass artist; 1992 Jean Johnson (Member) administrator; 1994 Tamara Jaworska (Member) weaver; 1997 Lois Etherington Betteridge (Member) metalsmith.

[4] Robert Jekyll, "Looking Down The Road," *Ontario Craft*, Sept./Oct. 1996, pp. 17–18.

[5] Cultural inquiries included Federal Cultural Policy Review Committee (Applebaum-Hébert) 1982; Special Committee for the Arts in Ontario (Macaulay) 1984; Royal Commission on The Economic Union and Development Prospects for Canada (MacDonald) 1985; Task Force on Funding of the Arts in Canada to the Year 2000 (Bovey) 1986; Task Force on Status of the Artist (Siren-Gélinas) 1986.

[6] Recent Bronfman Award recipients from Ont.: Harlan House, clay, 1989; Dorothy Caldwell, fibre, 1990; Susan Warner Keene, fibre, 1991; Michael Fortune, wood, 1993; Dan Crichton, hot glass, 1994; Steven Heinemann, clay, 1996; William "Grit" Laskin, mixed media (guitar-maker) 1997. The first recipient in 1977 was Robin Hopper, clay, who had moved from Ont. to B.C. by the time he received the award. He was succeeded by Lois Etherington Betteridge, metal, in 1978 and Michael Wilcox, bookbinding, in 1985.

[7] For background on the Muskoka studio tour participants, read my article "Surviving in Paradise" in *Ontario Craft*, Fall 1988, and *Muskoka Originals Artistry and Inspiration on the Muskoka Autumn Studio Tour* by Ruth Louden and Scott Williams (Toronto: Witnorth, 1998). Tours are too numerous to list in full, but those with senior status are Barrie and Orillia 1984; Kawartha 1985; Guelph 1985; Merrickville 1986; Kingston and North 1987; Elora 1987; Haliburton County 1988; and Thousand Islands Parkway 1989. Edward Lucie-Smith in "Craft Today," p. 275 of *The Story of Craft*, also notes that many middle-class urban craftspeople have chosen to lead a rural way of life, as far from urban sprawls as possible.

[8] To read more about Sandra Orr see Ruth Weinstock's "True Believers" in *CraftNews*, July 1990.

[9] For a more complete picture of the craft gallery scene in Ottawa in the early Eighties, read Angela Marcus, "Along Sussex Drive: Craft In Three Dimensions," *Ontario Craft*, Vol. 7, #4, Winter 1982, pp. 14–16, and "Handmade in Ottawa," *Ontario Craft*, Vol. 6, #1, Spring 1981, pp. 17–18.

[10] Peter Dormer, *The New Ceramics*, p. 196.

[11] Among alternate galleries in Toronto that emulated Johnson's work at Merton Gallery were Shaw-Rimmington, Tatay, Gallerie Dresdnere, Del Bello, Neo-Faber, and Nancy Poole's Studio. Before locating in Toronto, Poole first ran a similar gallery in London, where she showcased craft from time to time, along with Trajectory, Thielsen, Sandy Snelgrove, White Gallery, Middle Earth Studio, and Gibson Gallery. In Kingston, Thelma Edge opened Upper Edge Gallery in 1971.

[12] Minutes of OCC's board of directors, Nov. 27, 1978, meeting record a motion by Hart Massey that the gallery "exhibit work of only the highest quality and that the gallery be upgraded to equal status with other professional, commercial, and public galleries in the leading cities of the world … the gallery would present models of mastery in design and of excellence in the handling of materials."

[13] For the record, OCC ended its annual association with CNE's Arts, Crafts and Hobbies Building in 1982, a relationship begun by HAC almost fifty years earlier.

[14] OCC's Craftmen's Advisory Committee at its Mar. 12, 1982, meeting unveiled results of a survey of members who, like Hodge, believed exhibitions educated the public and made it more aware of crafts. The minutes outlined an extensive list of suggested initiatives that any organization would have been hard pressed to carry out.

[15] Christopher Hume, "Celebration '84: A Sense of Occasion," *Ontario Craft*, Fall 1984, p. 26–27.

[16] For comprehensive reading on the exciting Eighties in the jewellery field, see Anne Barros, *Ornament and Object: Canadian Jewellery and Metal Art 1946–1996*. As well, Dormer and Turner provide valuable insights in *The New Jewellery Trends + Traditions*. Myrna Gopnik's "Commentary" in *Ontario Craft*, Fall 1986, provides an overview of the new jewellery from the wearers' and collectors' perspective.

[17] For a profile of Dan Crichton, see Stuart Reid's "Daniel Crichton: Guru of Glass," *FUSION* Magazine, Vol. 19, #2, Spring 1995, p. 12.

[18] Both Schantz and Crichton have inspired a generation of younger artists who have animated the glass scene in Canada. Ontarians most active in gallery circles include Brad Copping, Laura Donefer, Ian Forbes, Irene Frolic, Jeff Goodman, Kevin Gray, Kevin Lockau, Claire Maunsell, Susan Rankin. A sampling of additional studio craftspeople, by no means complete, would include Mark Armstrong, Susan Belyea & Kerry Fletcher, Shirley Elford, Clark Guettel, Gregor Herman, Susan Higgins, Toan Klein, Richard Kreamer & Maria Rihte, Andrew Kuntz, Tim Laurin, Mark Lewis, Tim Maycock, John Robinson, Ed Roman, Cheryl Takacs, Paulus Tjiang, Heather Wood & John Kepkiewicz.

[19] It would be remiss not to mention the accomplishments and influence of an older furniture designer, Orillia-born Thomas Lamb, a graduate of Ryerson Institute's program of Architecture, Furniture, Industrial Design and Graphics. When a student, Michael Fortune spent time with Lamb at Curvply. By the mid-Eighties, Lamb was acknowledged as Canada's foremost designer of furniture, in the opinion of design historian Virginia Wright. See her profile of Lamb in *Ontario Craft*, Fall 1986, pp. 15–18.

[20] Michael Fortune has twice been profiled in *Ontario Craft*: Adam Smith's "Staying Power," Spring 1986, and Rachel Rafelman's "Fortune's Finest Hour," Winter 1993. As well, he was included in an article by the author, "As The World Turns" in *Ontario Craft*, Spring 1992, and in "Fortune Designs Caribbean Export Furniture," *CraftNews*, Vol. 15, #6, Aug. 1990, pp. 1 and 10.

[21] Outstanding members of Ontario's contemporary bookbinding and book-arts field who are still active include designer-binders Michael Wilcox of Woodview and Don Taylor and Reg Beatty of Taylor-Murdoch Studio, Toronto. In the restoration and conservation branch, Betsy Eldridge of Toronto is a leading teacher; practitioners are Kate Murdoch of Toronto, Shelagh Smith of Wood-bridge, and Jill Willmott of Kingston.

Conservators in the works of art-on-paper category are Beatrice Stock and Barbara Rosenberg of Toronto. Edition binders for their own private presses are Gerard Brander à Brandis, Stratford; Margaret Locke, Kingston; Will Rueter, Toronto; Alan Stein, Parry Sound; Michael Torosian and George Walker, Toronto.

22 Robert Muma, *Craftsman*, Sept., 1980. As well as the work of Lingwood, Trotter, and the Williams Studio, superb functional leather objects have been designed and made for two decades in the studios of Michael Rowland in Merrickville, Debbie and John Sturrock in Kitchener, Richard Bannister in Carleton Place, Lucy and Ron Tidrow of Arrowsmith Designs in Ottawa, and Phil and Bonnie Hobbs in Lakefield.

23 The Deutsch Ledermuseum in Offenbach, Germany, mounted a touring exhibition of Lingwood's work, which travelled to France, Holland, England, and ended in Ontario in spring 1997. In her catalogue introductory remarks, curator Rosita Nenno said, "Lingwood is the indisputable authority, with the broadest knowledge of creative leather art around the globe. His boxes and bowls are sculptures of our time; their design obeys the morphological language of the late 20th century."

24 Cheryl Hall (now Sarah Hall), "Art or Anti-Art?" *Canada Crafts*, Oct./Nov. 1978, p. 11.

25 Among those currently associated with the provincial stained-glass field are Doreen Balabanoff, Stephen Brathwaite,

Mimi Gellman, Ted Goodden, Chris Goodman, Eve Guinan, Sarah Hall, Robert Jekyll, Rosemary Kilbourn, Kathy and Jane Irwin, Sue Obata, Stuart Reid, Gundar Robez, Steve and Tom Smiley, John Stonkus, Ernestine Tahedl, Patti Walker, Chris Wallis, Gustav Weisman, David Wilde, and Angela Zissoff.

26 Robert Jekyll, "Viewing Stained Glass," *Canada Crafts*, Oct./Nov. 1978, p. 7.

27 For more details on Sarah Hall, read Marie Caloz, "Sacred Spaces," *Ontario Craft*, Fall 1992, pp. 8–12.

28 In *Ontario Craft*, Spring 1986, p. 19, stained-glass artist-designer Robert Jekyll talked about the impact of the economic depression on craftspeople and architects in the early Eighties.

29 For those interested in more detail on the Sheridan closings, see *CraftNews*, Apr. 1984. For general articles on the crisis in craft education in Ontario, see Skye Morrison's "Viewpoint" in the same issue.

30 For further reading on OCC's brief, see my articles in *Craft-News*, Jan. and Feb. 1988.

31 For further reading on this issue see the Report Summary from *The Economic Impact of OAC-Funded Arts Organizations*.

32 Robert Jekyll, "Looking Down the Road," *Ontario Craft*.

Ceramist Tim Storey has created a stable of whimsical figures. His *Para-Medic Ambu-Beast* won a clay award at *Art In Craft* in 1975.

OCC Archives

201

School, where she saw to it that jewellery making was included in the curriculum. She herself designed jewellery for Tiffany's in New York. A Mackie Cryderman Memorial Exhibition held at the London Public Library and Art Museum in 1971 highlighted her accomplishments.

Nunzia D'Angelo 1906–1968

Along with jeweller Nancy Meek, D'Angelo worked from a studio in Toronto's Greenwich Village district in the '30s and '40s, one of the earliest professional potters in the city to earn her livelihood from the wheel. Although born and educated in Toronto, D'Angelo considered herself Italian to the core, and her pottery reflected a Mediterranean elan. A graduate of Central Technical School's art program in 1930, she trained as a teacher and assisted her mentor, "Bobs" Howarth, in Central's pottery studios. She spent a year working with ceramic engineer Robert J. Montgomery at the University of Toronto, experimenting with Ontario clay bodies that held potential for studio potters. She married Czechoslovak ceramic artist Jarko Zavi in 1941, and their studio home at 94 Gerrard West was the focus of considerable media attention and interest during World War II. In 1946 they moved permanently to the Cobourg area, where they established a busy studio.

Ankaret Dean 1932–

It's a bit of a stretch to move from X-ray technology to basketmaking, but British-born Dean did just that. After marriage and four children, she made the transition to craftsperson when she became a full-time weaving student at Sheridan College in the 1970s and moved on to graduate studies. Since then, she has become a major influence in the development of basketry as a medium for expression and is acknowledged as its most effective gospeller. Dean herself is especially fond of willow and natural materials and has passed along her working techniques and philosophy at the Haliburton School of Fine Arts for nearly 20 years. Her energy and enthusiasm helped to create The Basketry Network almost a decade ago, and in addition, she is a prolific writer, teacher, exhibitor, community activist, and founding editor of the quarterly publication, *The Basketry Network*, now 15 years old.

Andrew Fussell 1904–1983

For decades, the most popular and enthusiastic art metalwork instructor in Toronto, Andrew Fussell did it all the hard way. A keen learner and dogged worker, he arrived from England in 1926 as a penniless 22-year-old. After six years of evening courses, including metal studies at Central Technical School and Northern Vocational, he was able to open his own studio at 109 Bloor Street West in Toronto, and eventually purchased 10 Asquith Avenue as a studio home. He helped form MAG, served as president and treasurer, and sat on the board of CHG. In addition to his studio commissions and holloware, he produced a popular line of smaller wares for sale in retail shops.

Suzann Greenaway 1949–

No one, including Greenaway herself, ever dreamed that when she opened Prime Canadian Crafts in 1979 she would be one of the country's few survivors in the precarious world of commercial galleries. She entered the retail scene in the mid-'70s by joining the staff of The Pottery Shop at 100 Avenue Road, soon becoming its manager. Ceramics are still the focus of her love affair with crafts, but her gallery handles the finest work in many craft disciplines. Several of her stable of artists have received the Saidye Bronfman Award for Excellence in the Crafts. By striving to develop a collector-patronage system, Greenaway has worked over the years to encourage her artists to hang tough and keep going through economic highs and lows. Her dogged determination to profile and nurture the country's best has won her legions of admirers, and secures her role as a major influence on contemporary crafts.

Sarah Hall 1951–

Furthering a lifelong interest in light and colour, Hall began a creative arts course at Sheridan College in 1974 and followed it with an intensive five-year stained-glass study, apprenticeship, and travel program overseas. While respecting the history and traditions of the medium, her work is dazzlingly innovative, energetic, playful, and yet spiritual. In demand for secular and religious work at home and abroad, Hall has completed commissions for schools, churches, hospitals, residences, and banks, each based on a particular technique drawn from her lexicon of leaded glass, acid etching, sandblasting, appliqué, lamination, silver stain painting, gold leafing, and reverse painting. Her studio is one of the country's best equipped, busiest, and well organized, and she herself the subject of articles, reviews, a Rhombus video, and recipient of numerous awards.

Mary Eileen "Bunty" Muff Hogg 1914–

A celebrated craft exponent and catalyst, Hogg is a trained weaver who spent most

of her professional life as a government art and craft adviser and coordinator, in which capacity she earned a reputation for contagious enthusiasm and willingness to help. She received the Queen Elizabeth II Jubilee Medal in 1977 for her outstanding contribution to crafts; Membership in OC in 1979; and a Confederation Medal 1992. Within the crafts community, she is a founding member, honorary life member, and former director of CCC; of OCC, which gave her a John Mather Award in 1983; and of OHS, which she helped organize. She was also treasurer and vice-president of WCC, which also made her an honorary life member.

Harlan House 1944–

Revered and admired from coast to coast, Harlan House came to Ontario from Alberta in 1973 and settled in bucolic Lonsdale near Kingston, where he and his wife, Maureen, are business partners and spectacular gardeners. His work in clay mirrors his devotion to their plant and animal surroundings and his avowed calling to make "things for flowers when you live among them." As a master craftsperson concerned with perfection, he controls every aspect of the creative process. An artist among artists, he achieves a stirring purity of line whether making plates, mugs or vases, dinnerware sets or household accessories. Twice in the '80s his work received honours: a Joan Chalmers Award for Excellence in 1986, and a Saidye Bronfman Award in 1989, the citation acknowledging a man with "the courage to experiment and the confidence to explore." In 1996 he was elected to RCA, and in 1997 he received a Jean A. Chalmers National

Crafts Award for continuous creativity and excellence.

Zema "Bobs" Coghill Howarth 1900–1987
Peter Howarth 1889–1986

A wellspring of pottery instruction and leadership for almost four decades, South African-born Zema "Bobs" Howarth came to Toronto with her husband, Peter, from the Royal College of Art in London. While he designed stained-glass windows, painted, and directed the art department at Central Technical School, she painted and ran the pottery department on a part-time basis, because married women were seldom permitted to work full-time. Beginning in 1923, she influenced thousands to recognize and appreciate good pottery and to regard it as a major art form. She was, as well, a devoted arts champion. Both she and her husband were founders of HAC, and he was its first vice-president. She was a supporter of the CGP when it was formed in 1936 and its first honorary president. Both Howarths were prominent members of the Ontario painting community and active until they died.

Alan Jarvis 1915–1972

Rhodes scholar, museology specialist, sculptor, metalsmith, editor, gallery administrator, and general Renaissance man, Alan Jarvis studied art metalwork in the '30s with Rudy Renzius in Toronto, shared a studio with Harold Stacey, and remained a champion of craft as art. Director of the National Art Gallery from 1955–59, he resigned and moved on to edit *Canadian Art* magazine, where he provided a forum for contemporary fine craft. He was called on to open The Pottery Shop in 1962, and two years later did the same in Stratford for an exhibition

Four Artist Craftsmen, which provided a platform for one of his beliefs: "As I see it, Art is a Crafty Business."

Jean Johnson 1924–

Toronto-born Jean Johnson managed Toronto's Merton Gallery in the '70s, where she pursued a rather radical notion: presenting fine craftwork in a commercial gallery setting. When approached to coordinate Harbourfront's neophyte craft studio in 1979, she was excited by the prospect of working in a place where the public would see things being made, be turned-on to buy craft, or at least become better informed about the field. As a follower of William Morris and the Arts and Crafts Movement, Johnson believes that people's lives are enriched when making objects with their hands. With missionary zeal, she developed, at Queen's Quay, a vibrant mix of international lectures, workshops, cooperative ventures with high schools, conferences, and studio support for craft graduates. Her work in the craft field was recognized in 1993 with membership in OC.

Bailey Stern Leslie 1904–

Not only was her career the longest in pottery circles, it brought her international recognition and esteem. The best known of Toronto's Five Potters, Leslie was born in Poland, spent her early years in Cobalt, and moved to Toronto when a teenager. She completed her B.A. from the University of Toronto in 1926, and her M.A. in child psychology in 1928. While pursuing nursery-school training at The Institute for Child Study, she began pottery studies at Central Technical School under "Bobs" Howarth, since hand-building clay was

regarded as remedial therapy for young children. She was hooked. In 1945 she furthered studies at Alfred University in New York State. Twice president of CGP, she was a consistent prize-winner and rigorous experimenter of glazes. At home with classic forms, her work has more than stood the test of time.

Jane Mahut 1928–

Founding director of the Koffler Gallery in North York, Mahut broke exhibition ground for crafts. In her 18 years with the gallery, she put together more than 50 craft shows and made it possible for Canadian craft to be shown abroad — in 1988, the gallery's *Glass in Sculpture* exhibition travelled to Finland and West Germany. Among other accomplishments, Mahut introduced the first professional Ceramic Mural Building Workshop and Symposium, with an international artist, in 1977. Through her pioneering work at the gallery, she helped artists and craftspeople from the early stages of their careers to attain professional status.

Adelaide Marriott 1883–1977

Born and educated in Ontario, Marriott was a rarity for her time: the cultured working woman. When most women might have one routine job, she held two relatively high-profile ones: first manager of The Guild Shop at Eaton's College Street 1932–44, and dean of residence of the Margaret Eaton School 1932–41. She next moved to the University of Toronto where she was assistant dean of women until 1955, and pursued a string of activities as a quintessential committee person and organizer. As well as her stellar executive and volunteer work with HAC and CHG, she was affiliated with the

Architectural Conservancy of Ontario, Zonta International, Canadian Conference of the Arts, and the Canadian United Nations Committee. In 1967 she received a Canada Medal for her contribution to arts in Canada, and in 1973 York University made her an honorary doctor of laws.

Donald Lloyd McKinley 1932–1998

For almost three decades as head of the furniture program at Sheridan College, Donald McKinley stimulated, aggravated, provoked, and inspired some of the country's leading furniture designer-makers: Michael Fortune, Peter Fleming, Paul Epp, Robert Diemert, and John Ireland, to name a few. A second-generation pedagogue and Fulbright Scholar, McKinley came to Ontario from New Hampshire with his first wife, Ruth Gowdy McKinley, a potter, and during his time at Sheridan spent 80 to 100 hours a week teaching, reading, reflecting, and problem-solving. His commitment to his students was inspirational, and his influence in the woodworking community in Canada and the United States legendary.

Robert J. Montgomery 1886–1952

Called "the guiding star" of Ontario's early studio potters, Montgomery's leadership from a professor's chair was instrumental in the formation of CGP in 1936. A native of Gallipolis, Ohio, Montgomery graduated from Ohio State University in 1911, to which he added an engineering degree in 1928. He came to the University of Toronto in 1925 as head of its ceramic and non-metallic division of the Department of Metallurgy, from where he retired in 1946. First president of the Canadian Ceramic Society, he lectured on, wrote about, and

organized a host of events that centred on the development of ceramics in Canada at every level. His work in Ontario's clay community was extensive, his enthusiasm boundless, and his support unwavering. He also extended his involvement with the Ontario craft scene by serving on the executive of CHG.

Ann Mortimer 1934–

Variously described as Canada's craft spokesperson, selfless champion, competent organizer, confident and sensitive ceramist, Newmarket's Ann Mortimer is a woman of myriad abilities. From the time she arrived on the provincial clay scene, she has been involved in craft organizations, teaching, jurying, art consulting, organizing conferences, and, in whatever time is left over, preparing sculptural work for some 100 exhibitions. President of CGP, CCC, and OCC, she remains active with the Ceramic Arts Foundation and the International Academy of Ceramics. She views her involvement with organizations as opportunities to meet craftspeople, especially clay artists around the world, to learn from them, and to accept and embrace change. Whatever her pursuit, she has resolutely championed professionalism at every level, being accountable, accessible, and to accept the challenge of stewardship.

Nancy Meek Pocock 1910–1998

Her life has many firsts. Together with potter Nunzia d'Angelo, she developed a career as a custom jeweller in Toronto's Gerrard Street West. She began exhibiting at WAAC, Eaton Auditorium, CNE, and AGT, demonstrating that with pluck, perseverance, and a bit of luck women could forge a career in

crafts, even in an economic depression. Her jewellery career spanned more than 40 years, during which she lobbied for craftspeople, held executive positions in craft organizations, organized exhibitions at the CNE, participated in international exhibitions, served as den mother to fellow artists, married, and raised a family. She was invested with the Order of Ontario in 1992 for her work with refugees in which context she was known internationally as "Mama Nancy."

Jorgen Poschmann 1927–
Clay was more than a passion, it was his heritage. Born to a Danish family, which owned a porcelain dinnerware business for three generations, Poschmann first trained as a potter, then as a chemical engineer at the University of Copenhagen, and went on to Germany, England, and the United States to study various aspects of ceramic engineering. While enroute home to take over the family factory, he met Brigadier Wilfred Mavor, then president of Ferro Canada, a large multi-national corporation in the ceramics field. Mavor persuaded Poschmann to remain to conduct research on glazes, frits, and colours, and Ontario became his new home. In 1957 he went on his own to develop The Pottery Supply House Limited in Oakville, for decades the main source of clay and pottery supplies in the east. Poschmann has made himself available to anyone who calls, whether it's about ceramic engineering, sponsoring a studio potter, or providing information. Although he has turned the business over to his offspring, he continues to attend exhibitions and act as a consultant in Third World countries.

Rudolph "Rudy" Renzius 1899–1968
The Renzius studio at 65 Gerrard Street West opened in 1931 in Toronto's Greenwich Village, and soon enlivened the Toronto craft scene. Along with his growing clientele, Renzius became known as mentor to a generation of metal artists who went on to establish careers in Ontario. Born in Malmo, Sweden, to a family of smiths, Renzius trained first as an electrical engineer and then as a metal craftsperson under George Jensen in Malmo, Just Anderson in Copenhagen, and Von Mayerhofer in Munich, Germany. Although specializing in pewter, he also carved wood sculptures and fashioned jewellery. He was a member of the Chicago Society of Artists (a city where he lived prior to coming to Toronto), Swedish American Art Association, MAG, and other organizations. His work is in a number of private collections and in the International Museum of Göteborg, Sweden. In 1935 he relocated to Newmarket to direct art and manual crafts at Pickering College for 25 years.

Ann Roberts 1936–
South-African born-and-educated Roberts had the good fortune to have an artist mother who told her nothing was impossible and if you needed to do something, there was always a means. This has been her working credo and the clay community everywhere has been the beneficiary. By 1960, Roberts was married and living in Montreal and soon president of Montreal Potters' Club; by 1967, she had moved to Waterloo where she helped found the Waterloo Potters' Workshop. Since obtaining her MFA in ceramics and joining the faculty at the University of Waterloo in 1977, she has continued to exhibit, teach full-time, work tirelessly at the community level, and spearhead building the Canadian Clay and Glass Gallery in Waterloo. Admitted to the International Academy of Ceramics in 1988 and to RCA in 1997, she remains active as a spirited juror, speaker, exhibitor, and this year, organizer of the 1998 Canadian conference of the International Academy.

"Millie" Helfand Ryerson 1913–
Although she is better known in Montreal to where she moved almost 30 years ago, Ryerson was once the best-known and beloved craft godmother in Toronto. Born in 1913, she attended Oakwood Collegiate, trained as a dancer, and was an early member of the University of Toronto's occupational therapy course. In 1949 she opened a craft outlet, The Artisans, in Toronto's Greenwich Village, which she operated for 16 years. Resolutely idealistic and non-commercial, the shop was a base from which Ryerson assisted, counselled, and otherwise encouraged creativity, invention, and the thinking process. In 1988 she was awarded membership in OC for pioneering craft workshops in Montreal, and in 1994 was accorded an honorary Doctor of Laws by Montreal's Concordia University.

Harold Gordon Stacey 1911–1979
Acknowledged as a giant among metalsmiths, Stacey was the most accomplished of the early makers. A careful, meticulous craftsperson, Stacey was unquestionably the artist among Toronto metalsmiths, and to those who understood and appreciated his standards, an inspiring teacher. With no flair for self-promotion, administration, or paper-

work, he nonetheless ran a productive studio and left behind a body of work that is considered classic. His range included coffee services, jewellery, trophies, lamps, challices, ash trays, bowls, cigarette boxes, cutlery, as well as custom-design architectural and liturgical work.

Donald A. Stuart 1944–

A remarkable blend of energy, commitment, pedagogical gifts, and caring artistry, Stuart's accomplishments as a metalsmith were honoured in 1994 when he added the M. Joan Chalmers Award for Excellence to his other laurels, including admission to RCA in 1986. He fashions objects in which beauty and craftsmanship are integrated with function, continuously exploring new forms, developing new techniques, working with new materials. Equally at home with jewellery making, holloware, liturgical, and other commissions, Stuart originated a metals program at Georgian College in Barrie for aspiring smiths, which he continues to direct. He became the first Canadian to be elected president of SNAG, in 1997.

Walter T. Sunahara 1935–

Educated at H.B. Beal Technical School in London, Sunahara went on to study drawing and painting at OCA, followed by further studies in Japan. On his return in the mid-'60s, he joined the Community Programmes Branch of the Ontario Department of Education, and in 1977 was seconded to the OAC, from where he retired in 1993. As the Council's senior associate officer, Sunahara became the éminence grise and beloved mentor of craft activity in the province. He has curated and juried exhibitions, exhibited himself, taught, coordinated conferences, and volunteered countless hours to craft organizations. He is remembered as an enabler and linchpin of grass-roots craft development in Ontario.

Frank Tucker 1950–

As soon as he graduated from college in 1975 with a business diploma, Tucker rented a warehouse north of Toronto and set his sights on a career in the pottery supply business. In 1981 he acquired Rodaco Clay, a business begun by potter Ron Roy a decade earlier, and he retained Roy to oversee his labs. Two years later he began a kiln-building division, ConeArt Kilns Inc., and in a few more years, purchased Stratford Clay Supply Ltd. Now a major presence in the clay field, his business annually handles more than a million kilos of clay, most of it from the United States. In 1995 he became the publisher of Canada's national pottery magazine, *Contact*; whenever he gets the chance, he also supports new people in the field through award money and encouragement. If it's leading edge, Tucker is sure to be close at hand.

Yvonne Williams 1901–1997

There's never been anyone in craft circles quite like stained-glass artist Williams. One of the first women to strike out on her own in a male-dominated field, she was also its most resolute figure, developing a career that spanned five decades. Discarding the prevailing Victorian imagery, she chose to work within expressionism and symbolism, a daring approach at the time that eventually won the admiration of architects, clergy, public, and aspiring, younger stained-glass artists. Her North Toronto studio was also innovative, a radically egalitarian Renaissance sort of place that motivated many to enter the profession and served as the only source of basic education in the stained-glass field. The Royal Architectural Institute of Canada honoured her with an Allied Arts Medal in 1957, and she was elected to RCA in 1965.

Donn Zver 1948–

The right leader at the right time, Hamilton's Donn Zver brought provincial potters together in OPA and led its 30 affiliated guilds for five years. An early graduate of Sheridan College, he soon opened his own functional pottery studio on his grandfather's farm at Troy while teaching part-time. His workshops throughout Ontario were noteworthy, and he was regarded as a guru who ate, slept, and breathed his subject. His commitment to clay was singular, and under him the provincial clay organization became the most lively craft media guild in the province. Today, Zver continues to operate an expanded studio and showroom at Troy, and in 1997 took on another challenge by adding The Potters Cafe to his showroom.

Research Sources

Toronto
Archives of Ontario
Art Gallery of Ontario Library and
 Archives
The Craft Studio at Harbourfront Archives
Canadian National Exhibition Archives
Central Technical School Archives
The Guild, Scarborough
Harbourfront Centre Archives
Hamilton Public Library
Junior League of Canada Archives
Lyceum and Women's Art Association of
 Canada Archives
Ontario Arts Council Library and
 Research Centre
Ontario College of Art Archives
Ontario Crafts Council Archives
Ontario Institute for Studies in Education
 Archives
Province of Ontario Art Collection
Royal Ontario Museum Library and
 Archives
R.W.B. Jackson Library, Ontario Institute
 for Studies in Education
Toronto Board of Education Records,
 Archives and Museum
Toronto City Archives
Toronto Reference Library
Toronto Urban Affairs Library
York University Archives
Waterloo
University of Waterloo Rare Book Library
Canadian Clay and Glass Gallery Archives
Ottawa
Canadian Museum of Civilization Library
 and Archives
National Archives of Canada

Kingston
Queen's University Archives
London
University of Western Ontario Archives
Montreal
Canadian Handicrafts Guild (Quebec)
 Archives
McCord Museum Archives

Craft Periodicals

Artisan 1977-80
Canada Crafts 1975-1981
Clay Products News and Ceramic Record 1928-
 1964 (became *Canadian Clay and Ceramics*
 1965-1983)
Craft Dimensions/Artisanales 1970-75
Craft Horizons 1949-78 (became *American
 Craft* in 1979)
CraftNews 1976-present
Craft Ontario 1966-75
Craftsman 1976-80 (became *Ontario Craft*
 in 1981)
Craftsman/L'Artisan 1968-74
Fusion Magazine 1986-present
Ontario Potter 1979-1982
Tactile 1966-76

Monographs and Selected Articles

Bériau, Oscar A. "Home Weaving in Canada." *Canadian Geographical Journal*, vol. xxvii no.1, July 1943.

Bovey, Wilfred. "Canadian Handicrafts." *Survey of Domestic Art and Craft in Canadian Intellectual and Economic Life*, 1938.

Casas, Teresa. *The Canadian Guild of Potters 1936–1946*. Unpublished University of Toronto paper, 1986.

Canadian Crafts Council. *Canadian Crafts In The Twenty-First Century*. The Visioning Workshop, April 1991.

Condon, E. Jane. *Canadian Arts Consumer Profile*, 1994. (Visual Arts and Crafts Supplementary Volume, Arts Policy Branch of the Dept. of Canadian Heritage).

Crowell, Ivan H. "Teaching Handicrafts in Canada." *Canadian Geographical Journal*, vol. xxvii, no.2, August 1943.

Deichmann, Erica & Kjeld. *A Special Study on Canadian Handicrafts With Particular Reference to New Brunswick*, June 1950 (prepared as a Brief to the Royal Commission on National Development in the Arts, Letters & Sciences).

DeVille, Barry and the Canadian Crafts Council. *Crafts and Craftsmen in Canada: A Report of a Survey on the Views of Craftsmen, Their Background and Present Circumstances*, 1978.

French, William. "Talented Young Potter Putters in Dreams of a Village." *Globe and Mail*, March 16 1960.

Gibbon, J. Murray. "Canadian Handicraft Old and New." *Canadian Geographical Journal*, vol. xxvi, no.3, March 1943.

Home, Ruth M. "Pottery in Canada." *Canadian Geographical Journal*, vol. xxviii, no.2, February 1944.

Human Resources Development Canada. *Work in Progress: Human Resource Issues in the Visual Arts and Crafts*, 1991.

Kettle, H.G. "The Canadian Handicraft Movement." *The Canadian Forum*, July 1940.

Keay, Peter. "The New Look in Canadian Pottery." *Canadian Homes and Gardens*, April 1959.

McLeod, Ellen M.E. *Enterprising Women and The Early History of the Canadian Handicraft Guild 1906-1936*, M.A. Thesis, Carleton University, 1994.

Murray, Jean. "Heirlooms of Tomorrow." *Canadian Homes and Gardens*, April 1950.

Nobbs, Percy E. "Metal Crafts in Canada." *Canadian Geographical Journal*, vol. xxviii, no.5, May 1944.

Ontario Arts Council. Report Summary. *The Economic Impact of OAC-Funded Arts Organizations*, 1996.

Peck, M. A. "Handicrafts from Coast to Coast." *Canadian Geographical Journal*, vol. ix, no.4, October 1934.

Storey, Norah. *Weaving in Canada*, June 1950 (prepared as a Brief to the Royal Commission on National Development in the Arts, Letters & Sciences).

Thompson, Allison. *A Worthy Place in the Art of Our Country: The Women's Art Association of Canada 1887-1987*, unpublished M.A. Thesis, Carleton University, 1989.

Traquair Ramsay. "Hooked Rugs in Canada." *Canadian Geographical Journal*, vol. xxvi, no.5, May 1943.

Towers, Kathleen. "Pottery...A Canadian Handicraft." *Canadian Homes & Gardens*, June 1948.

Wyn Wood, Elizabeth. "Canadian Handicrafts." *Canadian Art*, Crafts and Design Issue, vol.11, no.5, Summer 1945.

Harbourfront:

Council of the Corporation of the City of Toronto. *Appendix "A" to the Minutes of Proceedings for the year 1975*. Toronto, The Carswell Company Limited, 1976.

Harbourfront. Toronto, 1978.

Harbourfront Development Framework. Harbourfront Corporation, Toronto, 1978.

Harbourfront Site History. City of Toronto Planning and Development Department Branch, Toronto, 1978.

Harbourfront Part I — Official Plan Recommendations. Toronto Planning Board Committee on Buildings and Development, Toronto, 1979.

History of the Development of Harbourfront. City of Toronto Planning and Development Department, Toronto, 1983.

Planning Harbourfront 1 Technical Report. Ministry of State, Urban Affairs Canada, Ottawa, 1975.

Selection of Craft Exhibition Catalogues with essays

Canadian Fine Crafts 1966-67. Ottawa: National Gallery of Canada, 1966.

Abstract Expressionist Ceramics. Irvine: University of California, 1966.

Craft Dimensions Canada. Toronto: Royal Ontario Museum, 1969.

Artisan '78: The First National Travelling Exhibition of Contemporary Canadian Crafts. Ottawa: Canadian Crafts Council, 1979.

The Indusmin Collection. Toronto: Art Collection of Canada, 1979.

Connections: Donald Lloyd McKinley 1967-1981. North York: The Koffler Gallery, 1981.

From Our Hands. Toronto: The Art Gallery of Harbourfront, 1982.

Quillwork. Manitoulin Island: Ojibwe Cultural Foundation and Art-I-Craft, 1984.

Works of Craft from the Massey Foundation Collection. Ottawa: National Museums of Canada, 1984.

Handmade Paper; the medium/the structure. Burlington: Burlington Cultural Centre, 1985.

Raku Then and Now. North York: The Koffler Gallery, 1986.

Fibre: Tradition/Transition. Windsor: Art Gallery of Windsor, 1988.

Glass in Sculpture. North York: The Koffler Gallery, 1988.

Consuming Passions Bonita Bocanegra Collins. Burlington: Burlington Cultural Centre, 1988.

The Art of the Book. Toronto: The Craft Gallery, 1988.

Lois Etherington Betteridge, Silversmith: Recent Work. Hamilton: Art Gallery of Hamilton, 1988.

In The Steps of Our Ancestors. London: Museum of Indian Archaeology, 1989.

Stephen Hogbin: Painted Reliefs. Owen Sound: Tom Thomson Memorial Art Gallery, 1989.

Burlington Cultural Centre: Fifth Anniversary of the Permanent Collection. Burlington: Burlington Cultural Centre, 1989.

Art That Works: The Decorative Arts of the Eighties Crafted in America. Alexandria, Virginia: Art Services International, 1990.

Re: Turning 1970-1990: Works by Stephen Hogbin. Toronto: John B. Aird Gallery, 1990.

20/20 Hindsight: A Harlan House Retrospective 1969-1989. North York: The Koffler Gallery, 1990.

The Turning Point: The Deichmann Pottery 1935-1963. Ottawa: Canadian Museum of Civilization, 1991.

Folk Art Treasures of Huron County. Blythe: Blythe Centre for the Arts, 1991.

Canadian Glassworks 1970-1990. Toronto: The Craft Gallery, 1991.

Austausch/Exchange: Work by Craftspeople in Baden-Württemburg and Ontario. Toronto: The Craft Gallery, 1991.

A Treasury of Canadian Craft. Vancouver: The Canadian Craft Museum, 1992.

Illuminations. Fergus: Wellington Country Museum & Archives, 1992.

Dora Wechsler 1897-1952. North York: The Koffler Gallery, 1992.

Ann Roberts: Harvest: Coming Full Circle. Kitchener: Kitchener-Waterloo Art Gallery, 1992.

The Challenge of Metals: Don Stuart. Barrie: MacLaren Art Centre, 1993.

The Earthly Paradise. Toronto: Art Gallery of Ontario, 1993.

Vision to Reality 1981-1993. Waterloo: Canadian Clay and Glass Gallery, 1993.

Achieving the Modern: Canadian Abstract Painting and Design in the 1950s. Winnipeg: Winnipeg Art Gallery, 1993.

Made By Hand: The Pleasures of Making. Vancouver: The Canadian Craft Museum, 1993.

The Collector's Eye: Contemporary Ceramics American, Canadian and British from the Collection of Aaron Milrad. North York: The Koffler Gallery, 1994.

Form and Fantasy: Ceramics by Theo and Susan Harlander. Whitby: The Station Gallery, 1995.

Susan Warner Keene: Out of Nature: A Survey of Fibre Work from 1982 to 1995. Burlington: Burlington Art Centre, 1995.

Rex Lingwood Boxes and Bowls?. Offenbach am Main, Germany: Das Deutsche Ledermuseum, 1995.

Teachers, Mentors and Makers. Toronto: The Craft Gallery, 1996.

Useful Intentions Selections from the Burlington Art Centre Permanent Collection. Burlington: Burlington Art Centre, 1996.

White on White: Contemporary Canadian Ceramics. Waterloo: Canadian Clay and Glass Gallery, 1996.

Celebration: 50th Anniversary of the Metal Arts Guild 1946-1996. Toronto: The Metal Arts Guild of Ontario, 1996.

Precious Intentions. Burlington: Burlington Art Centre, 1997.

Contemporary Studio Ceramics: Collection of the Winnipeg Art Gallery. Winnipeg: Winnipeg Art Gallery, 1997.

Books

Abrahamson, Una. *Crafts Canada: The Useful Arts*. Toronto: Clarke, Irwin & Co. Ltd., 1974.

Adamson, Anthony. *Wasps in the Attic*. Toronto: private publication, 1987.

America's Quilts. Lincolnwood, Illinois: Publications International Ltd., 1990.

Barros, Anne. *Ornament and Object: Canadian Jewellery and Metal Art 1946-1996*. Toronto: Boston Mills Press, 1997.

Bayer, Fern. *The Ontario Collection*. Toronto: Ontario Heritage Collection, Fitzhenry & Whiteside, 1984.

Bothwell, Robert; Drummond, Ian; English, John. *Canada Since 1945: Power, Politics and Provincialism*. Toronto: University of Toronto Press, 1981.

Bradfield, Helen; Pringle, Joan; Rideout, Judy. *The Art of the Spirit: Contemporary Canadian Fabric Art*. Toronto: Dundurn Press, 1992.

Cameron, Duncan. *Campus in the Clouds*. Toronto: McClelland & Stewart Limited, 1956.

Cartlidge, Barbara. *Twentieth-Century Jewelry*. New York: Harry N. Abrams Inc., 1985.

Chalmers, Floyd S. *Both Sides of the Street*. Toronto: MacMillan of Canada, 1983.

Clark, Garth. *A Century of Ceramics in the United States 1878-1978*. New York: Dutton, Everson Museum of Art, 1979.

American Ceramics 1866 to the Present. Revised Edition, New York: Abbeville Press, Inc., 1987.

The Potter's Art. London: Phaidon Press Limited, 1995.

Colchester, Chloë. *The New Textiles Trends + Traditions*. London: Thames and Hudson Ltd., 1994.

Corbett, E. A. *We Have With Us Tonight*. Toronto: The Ryerson Press, 1957.

Darling, Sharon S. *Chicago Metalsmiths*. Chicago: Chicago Historical Society, 1977.

Dormer, Peter. *Design Since 1945*. London: Thames and Hudson Ltd., 1993.

The New Ceramics Trends + Traditions. Revised Edition. London: Thames and Hudson Ltd., 1994.

The New Furniture Trends + Traditions. London: Thames and Hudson Ltd., 1987.

Dormer, Peter; Turner, Ralph. *The New Jewelry Trends + Traditions*. Revised Edition. London: Thames and Hudson, Ltd., 1994.

Greene, H. Gordon (ed). *A Heritage of Canadian Handicrafts*. Toronto: McClelland & Stewart Limited, 1967.

Gwyn, Sandra. *The Private Capital*. Toronto: McClelland and Stewart Limited, 1984.

Tapestry of War. Toronto: Harper Collins Publishers Ltd., 1992.

Horn, Michiel. *The League for Social Reconstruction Intellectual Origins of the Democratic Left in Canada 1930-32*. Toronto: University of Toronto Press, 1980.

Ioannou, Noris (ed). *Craft in Society: An Anthology of Perspectives*. South Fremantle: Fremantle Arts Centre Press, 1992.

Jarvis, Alan (ed). *Douglas Duncan A Memorial Portrait*. Toronto: University of Toronto Press, 1974.

Kardon, Janet (ed). *The Ideal Home: The History of Twentieth Century American Craft 1900-1920*. New York: Henry N. Abrams Inc., 1993.

Kidd, J. Roby and Selman, Gordon R. (ed). *Coming of Age: Canadian Adult Education in the 1960s*. Toronto: Canadian Association for Adult Education, Welcome Limited, 1978.

Kidd, J. R. (ed). *Adult Education in Canada*. Toronto: Canadian Association for Adult Education, Garden City Press, 1950.

Lemon, James. *Toronto Since 1918*. Toronto: James Lorimer & Co., 1985.

Levin, Elaine. *The History of American Ceramics 1607 to the Present*. New York: Harry N. Abrams, Inc., 1988.

Liddell, Jill. *The Patchwork Pilgrimage*. New York: Viking Studio Books, 1993.

Litt, Paul. *The Muses The Masses and the Massey Commission*. Toronto: University of Toronto Press, 1992.

Lucie-Smith, E. *The Story of Craft: The Craftsman's Role in Society*. Ithaca, N.Y.: Cornell University Press, 1981.

MacSkimming, Roy. *For Art's Sake: A History of the Ontario Arts Council 1963-1983*. Toronto: Ontario Arts Council, 1983.

Manhart, M. and Manhart, T. (eds). *The Eloquent Object: The Evolution of the American Art in Craft Media Since 1945*. Tulsa: The Philbrook Museum of Art, 1987.

Margetts, Martina (ed). *International Crafts*. New York: Thames & Hudson Inc., 1991.

Massey, Hart (intro). *The Craftsman's Way: Canadian Expressions*. Toronto: University of Toronto Press, 1981.

Stephen Harris Designer/Craftsman. Toronto: Boston Mills Press, 1994.

McCall-Newman, Christina. *Grits*. Toronto: MacMillan of Canada, 1982.

McMorris, Penny and Kile, Michael. *The Art Quilt*. San Francisco: Quilt Digest Press, 1986.

McNaught, Kenneth. *A Prophet in Politics: a Biography of J. S. Woodsworth*. Toronto: University of Toronto Press, 1959.

McRae, D.G.W. *The Arts and Crafts of Canada*. Toronto: The MacMillan Company of Canada Limited, 1944.

Norris, Jessie A. *The Book of Giving*. Toronto: OHS, 1979.

Nowell, Iris. *Women Who Give Away Millions: Portraits of Canadian Philanthropists*. Toronto: Hounslow Press, 1996.

Parkin, Jeanne. *Art in Architecture: Art For the Built Environment*. Toronto: Visual Arts Ontario, 1982.

Paz, Octavio. *In Praise of Hands: Contemporary Crafts of the World*. Toronto: McClelland and Stewart, 1974.

Rice, Paul. *British Studio Ceramics in the 20th Century*. London: Barrie & Jenkins, 1989.

Robertson, Seonaid Mairi. *Craft and Contemporary Culture*. London: UNESCO, George G. Harrap & Co. Ltd., 1961.

Ross, Judy Thompson. *Down To Earth*. Toronto: Nelson Canada Limited, 1980.

Ross, Malcolm (ed). *The Arts in Canada: A Stocktaking at Mid-Century*. Toronto: MacMillan, 1958.

Russ, Joel and Lynn, Lou. *Contemporary Stained Glass: A Portfolio of Canadian Work*. Toronto: Doubleday Canada Limited, 1985.

Shadbolt, Doris. *Bill Reid*. Vancouver/ Toronto: Douglas & McIntyre, 1986.

Shenstone, Douglas A. *For The Love of Pewter*. Toronto: Metal Arts Guild, 1990.

Thomson, Watson. *Pioneer in Community: Henri Lasserre's Contribution to the Fully Cooperative Society*. Toronto: The Ryerson Press, 1949.

Tippett, Maria. *Making Culture: English-Canadian Institutions and the Arts Before the Massey Commission*. Toronto: University of Toronto Press, 1990.

Volpe, Tod M. and Cathers, Beth. *Treasures of the American Arts and Crafts Movement 1890-1920*. New York: Harry N. Abrams, Inc., 1988.

Walker, Marilyn. *Ontario's Heritage Quilts*. Toronto: Stoddart, 1992.

Watson, Oliver. *Studio Pottery: Twentieth Century British Ceramics in the Victoria and Albert Museum Collection*. London: Phaidon, 1994.

Withrow, Oswald C. J. *The Romance of the Canadian National Exhibition*. Toronto: Reginald Saunders, 1936.

Wright, Virginia. *Modern Furniture Design in Canada 1920-1970*. Toronto: University of Toronto Press, 1997.

Acknowledgements

Any book that centres on people requires more thank-yous than space allows. First and foremost, none of my research and photographic documentation could have happened without incentive funding and moral support from three sectors: The Jean A. Chalmers Fund for the Crafts, administered by the Canada Council for the Arts; The Ontario Heritage Foundation; and the Ontario Arts Council's Design Arts Programme, which, sadly, no longer exists. Words cannot express what their backing has meant. Essential, too, was assistance and support from my cultural partner, the Burlington Art Centre, under its able and enthusiastic director, Ian Ross.

In the world of archives, where I spent so much time, I must single out the University of Waterloo's Susan Bellingham and Jane Britton, who administer the Breithaupt Hewetson Clark Collection. Apart from being a joy to work with in person and via fax, the two have an appreciation and knowledge of their material that set a standard for the entire field. At the Archives of Ontario, Greg Brown went beyond the call of duty time and again, and assistance was always willingly provided in the reading room by a corps of professionals, most notably Leon Warmsky and Karen Bergsteinsson. At the Royal Ontario Museum, Julia Matthews and Charlotte Goodwin cheerfully ferreted out the obscure.

Craftspeople themselves gave generously of their time in talking to me, some at great length, when I'm sure they would have much preferred to be at their wheels or jeweller's benches. Many names appear in these pages, but there are legions of others who have provided background, interpretation, insights, and, in some cases, photographs. Among those who were badgered by fax and phone for minute details, and never complained, were Anne Barros, Marie Aiken-Barnes and Gordon Barnes, Aggie Beynon, Dorothy Burnham, "Bunty" Hogg, Tess Kidick, Nancy Meek Pocock, Jorgen Poshmann, Ann Roberts, Donn Zver. Early in my project Ann Mortimer made available to me photographic material from the Canadian Guild of Potters, which, in a far-sighted move she had rounded up from older members during her presidency. Teresa Casas provided her graduate paper on the early years of the Potters Guild and allowed me to quote from it. Susann Greenaway, Betty Kirby, Connie Jefferess, Jane Mahut, Roz Morrison, Ron Roy, Adam Smith, Jonathan Smith, Walter Sunahara, Joan and Gerry Tooke, and Peter Weinrich also filled in cracks and helped set the record straight.

Families, too, came to my rescue. In New Brunswick, Renee Renzius Brandie was invaluable in piecing together the career of her father, Rudy Renzius. Without Callie Stacey and her brother Robert, I would not have been able to write more than a few terse sentences about their father Harold; Joan Fussell was unstinting in providing information about her father, Andrew, and lending me work to be photographed; Janette McGibbon did the same for her uncle, Douglas Boyd, and William Bannister for his mother, "Rie" Donker Bannister. With uncommon generosity and trust, Adria Zavi Trowhill lent me the scrapbooks of her mother, Nunzia D'Angelo, and allowed me to have work by both her parents photographed. Judy Pocock Watson generously lent me her mother's, Nancy Meek's, wartime letters, and provided insights into growing up in a craft-centred world. Private owners of craftwork were similarly obliging and cooperative as were craftspeople themselves, so that assembling images of work was a joy and pleasure. Most of the historical pieces were photographed by the incomparable Peter Hogan, who time and again served as father figure, sounding board, and soother of frazzled nerves.

A heartfelt debt of gratitude also goes to those who discussed the manuscript with me at various stages in its development. Their comments were sometimes painful, always insightful, and absolutely invaluable: Anne Barros, Belinda Beaton, Keith Betteridge, Joan Chalmers, Gerry Crawford, Susan Eckenwalder, Sandra Flood, Robert Jekyll, Marianne Kearney, Ellen McLeod, Shirley Morriss, Stuart Reid, and Lindsay Rogan. Much appreciated were encouragement by M. Joan Chalmers for the concept, coupled with the enthusiastic support and initial direction by Arnold Edinborough and Stephen Inglis. I was truly blessed by having as guide, reader, and mentor my sister, Joan Clark, an established novelist in her own right, who kept me on track over a five-year period. At my side was my husband, Gerry Crawford, who shouldered his way through craft exhibitions, studio tours, retail shops, endless drafts, proofreading, and innumerable panic attacks. His support, financial and emotional, was unwavering, and this book owes a great deal to his constancy.

Index: Individuals